# NATIONAL PARKS OF AMERICA

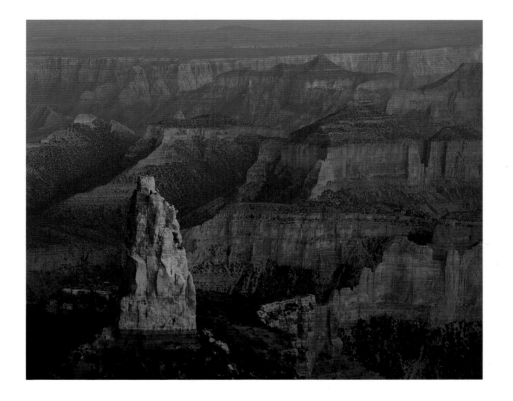

GRAPHIC ARTS CENTER PUBLISHING™

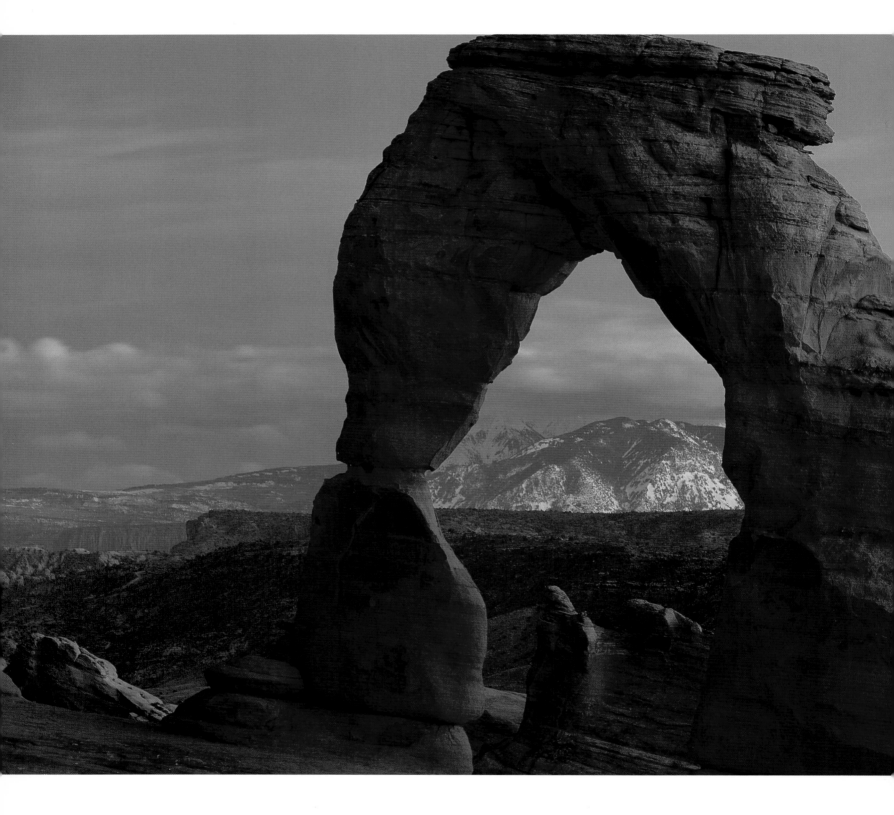

PHOTOGRAPHY BY DAVID MUENCH

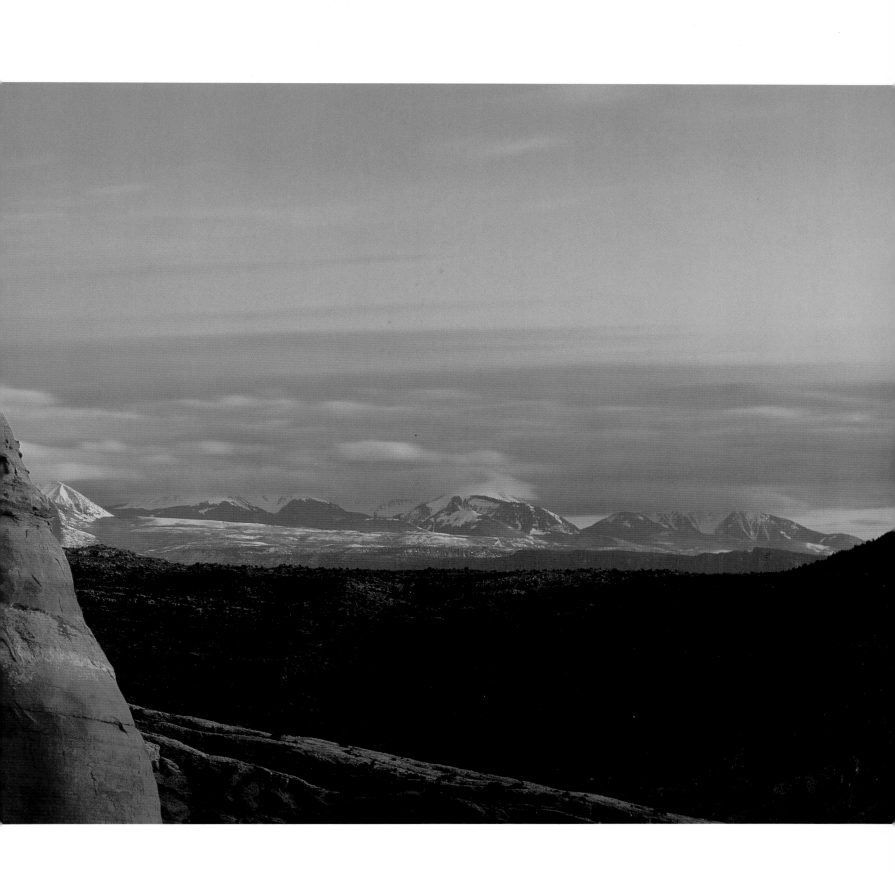

ESSAY BY STEWART L. UDALL AND JAMES R. UDALL

TO THE DEDICATED NATIONAL PARK SERVICE PEOPLE, PAST AND PRESENT, WHOSE
VISION AND HARD EFFORTS ARE SOURCES OF INSPIRATION AND INTERPRETATION
FOR THE PRESERVATION OF OUR NATIONAL PARKS' NATURAL BEAUTY.
DAVID MUENCH

▬ ▬ ▬

INTERNATIONAL STANDARD BOOK NUMBER 1-55868-124-8

LIBRARY OF CONGRESS NUMBER 93-70509

© MCMXCIII BY GRAPHIC ARTS CENTER PUBLISHING COMPANY

P.O. BOX 10306 • PORTLAND, OREGON 97210 • 503/226-2402

PRESIDENT • CHARLES M. HOPKINS

EDITOR-IN-CHIEF • DOUGLAS A. PFEIFFER

MANAGING EDITOR • JEAN ANDREWS

DESIGNER • BONNIE MUENCH

PRODUCTION MANAGER • RICHARD L. OWSIANY

CARTOGRAPHER • ORTELIUS DESIGN

TYPOGRAPHER • HARRISON TYPESETTING, INC.

COLOR SEPARATIONS • AGENCY LITHO

PRINTING • SHEPARD POORMAN

BINDING • LINCOLN & ALLEN

PRINTED IN THE UNITED STATES OF AMERICA

▬ ▬ ▬

HALF TITLE PAGE • GRAND CANYON NATIONAL PARK
TITLE PAGE • ARCHES NATIONAL PARK
OPPOSITE • WRANGELL-ST. ELIAS NATIONAL PARK AND PRESERVE

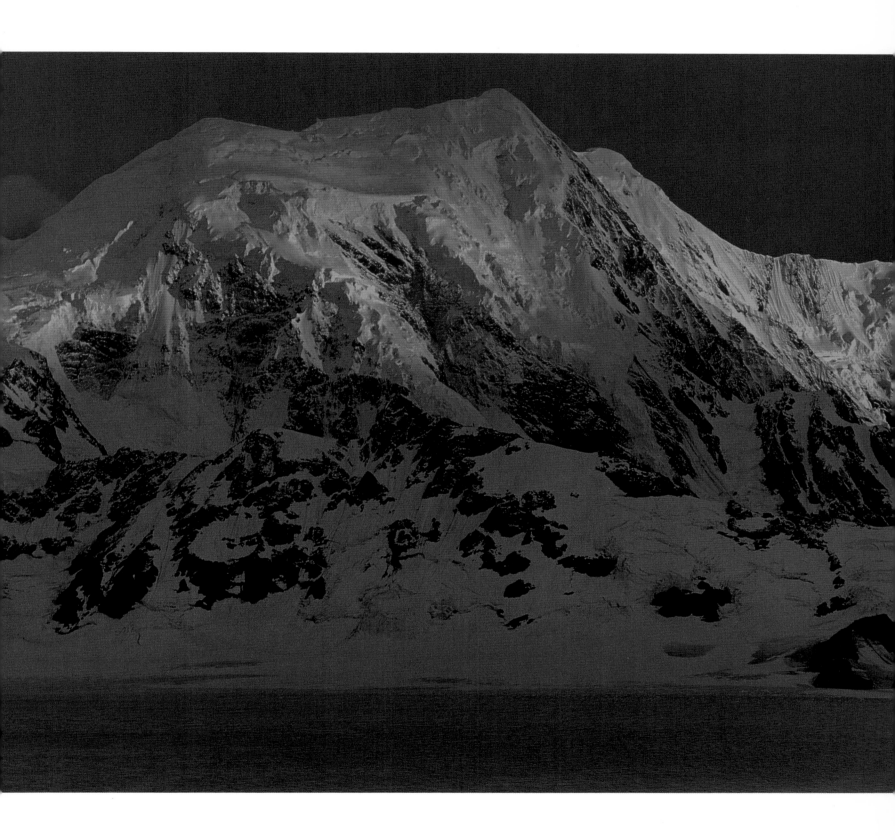

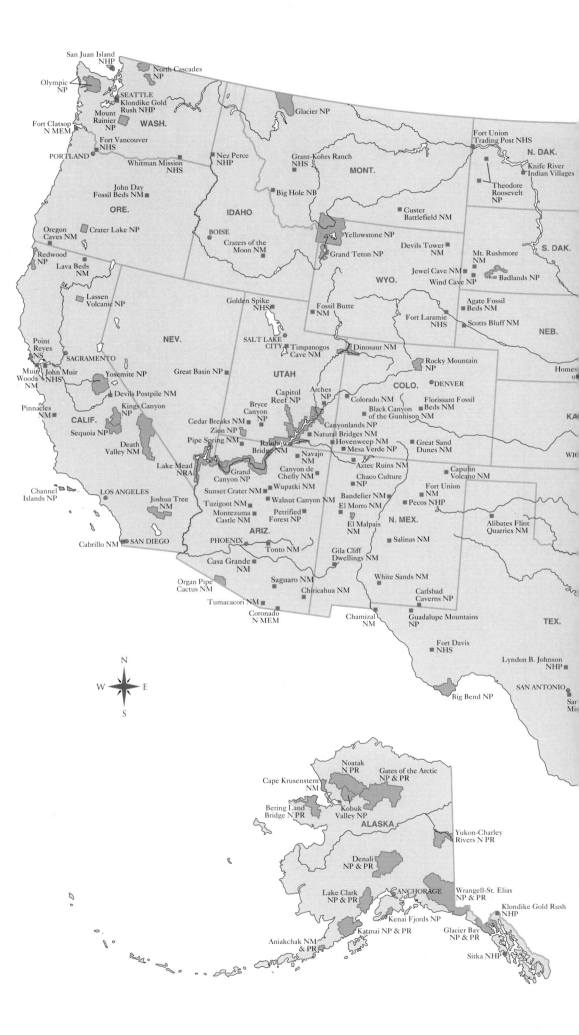

# NATIONAL PARKS OF AMERICA

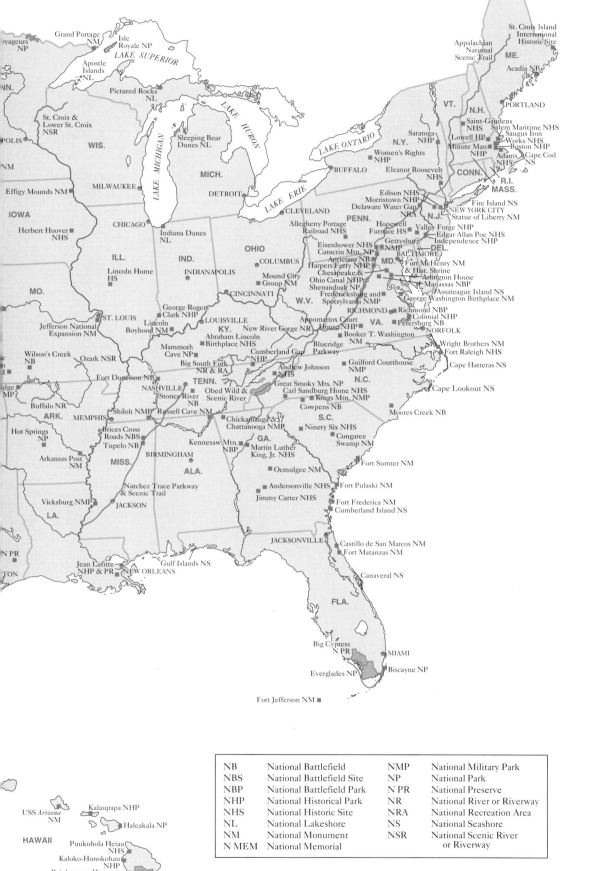

| | | | |
|---|---|---|---|
| NB | National Battlefield | NMP | National Military Park |
| NBS | National Battlefield Site | NP | National Park |
| NBP | National Battlefield Park | N PR | National Preserve |
| NHP | National Historical Park | NR | National River or Riverway |
| NHS | National Historic Site | NRA | National Recreation Area |
| NL | National Lakeshore | NS | National Seashore |
| NM | National Monument | NSR | National Scenic River or Riverway |
| N MEM | National Memorial | | |

A TRIBUTE
by Stewart L. Udall and James R. Udall

From 1859 when Charles Weed made the first-known photographs of Yosemite, land-scape photography and the national parks have been inextricably intertwined. By bringing the majesty of Yellowstone and Yosemite to public attention, pioneer photographers like Weed, Carleton E. Watkins, and William Henry Jackson were, in a sense, the midwives of the park idea. From their day forward, landscape photography and the national park system have evolved together, each nourishing the other.

The luminous lineage of American photographers who have focused on the parks includes, among others, Timothy H. O'Sullivan, John K. Hillers, George Fiske, Laura Gilpin, Ansel Adams, Edward and Brett Weston, Eliot Porter, and the artist whose work is exhibited herein, David Muench.

This is David's thirty-first large-format book, and it offers an opportunity to contemplate the scope of his work. For three decades, he has trained his transcendental eye on our parklands, seeking to capture their magic in patterns of light and form. Where earlier photographers were often limited to one geographic region, with an assist from swifter modes of travel, David has made the continent his oyster. Roaming America in search of optical mysteries, each of his field trips is a journey of exploration.

Hinting of the challenge facing those who would capture the glory of the national parks on film, the late Ansel Adams once said, "The landscape is possibly the most difficult subject material to work with; it offers the minimum control of point of view in reference to composition and confronts the photographer with extremes of light and shadow. . . ." Anyone who has tagged along in mountain and desert with a landscape photographer in pursuit of a single perfect image, soon learns how difficult a stalk it is: There is the rise before dawn, the gear-laden, beast-of-burden trudge into position, the minute analysis of terrain and photographic possibility, and, of course, whether shivering or sweating, always the waiting. Then, in that fleeting, unpredictable moment when light and shadow and setting congeal, comes the rush to bracket the evanescent essence before it vanishes again. I admire the devotion that David Muench brings to his craft, which so often demands the stamina of a mountain goat and the patience of a pilgrim.

This man's work evinces a profound empathy for the natural world. It bespeaks a desire to discover images which will inspire viewers to become converts to the cause of conservation, foot soldiers in the struggle to preserve our wildlands. Indeed, one gets the feeling in turning these pages that David Muench feels that the national parks are cathedrals and is conducting an unending search for compositions that declare, "This is a sacred place. Let it remain inviolate!"

My spirit quickens each time it enters my mind that David Muench is still footloose, still searching near and far horizons for another perfect portrait of the American earth.

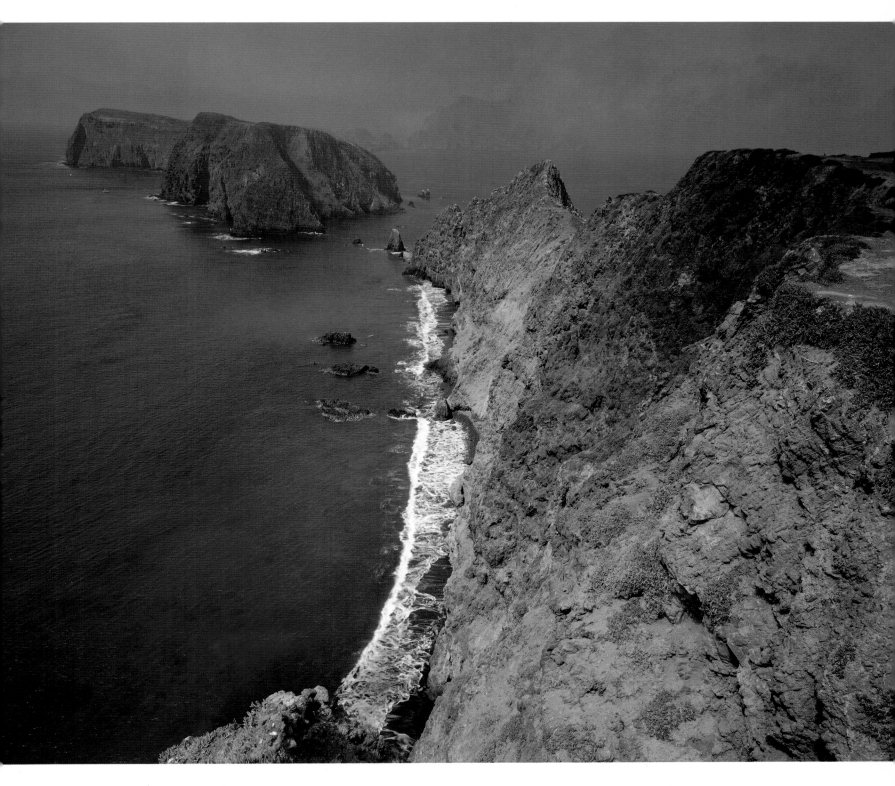

*The Channel Islands are of*

*the sea — craggy headlands,*

*quiet coves, and sandy beaches*

*surround five islands — isolated by*

*sculpturing forces of this Pacific*

*shoreline. Established 1980.*

ANACAPA ISLAND, CHANNEL ISLANDS

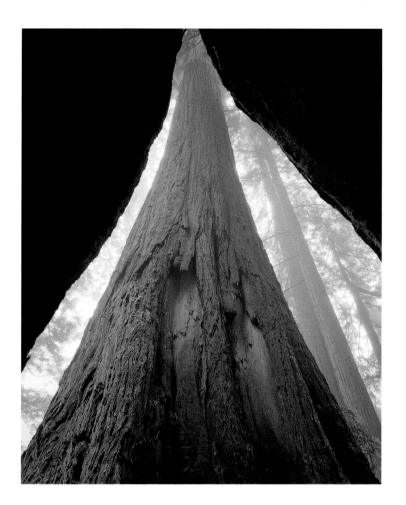

REDWOOD TRUNK, DEL NORTE REDWOODS

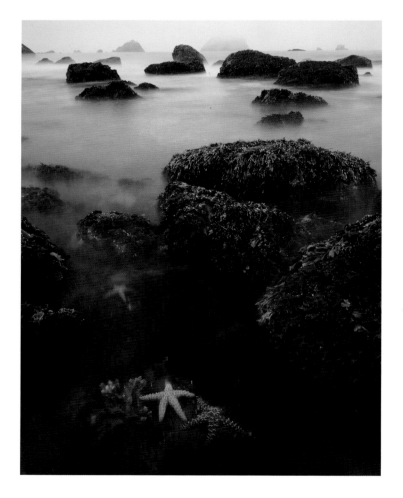

*Stillness and tranquility surround*

*the world's tallest living things.*

*Sequoia sempervirens tower into*

*fog-shrouded heights over all*

*other plants on earth. These*

*primeval ancients were crowded*

*by advancing ice sheets into*

*remnant stands along foggy*

*Northern California coastlines.*

*Redwood includes three state*

*parks—Prairie Creek, Jedidiah*

*Smith, Del Norte Coast. The park*

*was created in 1968, and is now*

*a World Heritage Site and*

*International Biosphere Reserve.*

TIDAL MOTION, DEL NORTE COASTLINE

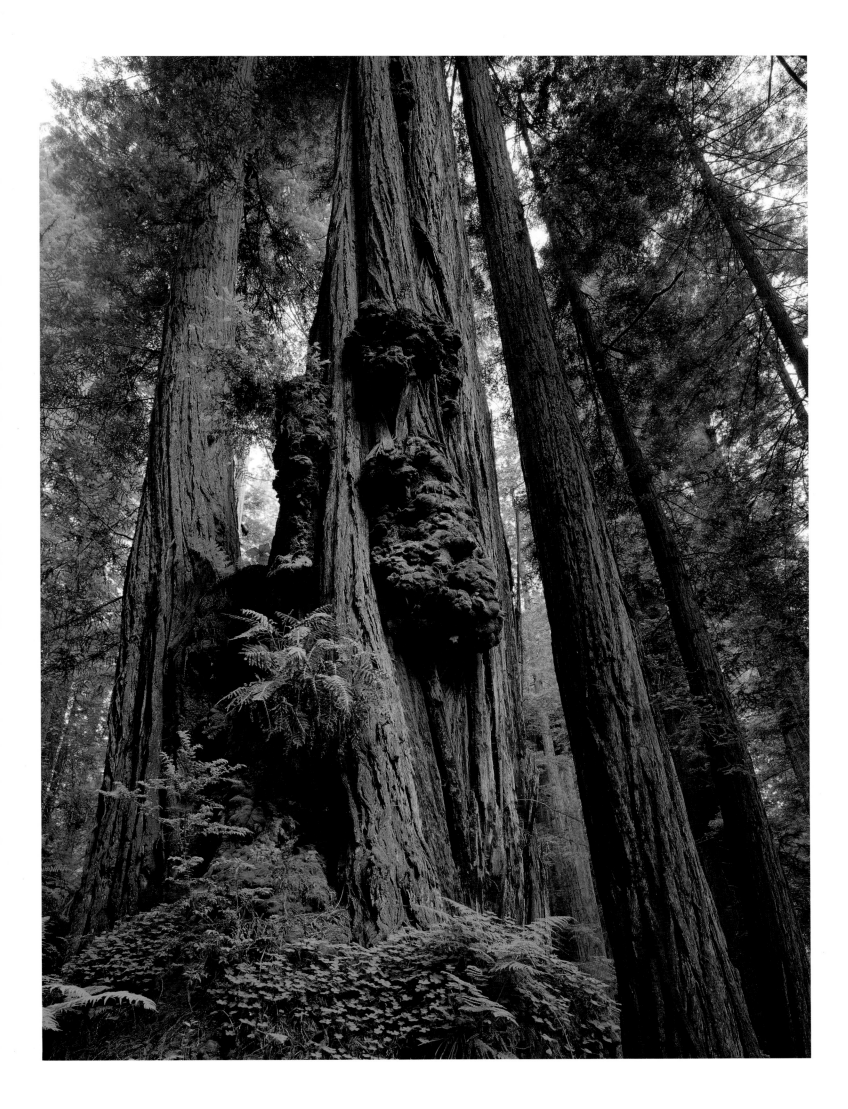

BURLED REDWOODS, PRAIRIE CREEK REDWOODS

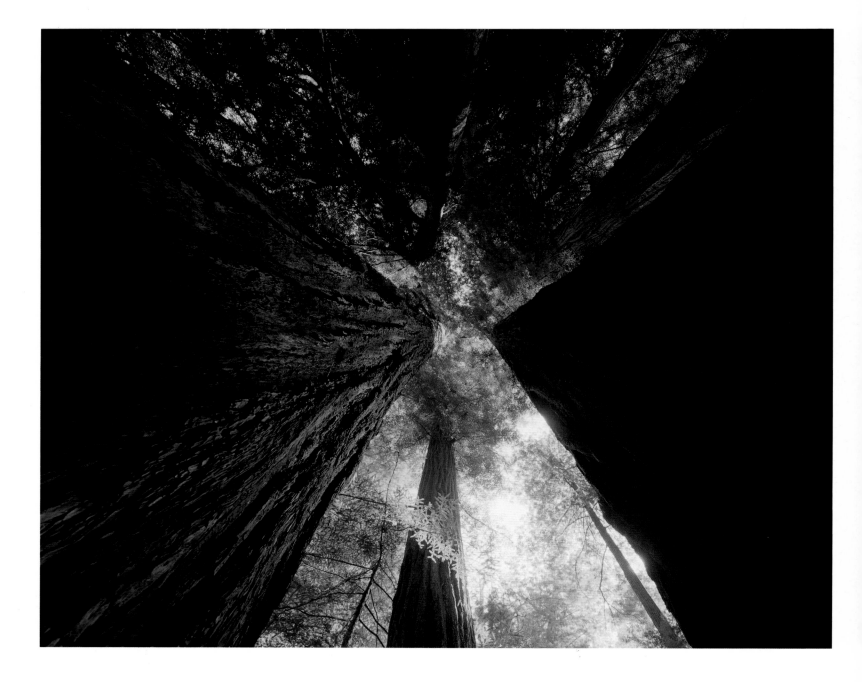

JEDIDIAH SMITH REDWOODS

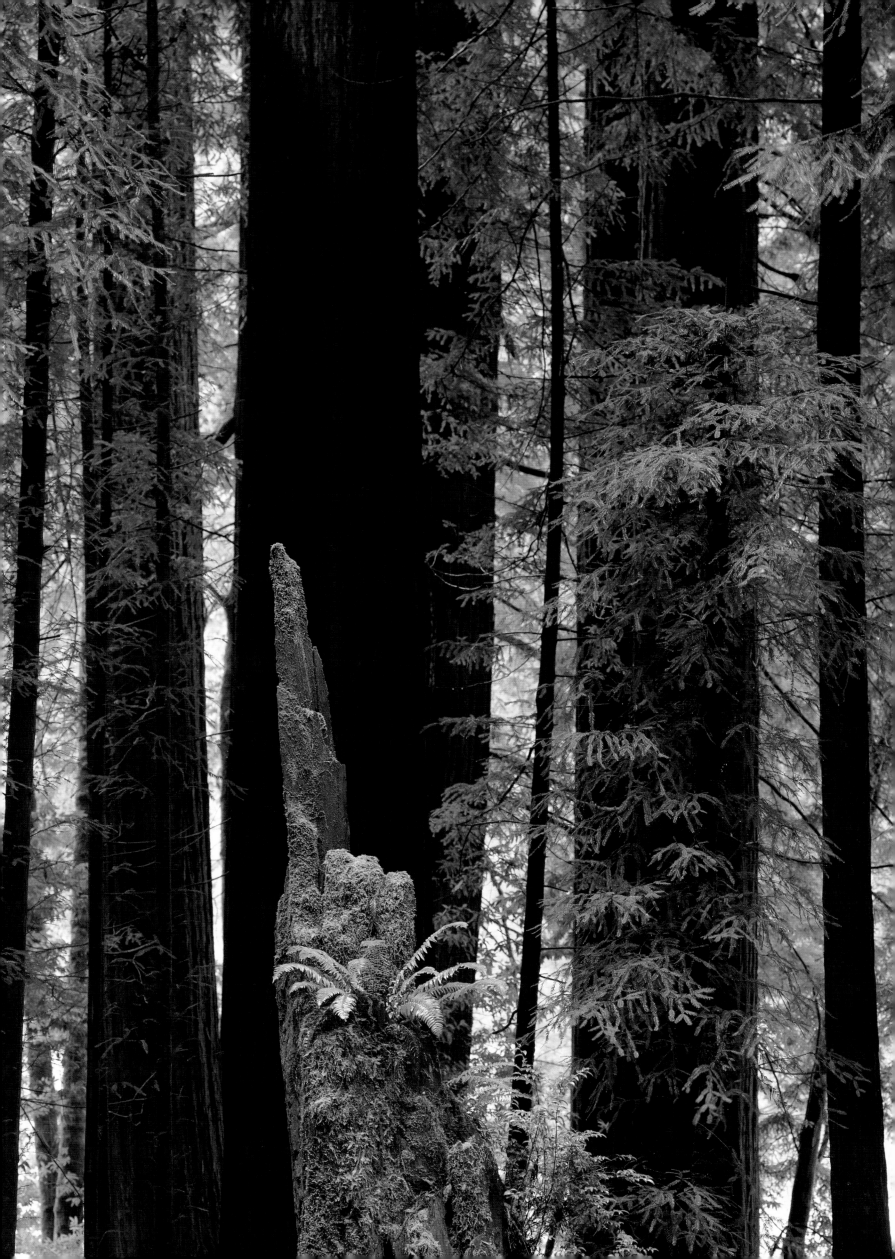

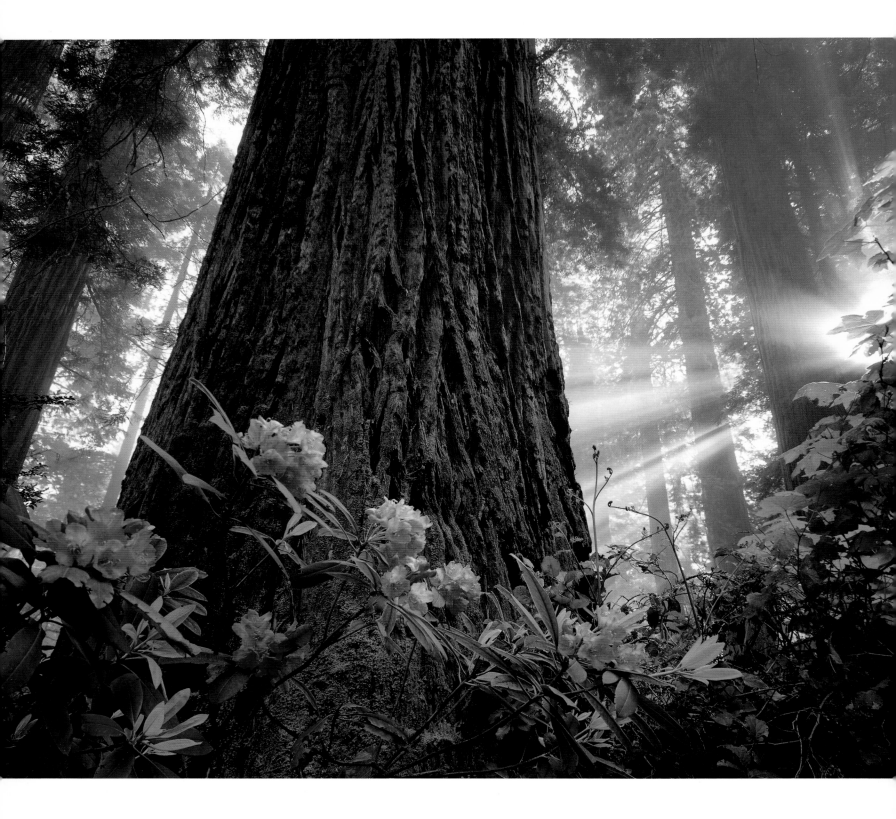

RHODODENDRON, DEL NORTE REDWOODS

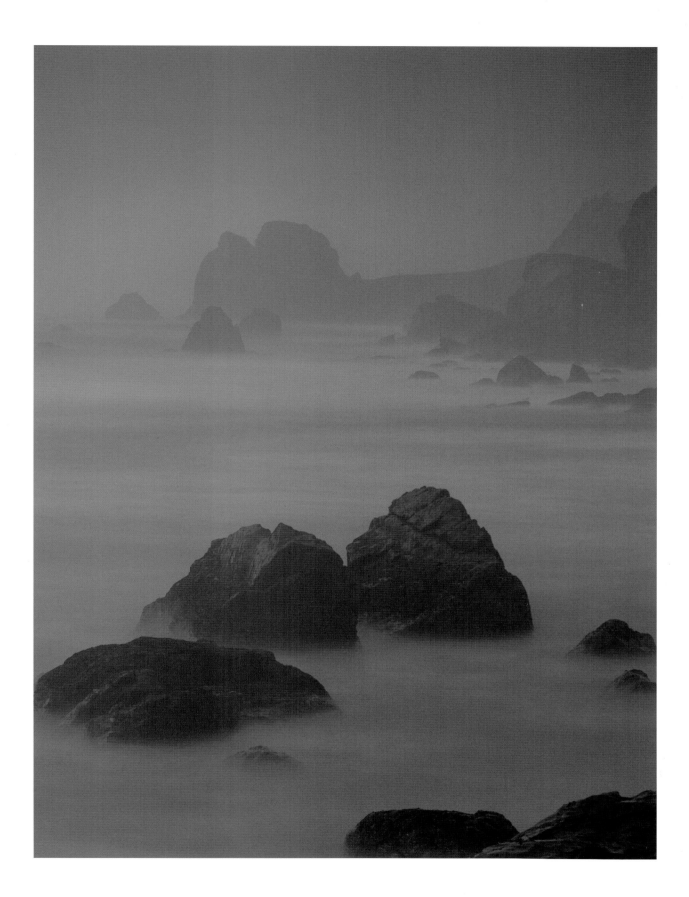

EVENING SURF, DEL NORTE

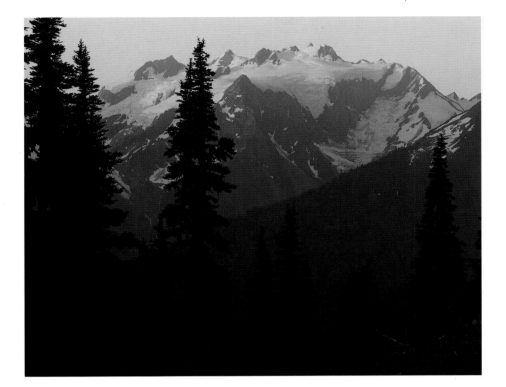

MOUNT OLYMPUS FROM THE HIGH DIVIDE

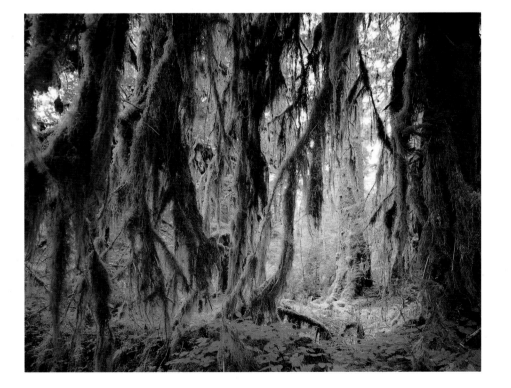

MOSS LADEN SPRUCE, HOH RAIN FOREST

*Three distinct ecosystems are shaped by water and ice — a Pacific shoreline, temporate rain forest, and alpine forest and meadow. The coastline of seastacks and tide pools are the dynamics of land meeting the sea. The community of dense, lush greenery — with maple and mosses, huge pines — makes up a rare temperate rain forest. Subalpine zones above thin out the forest to spacial wildflower spreads and stunted trees. Olympic was created in 1938 and is both a World Heritage Site and International Biosphere Reserve.*

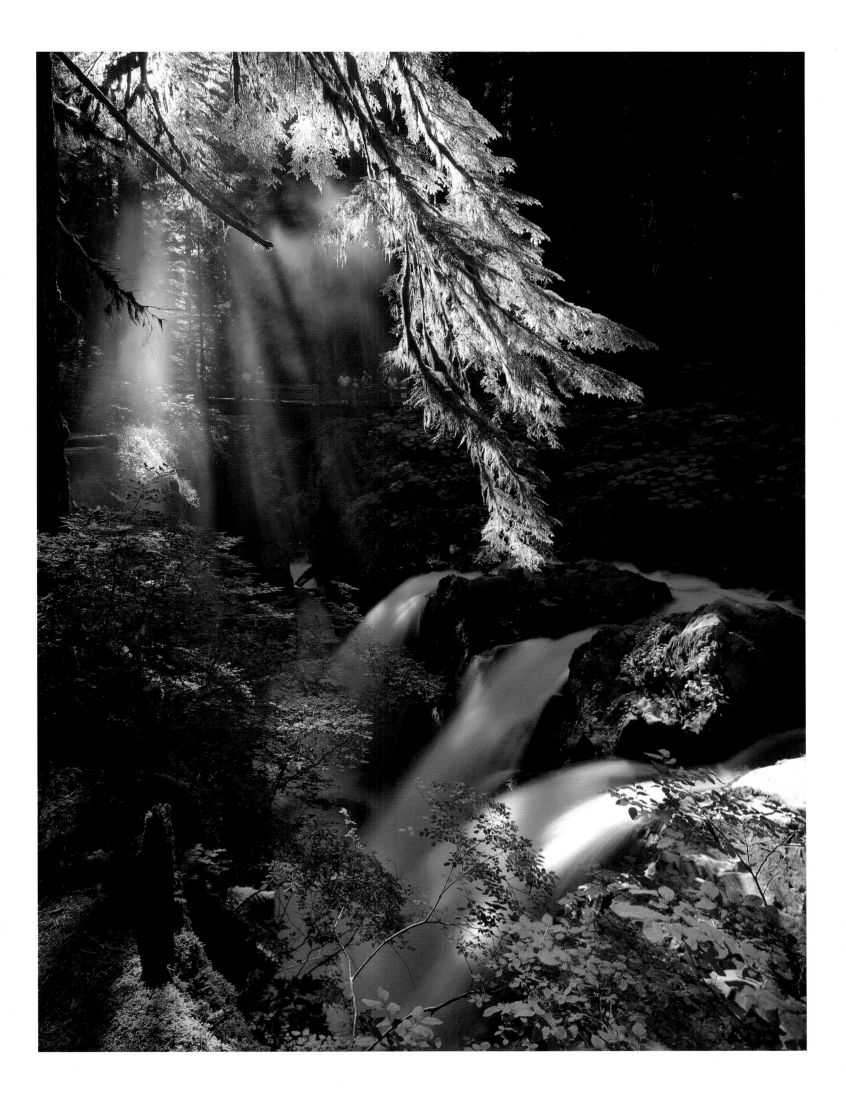

CASCADE, SOLDUC RIVER VALLEY

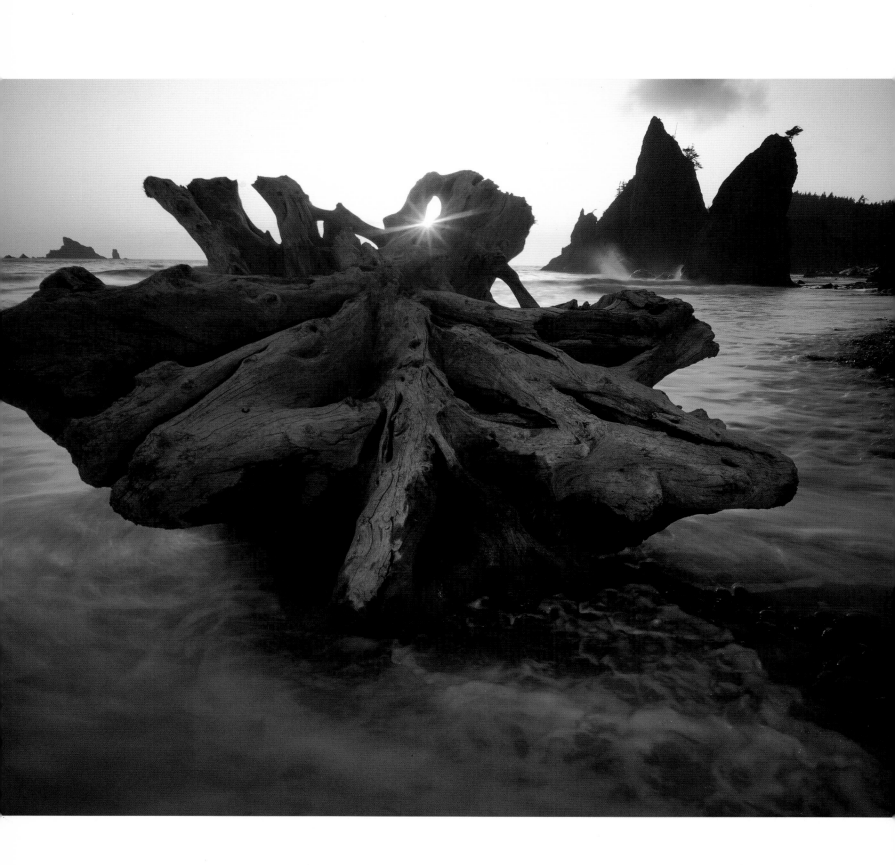

BLEACHED SPRUCE IN SURF, RIALTO BEACH

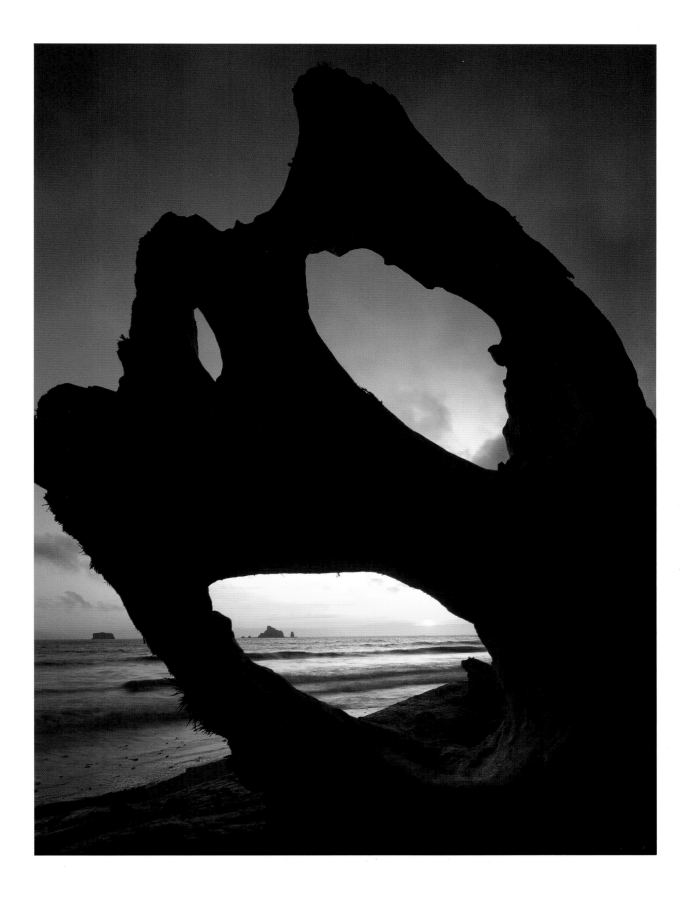

DRIFTWOOD WINDOWS, OLYMPIC COASTLINE

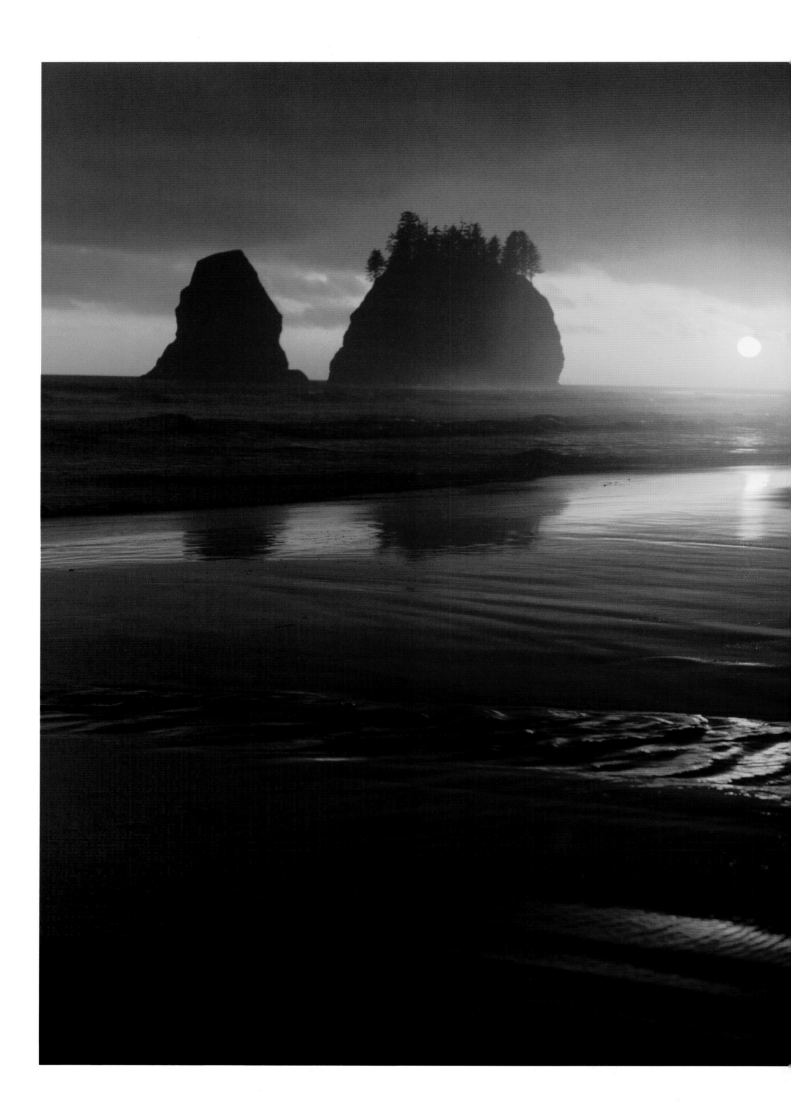

SEASTACKS, SECOND BEACH

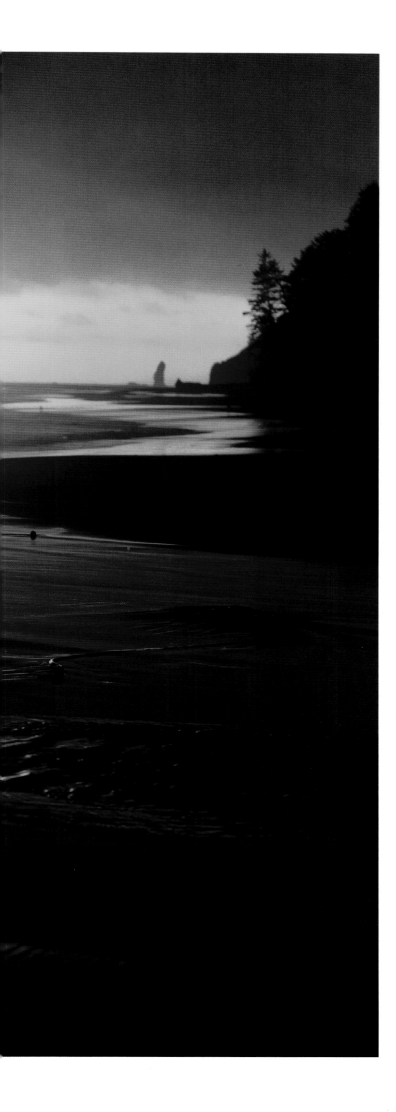

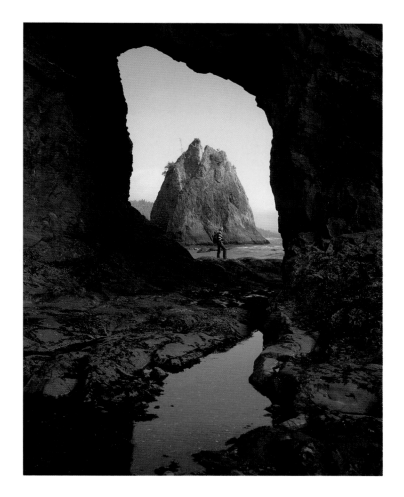

ARCH, RIALTO BEACH

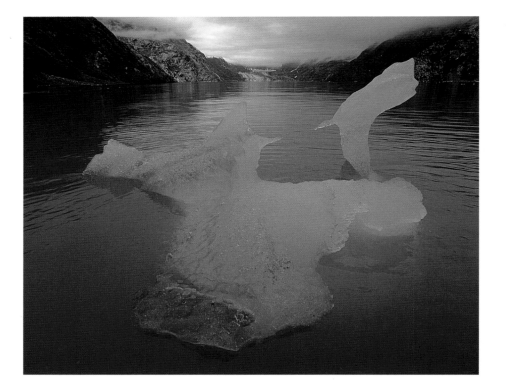

ICEBERG, JOHNS HOPKINS INLET

*Once beneath thousands of feet of ice, Glacier Bay is now an evolutionary landscape—a place of glacial retreat and advancing plant successions—an open book on primeval ice ages of the past. Spectacular remnants are some fifteen tidewater glaciers actively calving icebergs into the rhythms of tidal flow. Their hues betray origins—white are trapped air bubbles, blue are dense, green are of glacial bottoms. Established in 1980.*

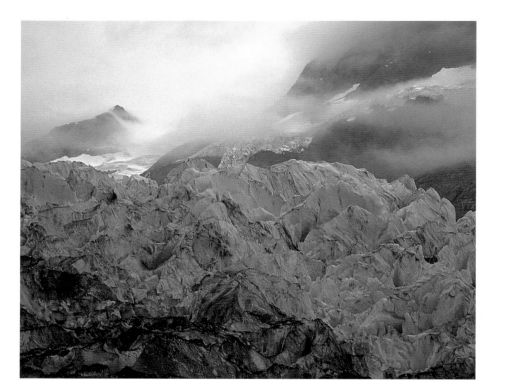

TIDEWATER GLACIER OF LAMPLUGH

LAMPLUGH GLACIER ICE FORMS

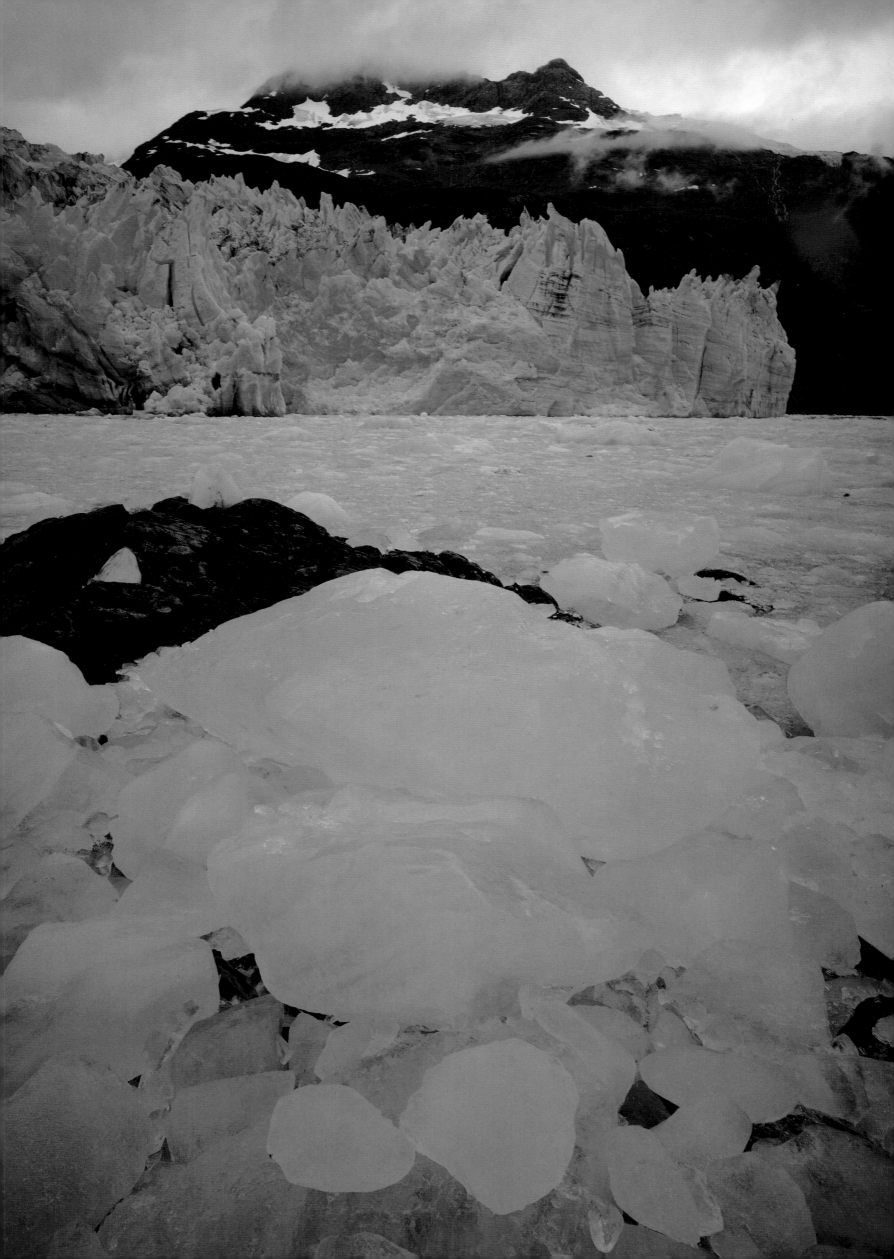

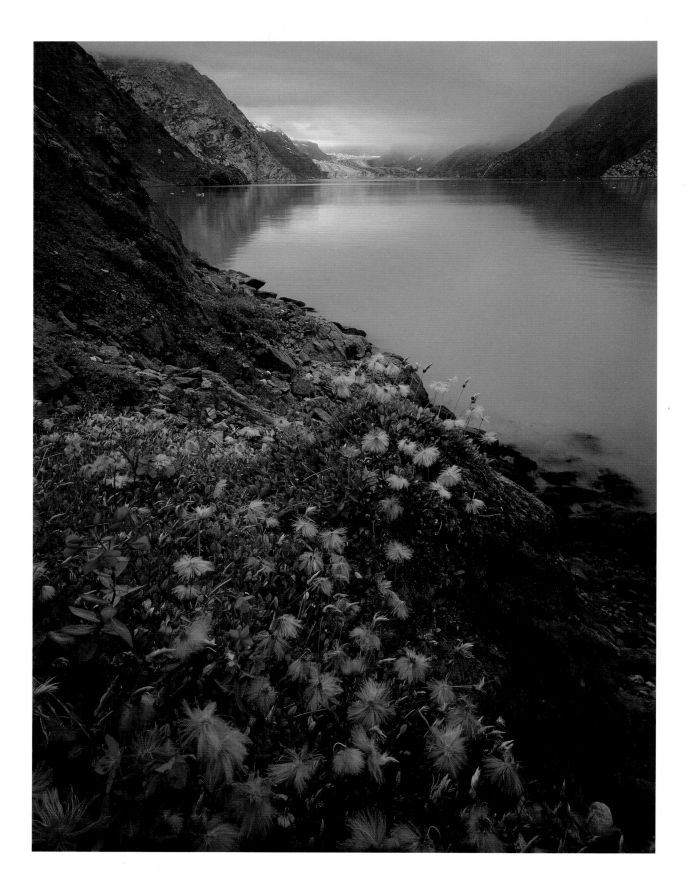

FIREWEED AND ARCTIC COTTON, JOHNS HOPKINS INLET

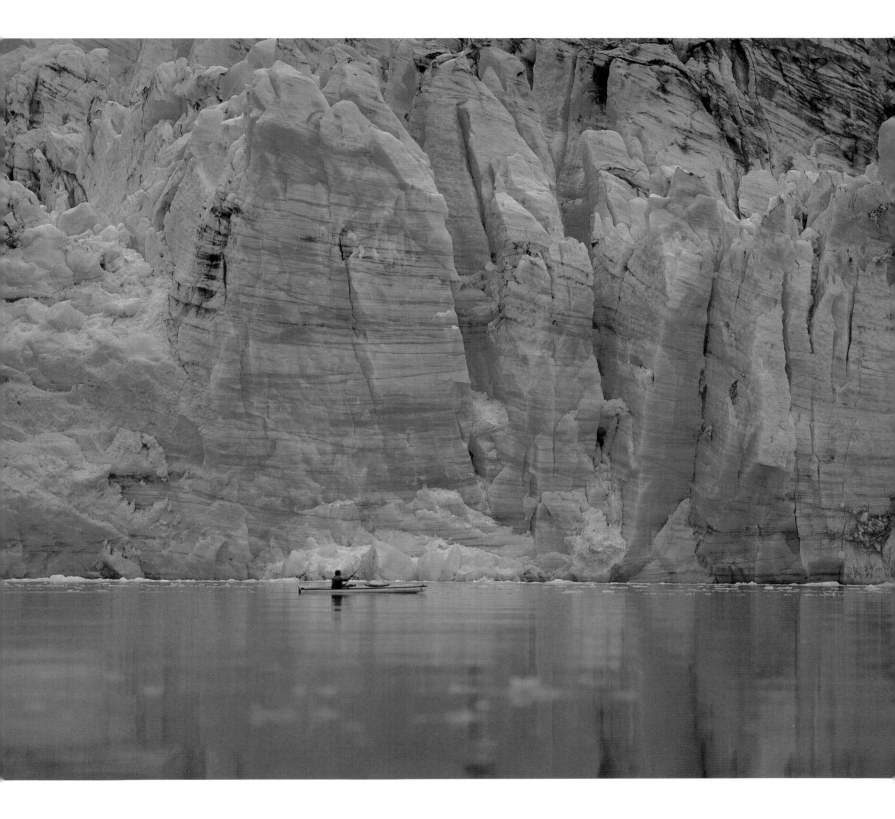

KAYAKER PASSES A TIDEWATER GLACIER

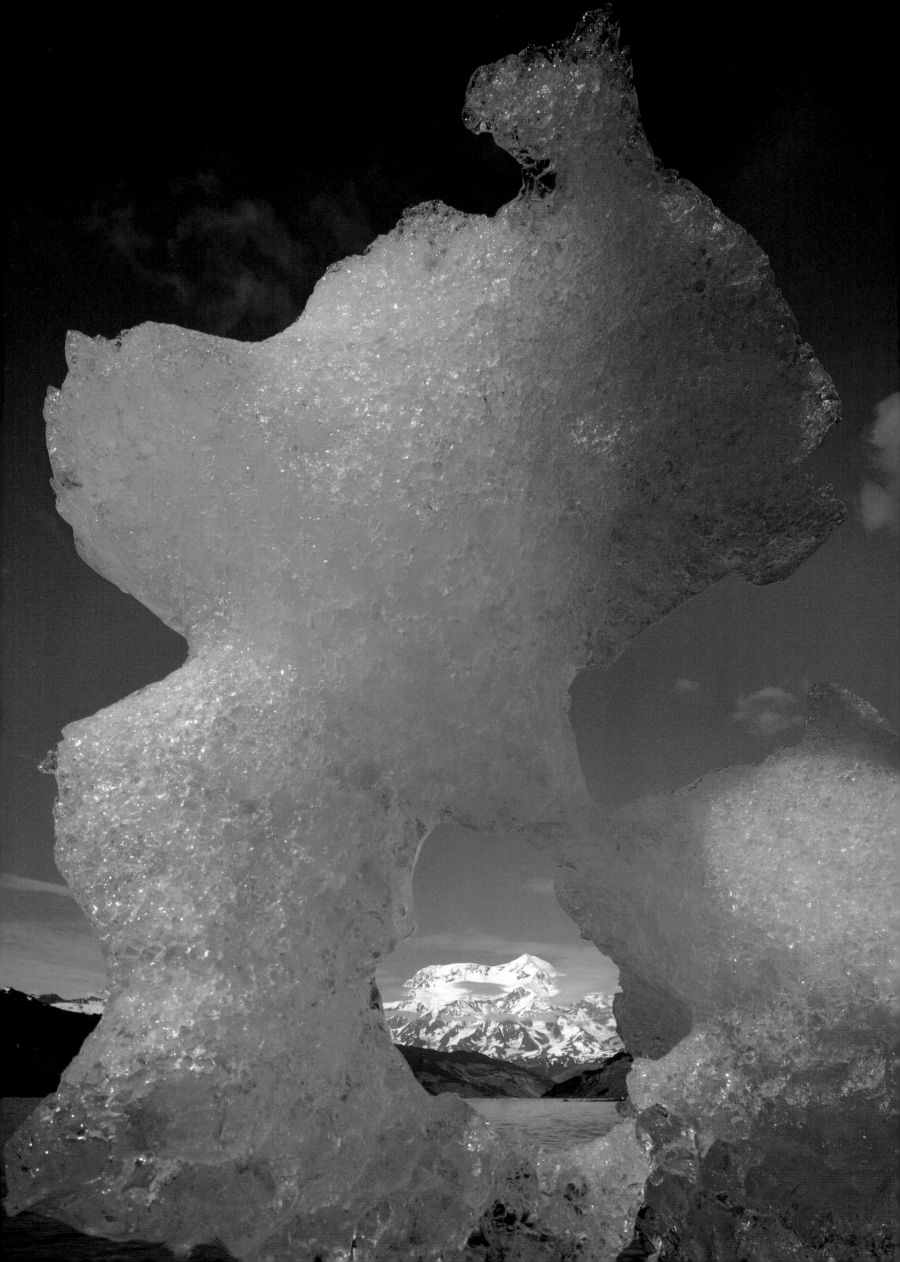

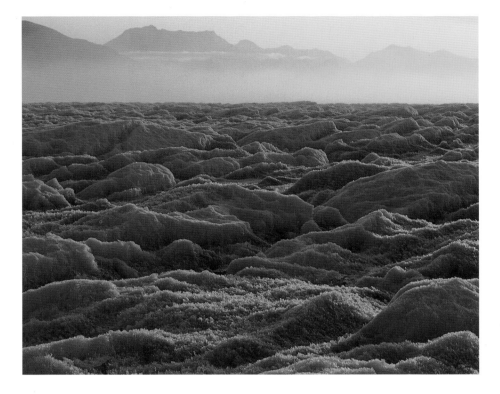

*Vast, rugged, enormous scale,*

*isolated, incredible — only begin*

*to hint the superlatives. Six*

*times the size of Yellowstone, this*

*is the largest park in the United*

*States. The world's tallest mountain*

*range is the St. Elias. Flying*

*over, you see ice and rivers*

*upon braided rivers, all under*

*changing impressions of light and*

*mood. The Wrangell and St. Elias*

*ranges combined hold nine of the*

*sixteen highest peaks in the*

*United States. Established 1980*

*and is a World Heritage Site.*

BAGLEY ICEFIELD, ST. ELIAS RANGE

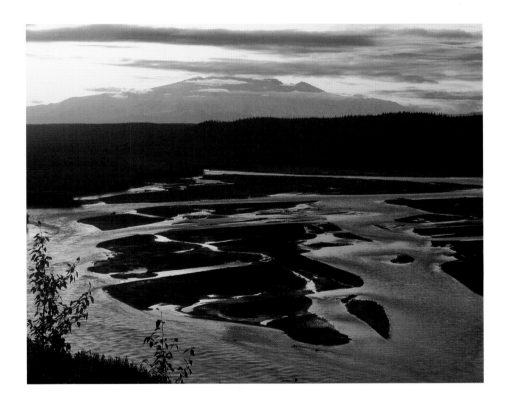

COPPER RIVER AND MOUNT SANFORD

MOUNT ST. ELIAS ABOVE ICY BAY

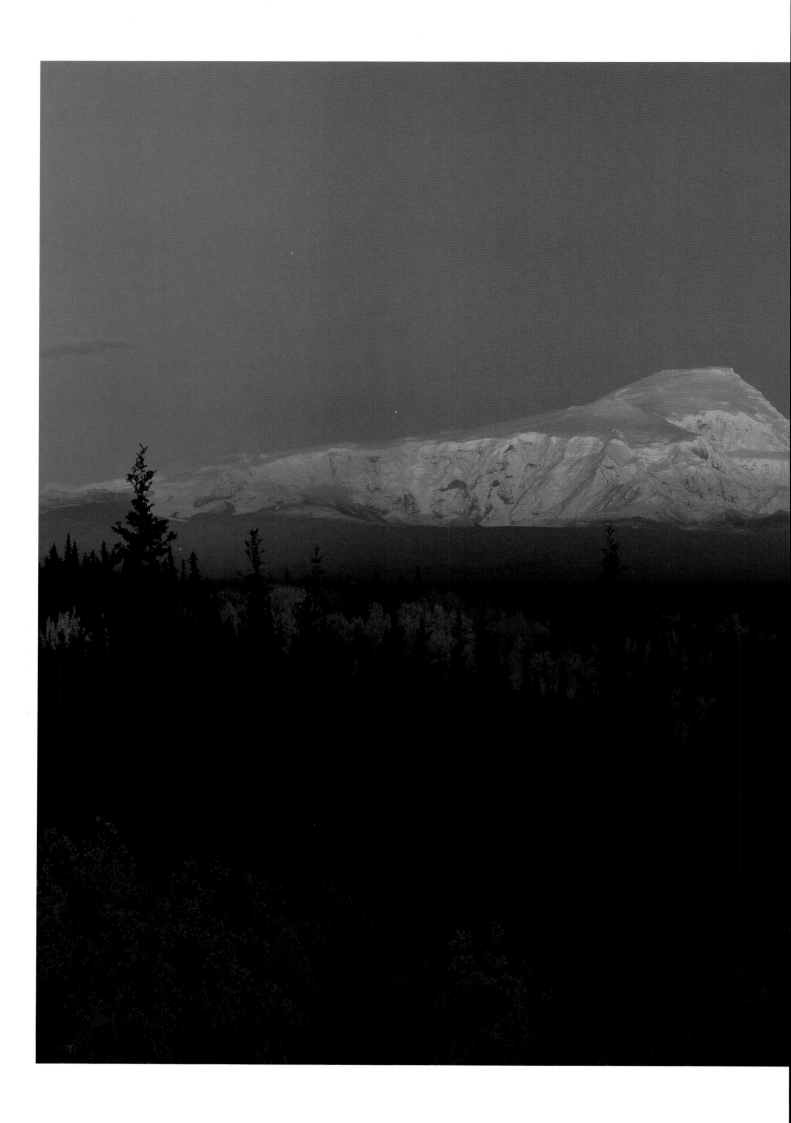

MOUNT SANFORD EVENING, WRANGELL RANGE

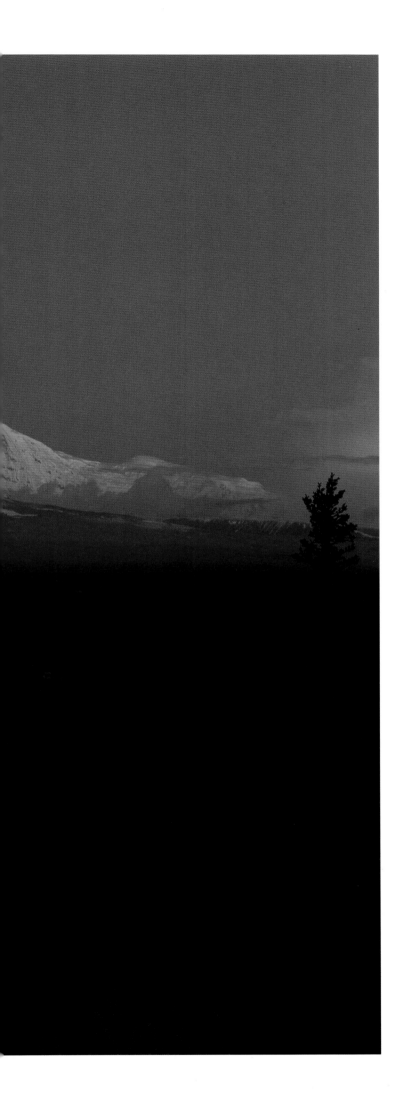

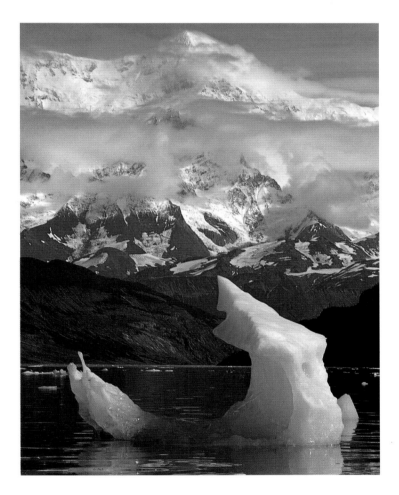

MOUNT ST. ELIAS, ICY BAY

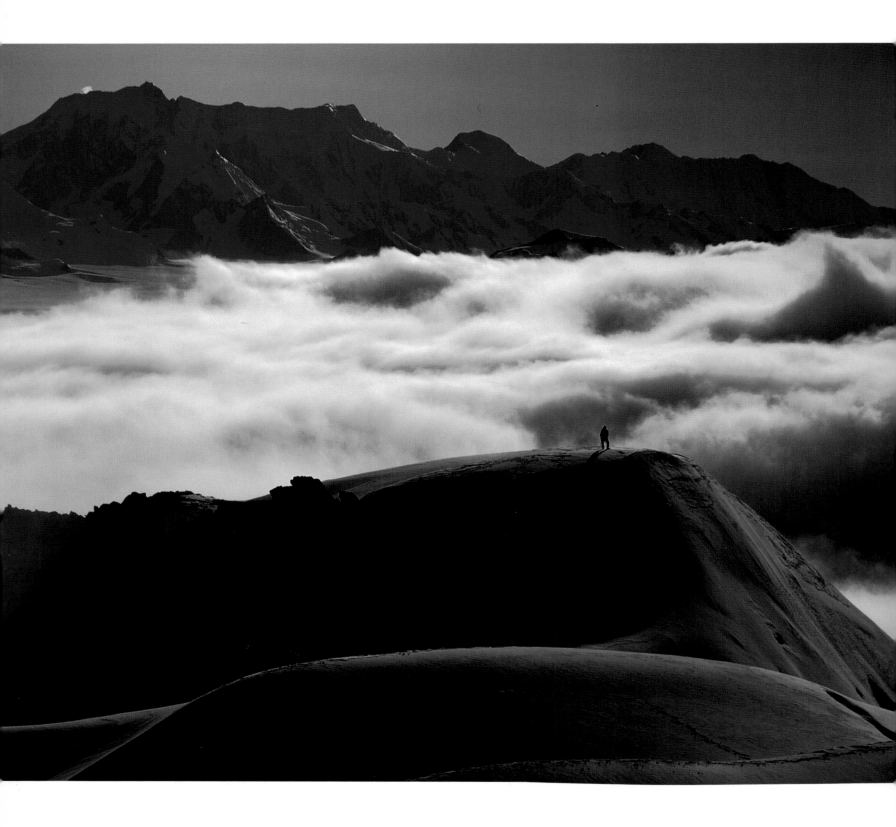

HIGH ABOVE THE ST. ELIAS RANGE

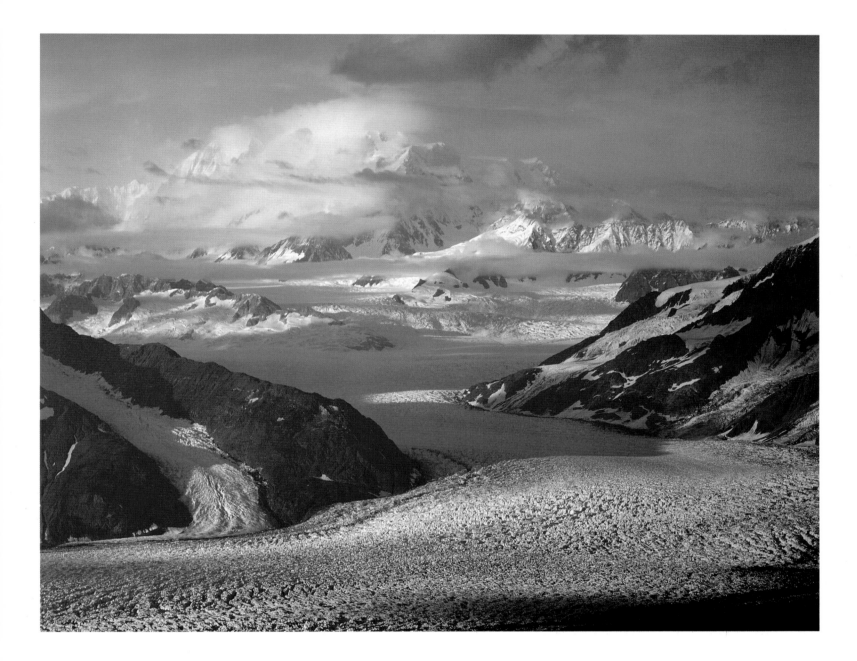

HUBBARD GLACIER AND MOUNT HUBBARD

BLEACHED SPRUCE ROOT SYSTEM, AIALIK GLACIER

*Carved by ancient ice and filled by waters of the Pacific, tidewater glaciers—trickling down from the Harding Icefield to sometimes fierce and stormy seas—are the essence of this dynamic coastal mountain landscape. Rocky peninsulas and headlands challenge waters of the Gulf of Alaska while the long fjords create some quiet interior coves and bays—like Harris, Aialik, Two Arm, and Thunder. Created 1980.*

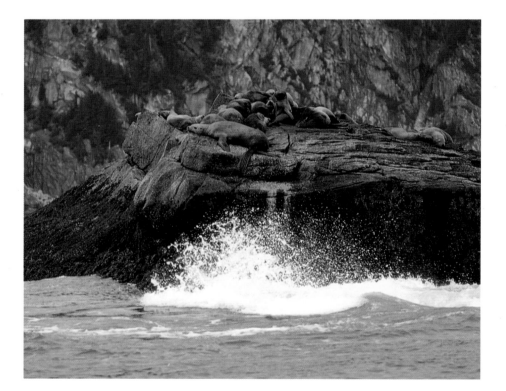

RESTING SEA LIONS IN HARRIS BAY

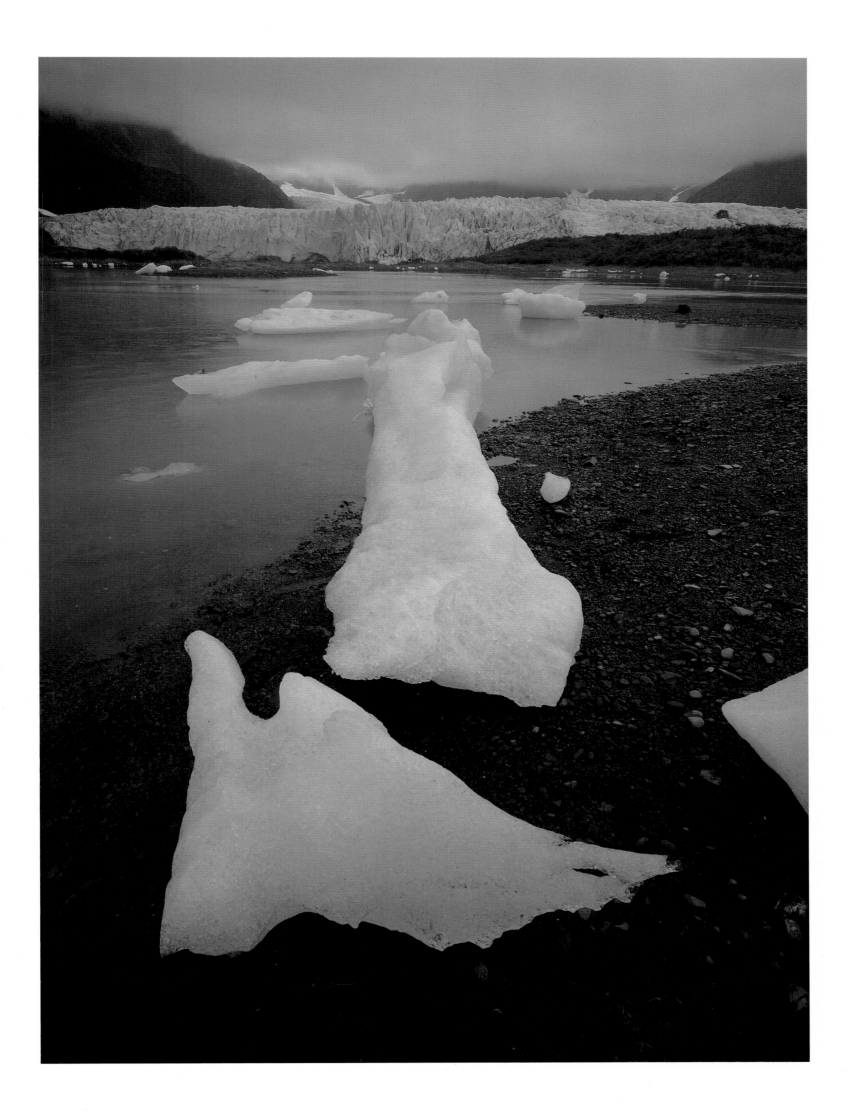

RECENTLY CALVED ICEBERGS, PEDERSON GLACIER

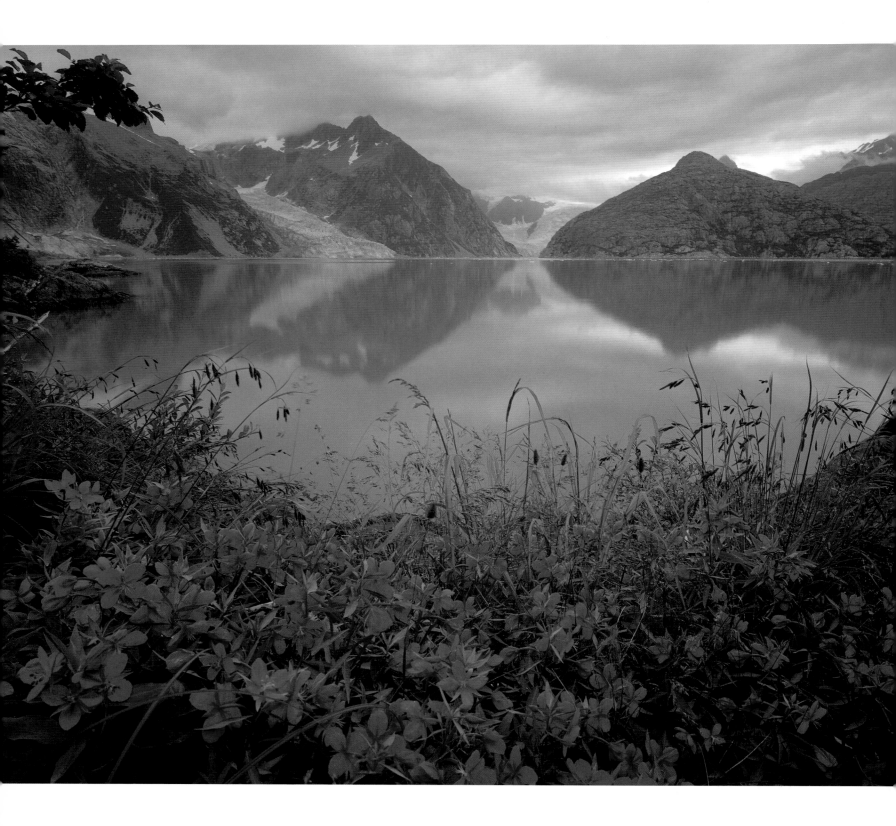

DWARF FIREWEED, NORTHWEST ARM, HARRIS BAY

GLACIAL INTERIOR, PEDERSON GLACIER

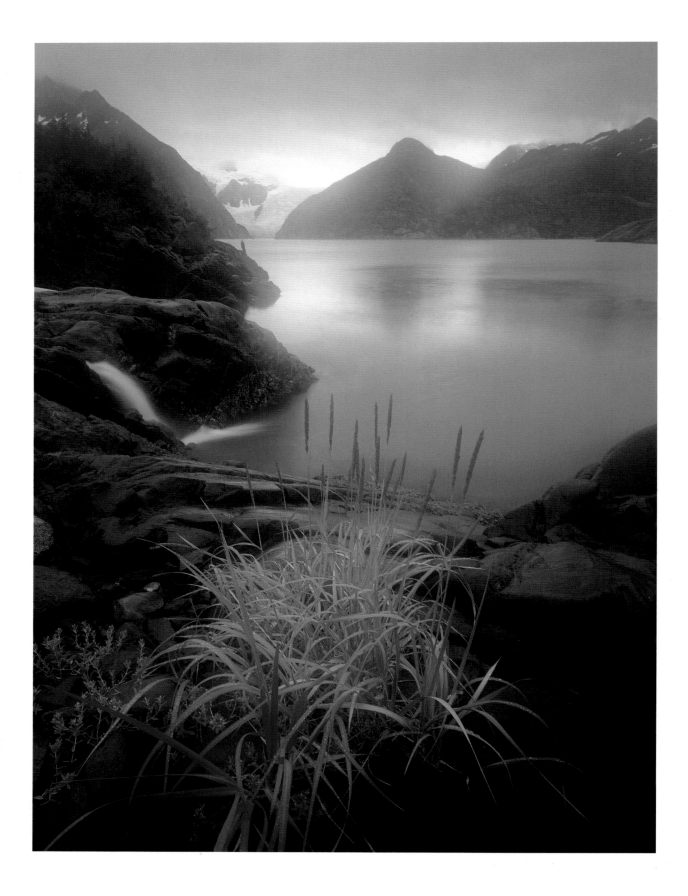

NORTHWEST ARM, HARRIS BAY

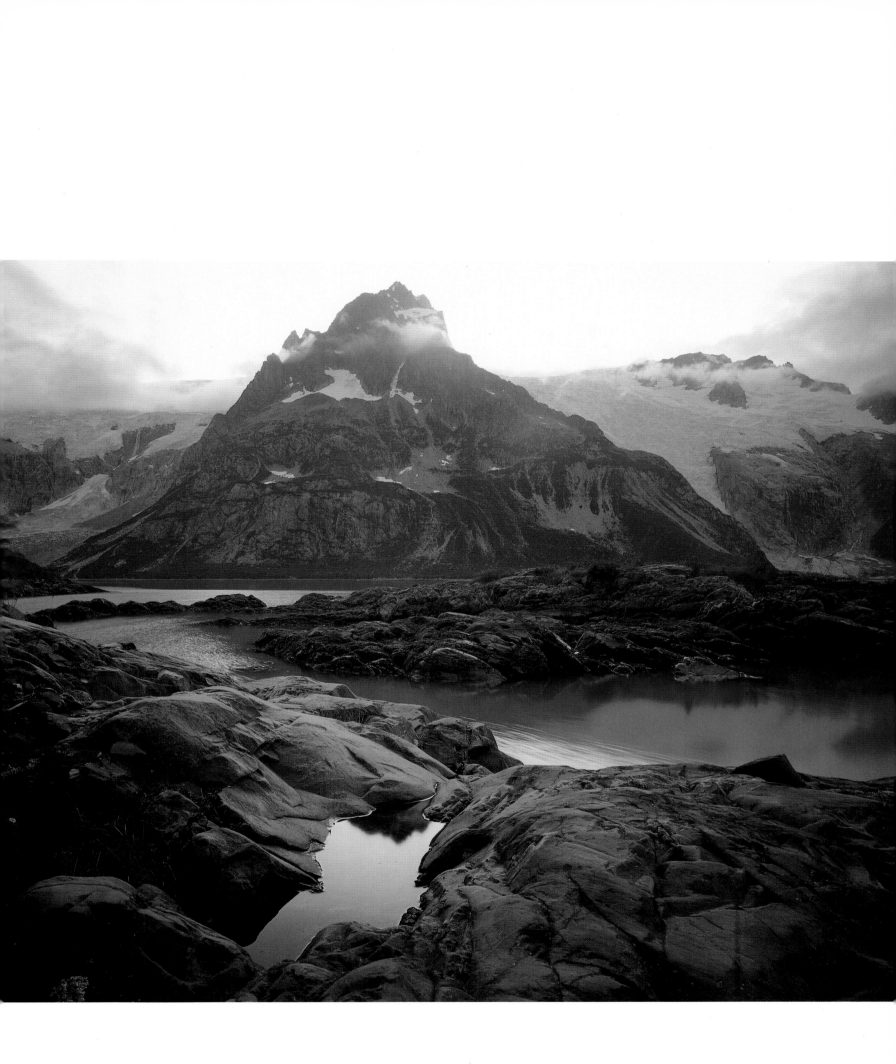

HEAD OF NORTHWEST ARM, HARRIS BAY

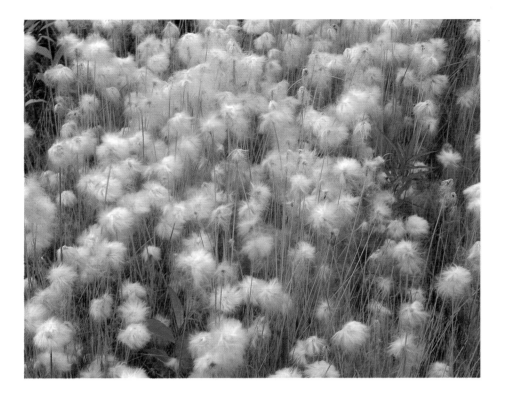

ARCTIC COTTON PATCH, ALASKA RANGE

*Denali is a great drama. The wildlife is impressively diverse and visible. Denali, the "High One," its stunning mass reaching 20,320 feet, is the rooftop of North America. More subtly, a subarctic wilderness of miniature plantlife exists as Taiga and Tundra. Taiga, "land of little sticks," is a scattered forest along rivers in the valley bottoms. Moist tundra contains tussocks of sedges and cotton grass with other dwarfed plants. Dry tundra is a rocky miniature landscape of berries and wildflowers. Established 1917.*

BERRY, LICHEN AND DWARF SPRUCE IN TUNDRA

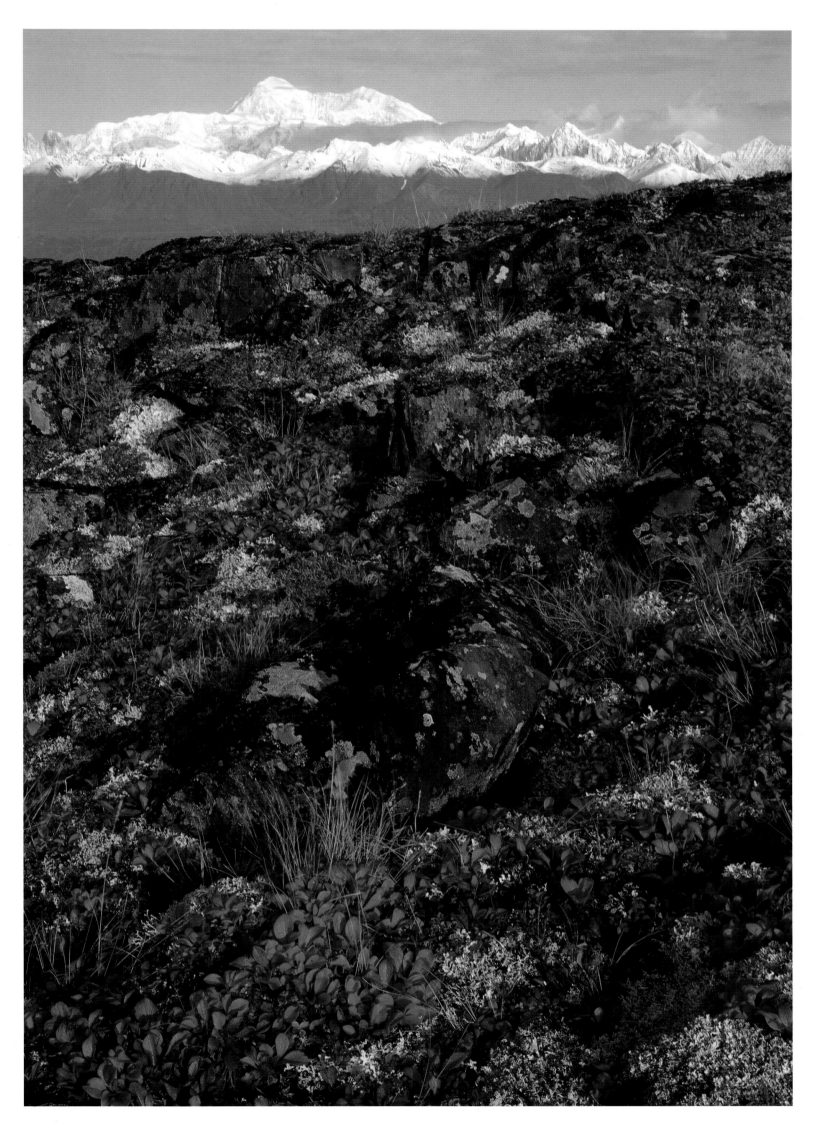

DENALI FROM KESUGI RIDGE

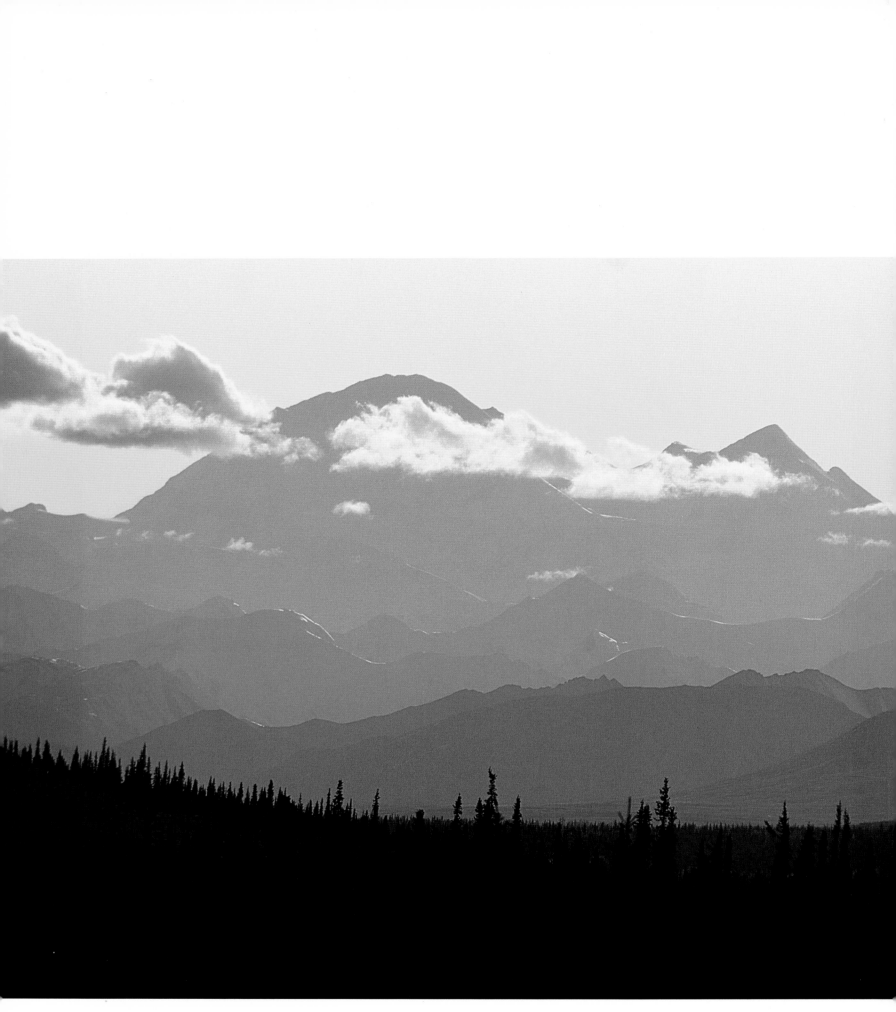

AUTUMN RIDGES OF MOUNT McKINLEY

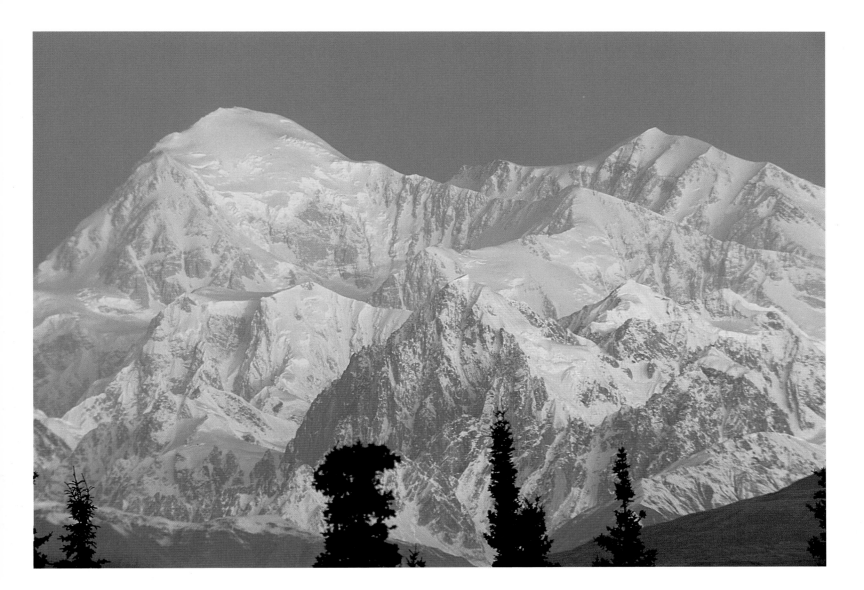

NORTH AND SOUTH PEAKS OF MOUNT MCKINLEY

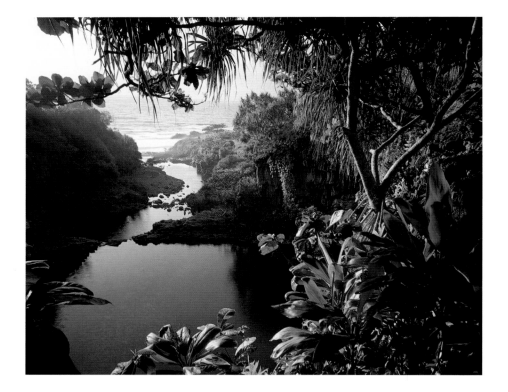

SEVEN POOLS, OHEO GULCH, KIPUHULU COAST

*"House of the Sun," Haleakala is a giant dormant volcano forming the eastern end of Maui in the Hawaiian Islands. It is a contrasting landscape of volcanics, rain forest, and coastline. A geologic creation story finds the Pacific Plate moving northwesterly over a magma plume, or hot spot, to form the volcano-islands. After an interlude of erosion creating Koolau and Kaupo Gaps comes the recent cinder cone and lava landscape. Established 1916.*

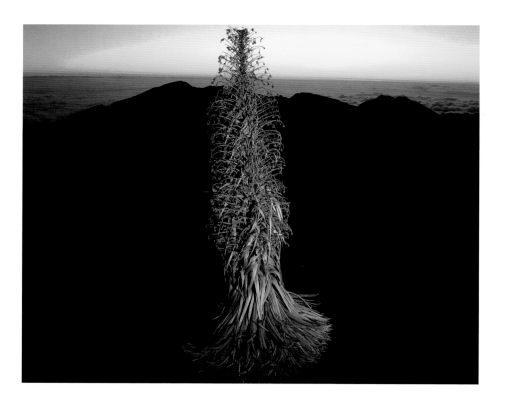

SILVERSWORD, DAWN FROM KALAHAKU

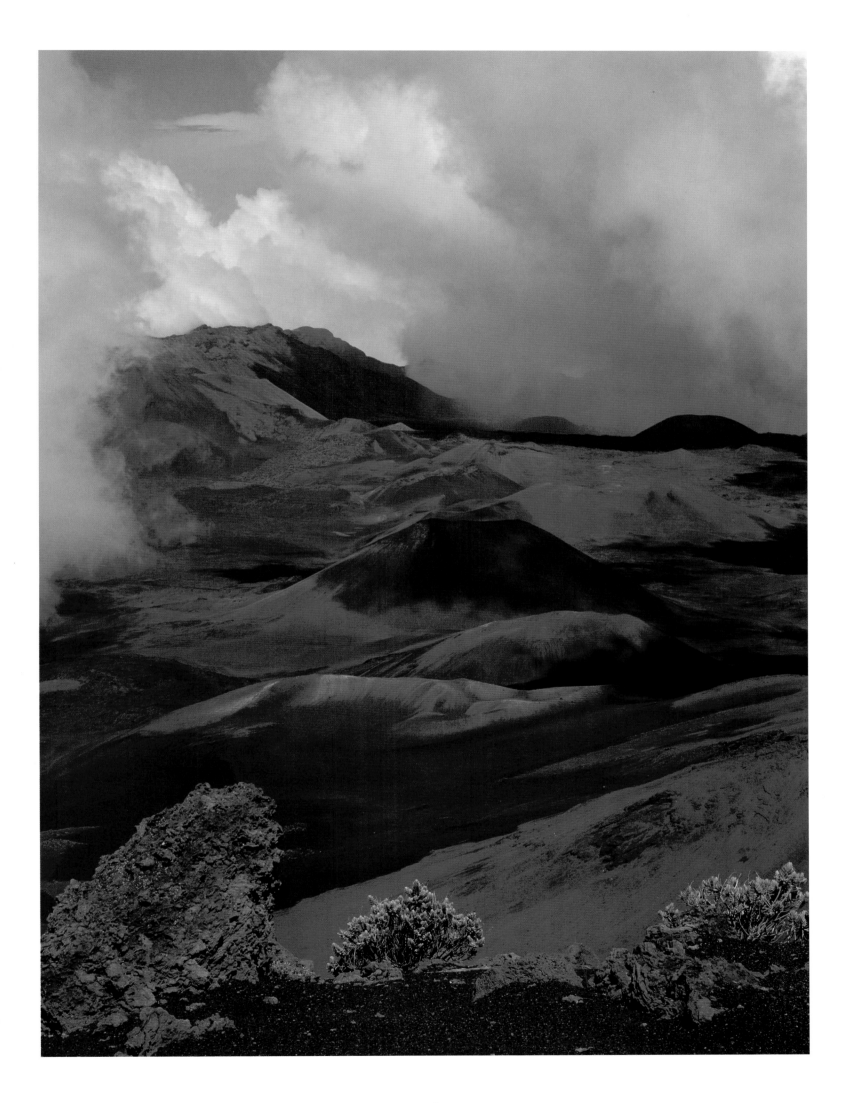

CINDER CONES, HALEAKALA CRATER

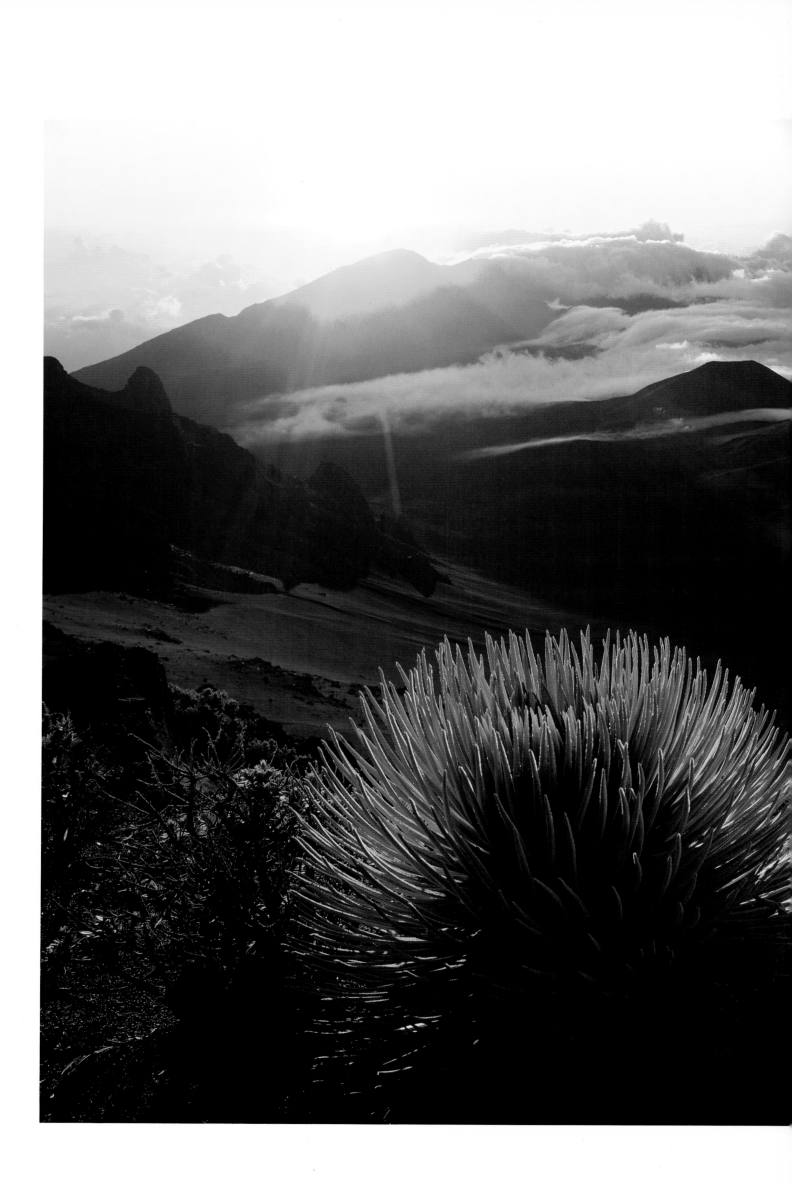

HOUSE OF THE SUN, HALEAKALA CRATER

PUU MAUI AND KAUPO GAP

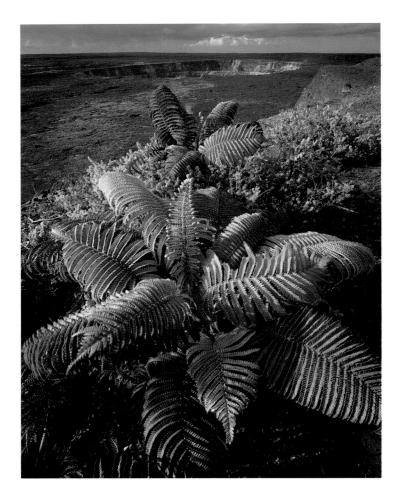

AMAU FERN, HALEMAUMAU CRATER, KILAUEA

*This is Pele's domain—fiery daughter of Earth Mother and Sky Father—unpredictable and tempestuous, one "steps lightly" in this "holy ground" on the Big Island of Hawaii. Volcanic Kilauea and Mauna Loa create an evolutionary dynamics of molten "aa" and "pahoehoe" lava, to early regrowth of lichens and ferns, to dense rain forest and rare bird species. Created in 1916, Hawaii Volcanoes is both International Biosphere Reserve and World Heritage Site.*

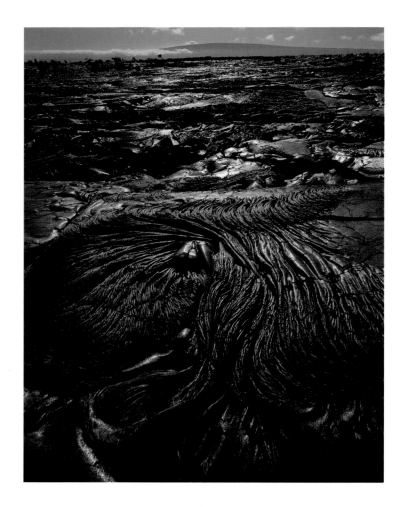

RECENT MAUNA ULU LAVA FLOW, MAUNA LOA

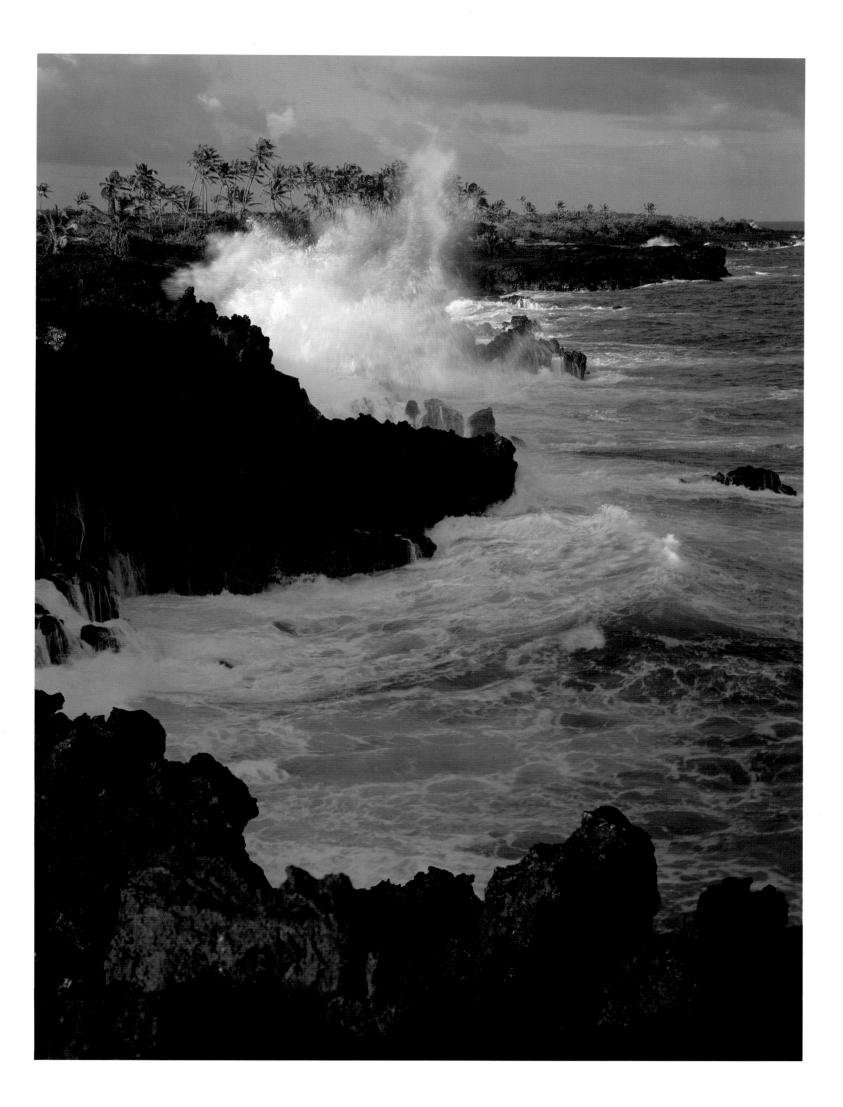

TRADEWINDS ON KALAPANA COASTLINE

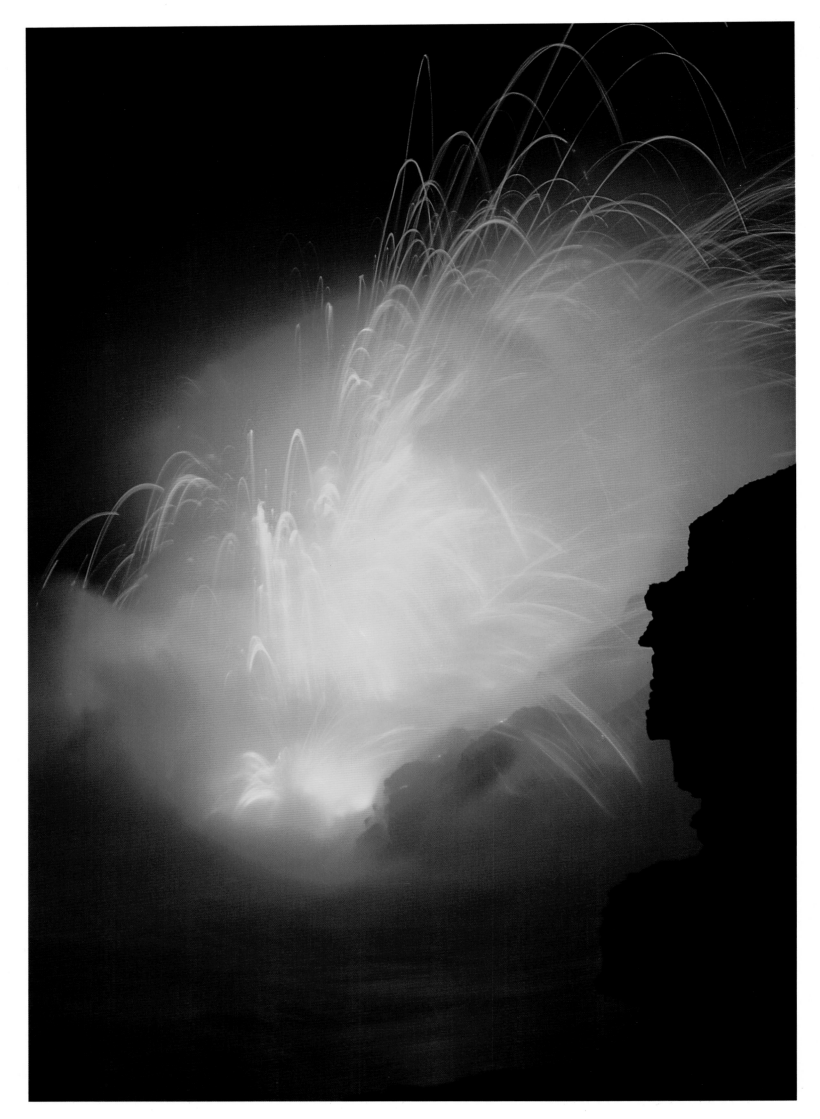

LAVA FOUNTAIN, KALAPANA

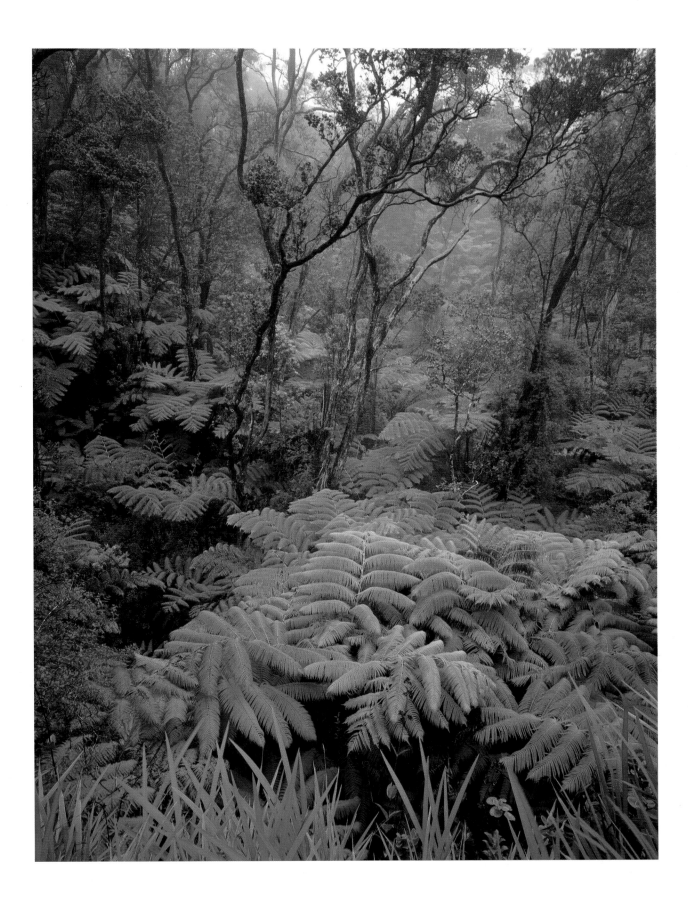

OHIA-HAPUU RAIN FOREST, KILAUEA IKI CALDERA

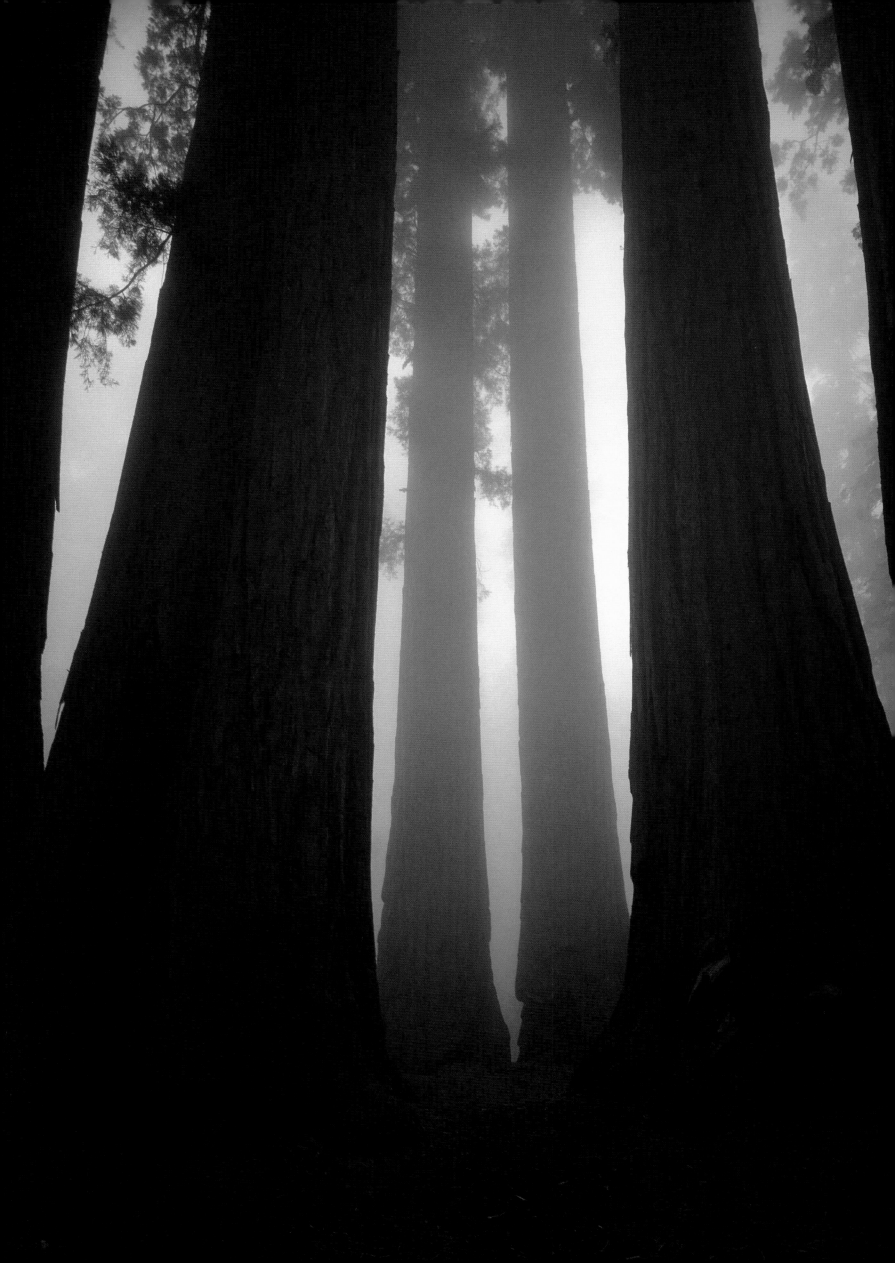

*The giant sequoias —*

Sequoiadendron giganteum *—are*

*the largest living things on this*

*planet. Escaping the last Ice Age*

*as a survivor to an ancient line of*

*fossil trees, they once mantled*

*the earth millions of years ago.*

*They are the whales of the land,*

*dwarfing us with their massive*

*fire-scarred, cinnamon-hued*

*trunks. Sequoia groves are on*

*the western slope of the glacially*

*carved Sierra Nevada Mountain*

*Wilderness. Established 1890.*

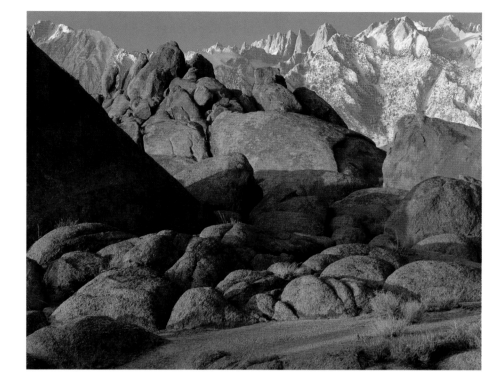

GRANITE BOULDERS, MOUNT WHITNEY

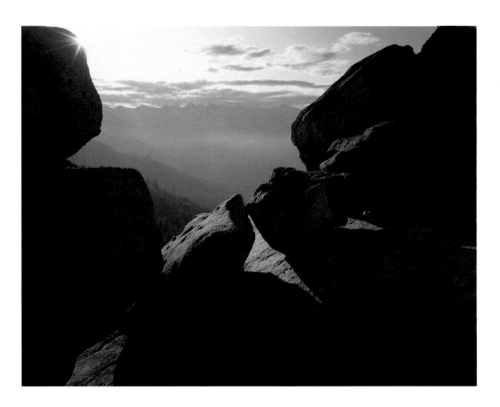

MORO ROCK, GREAT WESTERN DIVIDE

SEQUOIAS, PARKER GROVE

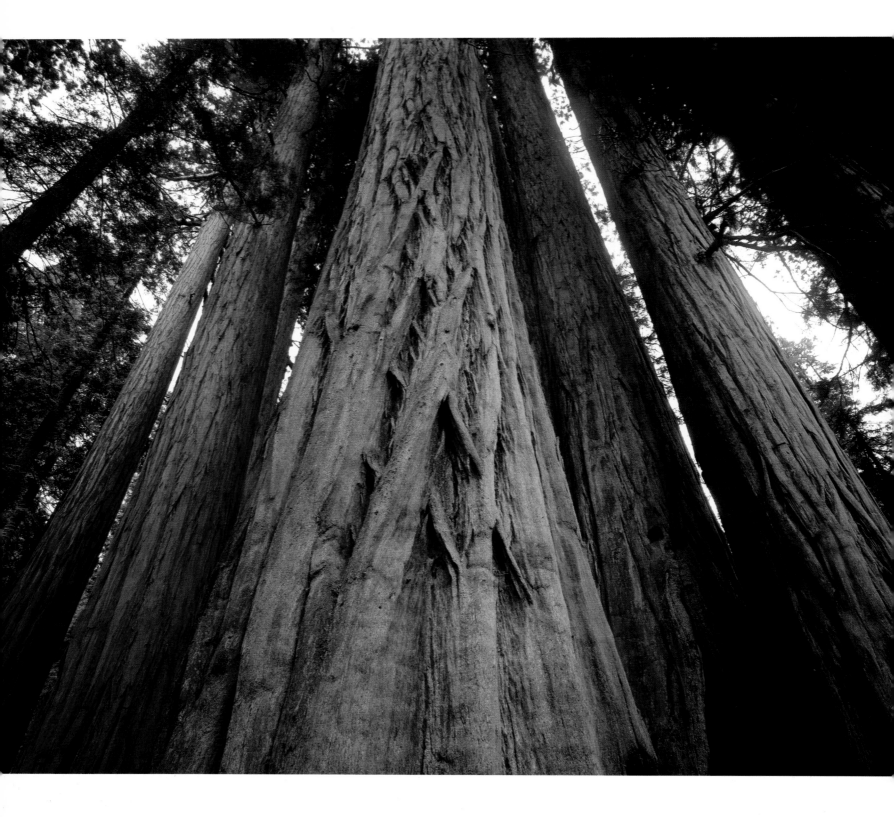

SEQUOIADENDRON GIGANTEUM, UNNAMED GROVE

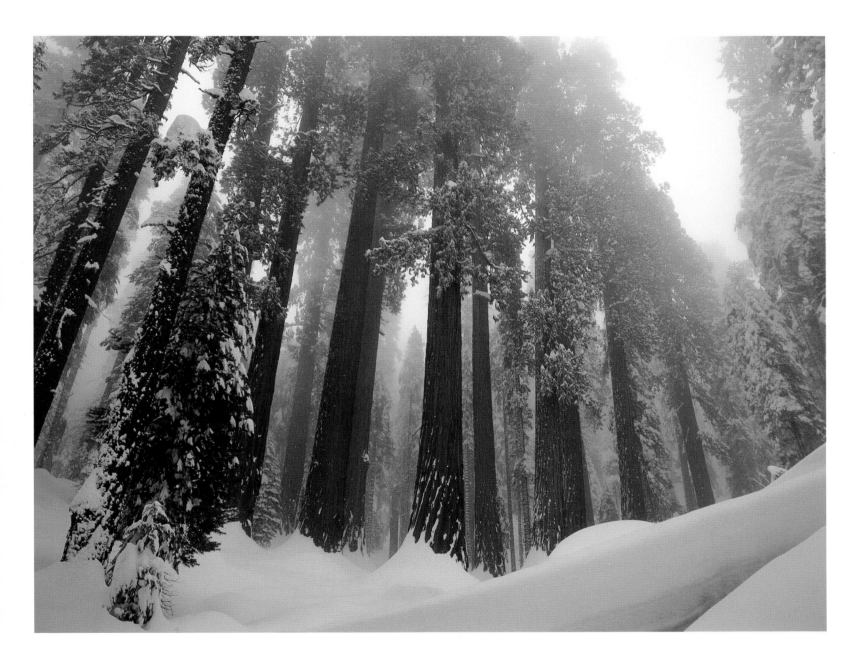

WINTER'S TRANSFORMATION, GIANT FOREST

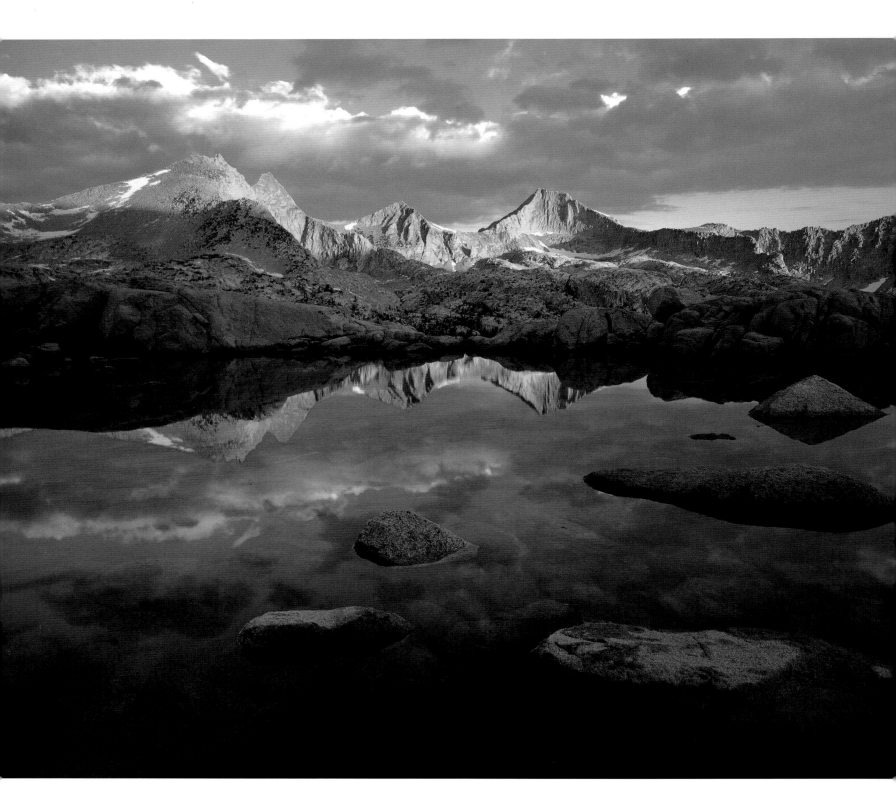

*A celebration of ice-sculpted ridges, sapphire lakes, crystal streams, and deep granite chasms comprise this primal rock landscape of the Sierra Nevada Range. A huge block of the earth's uplifted and tilted crust has been softened and refined by the elements. Established 1940.*

SPRING FLOW, SIXTY LAKES BASIN, MOUNT CLARENCE KING

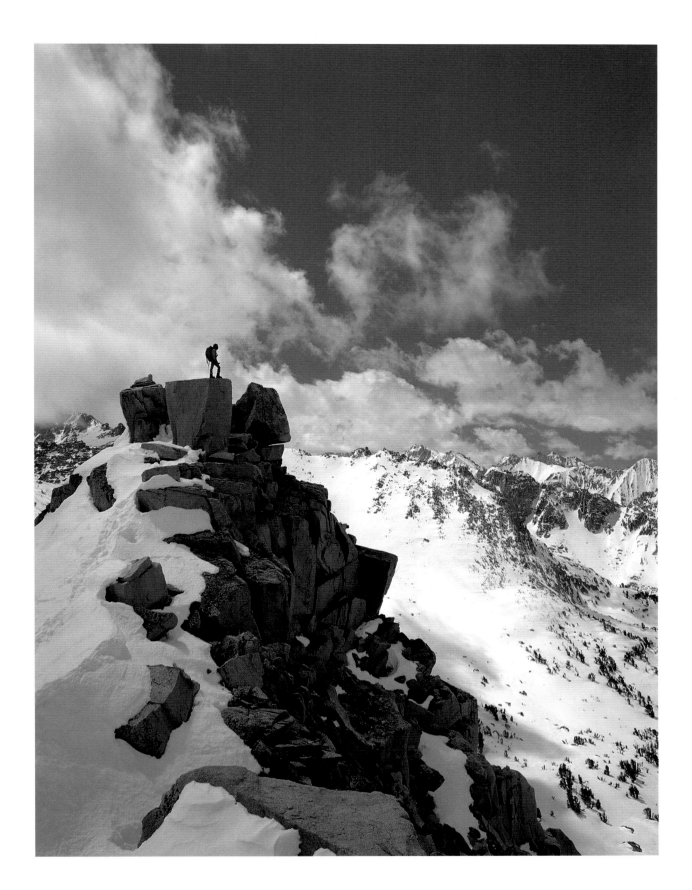

SOLITUDE OF WINTER, THE KINGS-KERN DIVIDE

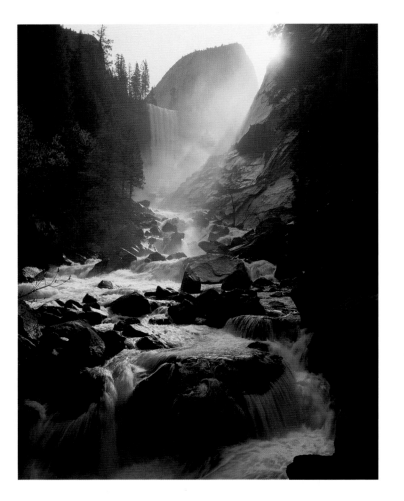

VERNAL FALLS OF THE MERCED RIVER

*Ancient beginning of fire and ice are Yosemite's major creators. John Muir wrote "No temple made with hands can compare with Yosemite." A sublime high country of snow-capped peaks, lakes, and canyons cradles the "incomparable valley" of Yosemite. Leaping waterfalls, granite monoliths, and sheer walls give a dramatic sense of scale in the world's most famous example of a glacial-carved canyon. Established 1890.*

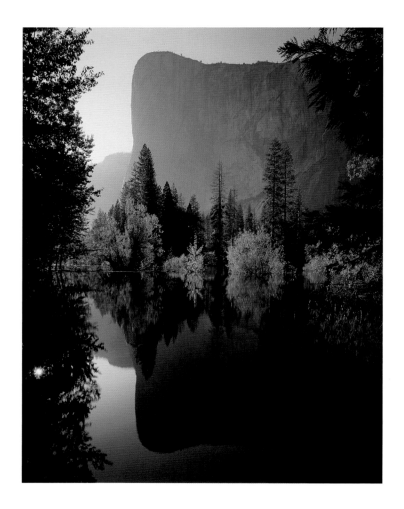

REFLECTION OF EL CAPITAN, MERCED RIVER

HALF DOME, OLMSTED POINT

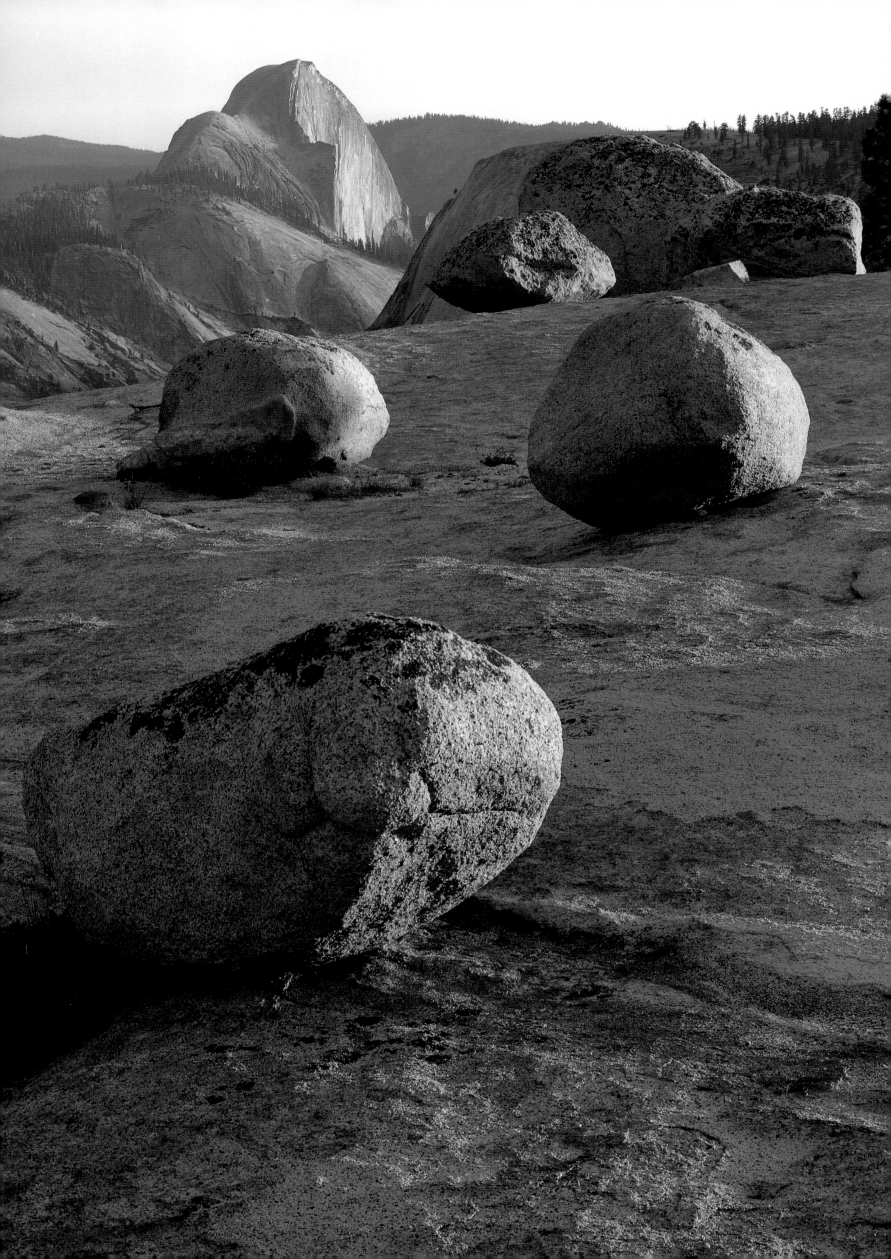

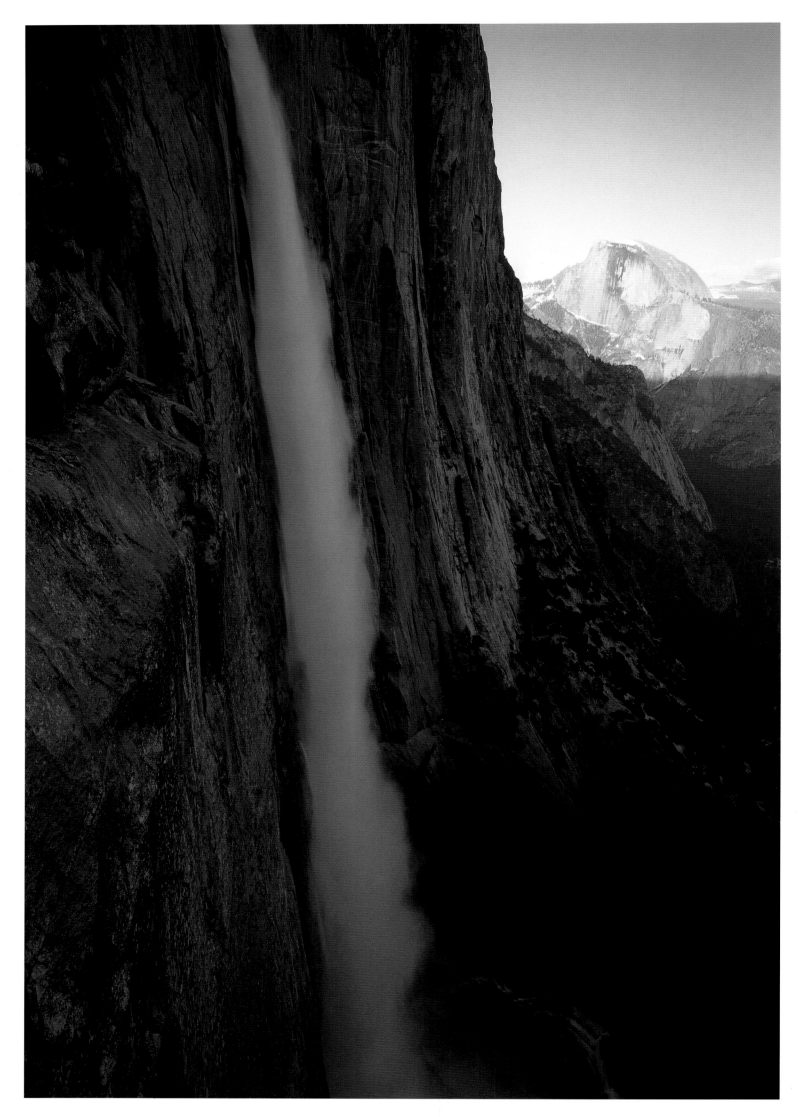

UPPER YOSEMITE FALLS AND HALF DOME

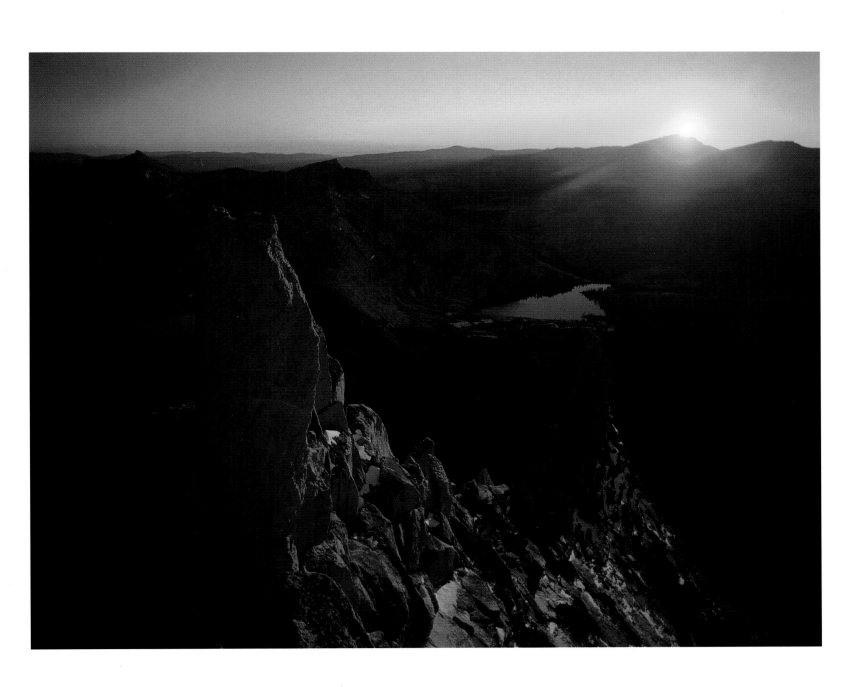

CATHEDRAL PEAK TOP, TENAYA LAKE, HIGH SIERRA

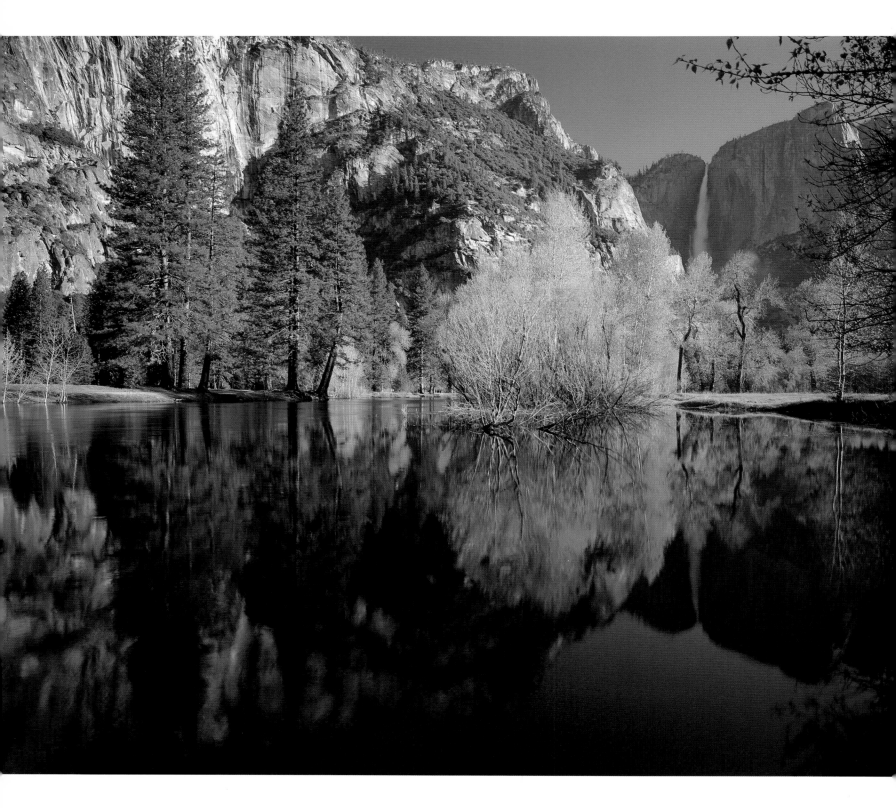

SPRING REFLECTION, MERCED RIVER, YOSEMITE VALLEY

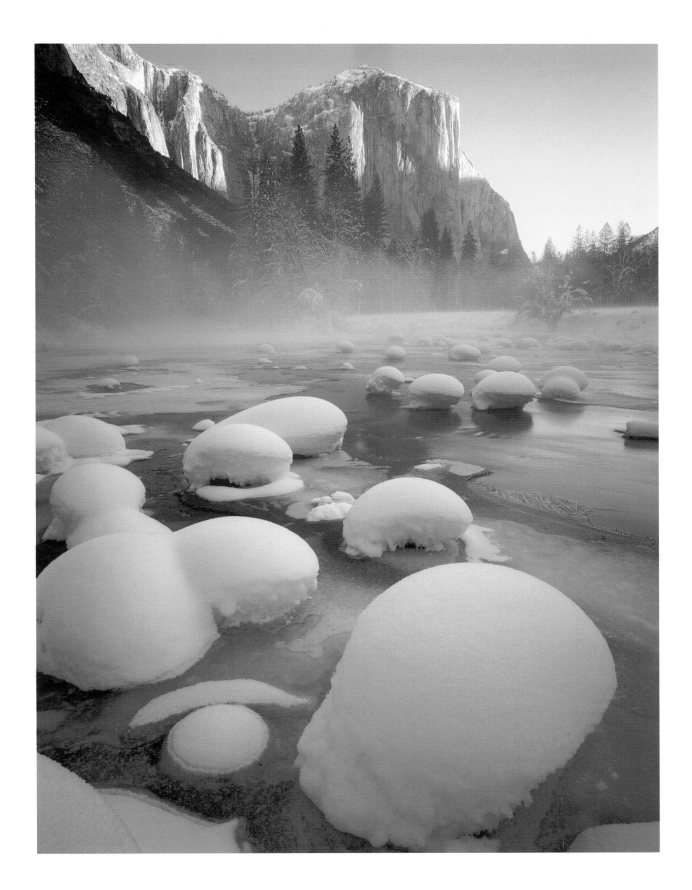

WINTER, MERCED RIVER WITH EL CAPITAN

62

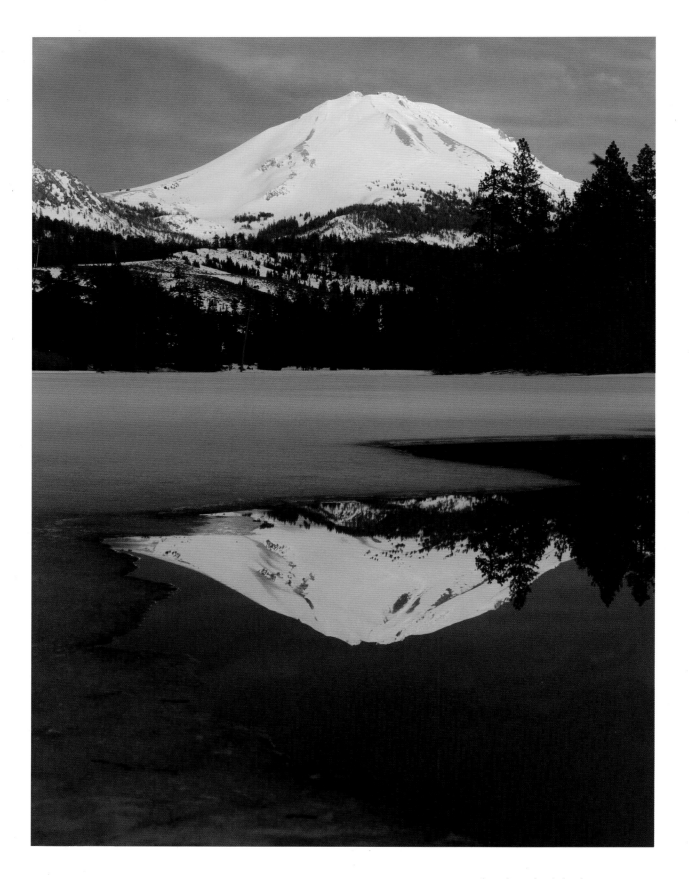

*An active volcanic landscape —*

*one of many that extend around*

*the Pacific Ocean in a great*

*Ring of Fire. Created 1916.*

EVENING REFLECTION, MOUNT LASSEN, MANZANITA LAKE

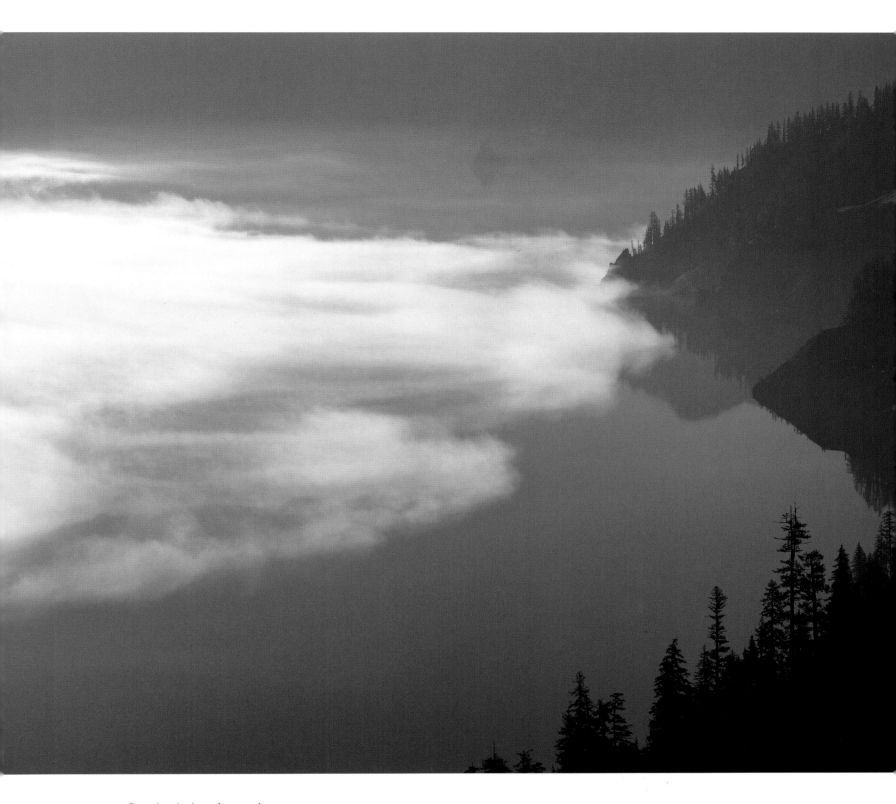

*Centuries of rain and snowmelt*

*have accumulated in Mount*

*Mazama's collapsed caldera to*

*more than nineteen hundred feet*

*deep, creating an intense blue gem*

*of tranquility. Created 1902.*

FOG ALONG SOUTH SHORE, CRATER LAKE

SUNRISE OVER WIZARD ISLAND, CRATER LAKE

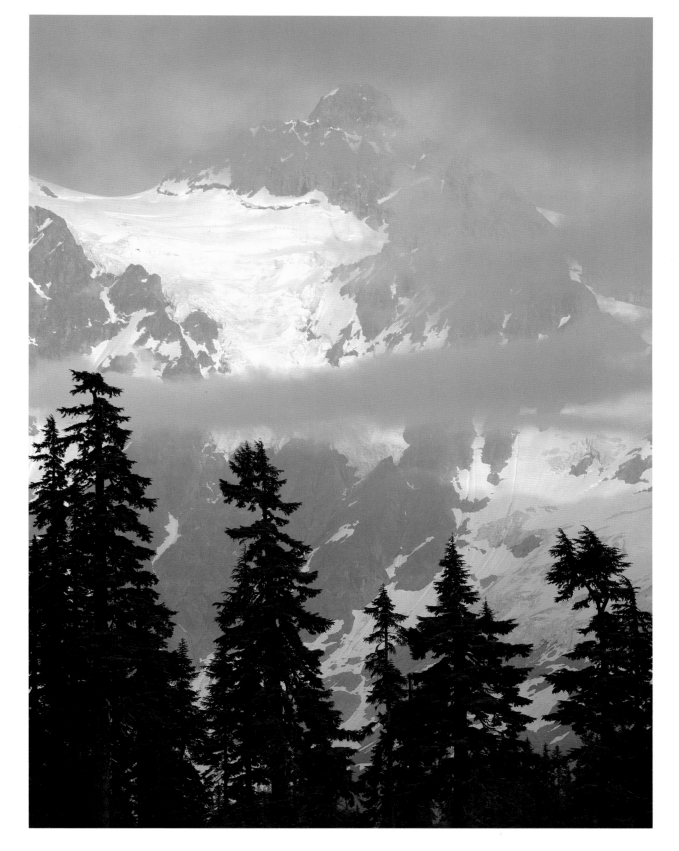

*A wild and rugged complex of*

*glacier-clad peaks rises almost*

*vertically out of some impressive*

*forested valleys of the Cascade*

*Range. Established 1968.*

HEMLOCK AND GLACIERS, MOUNT SHUKSAN, NORTH CASCADES

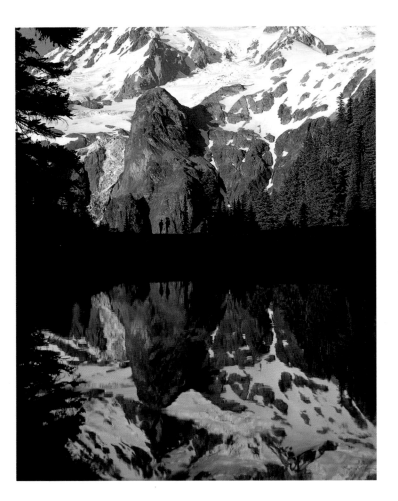

AURORA LAKE REFLECTIONS, KLAPATCHE PARK

*Famous landmark of the Cascade*

*Range, with its glistening icecap,*

*is a massive sleeping volcano.*

*This offspring of fire and ice soars*

*above a sea of lowland forests and*

*alpine fields of wildflowers to*

*float like an ethereal cloud.*

*Mount Rainier can dominate in*

*this mountain world, but favorites*

*are the numerous alpine-wildflower*

*parks along the encircling*

*ninety-three-mile Wonderland*

*Trail. Established 1899.*

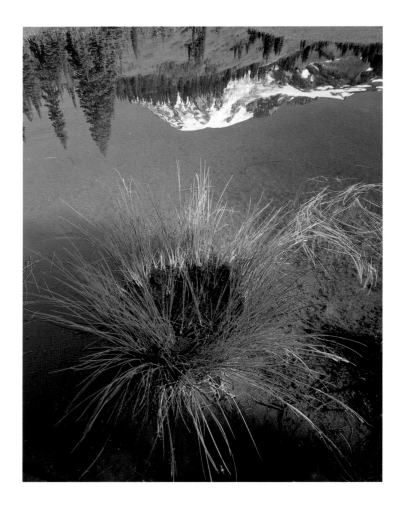

MOUNT RAINIER, PARADISE VALLEY

INDIAN PAINTBRUSH AND LUPINE, MOUNT RAINIER

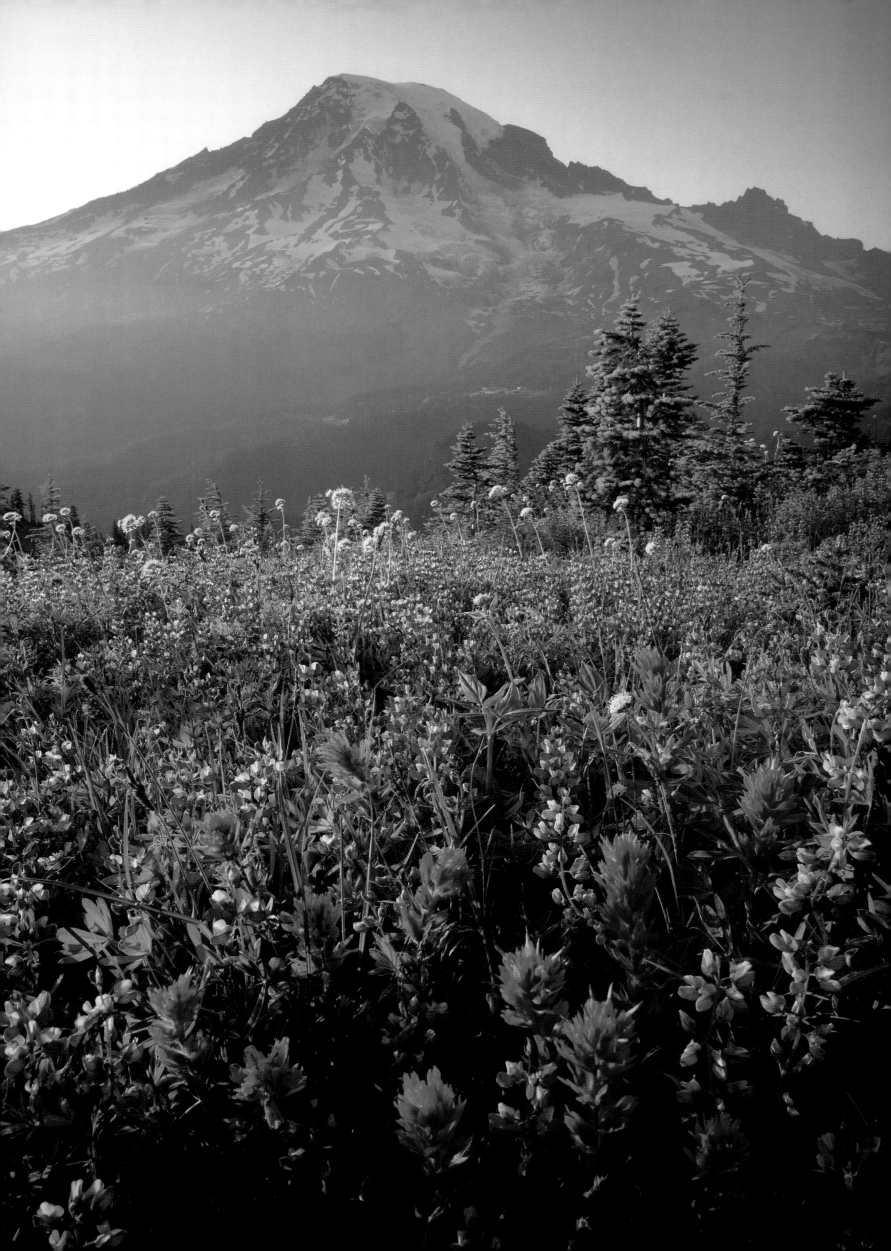

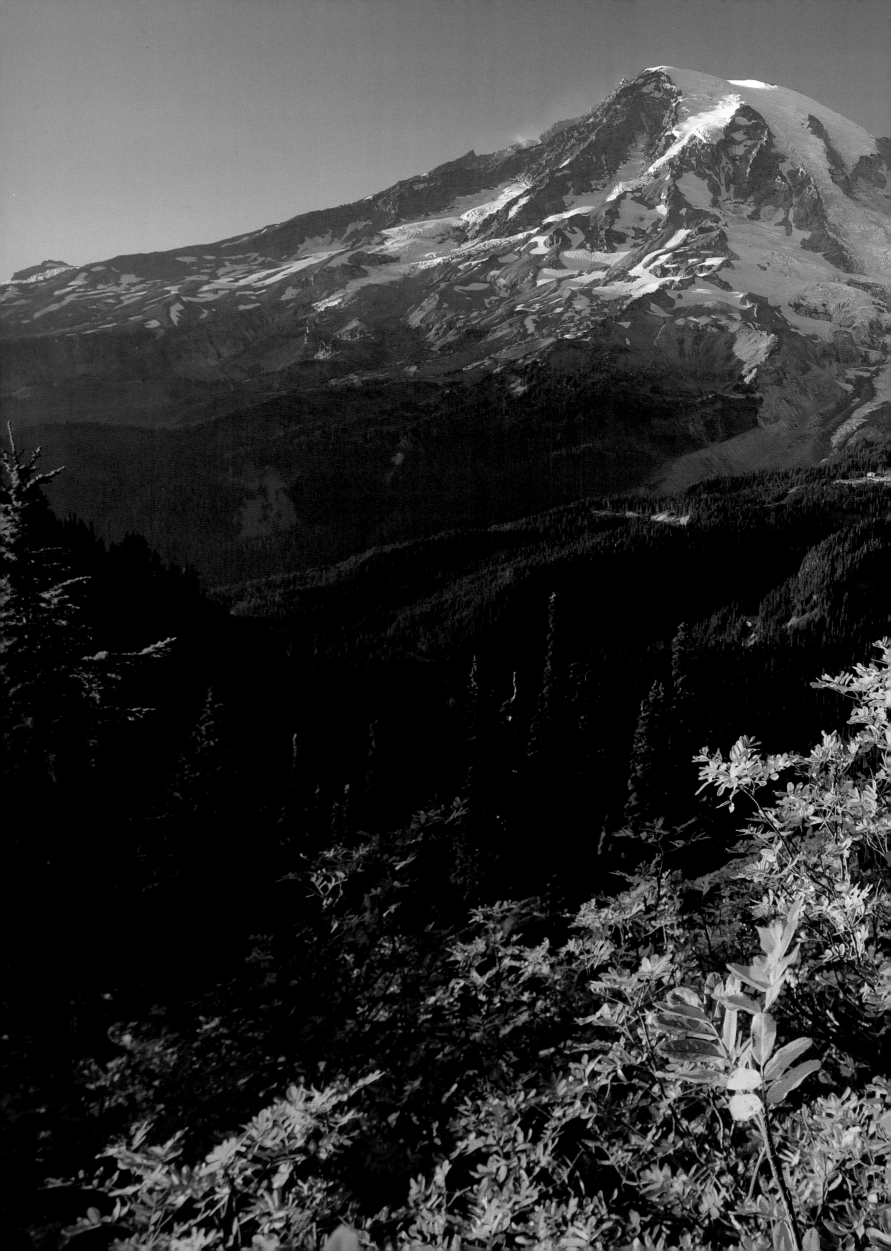

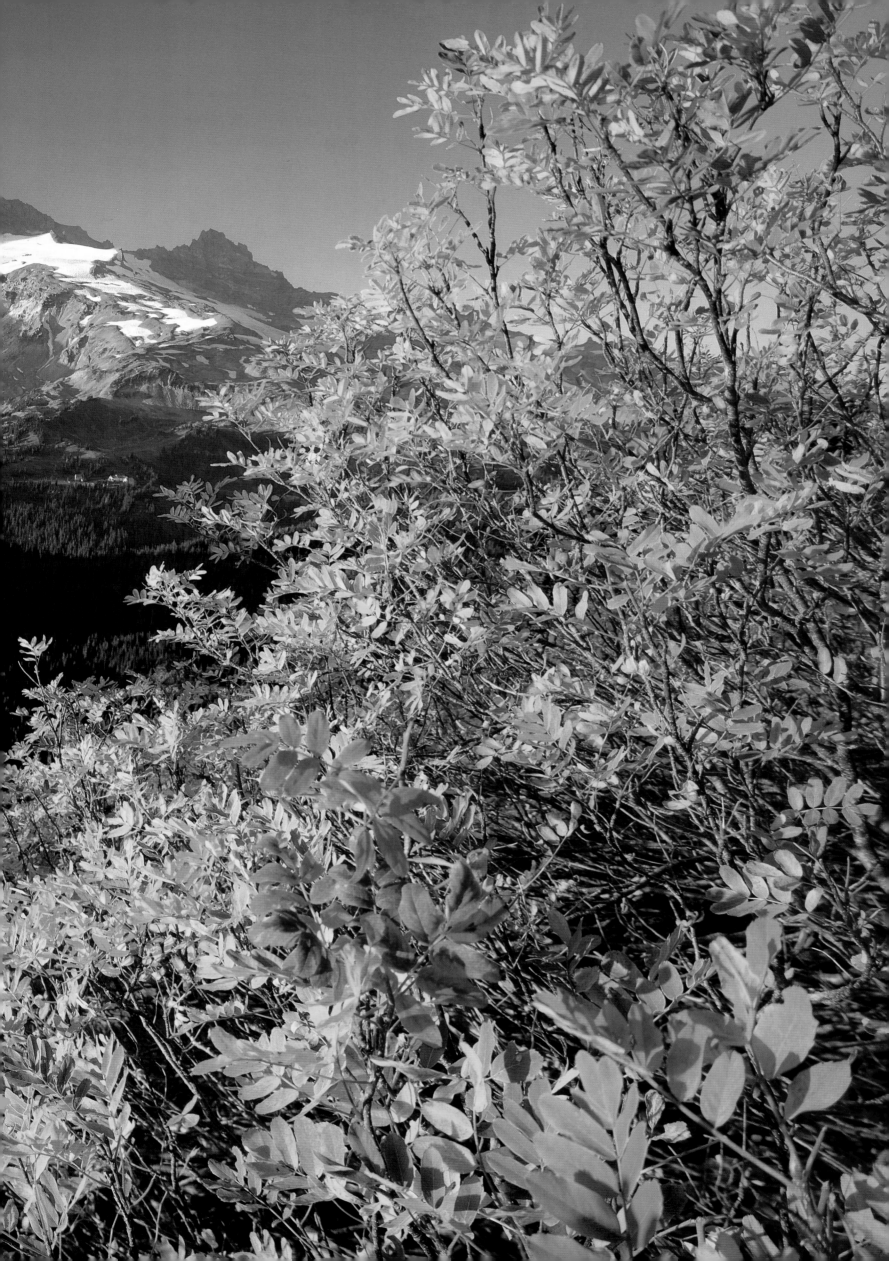

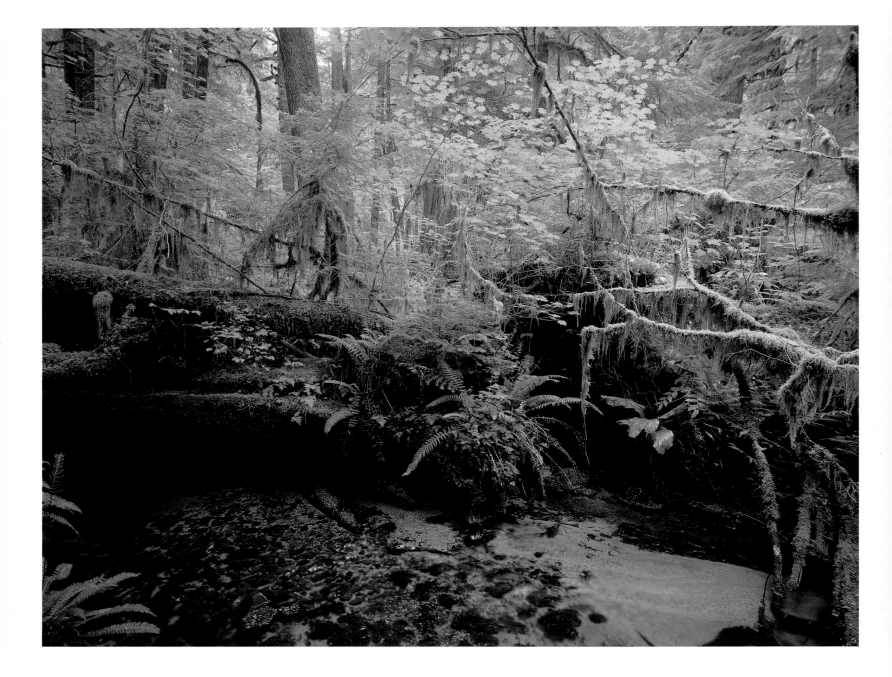

OLD GROWTH, CARBON RIVER RAIN FOREST

PRECEDING PAGES: MOUNTAIN ASH, MOUNT RAINIER

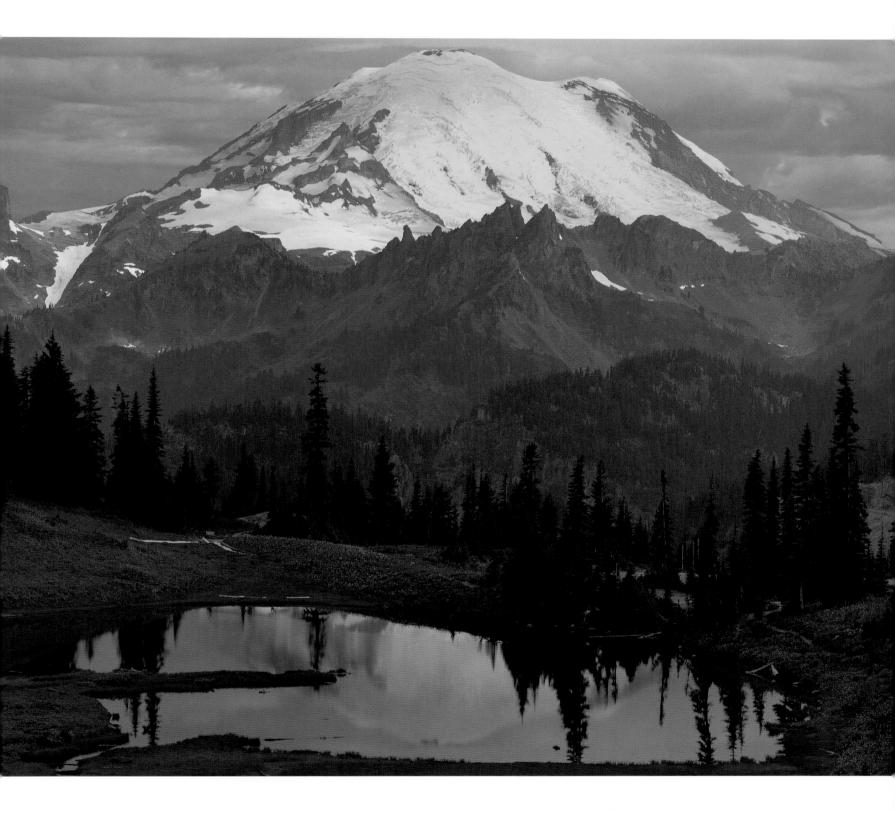

DAWN, MOUNT RAINIER AND COWLITZ CHIMNEYS

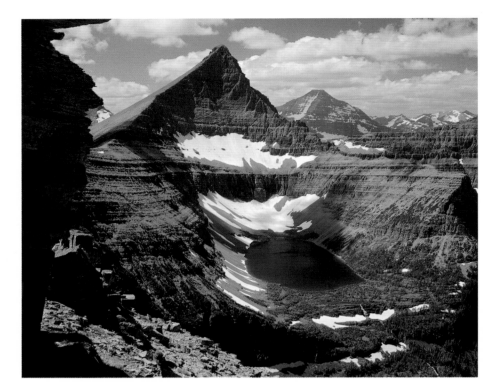

OLD WOMAN LAKE WITH FLINSCH PEAK AND MOUNT STIMSON

*Glistening glaciers, massive ranges of peaks, with their gigantic glacial-carved precipices, show a geologic personality that is Glacier. Limestone rock layers, once deposited in ancient seas, have been moved forceably into an overthrust position, then carved into the park's rugged landscape by glaciers. Cascading waterfalls bounding through alpine flowers into sparkling lakes complete a transformation of beauty. Established 1932.*

ROCK MOSAIC, McDONALD CREEK

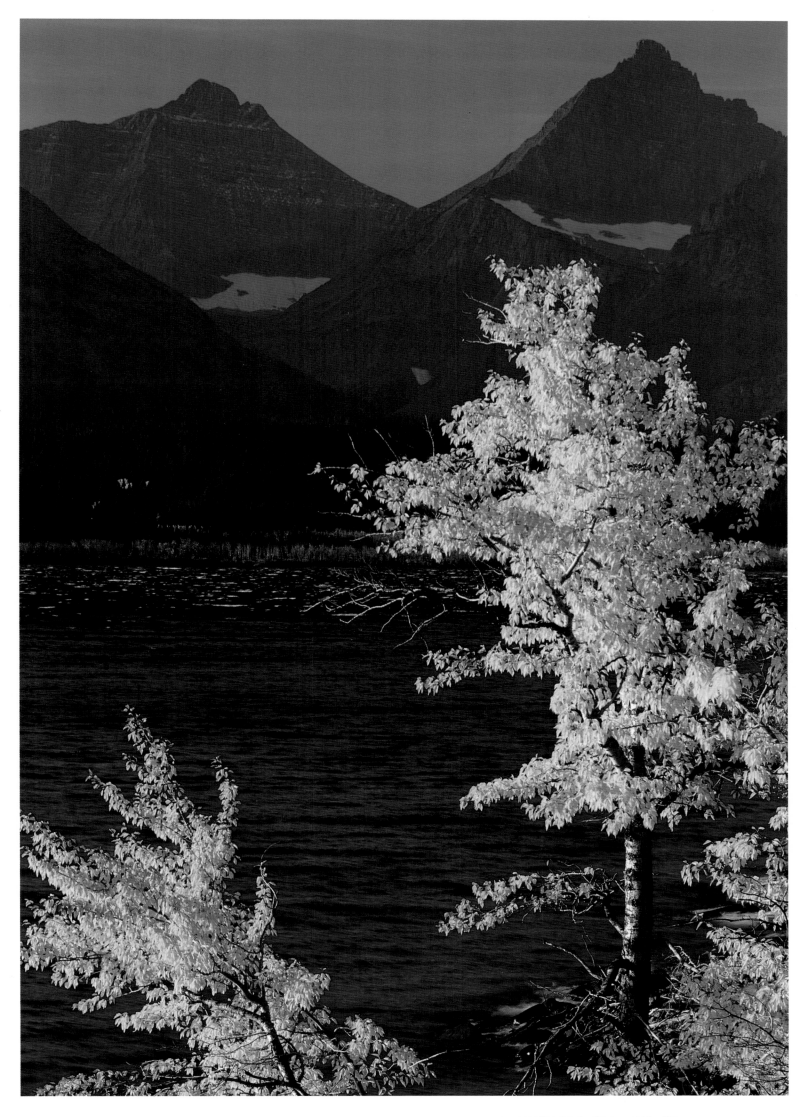

AUTUMN COTTONWOODS, ST. MARY LAKE

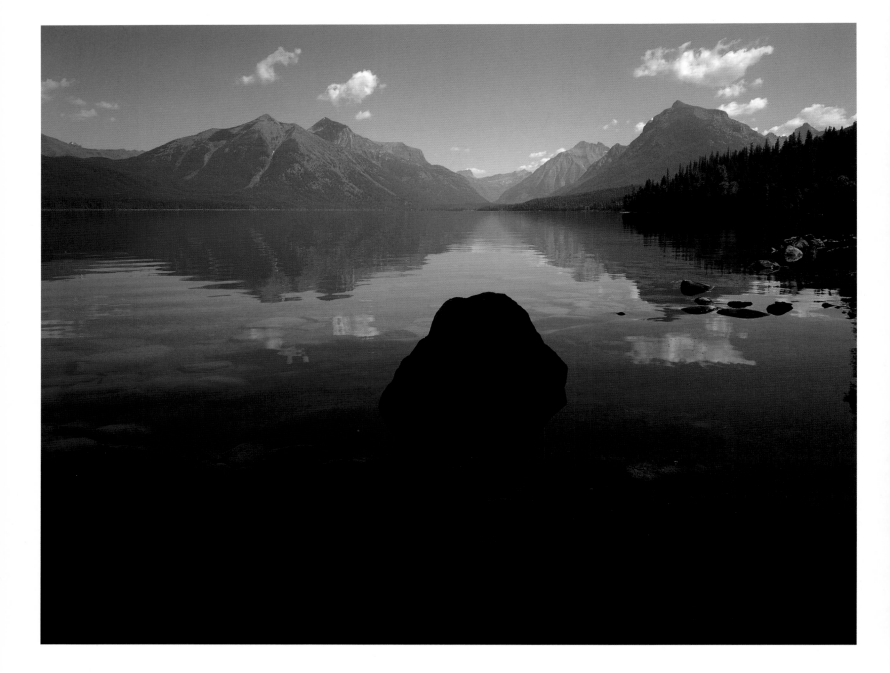

INDIAN SUMMER, LAKE McDONALD

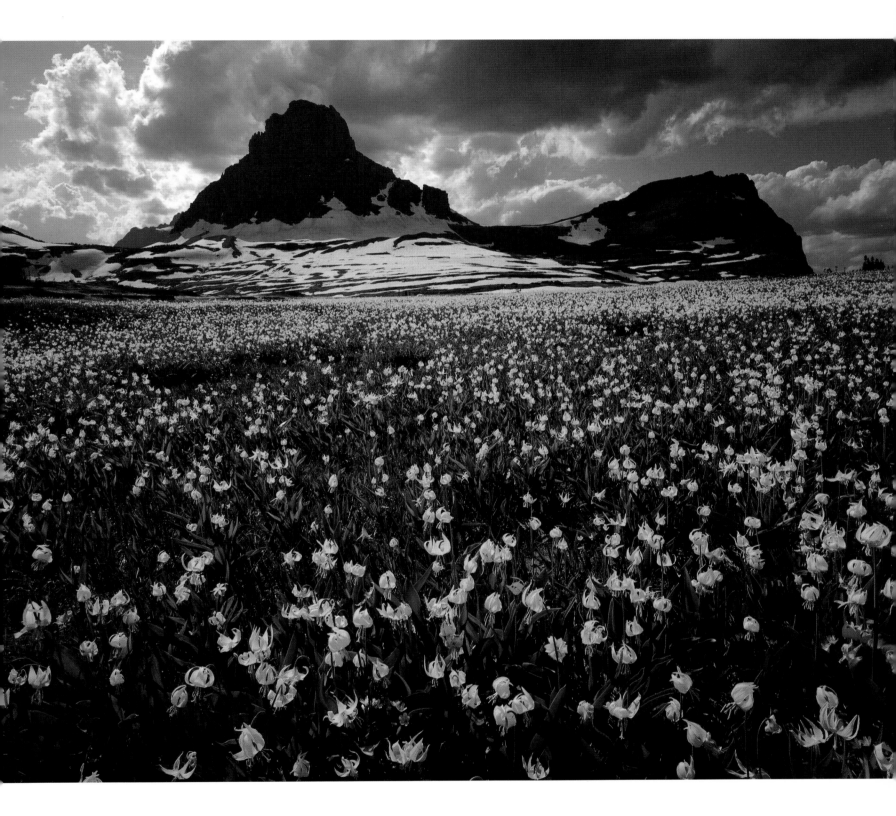

CONTINENTAL DIVIDE, LOGAN PASS

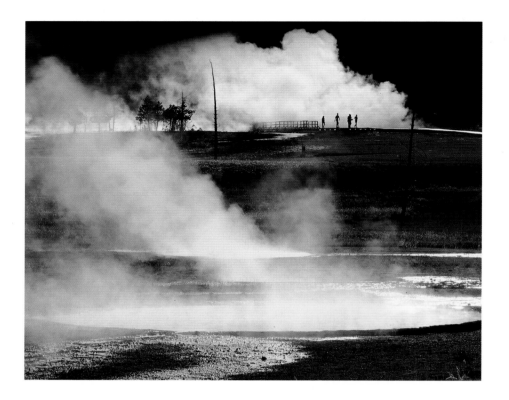

ALONG BOARDWALK, BISCUIT BASIN THERMAL SPRINGS

*A collapsed volcano featuring boiling hot springs, geysers and fumeroles are reminders of a violent landscape at Yellowstone. William Henry Jackson's photographs and Thomas Moran's sketches helped influence Congress to establish Yellowstone as the world's first national park in 1872. Today it is recognized as an International Biosphere Reserve and World Heritage Site.*

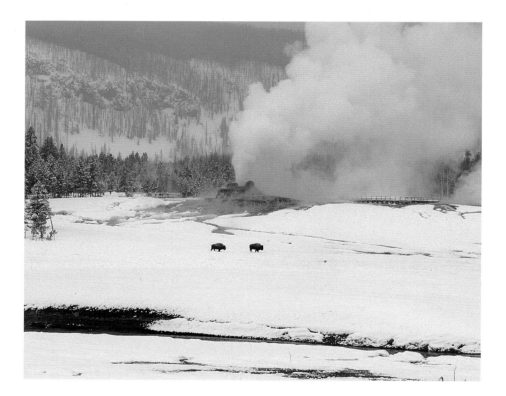

CASTLE GEYSER ACTIVITY IN UPPER GEYSER BASIN

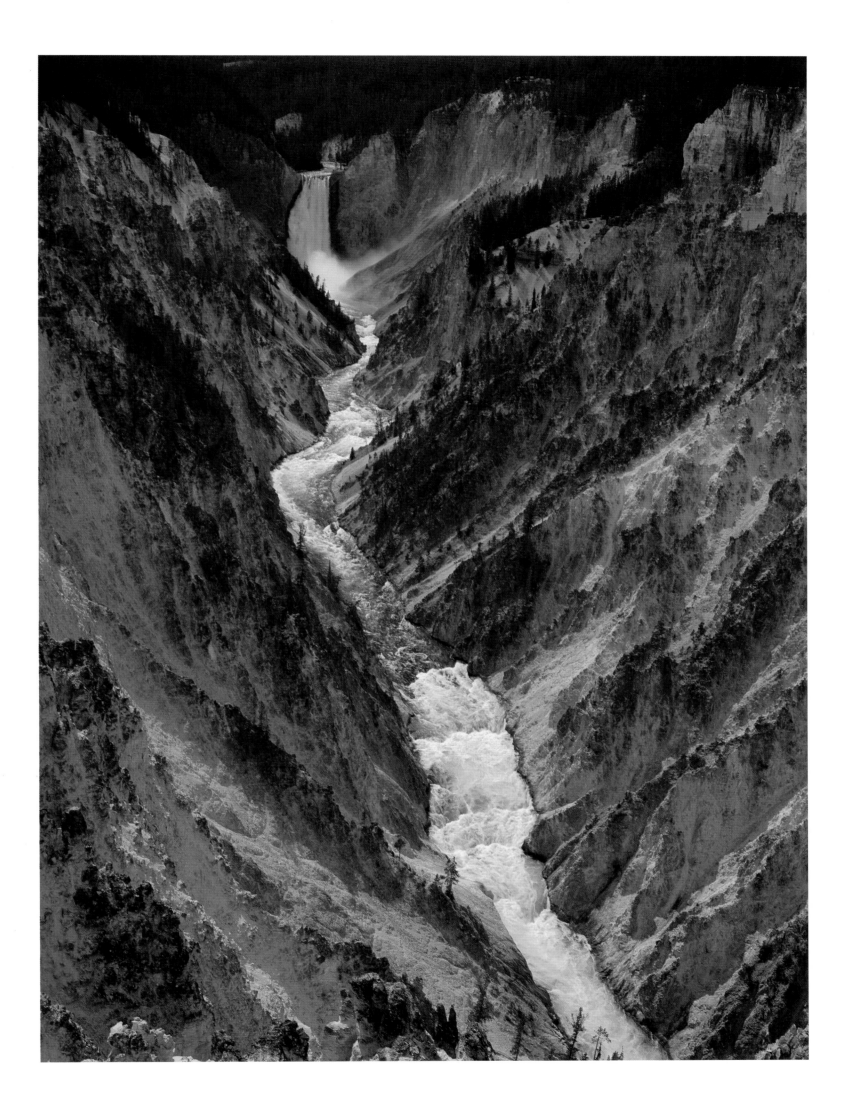

LOWER FALLS OF THE YELLOWSTONE RIVER

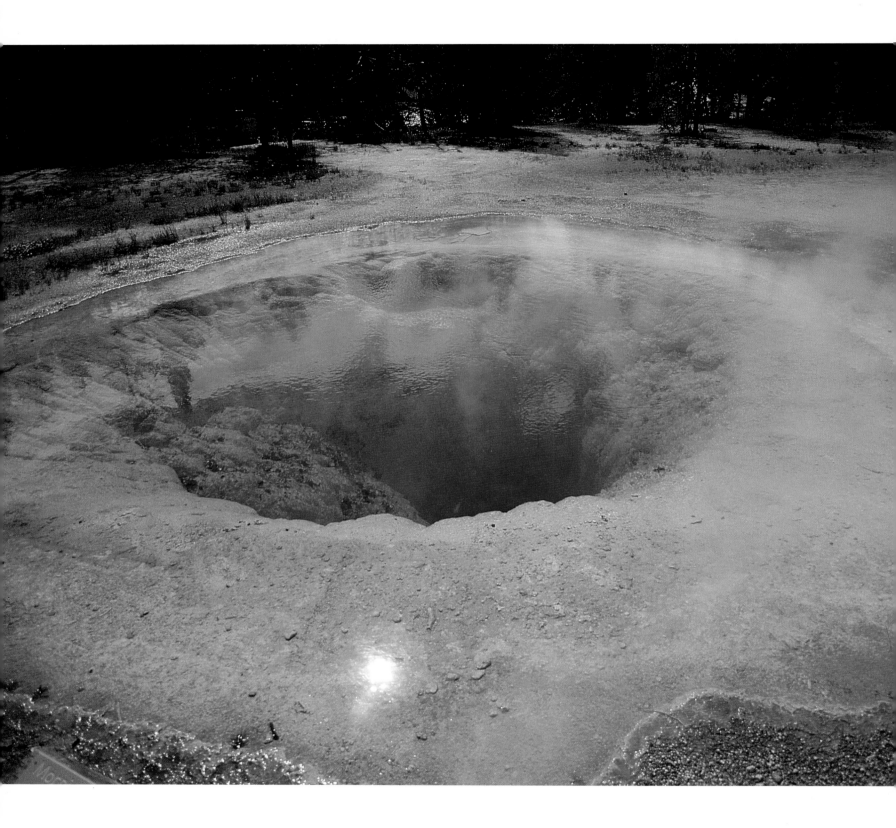

MORNING GLORY POOL, UPPER GEYSER BASIN

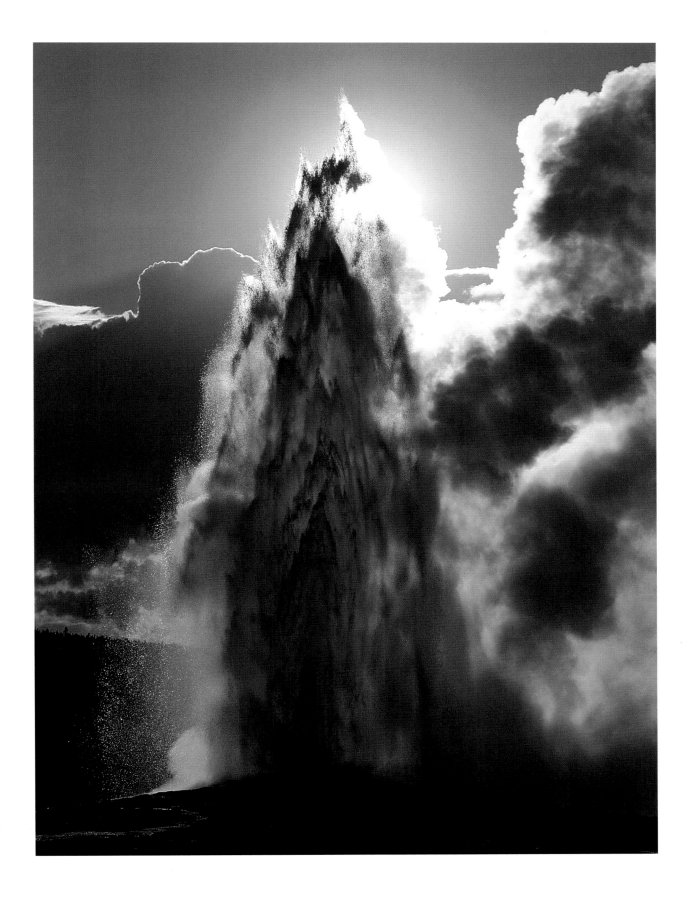

OLD FAITHFUL GEYSER, UPPER GEYSER BASIN

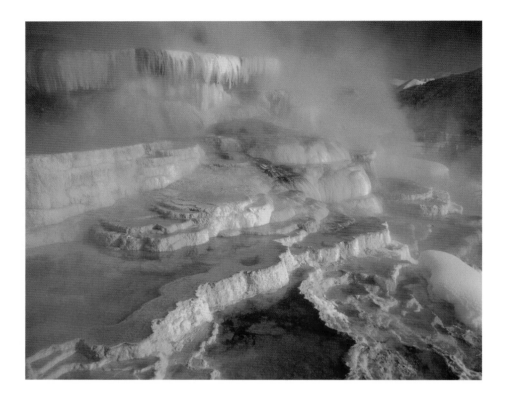

MINERVA TERRACE, MAMMOTH HOT SPRINGS

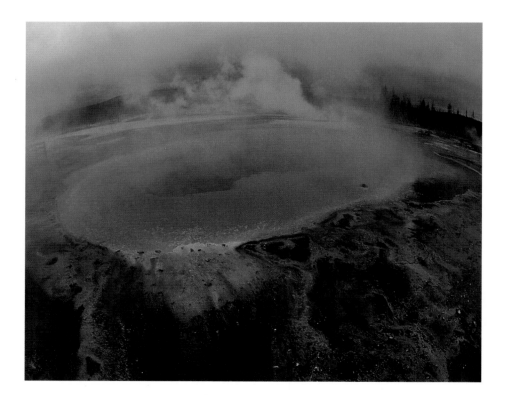

POOL ON GEYSER HILL, UPPER GEYSER BASIN

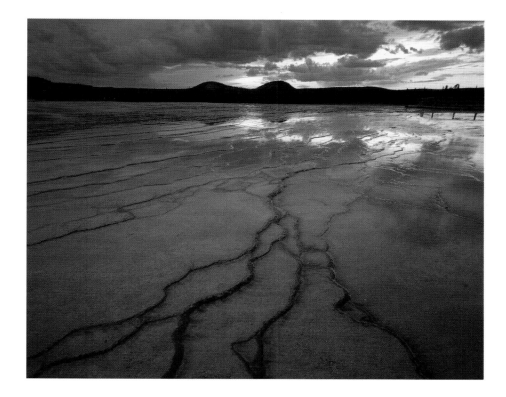

TERRACES, MIDWAY GEYSER BASIN

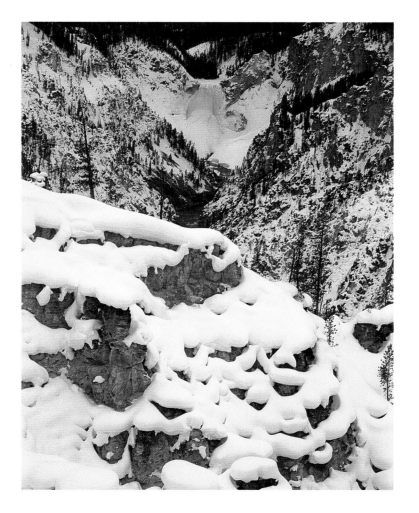

LOWER YELLOWSTONE FALLS, ARTIST POINT

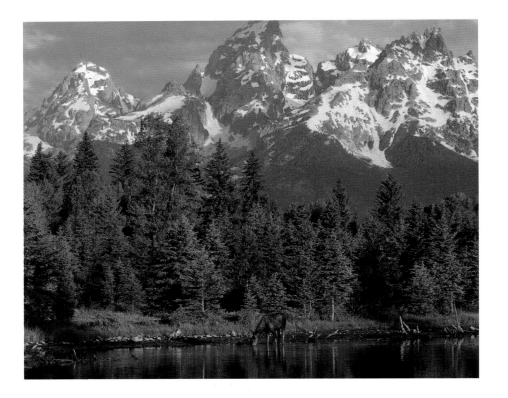

MOOSE FEEDING ALONG THE SNAKE RIVER

*A fault-block range in origin, the Teton Range makes a magnificent bold geologic statement, rising a sheer seven thousand feet above Jackson Hole and the Snake River. A string of jewel-like lakes is at the base, sometimes mirroring their prominence. Wildflowers in amazing profusion bloom among the sagebrush flats, up the canyons, and continue vivid color displays into the alpine zones. Established 1929.*

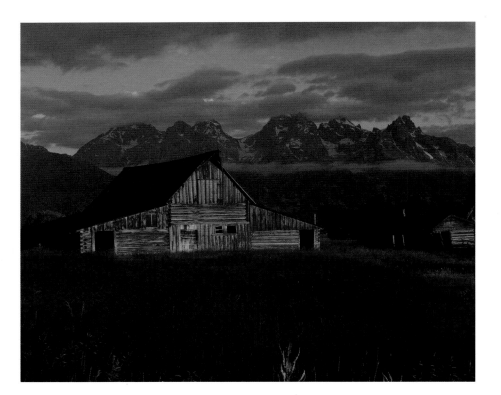

BARN WITH GRAND TETONS, JACKSON HOLE

GLACIER LILIES, UPPER CASCADE CANYON

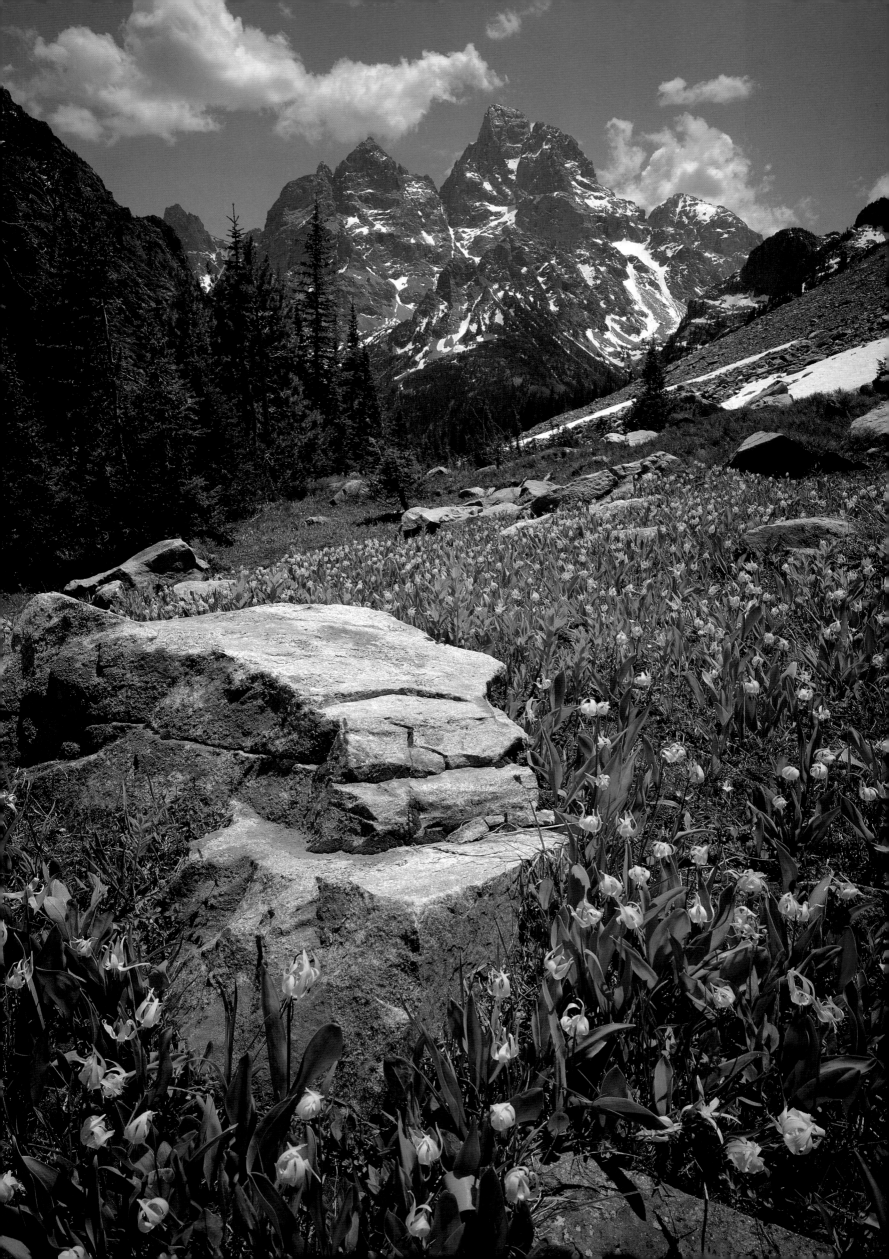

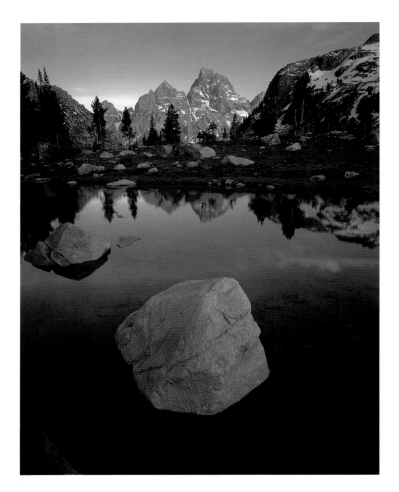

ALPINE REFLECTIONS, LAKE SOLITUDE

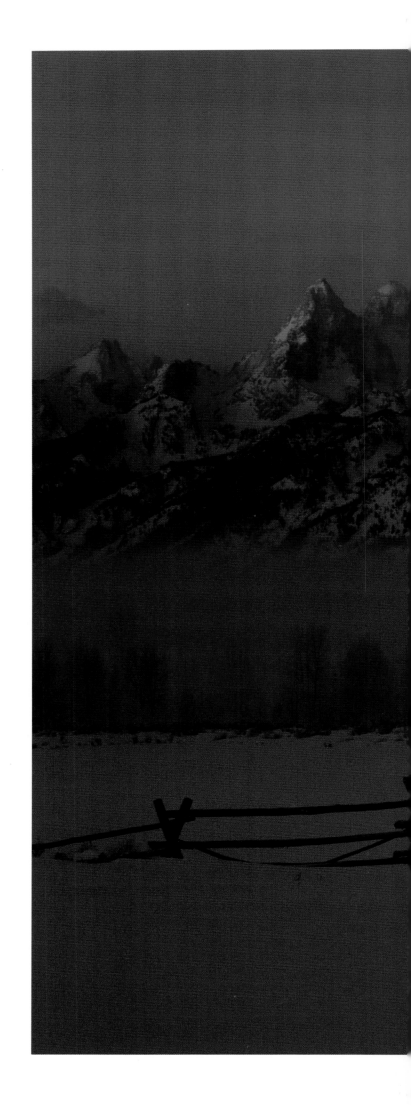

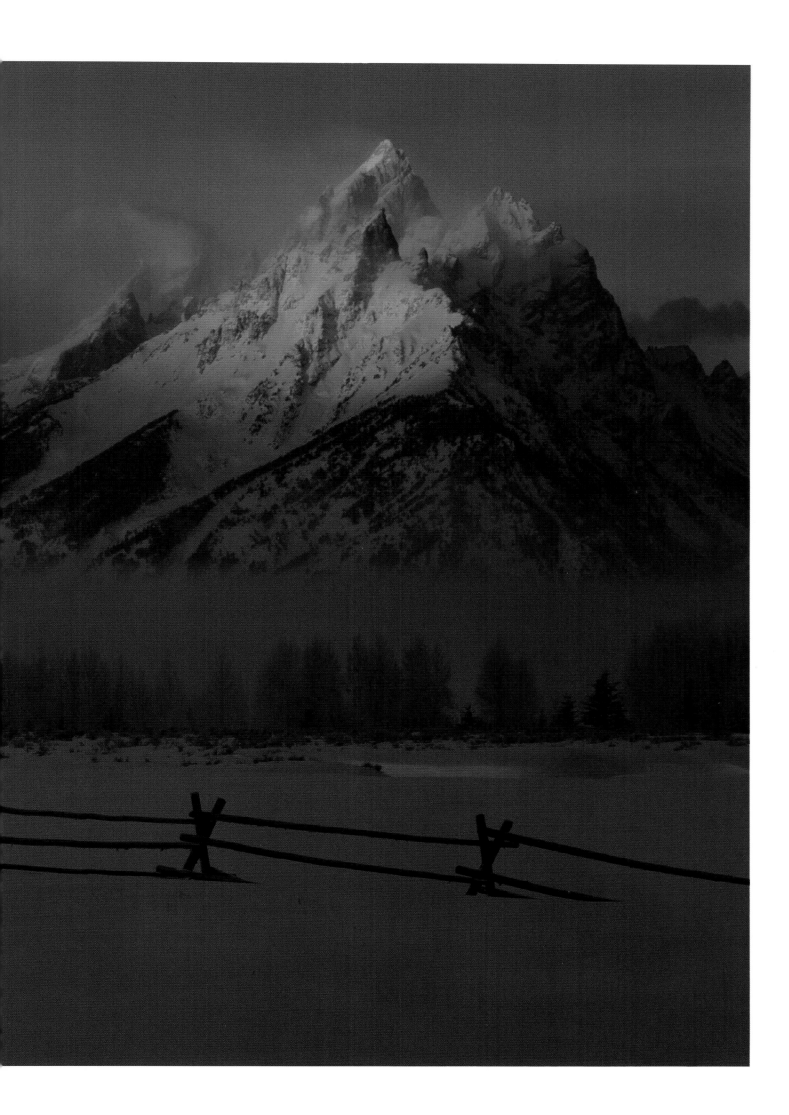

JANUARY DAWN, GRAND TETON RANGE

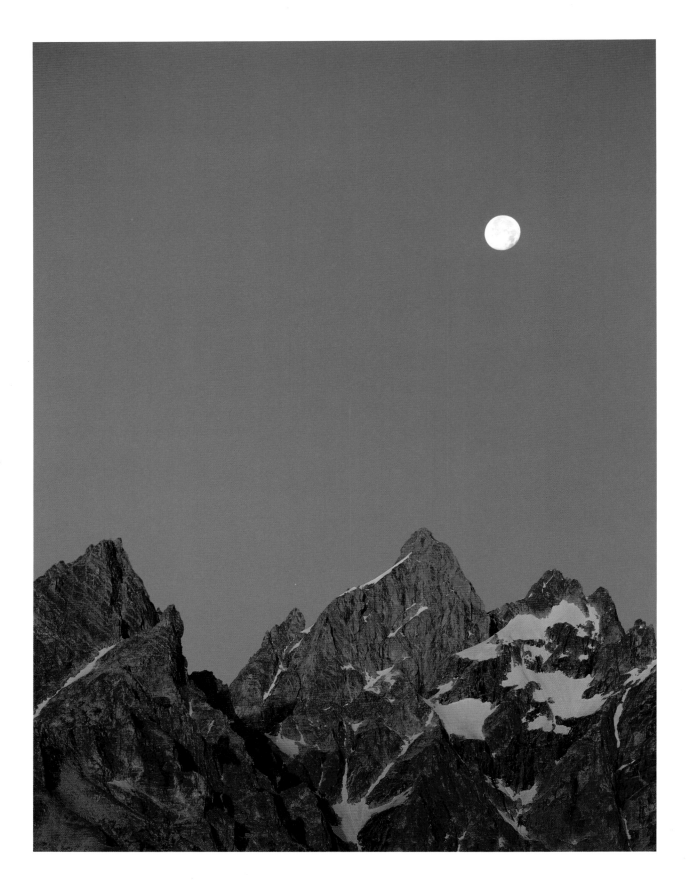

MOONSET, GRAND TETONS

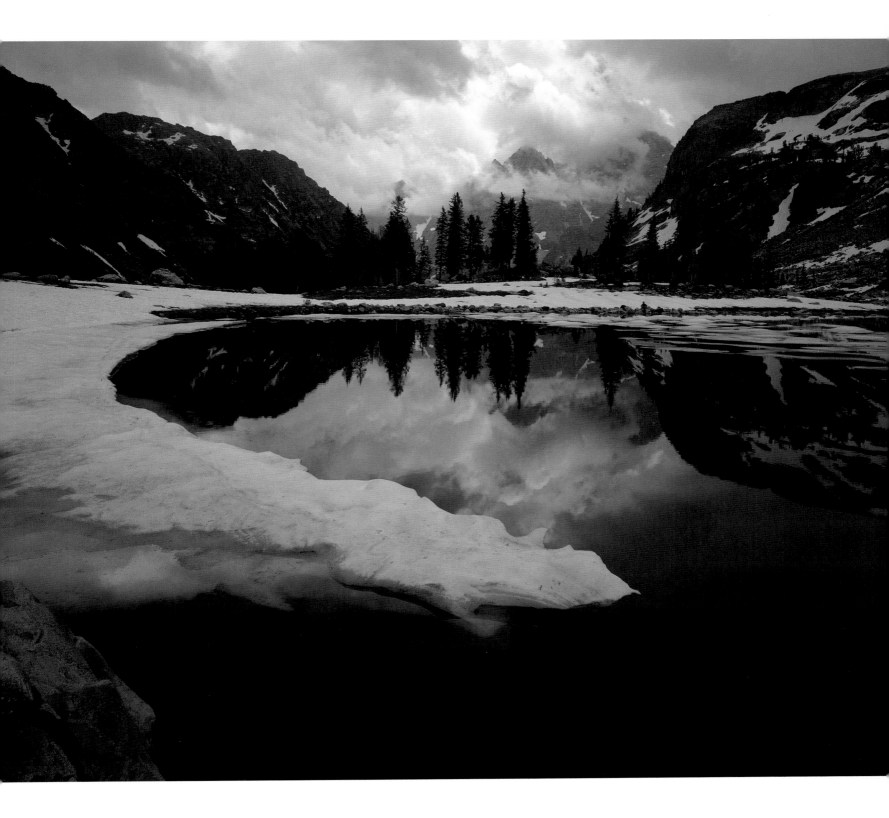

SNOWMELT DESIGN, LAKE SOLITUDE

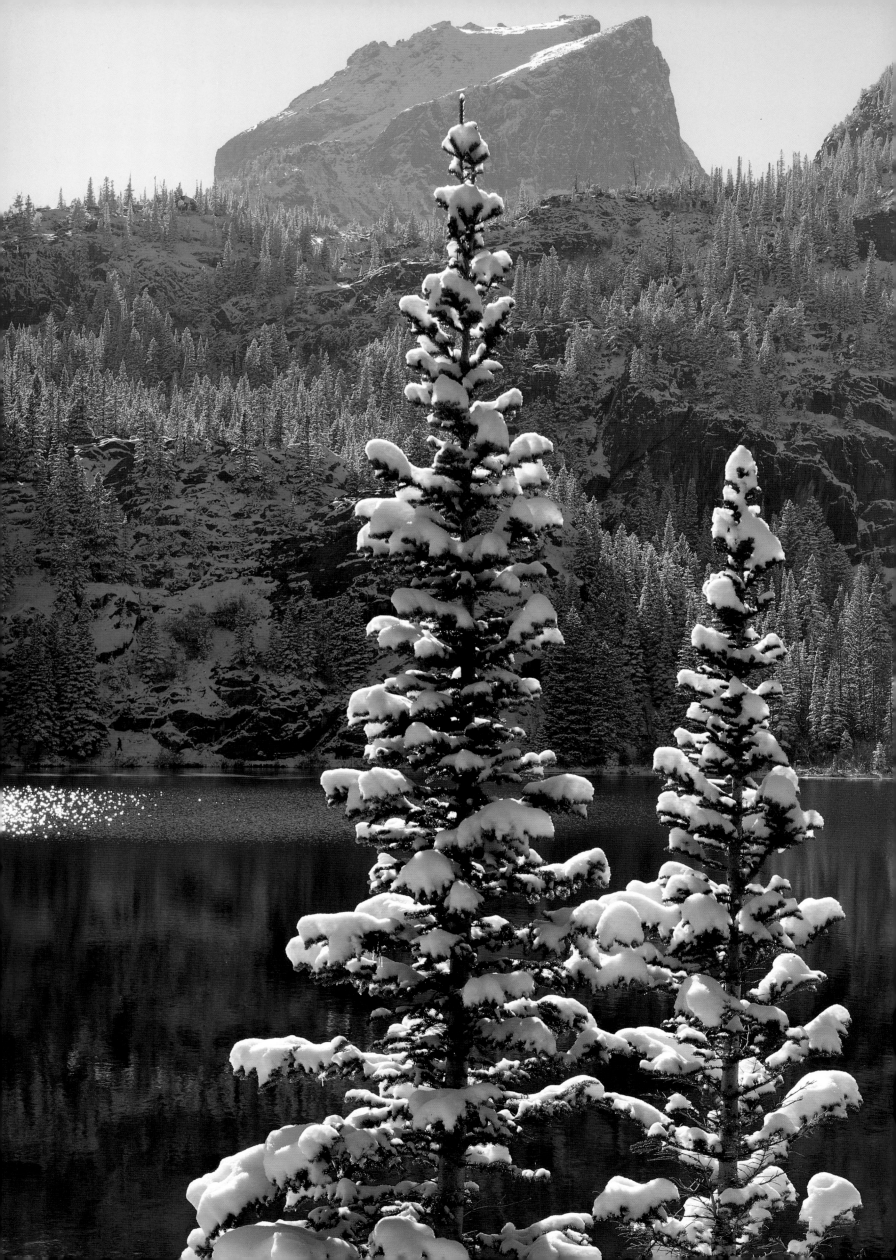

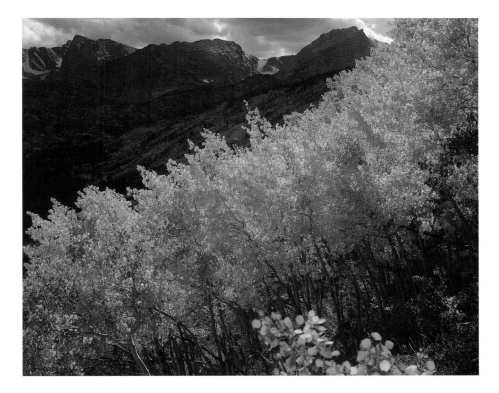

*A profound access to subliminal alpine country, with its lakes and wildflower carpets, reflects a landscape of change at Rocky Mountain. Open expanses of cool, dark forests give way to wildflower gardens, rare in beauty and luxuriance, including the blue Colorado columbine, before entering a harsh, fragile alpine tundra zone atop the Continental Divide. Established 1915.*

ASPEN TRANSITION BELOW THE CONTINENTAL DIVIDE

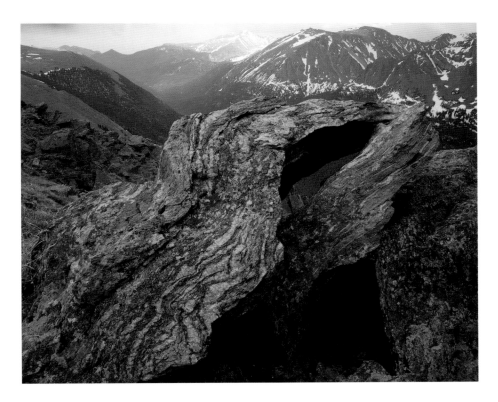

LONGS PEAK AND FOREST CANYON, TRAIL RIDGE

HALLETT PEAK AND BEAR LAKE

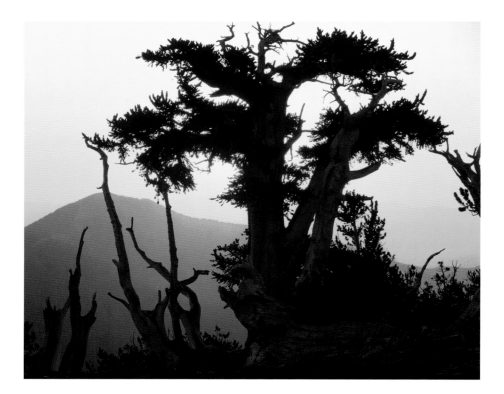

ANCIENT BRISTLECONE PINES ABOVE SNAKE CREEK

*A young park, Great Basin includes—high on windswept ridges and rock-strewn cirques of the Snake Range—extensive stands of the oldest-known living things,* Pirus longaeva, *the ancient bristlecone pines. As "living driftwood," beautiful sculptured pines survive in alpine adversity among peaks of this island in the desert. Underground are the beautiful formations of Lehman Caves. Established 1986.*

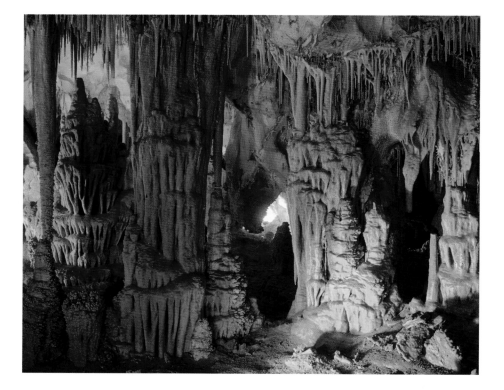

CAVERN FORMATIONS IN LEHMAN CAVES, SNAKE RANGE

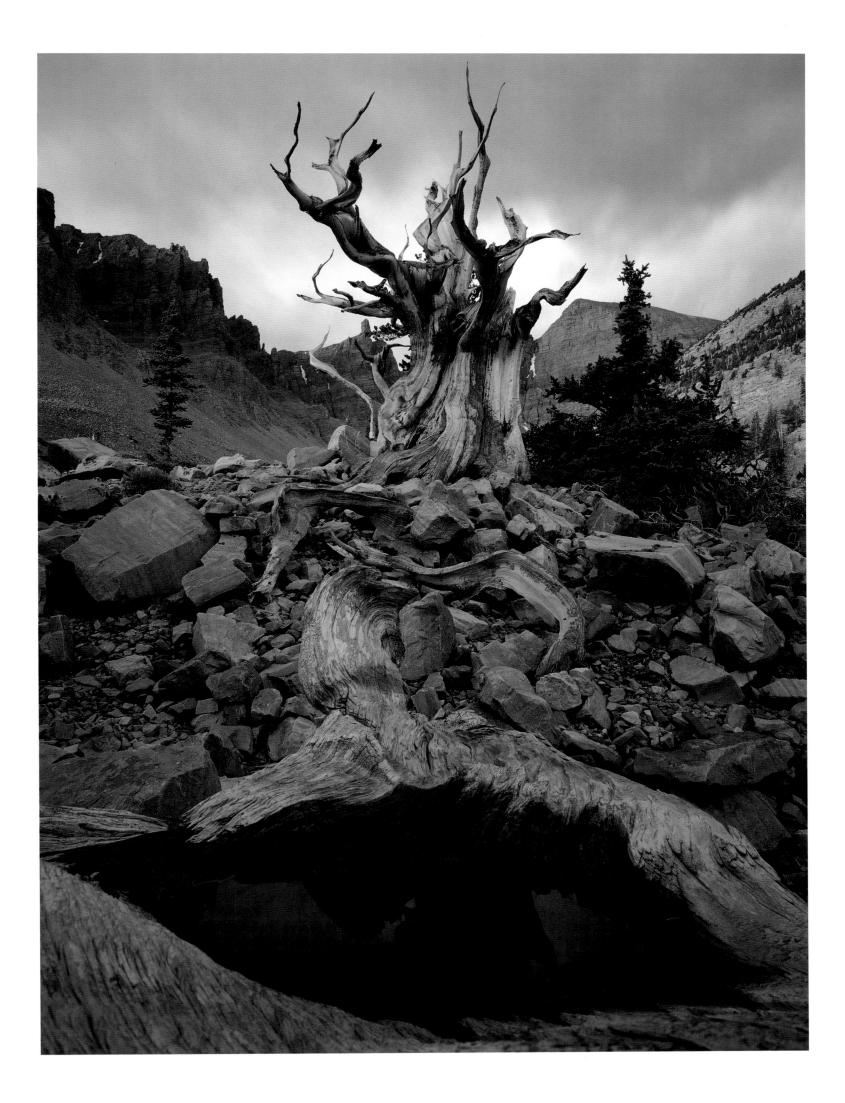

BRISTLECONE PINE SCULPTURE, WHEELER PEAK BASIN

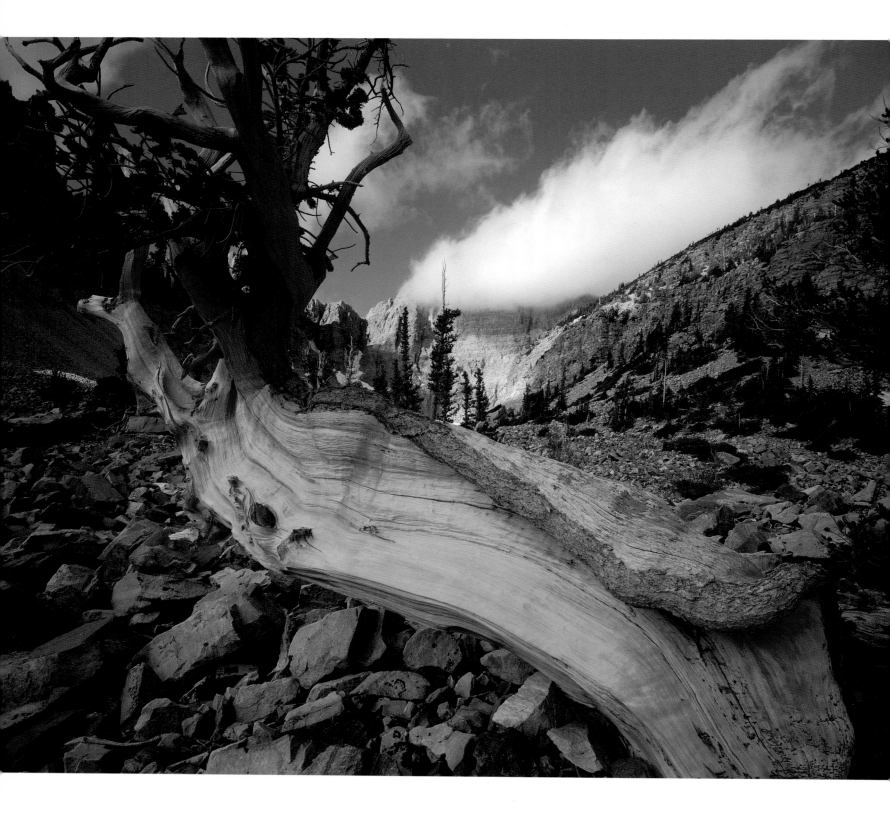

LIVING DRIFTWOOD AND WHEELER PEAK

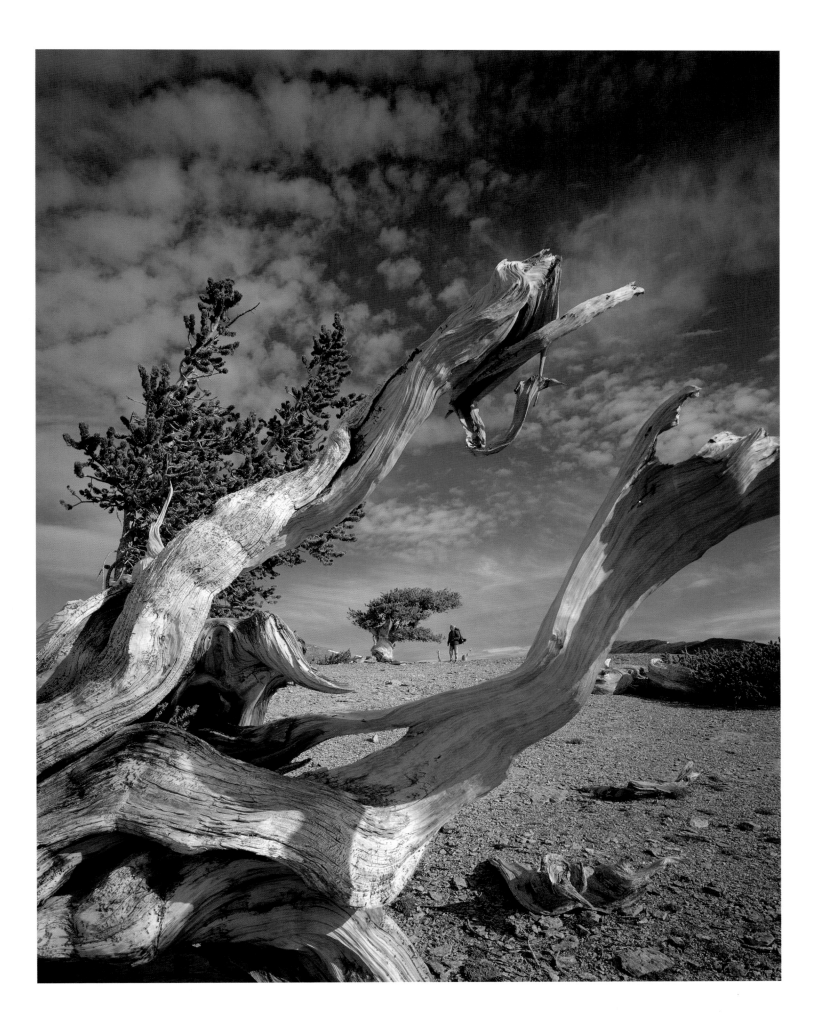

TIMBERLINE ANCIENTS, SNAKE RANGE

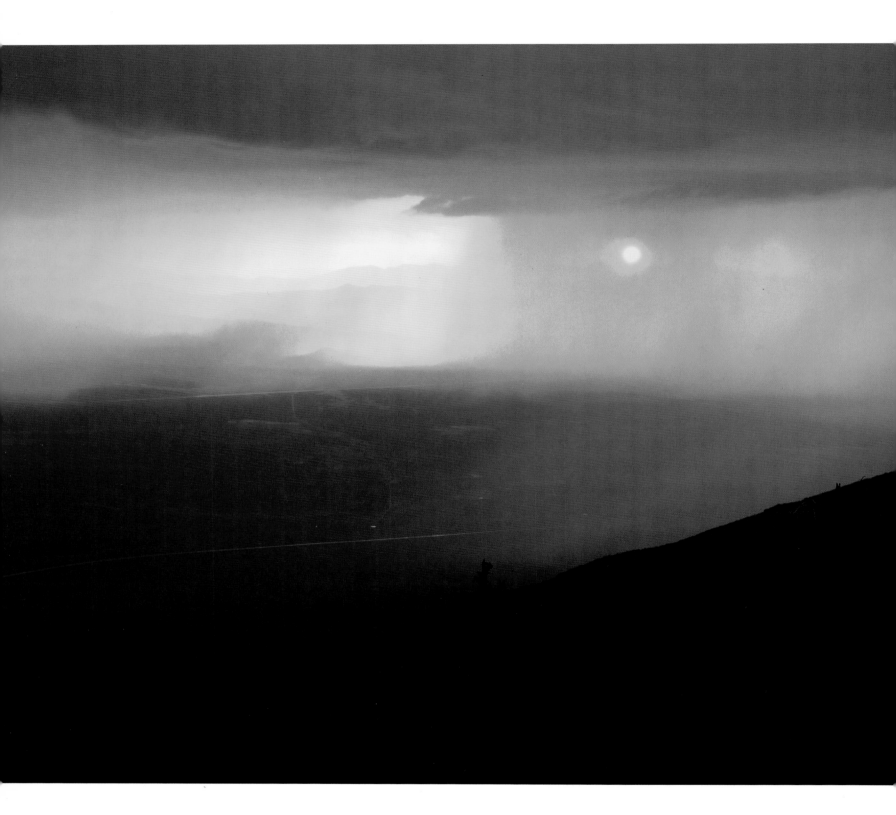

STORM, SNAKE RANGE, GREAT BASIN

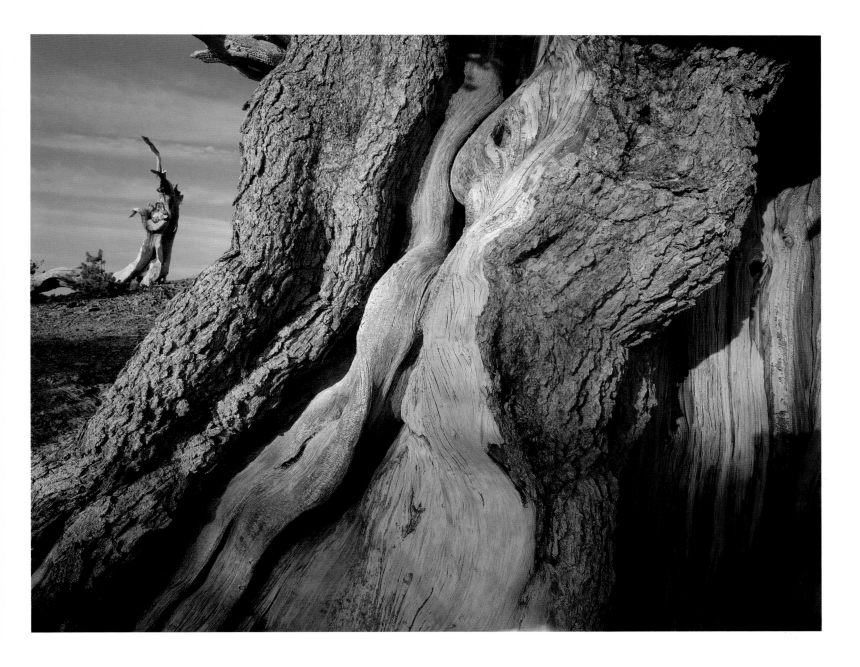

ANCIENT BRISTLECONE PINES, GREAT BASIN

## A GIFT TO THE FUTURE

by Stewart L. Udall and James R. Udall

One hundred twenty years ago, the American people fell in love with a new idea–the National Park idea. As a result of that romance, which is still going strong, we are blessed to live in a country where three out of every hundred acres have been preserved *in a natural state for all people for all time*. Dwell on that, for it is a miracle of sorts and becoming more so each day.

Three out of a hundred does not sound like much, but these holdings (in the aggregate, about eighty million acres) encompass some of Earth's select landscapes, including the Grand Canyon, Yosemite, Canyonlands, Glacier Bay, and Mount Rainier, to name just a few. The park system also contains a host of superlatives: the world's tallest, biggest, and oldest trees; the world's largest cave; the world's finest collection of natural stone arches; the world's most spectacular geysers; and North America's longest tidewater glaciers and loftiest summits and most stunning archaeological sites. Every American is a stakeholder in this superlative legacy. The parks are his and hers and yours. They are a fire burning, a torch handed down from generation to generation to–one hopes–generations yet unborn.

During our lifetimes, the two of us have been privileged to explore perhaps half of the fifty-one national parks in the United States, as well as a handful of parks in other countries. Although we do not know any park as well as we might wish, we have come to think of the Park System as another home. On foot and horseback, by canoe and raft, in jeeps and on cross-country skis, we have sought out the parks' hidden recesses, their subtle wonders, their wealth of wildlife. For us, as for millions of other Americans, parks have been places of physical adventure, intellectual stimulation, and spiritual rejuvenation. Many of our best memories and finest moments have occurred in parks. By opening our eyes to Nature's beauty, teaching us to see and to savor, parks have made us wealthy in ways that have nothing

to do with money. Without parks, we would be lesser people; America, a lesser country.

As an invention, the national park concept was so dazzling that, after the passage of 120 years, it still feels fresh today. Although it may not be "the best idea America ever had," as an Englishman once enthused, it certainly ranks up there on the same plane as baseball and the Bill of Rights. But where did the idea come from?

There are, in a sense, two histories. There is the long version, the dry, musty, footnoted history of pipe-smoking, pontificating professors. And there is the charming, fairy tale-like "immaculate conception" version around which the National Park Service once fashioned its hagiography. The long version begins two thousand years ago, with the Romans and their "holy woods," skips ahead to the Renaissance and nobles pursuing "beasts of the chase" in private hunting *parcs* (Old French, Middle English), lands in America with the *Mayflower*, then bushwhacks forward for two centuries through the Puritans' "howling wilderness." That gets you to the end of the first chapter and about 1807 when cedar waxwings were selling for two bits the dozen in Philadelphia. The fairy tale begins in the woods, too, with eighteen men sitting around a campfire in 1870 mulling two questions: How do we divide this Yellowstone wonderland? and, Whatever happened to Truman?

Truman was Truman C. Everts, the oldest member of the Washburn-Langford expedition which had come to Yellowstone to confirm or refute, for once and all, the tall tales and "roar-backs" that had issued from these precincts. Since the early years of the nineteenth century, this high plateau had been shrouded in fantasy. It was, rumor said, a place where rivers ran hot and you could set your watch by a towering geyser that shot 150 feet into the heavens. A place with a glass mountain and a waterfall that dwarfed Niagara. A place where you could hook a trout and, without moving, swing it still on the line into a boiling cauldron to cook. This, even the gullible found hard to swallow.

Twenty-five days earlier these men had entered Yellowstone. They had traveled south along the canyon and great inland lake of that name,

then swung north past the geyser they named Old Faithful. Two weeks into the journey, Everts, a fifty-four-year-old tax assessor, became separated from the party. Repeated searches came to naught, and, giving him up for dead, the rest of the men headed homeward. On their last night in what would become Yellowstone National Park, their thoughts turned to the future. If these men had shared the raider mentality of their day, they might have staked out a commercial bonanza for themselves. They could, quite lawfully, have filed homestead claims in the nearest land office and exploited key tracts of this paradise for profit. In the normal course of events, avarice would have held sway. This night, though, by some alchemy of smoke and starlight, another course appeared. But before describing it, let us give the professors another turn.

Aboriginal peoples the world over have always regarded certain landforms as sacred. But land preservation as an *American* ethic first surfaced in the 1820s and 1830s among the Transcendentalists. "In the woods is perpetual youth," wrote Ralph Waldo Emerson, the archdruid of that tree-hugging band of poets, utopians, and philosophers. "In the woods, we return to reason and faith. . . . The currents of the Universal Being circulate through me. . . ." Few of Emerson's callused countrymen shared these lofty sentiments. America's first centuries were hewed with an axe; we had always been a people who looked at a stump and saw progress. By 1830, however, wilderness was fast disappearing, and a few people were having second thoughts about what was being sacrificed in the name of development. But recognition of how wilderness had shaped the national character would come too late to save much of the East's

natural heritage. The region's last bison had fallen five years before. Elk, wolves, cougars, and bears were becoming scarce. The great flocks of passenger pigeons, once numbering in the billions, had been gunned into oblivion. If the country had been bound by the muddy moat of the Mississippi, then the national park idea would never have been realized. Luckily, there was another realm across the river, and it was in the spacious landscape of the West, the authentic New World, where the concept found its birthing room.

The professors might disagree, but it is our belief that the national park idea was *intrinsic* to the West, indwelling in that majestic landscape, waiting for someone like George Catlin, who steamed up the Missouri in 1832, to discover it. Catlin would later become famous as a painter, ethnographer, and self-promoter (he once toured Europe with a satchel of paintings and two live grizzly bears), but he was then an unknown artist hoping to capture "the grace and beauty of Nature" before it was extinguished by civilization's advance. At Fort Pierre, South Dakota, Catlin witnessed Sioux braves slaughtering bison to barter for whiskey. In despair, he climbed a knoll, unfolded a map of the United States, and pondered what might be done to avert the inevitable. "Many are the rudenesses and wilds in Nature's works which are destined to fall before the deadly axe and desolating hands of cultivating man," he wrote, adding, in a spark of genius: "Why could not the Indian, the buffalo, and their wild homeland be protected in a *magnificent park* . . . What a beautiful and thrilling specimen for America to preserve and hold up to the view of her refined citizens and the world, in future ages! A

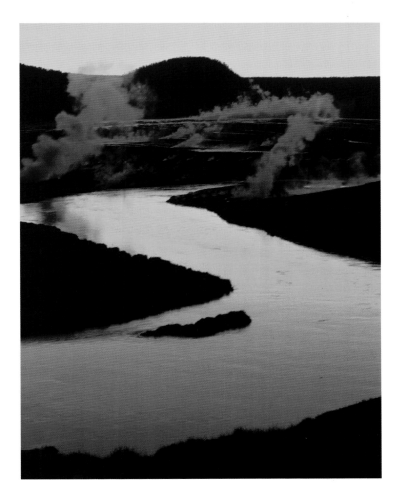

FIREHOLE RIVER, YELLOWSTONE

*nation's Park,* containing man and beast, in all the wild freshness of their nature's beauty."

In 1858, that self-appointed "inspector of snowstorms," Henry David Thoreau, who had suffered the disappearance of wild things in the East, restated Catlin's thesis in the *Atlantic Monthly:* "Why should not we . . . have our national preserves . . . in which the bear and panther and even some of the hunter race may still exist . . . for inspiration and our true re-creation?" Nobody paid much attention. As influential as Thoreau would later come to be, he was little regarded by his contemporaries. (During his life, this, the most parsimonious of men, whose words would later illustrate many a celebration of the national parks, had to rent a shed to hold his remaindered books.)

One who may have seen Thoreau's article was Horace Greeley, editor of the *New York Tribune.* On a visit to California in 1859, Greeley toured Yosemite Valley and a nearby grove of giant sequoias. The valley, he told his readers, was "the most unique and majestic of Nature's marvels." As for the trees, they were "of substantial size when David danced before the ark, when Solomon laid the foundations of the Temple, when Theseus ruled in Athens, when Aeneas fled from the burning wreck of vanquished Troy. . . ." Here, we whiff the insecurity that many Americans then felt about their young country's lack of history. This doubt would nourish the quest to save America's "earth monuments" and its "natural antiquities"—might not the sequoias be the pillars of our missing Parthenon, the Grand Canyon our Coliseum? Joining Greeley in the effort to prevent Yosemite from falling prey to the same hucksterism

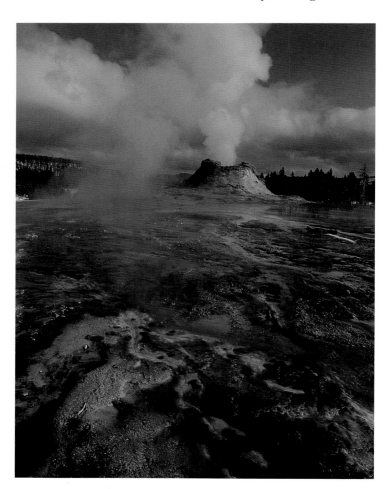

that had transformed Niagara Falls, the East's premier natural creation, into a tawdry spectacle of tourism was Frederick Law Olmstead, the noted landscape architect who was recuperating in California after finishing New York City's Central Park. In 1864, ten months before his assassination, Abraham Lincoln signed a bill granting Yosemite Valley and about four square miles of nearby sequoias to California as a state park. Yosemite thus laid the groundwork for what was to come in Yellowstone a few years later.

Back to the campfire. Nobody knows what was really said that night, but history credits a Montana attorney, Cornelius Hedges, for proposing "that there ought to be no private ownership of any portion of the Yellowstone region, but the whole ought to be set apart as a great National Park. . . ." His presentation was so eloquent that all the men—save one—agreed to work towards that end. On their return to civilization, Hedges, Washburn, and Langford's glowing descriptions of Yellowstone ran in papers across the country. The nation', fancy was further aroused when, after thirty-seven days in the wilderness, Truman Everts was found alive!

His slapstick saga is unrivaled in the annals of survival. The day after he was separated from the party, the nearsighted man lost the horse carrying his blankets, pistols, gun, fishing tackle, and matches. While searching for the horse, he lost his spectacles. Later, he would lose both his knives and one shoe. At night, he kept warm by soaking in hot springs. One night he fell asleep and scalded his hip. Another, he was treed by a mountain lion. A third, he spent in a bear's den. He lived on minnows and thistle roots, though twice he fasted for five days. When he discovered that he could

UPPER GEYSER BASIN, YELLOWSTONE

use the lens of his field glass to kindle a blaze, it flared into a forest fire and he was forced to flee for his life. A preacher came to him in a hallucination and told him to retrace his steps. When found and asked, "Are you Everts?" the emaciated man replied, "Yes. All that is left of him."

Thanks in part to the publicity generated by Everts' escapade, Yellowstone became a *cause célébre*. Seventeen months later, on March 1, 1972, President Ulysses S. Grant signed a bill, enjoining the Secretary of Interior to provide for the "preservation from injury or spoliation of all timber, mineral deposits, natural curiosities, or wonders within said park" and to prevent "the wanton destruction of fish and game . . . and their capture. . . ." In what would come to be seen as a precedent, Congress did not provide funds to run the new park, but it did appropriate $10,000 to buy Thomas Moran's painting, *Grand Canyon of the Yellowstone*. The seven- by twelve-foot canvas was hung in the Senate lobby as if to signify that a new idea had shouldered its way onto the national stage.

*That was a wonderful thing: that a hustling, restless, dollar-chasing young nation, with much of its population swarming like locusts over rich virgin land, should have been able to pause long enough to look into the future with such spiritual prudence.*

Freeman Tilden

Yellowstone was the world's first national park, and it is tempting to think of its establishment as marking some sort of grand ecological awakening. But this was not really the case. When Lincoln signed the Emancipation Proclamation freeing the slaves in the South, it was recognized as a moral divide in the nation's history. Yellowstone, though, appeared to be a pause between courses, a momentary dabbing of the lips in what historian Vernon Parrington later called the "Great Barbecue."

The frenzied raid on the West's natural resources that took place after the Civil War was the culmination of a process that had begun with the mountain men and their beaver traps. In 1872 there were still perhaps fifteen million bison roaming the Great Plains. A decade later, there would be fewer than a thousand. An estimated one to two million bison were killed each year from 1872 to 1875 by market hunters using specially designed rifles which could drop an animal on a far hillside. The hunters skinned the animals, cut out the tongues, and left most of the meat to rot. At Fort Worth, hides awaiting shipment were stacked in tall rows over a quarter-mile long. The wholesale butchery was driven by the Myth of Superabundance, the intoxicating belief that the nation's cornucopia of wildlife and forests and minerals was inexhaustible. The new machines of the Industrial Revolution allowed the orgy to feed on itself: As the railroads extended their tentacles west, construction crews gorged on bison, while locomotives burned nineteen thousand cords of wood a day.

Against this savage backdrop, Yellowstone seems an aberration. So why did the bill pass? And what was its true significance? Since the rugged, frigid plateau had not yet attracted loggers, miners, or cattlemen, there was little organized opposition. Although no elected official had actually seen the geysers, mudpots, and other "freaks of nature" the proposed park would protect, photographs by William Henry Jackson were displayed in the Capitol Rotunda. Here was proof-positive: Even an amiable idiot could see that the region was something special. Newspapers, magazines, and—perhaps more important—Jay Cooke, a powerful financier who desired the park as a drawing card for his Northern Pacific Railroad, endorsed the idea.

The vote boiled down to a question of *zoning*. As an invention, that is what the national park was: A new kind of land use regulation, the ramifications of which were unclear. The bill proposed to withdraw from settlement an area bigger than Rhode Island and Delaware combined and dedicate it as a "pleasuring-ground." Some senators found the notion disquieting. In floor debate, Cornelius Cole of California expressed his doubts, saying, "The geysers will remain, no matter where the ownership of the land may be, and I do not know why settlers should

be excluded. . . . I do not see the reason or propriety of setting apart a large tract of land of that kind in the Territories of the United States for a public park."

Had the bill been perceived as precedent setting, it would assuredly have received closer scrutiny. Fortunately, Yellowstone was conceived not as an example but as an *exception*. For all anyone in Washington knew, the world's first national park would be its last. In the end, Yellowstone benefited from being one of those rare, why-not? sounds-good-to-me votes legislators sometimes get to cast.

In hindsight, the bill's passage was remarkable on five counts. First, in what marked a new extension of the democratic ideal, Yellowstone was established as a public park. Second, the land was set aside, not for a year or a decade, but in *perpetuum*. Third, the land was conserved not for its utilitarian benefits—the sawlogs and minerals and game contained therein—but as a reservoir of spiritual and aesthetic amenities. Fourth, the withdrawal was notable for its scope; it did not protect just a few acres around Old Faithful and other scenic highlights—but more than two million acres. (Yellowstone remains the largest national park in the Lower 48, a splendid prototype of what a park should be.) Finally, the law broke new ground by acknowledging that Yellowstone—and, by extension, other untouched landscapes—was deserving of protection just as God made it. Two and one-half centuries after the *Mayflower* landed, Americans had finally found a place they could deem sacred, a place to treasure in its natural state.

Had the bill simply accomplished its intended outcomes, it would have been noteworthy. What makes it miraculous is all that it accomplished

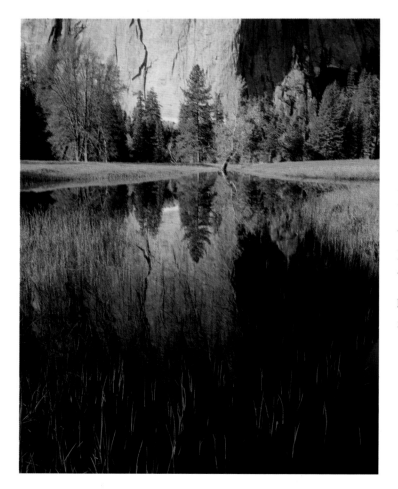

unintentionally. No one envisioned Yellowstone as the inspiration for a national park *system*—but so it would become. No one envisioned it as a wildlife refuge, where grizzly bears and the last bison in the Lower 48 would someday find sanctuary—but so it was. No one envisioned the law as protecting "wild rivers" or "endangered species" or an "ecosystem"—it would be decades before these concepts were promulgated—but so it did. And certainly no one intended that the bill would help launch an ethical and moral transition that would lead, inexorably and over time, to a profound shift in the American dialogue with the Earth, a turning from plunder towards stewardship. Here was the place where the nation began to emancipate itself from outdated and ultimately oppressive practices of land use that, had they continued, would have thoroughly and irreparably diminished the productivity of our landscape. To leave Yellowstone wild, we would need to tame ourselves.

The fledgling idea quickly took wing on a journey that has carried round the world. In 1876, Mexico dedicated El Desierto de los Leones National Park near Mexico City. In 1885, Canada founded Banff National Park. ("If we can't export the scenery, we'll import the tourists," said the superintendent of the Canadian Pacific Railroad.) Two years later, a Maori chieftain deeded the volcanic region of Tongariro to New Zealand for a national park on condition that it never be sold, desecrated, or exploited. In 1889, King Leopold II of Belgium established a national park in the Belgian Congo. In 1898, South Africa established what would become Kruger National Park. More than twice as big as Yellowstone, it encompassed the full panoply of African wildlife, including impala, cheetah, elephant, kudu,

EL CAPITAN, YOSEMITE

rhino, leopard, and lion. (The northern border of the park was delineated by a river Rudyard Kipling memorialized in one of his children's stories—the "great gray-green, greasy Limpopo.") Although true wilderness disappeared in Europe long ago, after the turn of the century many countries began to protect some of their remaining natural areas. Sweden dedicated two parks in 1909. The Swiss dedicated one in 1914. And, in 1918, Vladimir Ilyich Lenin introduced the park concept in the Soviet Union.

Meanwhile, back in its homeland, the national park idea awaited its bard, someone who could passionately communicate the glories of this new geography to other, increasingly city-bound Americans. It found that bard in John Muir. Born in Scotland, raised on a farm in Wisconsin, Muir was a prodigy, a mechanical wizard who seemed to be destined to make his fortune as an inventor—until an accident in a carriage factory almost cost him his sight. This event turned Muir's face towards nature. After tramping for more than one thousand miles through the South, where he caught malaria and almost died, Muir ended up in the Sierra Nevada working as a shepherd.

Muir was, his fellow herdsmen agreed, a queer sort. He spent hours observing black ants and measuring pine cones. He conversed with plants and trees. He penned letters to friends in sequoia sap. He studied water ouzels and wood rats, and sketched the dance of grasshoppers. Dismayed by the damage his woolly charges—"hoofed locusts" he called them—did to the alpine meadows, Muir quit herding. Moving to Yosemite, he took work in a lumber mill. His free time he spent in the surrounding wilderness, where he soon came to understand that men were eyewitnesses to creation if only they opened their senses to it. For Muir, animals, plants, even rocks and water were "sparks of the Divine Soul."

Compared to modern-day backpackers, Muir's camping equipment was rudimentary; his style, Spartan. He slept on the ground, not on a Thermarest. He carried no tent. Often, he would bivouac without blankets, huddled around a small fire, dozing on bare glacial rock. His diet was bread, oatmeal, and tea, occasionally leavened with a hunk of cheese or dried beef. If he was going to be away from camp all day, he would fasten a "durable crust" to his belt. Determined to stretch his senses to their limits, Muir sought the most intimate relation to natural forces, whether it required climbing to the top of a wind-bent fir, sleeping out in a mountain blizzard to feel the snowflakes on his face, or crawling along a ledge in the moonlight to witness a water-fall's plunge. Coming on a dead bear in the High Sierra, he wrote, "Toiling in the treadmills of life we hide from the lessons of Nature. We gaze . . . upon our beautiful world clad with seamless beauty, and see ferocious beasts . . . [but] bears are made of the same dust as we. . . ."

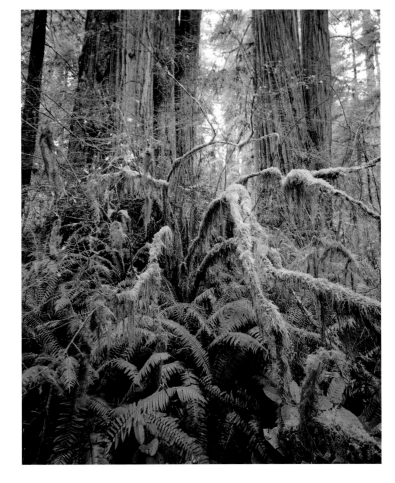

Having closed the schism between man and nature in his own life, Muir was the ideal apostle to help his countrymen do the same. In 1871, he came down from the summits to do battle with the enormous conceit that the world was made solely for men. Twitting those narrow thinkers who valued sequoias only in terms of board-feet, Muir wrote, "No doubt these trees would make good lumber after passing through a saw mill, as George Washington after passing through the hands of a French chef would

JEDIDIAH SMITH REDWOODS

have made good food." For the rest of his life, Muir threw himself into the fight to preserve "God's first temples." His writings galvanized support for the establishment of Yosemite, Sequoia, and Kings Canyon national parks in 1890. Two years later, Muir founded an organization to defend and extend the national park idea. This was the Sierra Club, which took as its unwritten charter Muir's belief that "pure wildness is the one great want" of our civilization. By the time Muir died, on Christmas Eve, 1914, his conviction that the best parts of the woodlands and wilderness should be preserved inviolate as sanctuaries for the human spirit had become one of the mainstays of the conservation creed. During his lifetime, he played a vital role in establishing six superb parks—Sequoia, Yosemite, Mount Rainier, Crater Lake, Glacier, and Mesa Verde, the latter notable for being the first park to protect a site of great historic and cultural, rather than scenic, significance.

Worldwide, the number of parks grew steadily from Muir's death to about 1960, when it began to skyrocket. The sixties and seventies were banner decades for national parks in the United States, with the establishment of Petrified Forest, Canyonlands, Redwoods, and North Cascades. In the 1970s, Guadalupe Mountains, Capitol Reef, Badlands, and Arches were added. And, in 1980, with a stroke of the pen, Jimmy Carter doubled the size of the park system when he signed the Alaska National Lands Conservation Act.

The U.S. National Park System today is the inspiration for 125 similar systems containing about thirteen hundred national parks and protecting more than 1.1 billion acres, or about 3 percent of the earth's surface. (The largest park? Located in Greenland, it is bigger than Texas.) The idea has evolved almost as rapidly as it has spread, and around the world we now find national archaeological parks, national marine parks, national historical parks, national cultural parks, and national battlefield parks—all progeny of the park idea.

Although Americans are justly proud of having invented the national park, the zeal with which other nations have embraced the idea suggests that Yellowstone National Park simply may have been the first articulation of a deep-seated human need, arising in the midst of the Industrial Revolution, to maintain contact with the natural world from which we sprang. "Perhaps the mind is not merely a blank slate. . ." wrote the great naturalist Joseph Wood Krutch, who had an intimate acquaintanceship with the Grand Canyon. "Perhaps it reaches out spontaneously toward what can nourish either intelligence or imagination. Perhaps it is part of nature and, without being taught, shares nature's intentions."

Does this explain the phenomenally rapid spread of the national park idea and the popularity of parks today? Did humankind make room for parks in our landscape because we have wilderness in our blood?

*For the animal shall not be measured by man. In a world older and more complete than ours they move finished and complete, gifted with extensions of the senses we have lost or never attained, living by voices we shall never hear. They are not brethren, they are not underlings; they are other nations. . . .*

Henry Beston

Although the original motivation for establishing national parks was anthropocentric and most park boundaries were drawn to meet the needs of humans rather than animals, the Park System has nonetheless proved an irreplaceable haven for wildlife. From Haleakala Crater in Hawaii to the shores of Acadia in Maine, America's national parks are a priceless repository of North America's native plants, birds, and wildlife. Each of the national parks is, in its own way, an American Eden. On the shuttle bus ride through Denali, the visitor stands an 80 percent chance of seeing moose, caribou, Dall sheep, and grizzly bears. There are more species of trees in the Great Smokies than in all of Europe. Olympic National Park harbors one of the last remaining temperate zone rain forests. The age-old minuet between timber wolves and moose continues on Isle Royale. Seals, sea otters, and great flocks of seabirds ply the fog-shrouded waters of Kenai Fjords. How can this biological heritage be conserved?

When Yellowstone was first established, the issue was only vaguely addressed. Congress appointed a superintendent, but niggardly refused to appropriate money to patrol the park. ("Not a cent for scenery!" solons were wont to bray, whenever the question came up.) Poaching was rampant in the early years, and in 1886 the United States Cavalry was sent in to restore order. The men in dun rode herd on the park until 1916, when the National Park Service was founded. The new agency's mandate was to "conserve the scenery and the natural and historic objects and the wildlife therein, and to provide for the enjoyment of the same in such a manner and by such means as will leave them unimpaired for future generations." This was a broad charter, with inherent, ambiguous contradictions between preservation and use that can never be fully resolved.

The twenty-two soldiers who were hired as the first park rangers tried to manage the natural resources in a sensible manner, but since wildlife management was then in its infancy, it was inevitable that mistakes were made. Governed by a "Lord-Man-knows-best" mindset, the National Park Service attempted to keep the balance of nature by putting a thumb on the scales. In practice, this meant extinguishing "wild" fires and extirpating "bad" animals such as wolves, cougars, and coyotes, while coddling "good" ones, specifically elk and bison. The predictable occurred: Forests grew dense, game populations exploded, and range productivity deteriorated.

Decades later, after much trial-and-error, we are just beginning to understand the Yellowstone eco-system. It is too early to say, "We know how Yellowstone works." We don't. Natural processes are vastly

more intricate that once believed. There are so many invisible feedback loops operating in that environment that its hidden workings may never be fully comprehended. (The larger question is too little asked: If our efforts to "play God" in parks have so regularly produced surprising and often unpleasant results, why are we so blithe about assuming that role everywhere on earth?)

By puncturing the myth of human omniscience, the parks offer a lesson of incalculable value. Heeding it, the Park Service has recently traded hubris for humility. "Hands-off" is today's watchword—but not all decisions can be abdicated to Mother Nature. Like it or not, the park managers have assumed a measure of evolutionary stewardship. Should we reintroduce wolves and other predators to those parks where they are missing? Since fire can be a tonic (sequoias, for example, will not sprout without it), should we allow lightning-caused fires to burn? Should we sometimes even *start* fires, and if so, when? And how do we control exotic, invasive species, such as wild boars in the Great Smoky Mountains or goats in Hawaii? These are the kinds of vexing questions with which today's park managers must grapple.

The national parks started out in the nineteenth century as a way to protect scenic treasures, but their mission has expanded on the way to the twenty-first century. In recent decades, the national park idea has been overtaken by the population explosion and global environmental degradation. Park managers have had to assume new burdens—foremost, the need to preserve endangered species and biological diversity. According to the National Science Foundation, "the rate of extinction over the next few decades

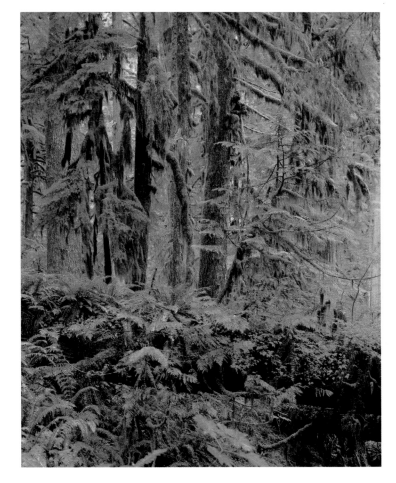

CARBON RIVER RAIN FOREST, MOUNT RAINIER

is likely to rise to at least one thousand times the normal background rate . . . and will ultimately result in the loss of a quarter or more of the species on earth." National parks have a critical role to play in averting this catastrophe; indeed, hopes for the recovery of many endangered species hinge on populations now largely confined to the parks. Although there is some precedent for this—at the turn of the century the last twenty bison in the United States sought refuge in Yellowstone—historically, park boundaries were drawn on the basis of criteria that had little or no ecological relevance. Almost all of the first national parks were located high in mountain ranges. Until 1930, lower-elevation forests, wetlands, grasslands, and coastal areas were absent from the system. Not until 1933, did the Park Service recognize that "perhaps our greatest natural heritage," rather "than just scenic features . . . is nature itself, with all its complexity and its abundance of life." The authorization of Everglades National Park one year later was a landmark. Here, for the first time, the center-piece of a park was an ecological setting rather than a scenic marvel. Even then, some skeptics questioned the need for a "snake swamp."

At 1.4 million acres, Everglades is the largest remaining subtropical wilderness in the United States and, next to Yellowstone, the largest national park in the Lower 48. But the "river of grass" is still too small to be a self-contained biological unit; indeed, it is only a bit bigger than the home range of a single male Florida panther. In fact, none of the national parks, with the exception of some in Alaska, is large enough to encompass the home ranges of all the animals that live within its borders. The Everglades also illustrates that

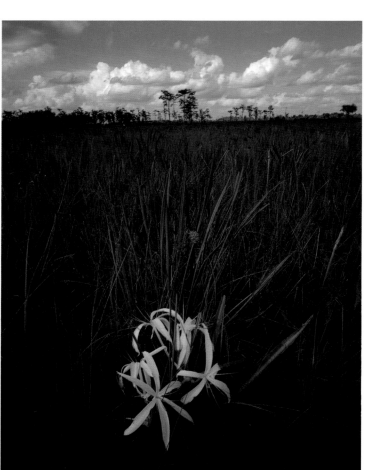

if we hope to preserve endangered species and ecological health over a century or more, natural processes taking place *outside* the parks must also be protected. For example, wading bird populations in the Everglades are down by 95 percent due to human-caused changes in the water cycle. An attempt to restore the natural hydrology of the region is underway. If it fails, within a few decades all of the living emblems associated with that national park—roseate spoonbills, red wolves, Florida panthers—may be gone. The park will still exist, of course, but scenery is a hollow virtue when ecological integrity has been lost. Fortunately, Everglades is, for the moment at least, an exception. The rest of America's national parks are in better shape. Indeed, many experts believe that if biodiversity has a chance anywhere in the world it is in North America, where a larger percentage of land has been set aside in national parks, forests, and wildlife refuges than on any other continent.

Ultimately, park management is creative rather than prescriptive, an art form more than a science. The long-term health of the parks will depend on our learning how to, in Aldo Leopold's phrase, "think like a mountain." In the future, the Park Service must become more adept at working with surrounding land-owners and other agencies to make ecological "wholes" out of today's pieces. At least for the larger, wide-ranging predators and ungulates, the illusion of the park as an "ark" has been shattered. The Florida panther cannot make it if it is confined solely to the Everglades. Neither Glacier nor Yellowstone is large enough to support a viable population of grizzlies over many centuries. The implication is clear: If we wish nature to survive inside parks, we must ensure its survival outside, too.

SWAMP LILY, EVERGLADES

In the first decades of the park system, the tourist was a rare bird. Today, though, many parks receive staggering numbers of visitors whose sheer numbers pose new challenges and opportunities. As drawing cards, the parks have succeeded beyond any prediction.

In 1883, during the annual congressional squabble over whether to appropriate money for the upkeep of Yellowstone, Senator George G. Vest of Missouri rose to speak. To a proposal that Yellowstone be surveyed and sold off, he replied that a people whose numbers would someday exceed 150 million would need the park as a "great breathing space for the national lungs." Since the population was then 53 million and the few tourists who went to Yellowstone had to endure a 232-mile wagon ride, many of Vest's colleagues accused him of hyperbole.

But history has proved him correct. As population has surpassed 250 million and transportation systems have improved, park visitation has skyrocketed. The parks received 37 million visits in 1951, 139 million in 1967, 260 million in 1991. (The trend in other countries has been similar: Kruger National Park in South Africa received 3 visitors in 1926, nearly 34,000 in 1936, 3 million last year.) Airplanes and automobiles have brought parks to the doorstep. You can be in Boston or Tokyo one morning, Big Bend the next. Fifty million people live within a day's drive of Shenandoah, 20 million within five hours of Yosemite. With tourism booming, some parks are becoming crowded. Last year, 4.3 million people came to see Grand Canyon. Yellowstone attracted 3.2 million visitors; Yosemite, 3.5 million; and Rocky Mountain, 2.7 million. Visitation to remote, less well known parks has also increased; at Denali, twentyfold since 1970.

Foreigners are arriving in record numbers. On some summer days, 40 percent or more of those at Grand Canyon are from overseas.

Although the backcountry attracts fewer people than what the Park Service has taken to calling the front-country, congestion is not limited to roads, parking lots, and visitor centers. In the Grand Canyon, for example, 19 people rafted the rapids of the Colorado River in 1952. Twenty years later more than 16,000 showed up, and the Park Service belatedly implemented a quota system. The waiting list for a private permit to run the river is now seven years. Plan ahead: Apply today, embark next century. Even the airspace over the Canyon is becoming clogged: The South Rim receives twice as much traffic as Washington, D.C.'s National Airport, mid-air collisions are an ever-present danger, and the buzz of planes and whop-whop-whop of helicopters is ubiquitous.

At what point does a park reach its "carrying capacity"? Although some Park Service officials dislike the term—it comes from range science and heretofore has been applied to herds of cattle and sheep—the question is increasingly unavoidable. Can a park be "overgrazed" by tourists in the same way a meadow can be by cows? How many people can share a viewpoint at one time? With park visitation growing exponentially (it is predicted to double by 2010), is there a point at which you must close the gate?

These are difficult questions. The perception of being crowded is relative. It depends a great deal on expectation and is also shaped by culture. Someone from Japan, where a national park may receive 85 million visits a year, will not find the South Rim crowded, even in midsummer. On the other hand, the same density of people and cars

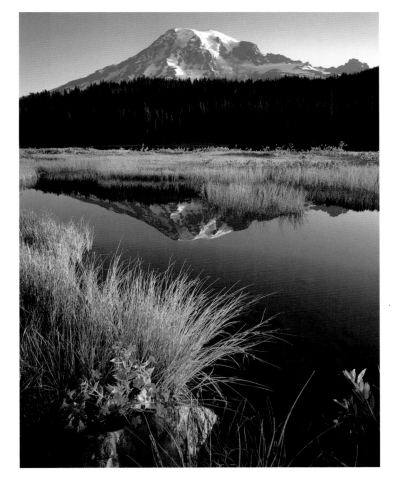

REFLECTION LAKE, MOUNT RAINIER

might dismay a long-time visitor. But clearly the parks *are* becoming more crowded. The suggestion that access to some parks should be limited, perhaps through a reservation system, has always been anathema to the Park Service (and to the concessionaires who provide tourist services), but the reality is that rationing is already taking place at the Grand Canyon and the other "crown jewels." On busy days the South Rim receives more than thirty thousand visitors. But there are beds and camping sites for just a few thousand. During the summer season, campgrounds in many parks fill by noon; an unknowing *paterfamilias* who arrives with his family at 5:30 P.M. will be forced to turn around and retrace his route. If the trade-off were a less crowded, less hectic visit, perhaps the public might not object as vociferously to a reservation system as the Park Service imagines. Tourists routinely book airline seats, motels, and car rentals in advance. Would calling ahead for a park reservation be so burdensome?

At many parks, the real problem is not too many people but too many cars. In 1915, the first automobiles arrived at Yellowstone. Their owners were required to chain their cars to a tree at the park boundary, and ride a stagecoach into the interior. Just four years later, some 10,000 cars carrying 40,000 tourists invaded the park—and the numbers have been mounting ever since. Initially, at least, the advent of the "tin Lizzy" was a blessing for the Park System. Cars made a park visit affordable for millions of middle-class families, who then became shareholders in the park idea. No longer would Glacier and other isolated parks be the exclusive domain of rich "dudes" from the East, who could afford the train ride West and the expense of

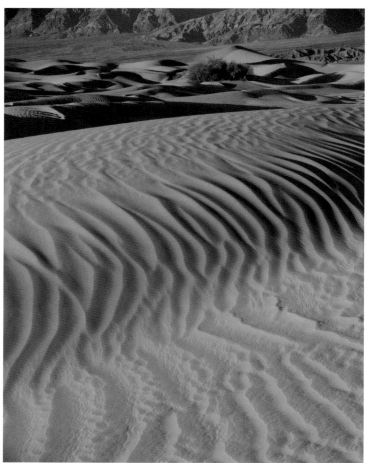

luxury hotels. But the sheer number of cars now wheeling through the gates threatens the very qualities the parks were created to safeguard. In addition to their physical impacts—the pollution they emit, the animals they hit, the congestion they cause—cars diminish the park experience. People come to parks to reconnect, in their own fashion, with the good Earth. But marvel and awe are elusive sentiments that dislike clamor and noise. At many parks, they have been hounded into the back country by snarled traffic and choking exhaust. At Great Smoky Mountains National Park, nearly 3.6 million vehicles arrive annually, causing gridlock on busy days. Studies there show that the average visitor spends seven times as much time inside the car as out of it. Indeed, 16 percent of park visitors never turn the motor off!

It is customary to lump visitors together, to think of them as the "hordes." But when people go to the trouble to come to parks, they are explicitly endorsing the park concept. The real issue with crowding is not that park visitors will damage park ecology (this does happen, but it tends to be localized), but that, at some point, the sheer numbers will begin to diminish the park *experience*. As the flood of cars and people swells, overwhelming roads, parking lots, and trails designed for the more modest visitation levels of forty years ago, there is a tendency for the Park Service to "channelize" the park experience. Along the two-lane road to Jenny Lake in Grand Teton National Park there used to be a number of pull-offs, where people could, on a whim, stop to take photographs or picnic. Now that the Park Service has blocked the pull-offs with large rocks, the only place to park is in the parking lot at the end of the road. From there,

PROPOSED NATIONAL PARK, DEATH VALLEY

visitors are herded with signs to a trail that goes along the shore of the lake. Here, the setting is heavenly, with the Tetons jutting overhead, seemingly within reach. Beauty seems at hand—until you take a closer look. To reduce pedestrian impact, the trail has been paved. Then, to keep people from trampling the bushes in a effort to smell the wildflowers, the Park Service *fenced* it.

Ultimately, the problem is not that the parks are crowded or that people travel in cars to see them. On the contrary, it is laudable that so many people want to see the national parks—heaven forbid the day they don't!—it is that so few visitors take the opportunity to go beyond viewing the parks to actually *experiencing* them.

> *Something hidden, Go and find it.*
> *Go and look behind the Ranges—*
> *Something lost behind the Ranges.*
> *Lost and waiting for you. Go!*
> Rudyard Kipling

In all probability the last time a President of the United States passed a night outside, sleeping on the ground, was in 1903 when Teddy Roosevelt came to Yosemite. Prior to arrival, he had written John Muir, expressing a desire to see "the giant grandeur of the place under surroundings more congenial than those of a hotel piazza or a seat on a coach." On their first day, the two men rode mules into the backcountry. That night, they camped in a grove of giant sequoias. "It was clear weather," Roosevelt wrote, "and we lay in the open, the enormous cinnamon-colored trunks rising about us like the columns of a vaster and more beautiful cathedral than was ever conceived by any human architect." Next day, they traveled through the forest to an overlook commanding a view of Half Dome. Here, they escaped a gathering snowstorm under the branches of a silver fir, rolling up in tarpaulins and blankets for the night. In the morning, the two men dusted the snow off and rode down into the valley, where Roosevelt proclaimed, "This has been the finest day of my life!"

In Roosevelt's exultation there is a lesson for all. His visit was memorable because he made the effort to engage Yosemite on its terms, to annex it to his own estate. This squares with the authors' experience. Our most vivid, most pleasurable moments in the national parks have occurred when we have been able to "cross the threshold," insert ourselves into the park landscape as a participant in the grand pageant of life. We think of the thunderstorm outwaited under an overhang in Zion, a lightning bolt flashing down to impale a sandstone pillar, the sudden, swift flash flood that followed, filling the canyon below. Of kneeling in the front of a small raft preparing to run Horn Creek Rapid with a nine-year-old grandson, his hand next to ours, grasping tight the lifeline. Of studying a ruin at Chaco, contemplating those men and women who quarried the stone and carried the roof beams on their shoulders from a forest sixty miles away. And of the late Bates Wilson, the one-of-a-kind ranger with whom we jeeped into Canyonlands long before it was a park, and whose love of that tortured landscape inspired others to see it protected.

By offering these examples, we do not mean to impugn sightseeing or sightseers. We have spent many hours doing the former and being the latter. The national parks *are* stunning and just seeing them can enrich life. It is perfectly possible to have an epiphany while standing on the rim of the Grand Canyon with a hamburger in one hand and a camera and postcard in the other. Indeed, it probably happens every day. But as a rule, what you can see from the roadside, no matter how breathtaking the panorama, only hints at what lies beyond. Scenery is just tapestry; the vista, the veil. To annex a landscape one must pull the gorgeous tapestry aside, lift the diaphanous veil, travel beyond visual impressions.

Human beings have five senses. Why, at the parks, is there such emphasis on one? Yes, the Grand Canyon has a gorgeous look—but it also has a feel, a song, a taste, a smell. One may learn more about the unfathomable antiquity of the Canyon and the forces that created it through the act of caressing a piece of river-polished schist three billion years old than in any number of stops at scenic overlooks.

The recipe for getting past the threshold is not complicated. The first ingredient is time. It takes time to know the parks. The long-standing tradition of "doing" as many parks as possible in a week's vacation is misguided. It is more rewarding to spend a week getting to know one park than rushing through three or four. The second essential is attention. To engage the parks with mind, body, and spirit takes focus. The third essential is courage. There is not one generic Grand Canyon—there is a Grand Canyon for each of us, which only we can discover and explore. This takes a measure of bravery, the willingness to create one's own personalized agenda, whether that is photographing wildflowers or rising early to watch the sun crest the horizon.

Some park lovers argue that it is inappropriate to encourage more people to explore on foot; that the trails could not take it; that it is best to keep the hordes on pavement, close to their cars. But anyone who knows what parks have to offer people is duty-bound to encourage others to delve more deeply. In truth, the vast majority of park visitors will always lack the curiosity, leisure, inclination, equipment, or skills to venture far from the roads. There are a thousand miles of trail in Glacier National Park; there is no need to worry about the backcountry being "loved to death." (Trail use in many national parks is actually *down* from levels of ten or fifteen years ago. The backpacking craze of the 1960s and 1970s is over; the baby boomers have kids now, and their knees ache.) Another once-fashionable fret—that the parks are destined to become "mere resorts"—is also dated. Though a few heavily used tourist areas have come to resemble *faux* Disneylands, in 1992 what is most remarkable about the parks is not how much has

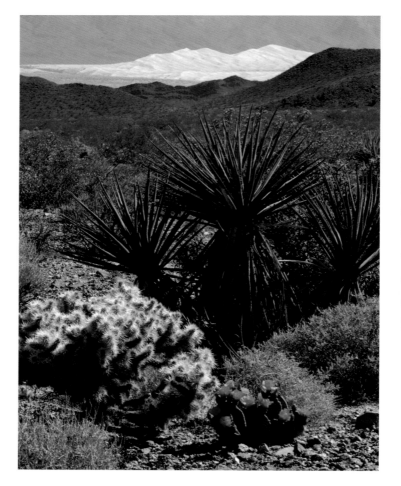

been given over to roads, hotels, and other development—only 2 percent of the land in Yellowstone and 5 percent in Yosemite, for example—but how much has been preserved as wilderness.

Perhaps because the first wilderness areas were located on Forest Service lands, many people do not associate wilderness with national parks. But of the approximately eighty million acres in the National Park System, about thirty-seven million have already been designated wilderness, nine million have received wilderness recommendation, and an additional twenty-eight million are being studied to see if they meet the wilderness criteria. As a rough guess, 80 percent of our parklands retain their primeval character. This wild empire breathes with the seasons, expanding in winter, contracting in summer. Backpackers throng the sunny High Sierra of Sequoia and Kings Canyon in July, but in January it is possible to ski for days without seeing another person and for more than three hundred miles without crossing a plowed road. At many parks—Capitol Reef, North Cascades, Gates of the Arctic, to name just a sampling—essentially the entire park is wilderness. The Grand Canyon receives as many visitors each summer day as Wrangell-Saint Elias, our largest national park, receives in a *decade*. Rest assured, thanks to the Park System, there are many places on this earth where solitude and serenity still reign, where glaciers hold sway, where man is insignificant.

It is customary to think of wilderness areas as being the sole province of muscular youths in the prime of life. And some are. Others, however, are quite accessible, reachable within a day or two on foot, by canoe or raft, and, in Alaska, by sea kayak, dogsled, or bushplane. With imagination and some planning, young

PROPOSED NATIONAL PARK, MOJAVE DESERT

children and grandparents can make it across the wilderness threshold. Even physical disabilities do not disqualify those with desire: Paraplegics have sea kayaked in Glacier Bay, rafted the Noatak, and paddled through Voyageurs and Big Bend.

Granted, the taste for wilderness exploration must be acquired, and that takes an investment of effort. But it is an investment worth making. National parks are tremendously generous: Whatever you expend in getting to know them, they will repay many times over. One need not possess John Muir's cast of mind to take the pulse of the primeval earth, or to discover the truth of his saying that "the truest way into the Universe is through a forest wilderness." The cosmic may not be commonplace in the parks, but neither is it exceedingly rare. Moments of personal clarity, insight, and even revelation abound. With some effort, anyone can experience what the novelist Mary Austin, writing at the turn of the century, described as the "flash of mutual awareness," the "transaction" between the human spirit and spirit of the land.

*Our people do not understand even yet the rich heritage that is theirs. Our people should see to it that they are preserved for their children and children's children forever, with their majestic beauty all unmarred.*

Theodore Roosevelt

Every celebration of the national park idea that has been published in the last twenty years has ended with a few cautionary words about storm clouds on the horizon. Those clouds have now arrived, and it is no longer possible to dismiss the challenges facing our national parks in a few paragraphs.

The great starburst of park creation this century has witnessed is drawing to a close. It is now last call for new parks, before population growth and other land demands shut the door. If the era of acquisition is nearly over, the era of attrition may be just beginning. Those who care about national parks cannot afford to take their survival for granted.

The romantic vision of parks as protected paradises has always been an illusion. There are few countries with national parks where the latter have not at some time been damaged beyond repair. In the developing world, the gravest threats to national parks are poverty, desperation, and strife. Parks in Croatia have been overrun during the civil war there. In Africa, elephants, rhinos, and other park wildlife are routinely poached for meat, ivory, or horns. In India, hungry squatters cut down forests to graze livestock in Ranthambhore National Park. But it is not the poor that threaten parks in Pakistan. There, Arab sheiks arrange lavish expeditions costing tens of millions of dollars, flying in C-130s loaded with oil and water tankers, personal servants, Range Rovers, and gyrfalcons to hunt endangered game birds. The parks in that nation, as in other impoverished countries, exist largely on paper.

Due to the steadfast vigilance of conservationists, the status of American parklands is less precarious. Nonetheless, our parks, too, are beleaguered by myriad threats: Pressure grows to open parks to hunting. Oil, mining, and logging companies encroach on park borders. Geothermal development outside Yellowstone threatens geysers inside. Tour companies, cruise ships, and air charter firms hard-sell parks to increase their profits; overflights of Grand Canyon are marketed in Las Vegas as a break from blackjack. Hurricanes topple pines in the Everglades. Oil spills foul beaches in Glacier Bay. Auto emissions damage trees in Sequoia. Each spring, as snow begins to melt, shadowy figures steal into Yellowstone's backcountry, hacking antlers from winter-killed elk. Packed out on horses, they are sold into the Asian aphrodisiac market, along with poached bear paws and gall bladders. Abandoned mines leach heavy metals into Wrangell-Saint Elias. Acid rain threatens to pickle thousands of lakes in ten western parks. Mongeese displace native animals in Channel Islands National Park. A century of fire control has turned some parks into tinderboxes. Global warming remains a wild card: By 2100, vegetation zones may have shifted two hundred miles northward at rates far faster than most trees can migrate. As parks are gradually transformed into habitat islands,

park boundaries begin to behave as "uni-directional filters": Animals leave, but few return.

The National Park Service, the agency charged with preserving the parks, has its own troubles. Never adequately funded, the Park Service has accrued a $2.2 billion backlog of deferred maintenance on park roads and infrastructure. Good science is the backbone of resource management, but the Service's science program remains an embarrassment. Poorly paid summer rangers now qualify, in some cases, for food stamps. Budget shortfalls force layoffs of large numbers of interpreters—those smiling men and women whose job it is to help visitors cross the threshold. Manipulation of resource decisions by political hacks in Washington demoralizes the agency's dedicated and competent staff. Concessionaires cut sweetheart deals that allow them to take much and give little. Now, perhaps more than at any time in its history, the Park Service needs strong leadership and adequate levels of funding to meet the challenges it faces.

In the long run, the greatest threat to the survival of parklands, here and abroad, may be overpopulation. National parks have been described as a "full stomach" phenomenon enjoyed only by those whose basic needs have been met. Since there is some truth to this, it is worth asking, How will these shrines fare in the overcrowded, hungry world on the horizon? There are five times as many people today as when Yellowstone was established. Increasing by some 250,000 per day, global population may double within the next fifty years to eleven billion, while the U.S. population rises to 340 million. Even at today's level, the human face is pained. Each year, the number of refugees and homeless and starving grows, while industrialization puts mounting pressure on the global environment. In light of these trends, the coming century appears to be a yawning crevasse. Can we cross it safely? And, if so, will we be able to bring the parks across safely as well?

National parks represent a pact with, and promise to, posterity. To date, with some exceptions, we have been able to honor that covenant. But there are no guarantees. In the next national emergency, there may be calls to pillage our national parks of whatever resources they contain. Precedents do exist: During World War I cattlemen were allowed to graze their animals in many Western parks; and during World War II the military requested permission to cut old-growth Sitka spruce in Olympic National Park. Ultimately, the welfare of America's parks and the welfare of Americans are intertwined. If times grow hard . . . well, we made lumber of sequoias once and presumably might do so again. But such a world bears no thinking about. If our situation ever becomes that desperate, we are doomed to lose more than our parks.

Happily, though, a better future can be imagined. That most of this planet's magnificent landforms have been protected in national parks nourishes the hope that our species possesses the wisdom to weather, if not entirely avert, the worst of the coming storm. Optimists about the future fall into two camps. One camp contends that technology will prove our salvation. That biogenetics and bioengineering and human ingenuity will feed the world and that, if all else fails, we will colonize planets where no campfire ever kindled. In this brave new world, natural landscapes will become, if not superfluous, even less important than they are today. Parks might be preserved as

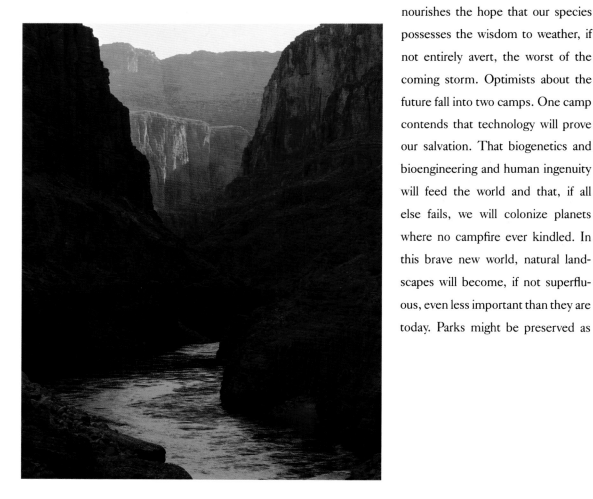

COLORADO RIVER, GRAND CANYON

pleasant keepsakes, but they will not serve much purpose. Over time, they will become outdated artifacts, dusty relics, attic pieces. The second camp contends that national parks, along with the environmental ethic they embody, are astride the trail to the future. In this view, the environmental awakening will accelerate. Technology and ingenuity will be employed, not to escape Earth, but to limit human numbers and develop less harmful ways of meeting our species' needs. This will be a new sort of progress, and it will entail a re-embrace of Nature's laws.

The spiritual and biological needs of human beings are immutable. Humankind will not find a new home on Mars—our species must live or die here, on this planet. (Those who dream of star trekking should spend a few days above treeline on Mount Rainier's glaciers: The relief one experiences—the *bliss*—of coming down to greenery gives the lie to the belief that we could be at home in the Void.) In coming decades, as the American face turns to the Earth as a leaf does to the sun, national parks will be regarded as even more precious than they are today. Glimmers of this value shift are already visible: A billion-dollar lode of gold has been discovered on the border of Yellowstone in critical grizzly habitat. A controversy erupts. Should it be mined? Regardless of the outcome, park lovers can take heart that the choice is even being posed. For millennia, gold has trumped all. But as human consciousness evolves, grizzly bears and the places they live will come to be more prized than bullion.

Americans need parks now more than ever. We need them as outposts of hope, where men and women can reconnect with the source of all life. We need them as repositories of biological diversity and as fonts of clean air and water. We need them as classrooms where the young can come to appreciate their green legacy and to seek durable values. Finally, we need parks as a baseline against which to measure our manmade world—and as a counterweight to our worst tendencies.

Some people argue that the park idea is vestigial. But troubles parks face today are due to human adolescence, not to any senescence in the park idea. Parks are not only on the trail to a better future, they are *guideposts* to that future. This does not mean that the park system will be the same a century from now as it is today. Change is the order of things. The park idea cannot remain static. Either the values it represents will inflate, finding wider sanctuary in the terrain of human awareness—or the parks will shrink under the assault of developmental pressures.

Development still is dominant. But the wheel of history is slowly turning. During the last thirty years, ecological thought has strengthened the concept of human stewardship. No longer do parks face direct invasion. A proposal to build dams in the Grand Canyon, once seriously debated, would never get off the drawing boards today. Instead, park values lap outwards. A power plant, guilty of befouling the Canyon's vistas, is cleaned up. The operating guidelines at a dam upstream are changed to protect its beaches and riparian wildlife. Elsewhere, clean air legislation helps safeguard forests in the Smokies. Citizen groups form to protect Yellowstone. Water management in south Florida is altered to benefit the Everglades. Progress is made.

Those who conceived the park idea so long ago did not understand its full implications. They did not understand how valuable national parks would prove to be—biologically, economically, and spiritually. They did not understand that tens of millions would travel endless miles to see them. They did not understand that the park concept would become a crucible in which Americans began to forge a more tender relationship with the land. Nonetheless, without fully meaning to, in a moment of great inspiration, they erected a high marker, a cairn on a mountaintop.

A century later, we Americans presume to think that we fully discern the shape of that cairn, that we can see it all. But perhaps we are wrong. Perhaps the park idea, like one of Yosemite's exfoliating granite domes, is still in the process of becoming. Perhaps the cairn is taller, brighter, and farther away than we think. If parks are not now regarded by most people as shrines, perhaps someday they will be.

We have not learned everything the parks have to teach. We have not fathomed all their primordial mysteries, nor plumbed their deepest depths. There is further to go along this trail. Moving forward, attuned to Nature's rhythms, we follow a fine path, headed in a noble direction.

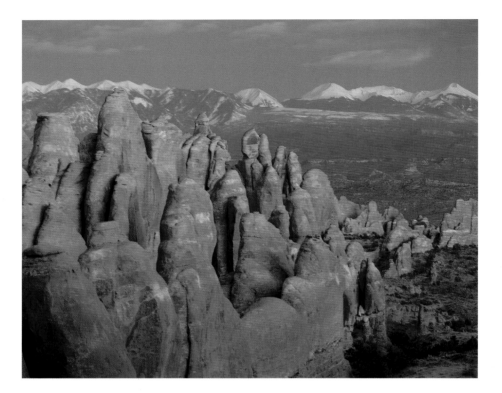

ENTRADA ROCKS IN FIERY FURNACE, SIERRA LA SAL

*The greatest concentration of natural arches in the world—some fifteen hundred are catalogued—includes a spectacular mix of pinnacles, spires, balanced rocks, fins, and slickrock domes. Arches is a sculpted rock landscape of Entrada and Navajo sandstone that is part of the greater canyonlands. Established 1971.*

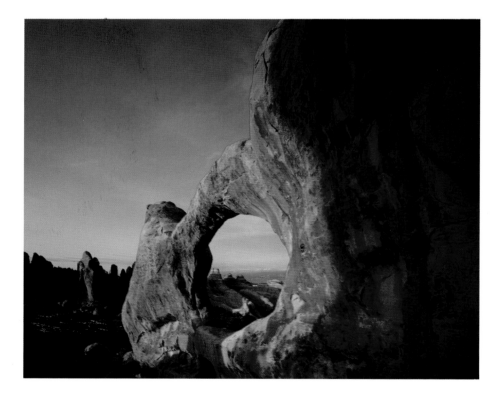

DOUBLE O ARCH, DEVILS GARDEN

DOUBLE ARCH, THE WINDOWS SECTION

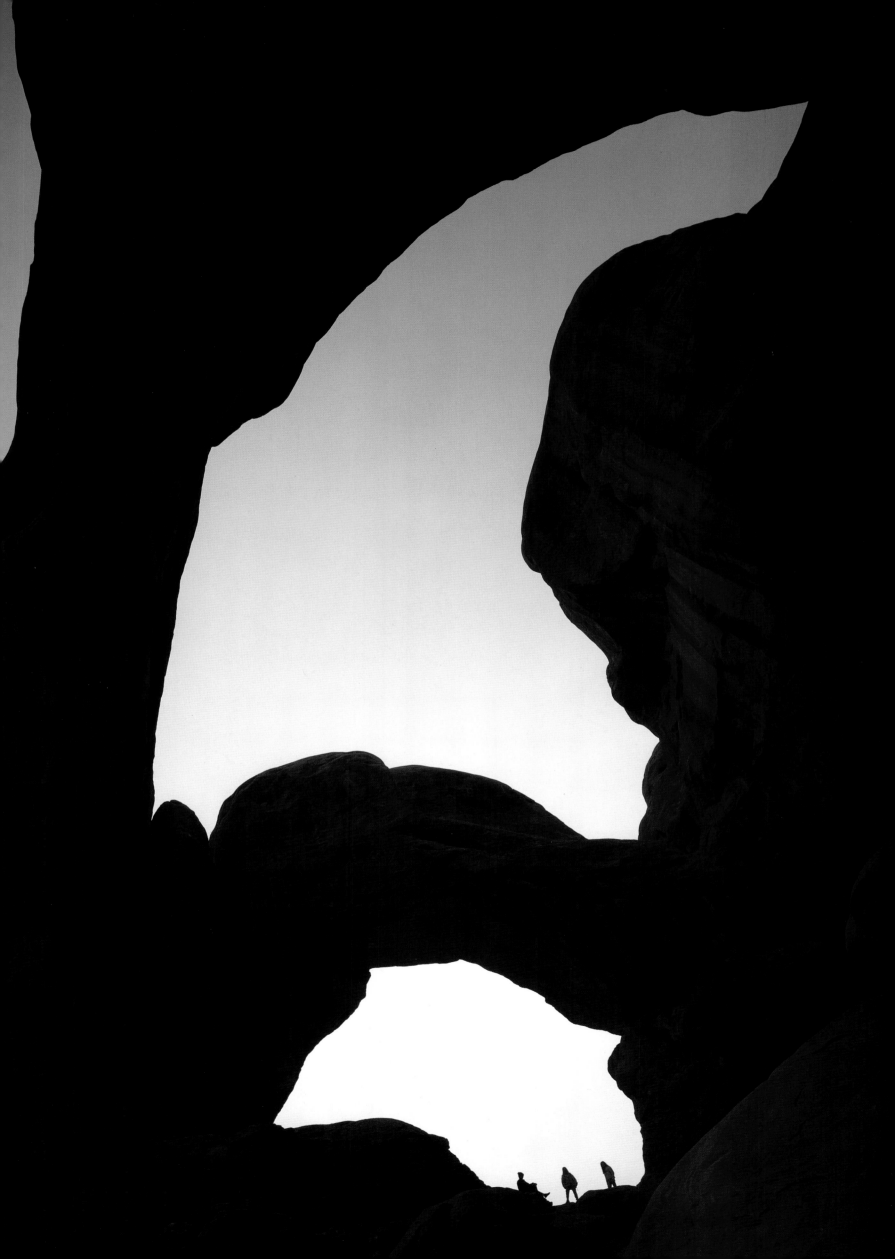

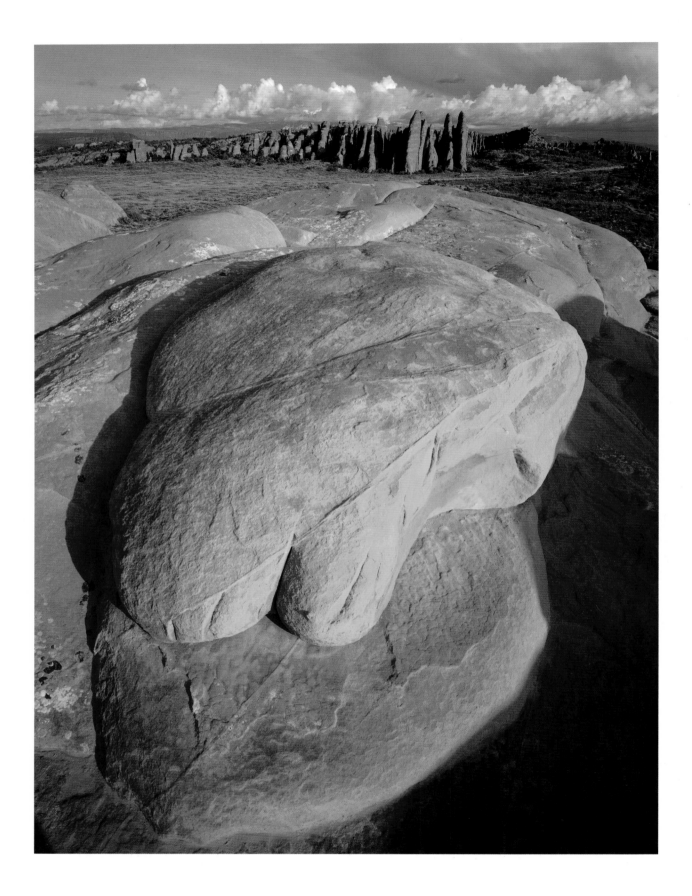

ENTRADA FINS, DEVILS GARDEN, ARCHES

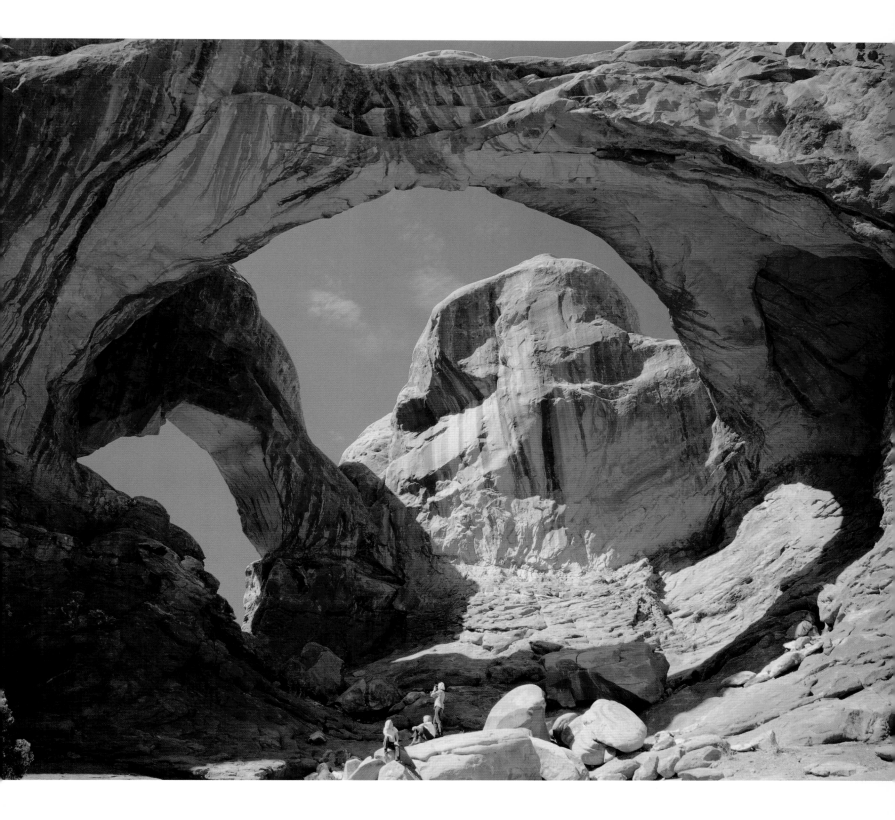

DOUBLE ARCH, ARCHES

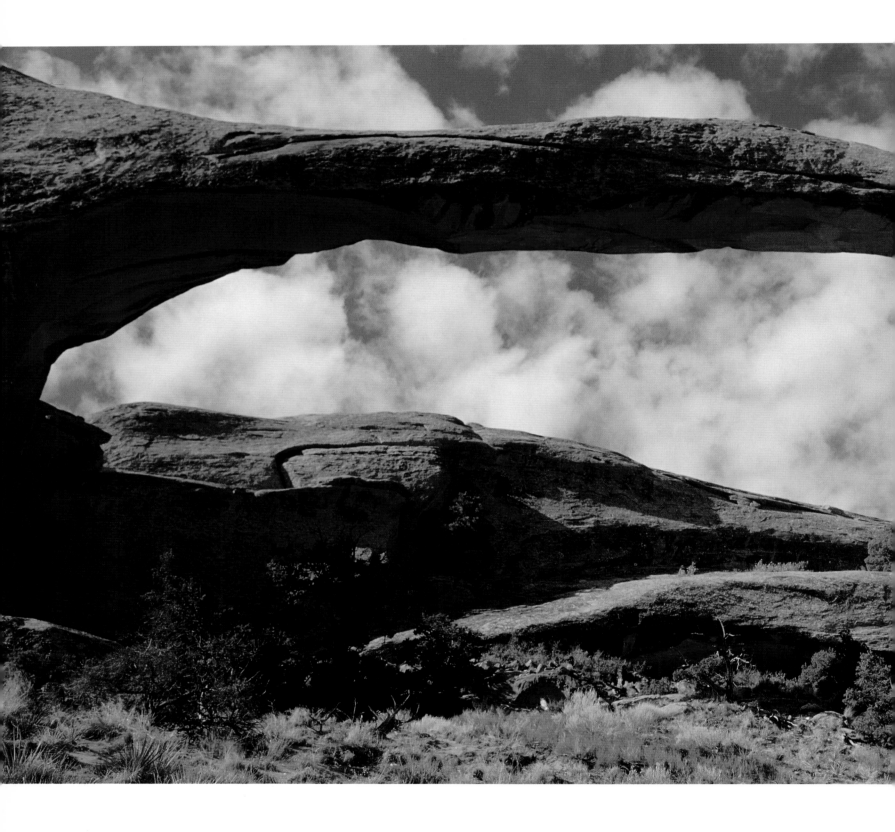

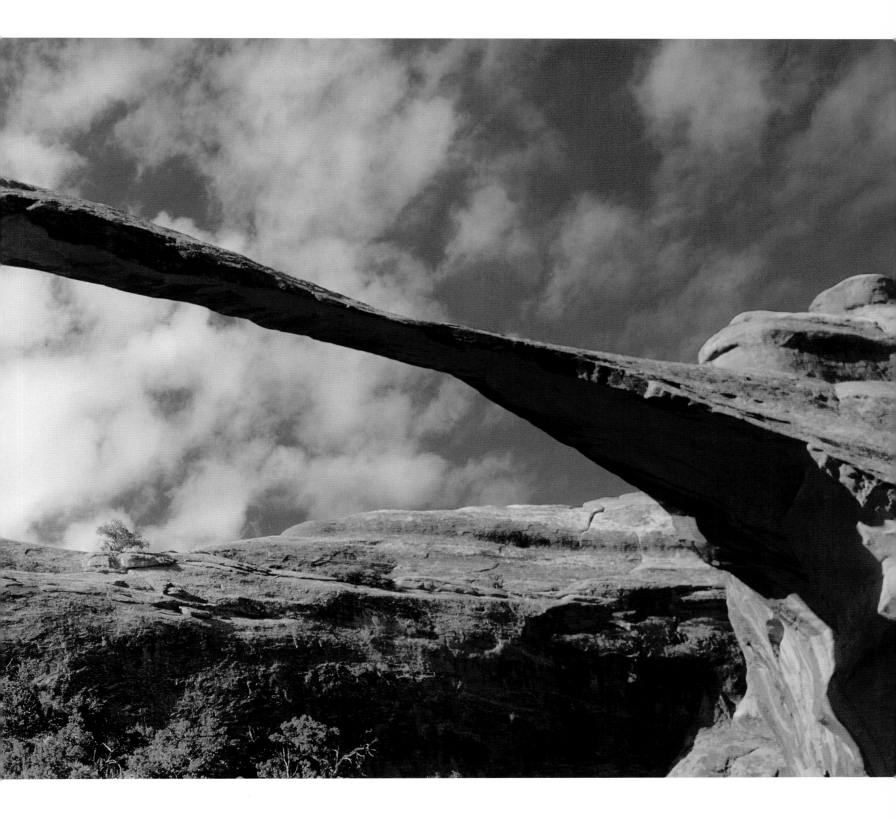

SPAN OF LANDSCAPE ARCH, DEVILS GARDEN

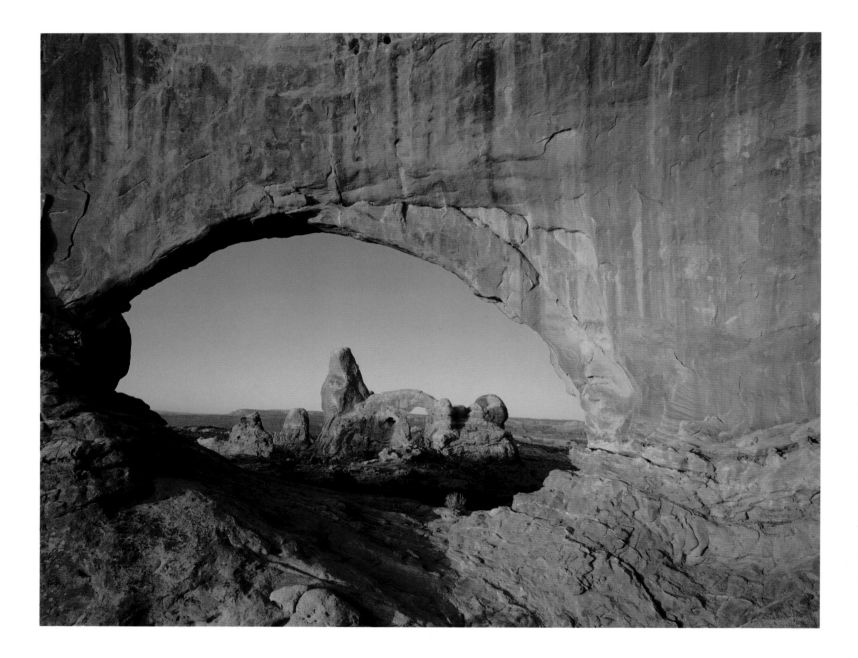

TURRET ARCH, NORTH WINDOW

DELICATE ARCH, SIERRA LA SAL

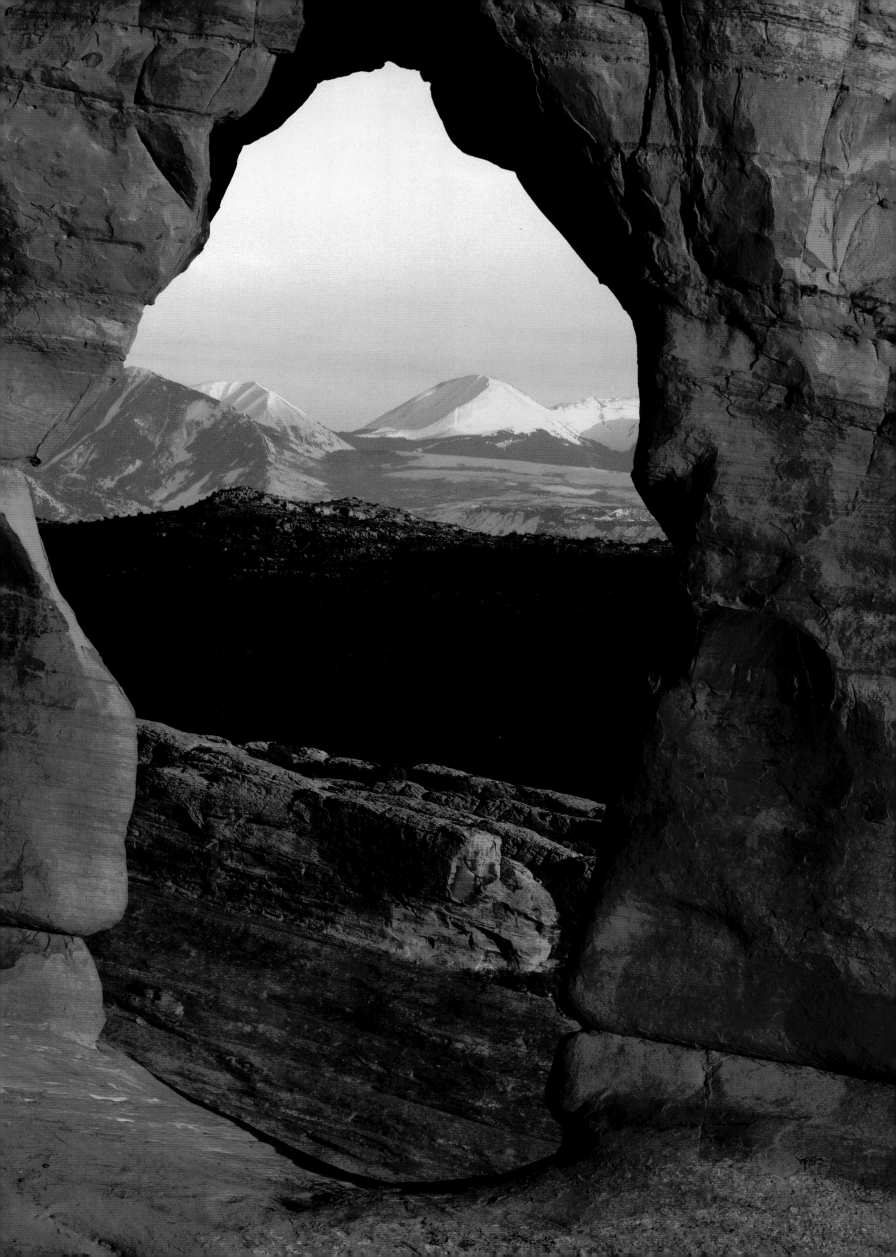

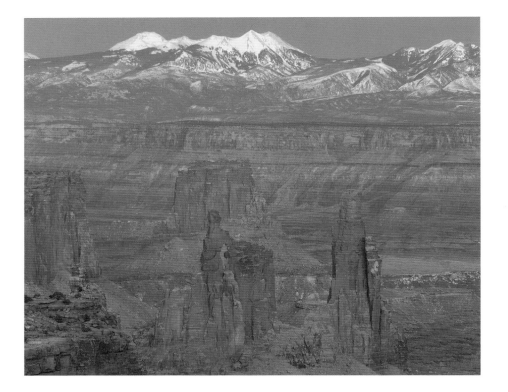

RIMROCK AND SIERRA LA SAL, ISLAND IN THE SKY

*In this landscape of sculptured rock forms, canyons, grabens, arches, pinnacles, prehistoric Anasazi ruins, and slickrock, solitude, silence, and time reign supreme. The Green and Colorado rivers join at the confluence among rock wilderness namesakes of The Maze, The Needles, Island in the Sky, Horseshoe Canyon, Cataract Canyon, and Deadhorse Point. Established 1964.*

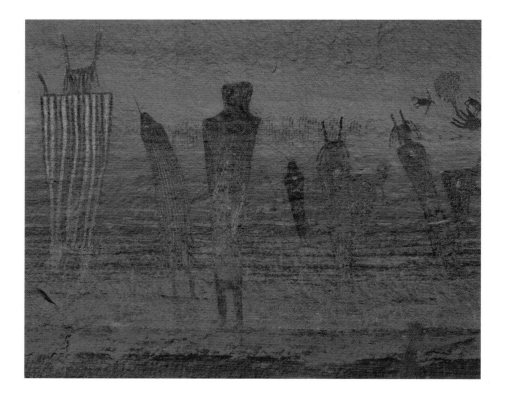

THE HARVEST SCENE, PICTOGRAPHS, THE MAZE

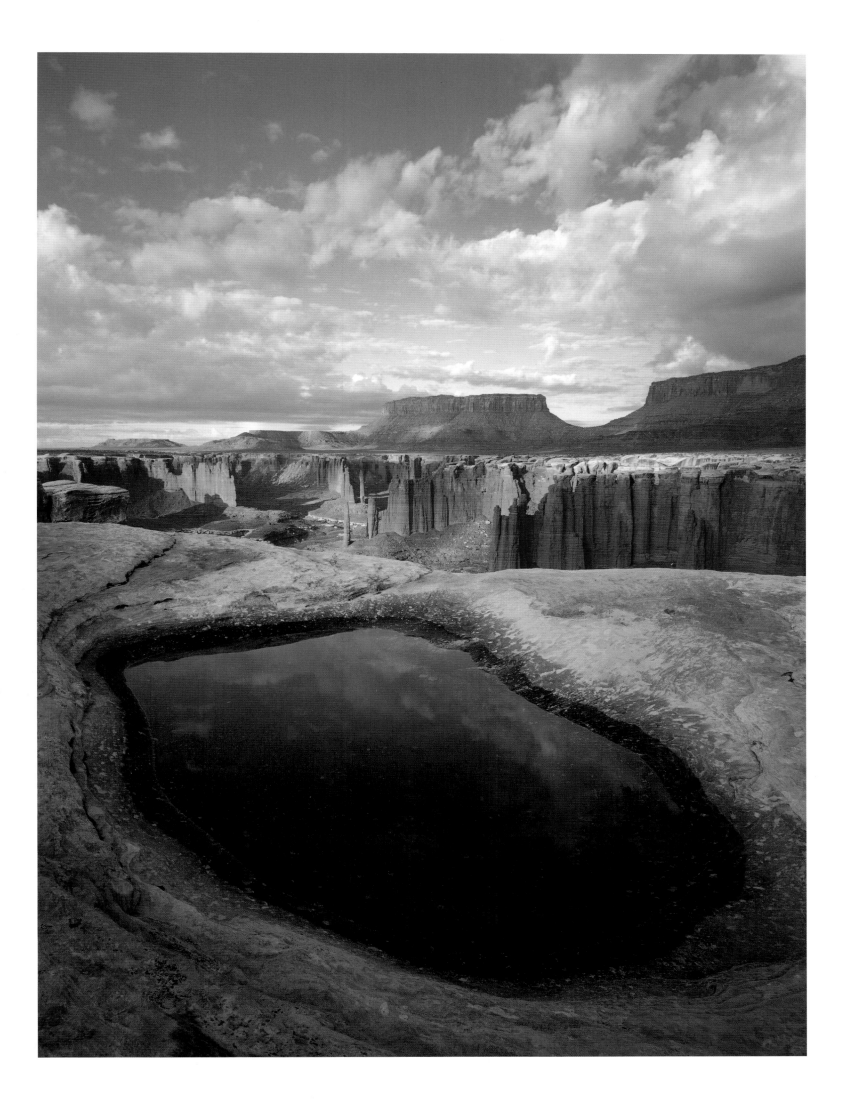

WHITE RIM, JUNCTION BUTTE, MONUMENT BASIN

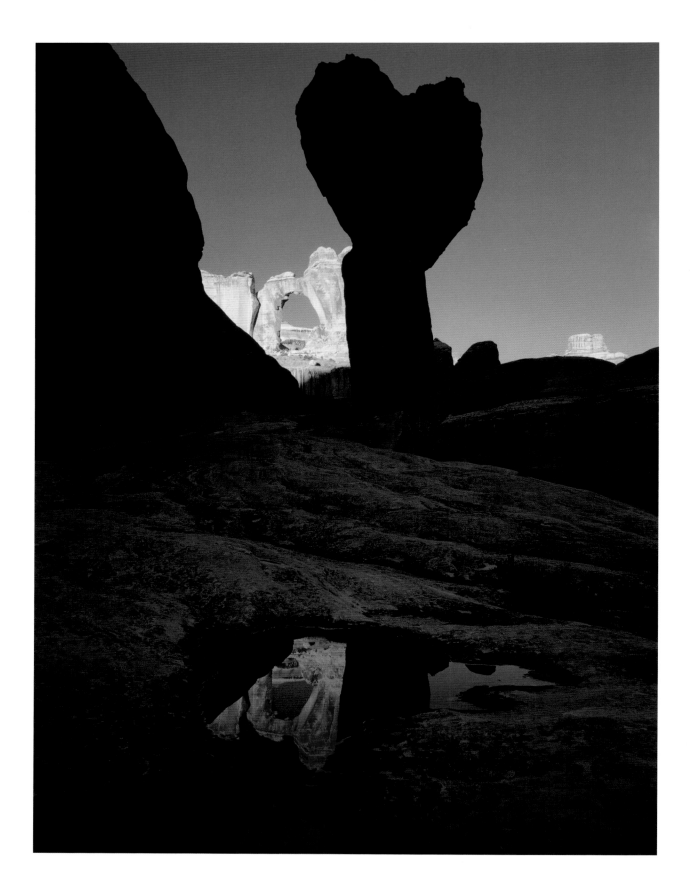

ANGEL ARCH AND MOLAR ROCK, SALT CREEK CANYON

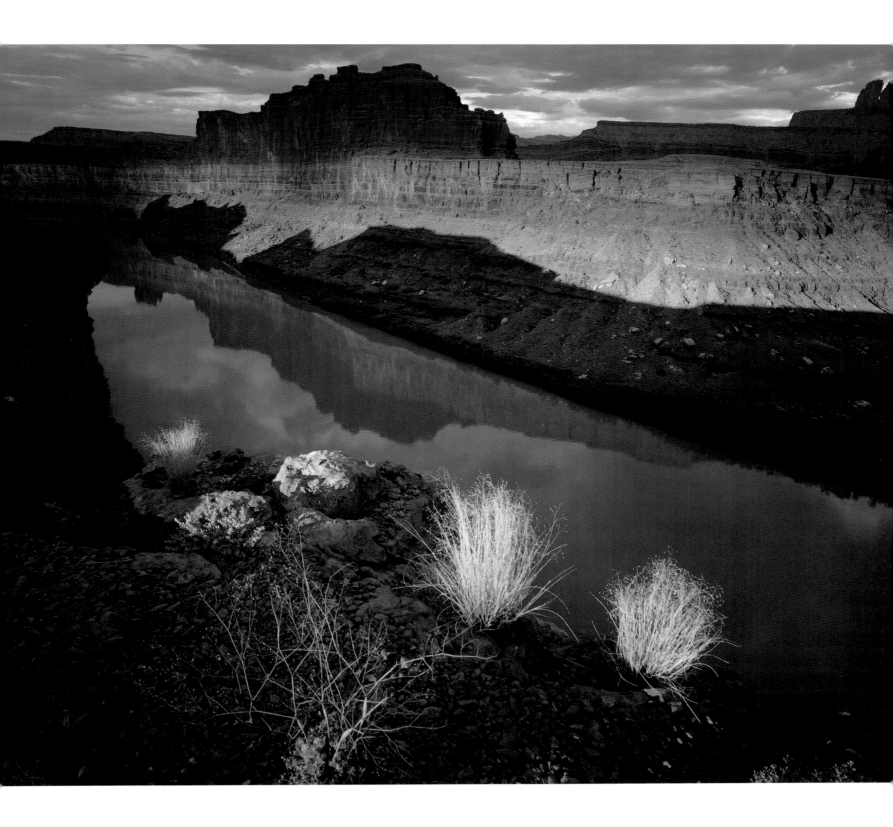

COLORADO RIVER AT THE GOOSENECK

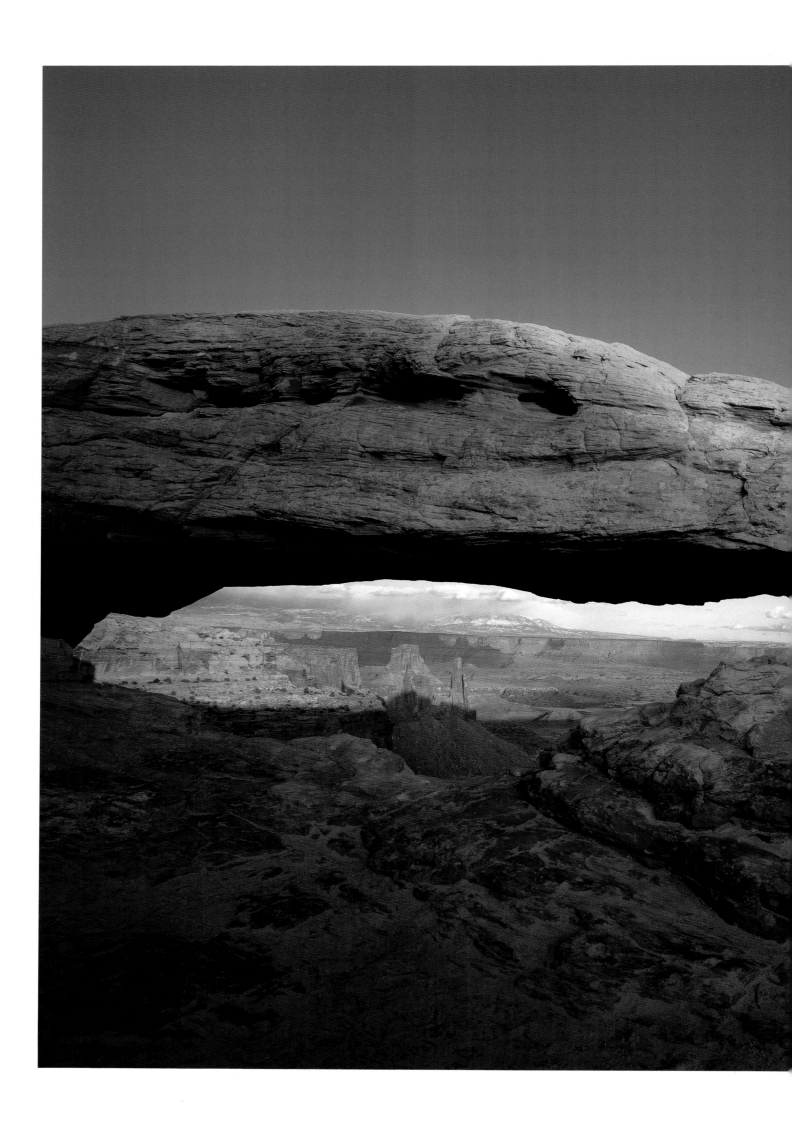

MESA ARCH, ISLAND IN THE SKY

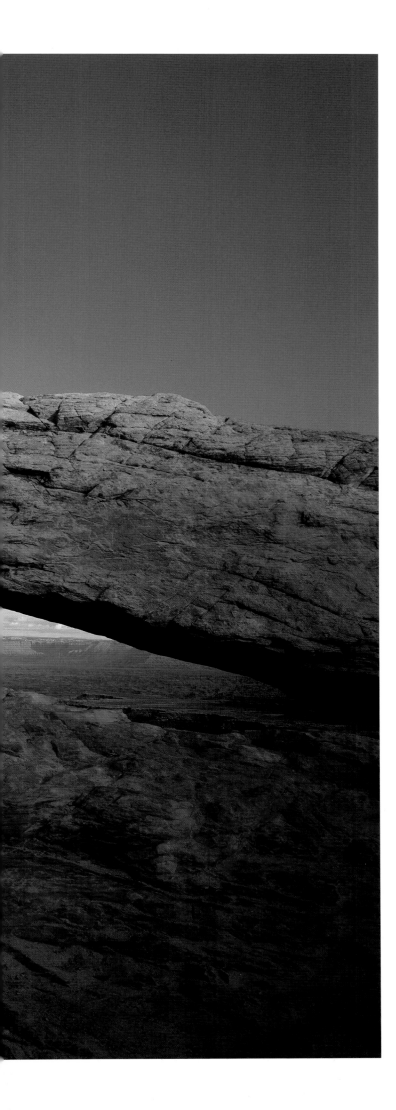

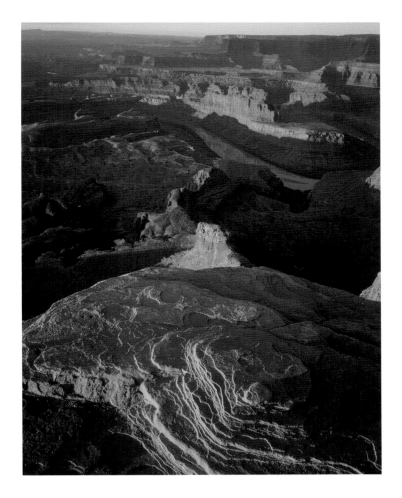

COLORADO RIVER FROM DEADHORSE POINT

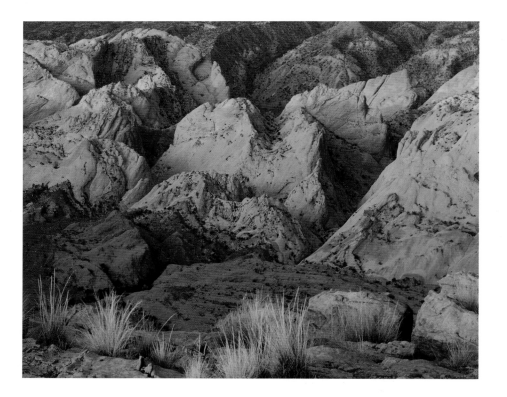

WATERPOCKET FOLD, HALLS CREEK OVERLOOK

*Waterpocket fold is a giant, uplifted and wrinkled hundred-mile-long rock wall in the earth's crust. The reef holds many sandstone "pockets," sometimes filled with water, and preserves a spectacular array of rock domes, monoliths, canyons, and arches/bridges, under a great desert sky. Interesting namesakes are Fremont River Gorge, Halls Creek Narrows, Muley Twist Canyon, and South Desert. Established 1971.*

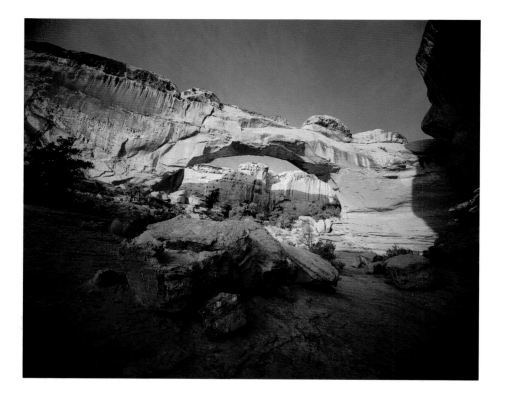

HICKMAN BRIDGE, FREMONT RIVER CANYON

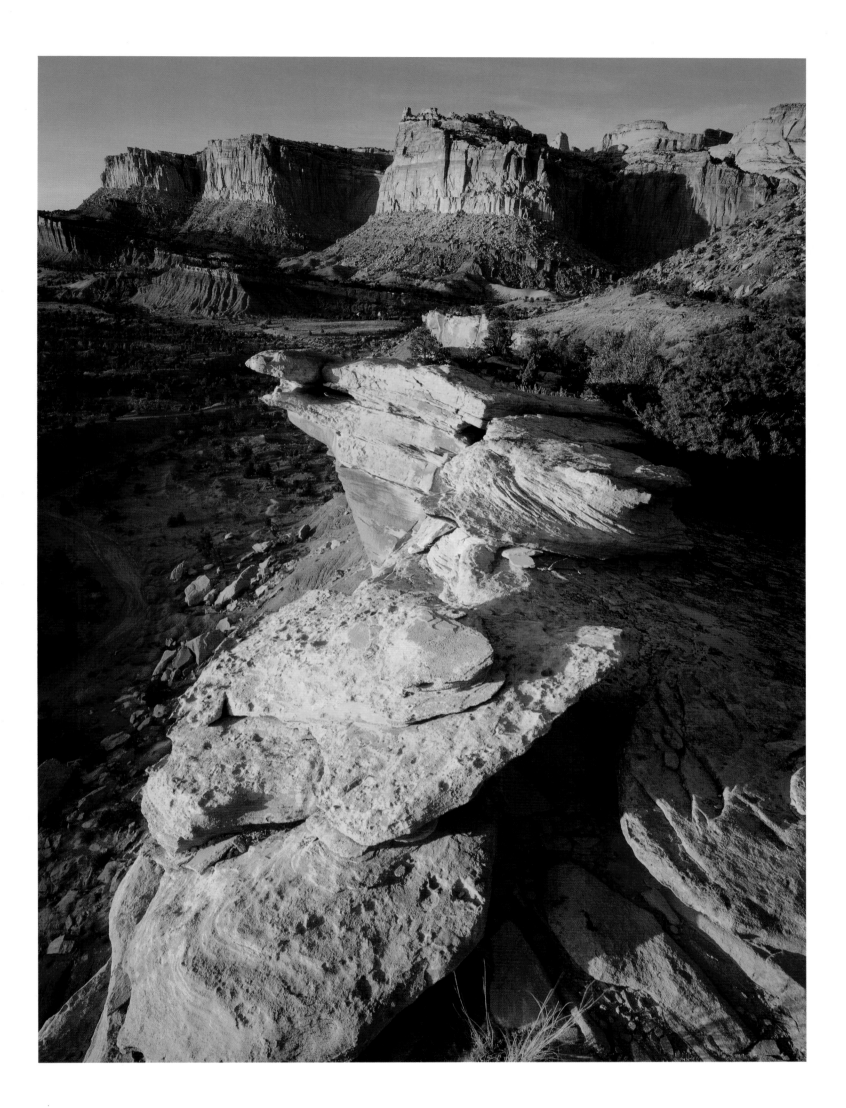

RIMS AND BUTTES OF CAPITOL REEF, CAPITOL GORGE

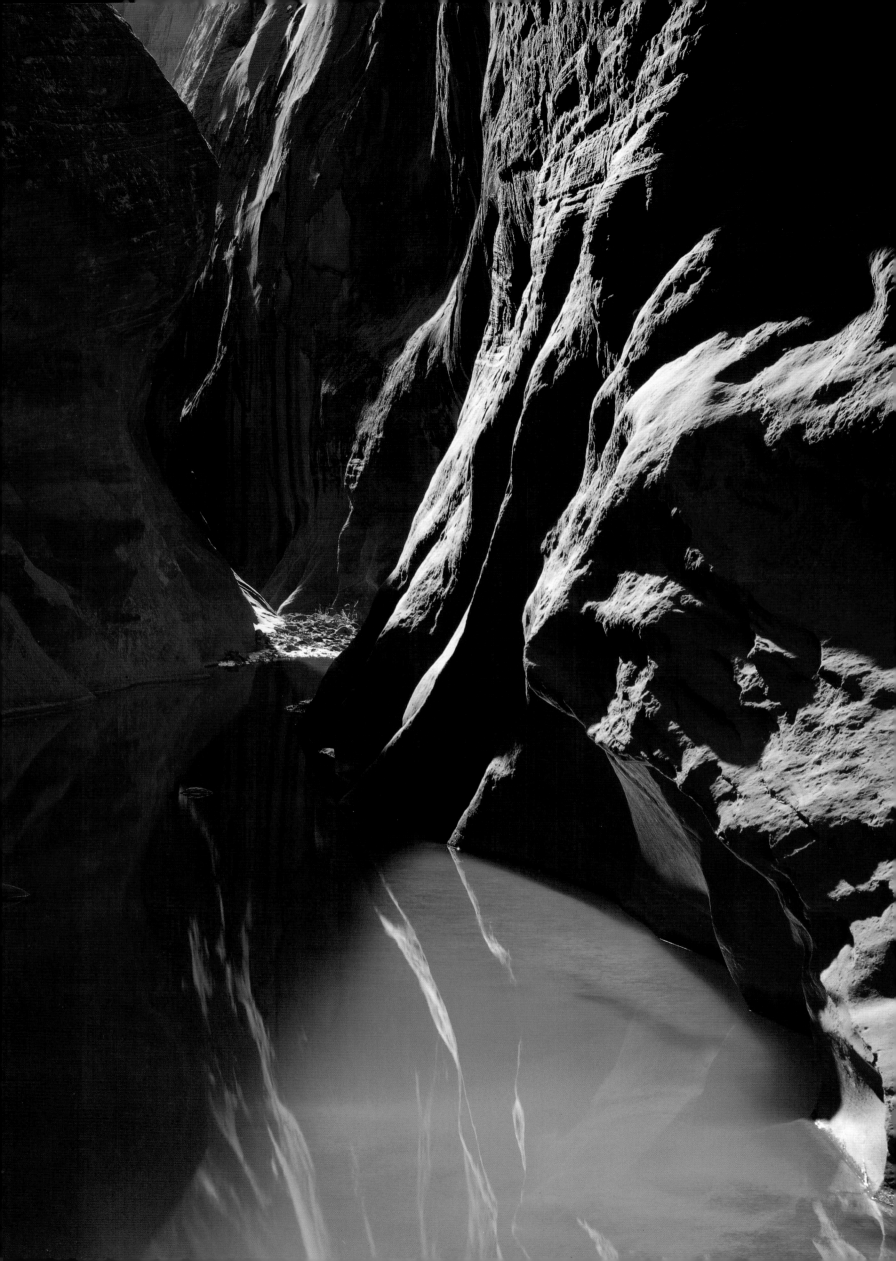

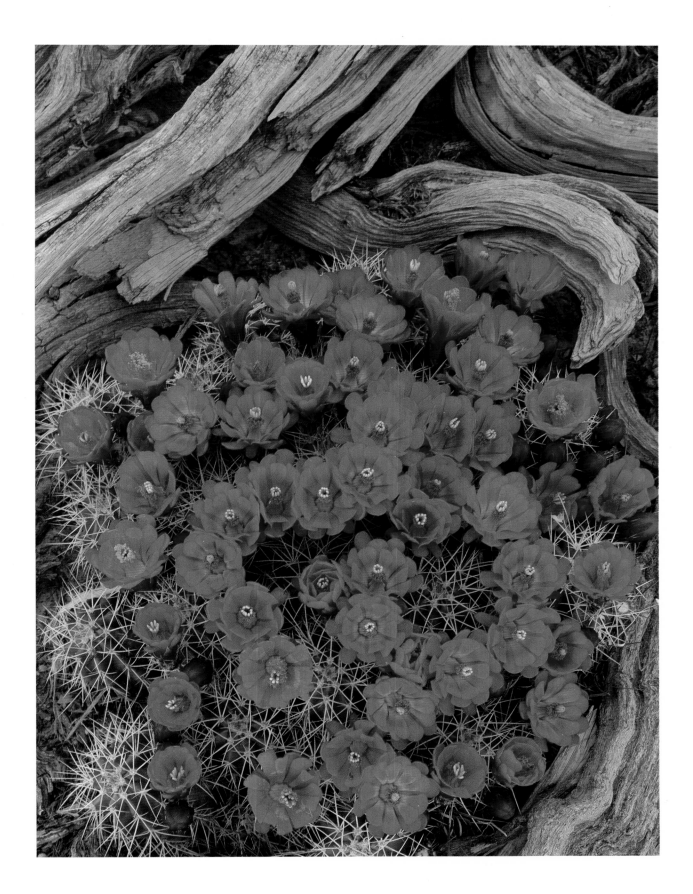

CLARET CUP CACTUS, CATHEDRAL VALLEY

LABYRINTH OF HALLS CREEK NARROWS

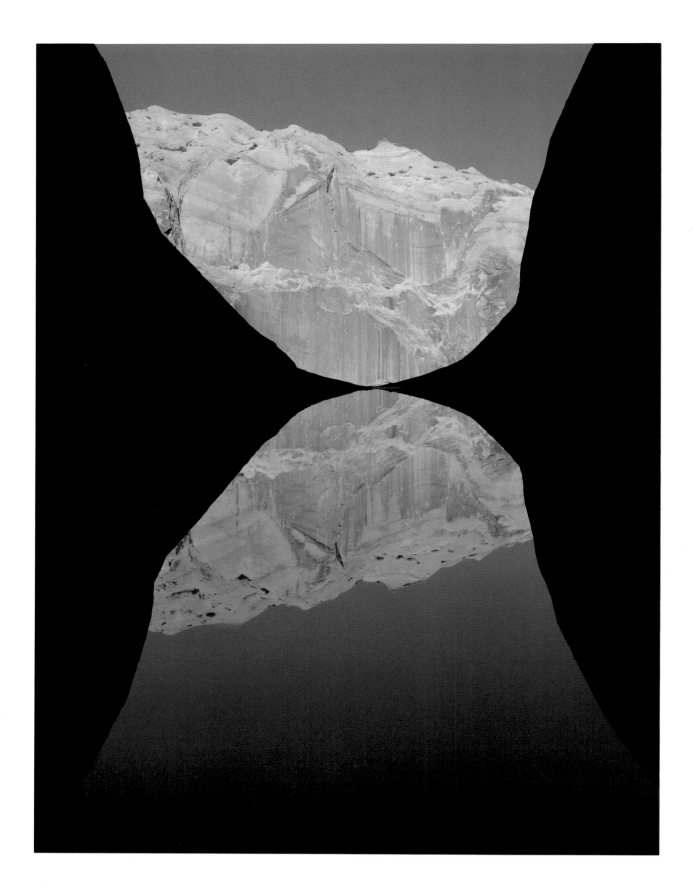

RAIN POOL, WATERPOCKET FOLD

POOL IN NARROWS AT BRIMHALL BRIDGE

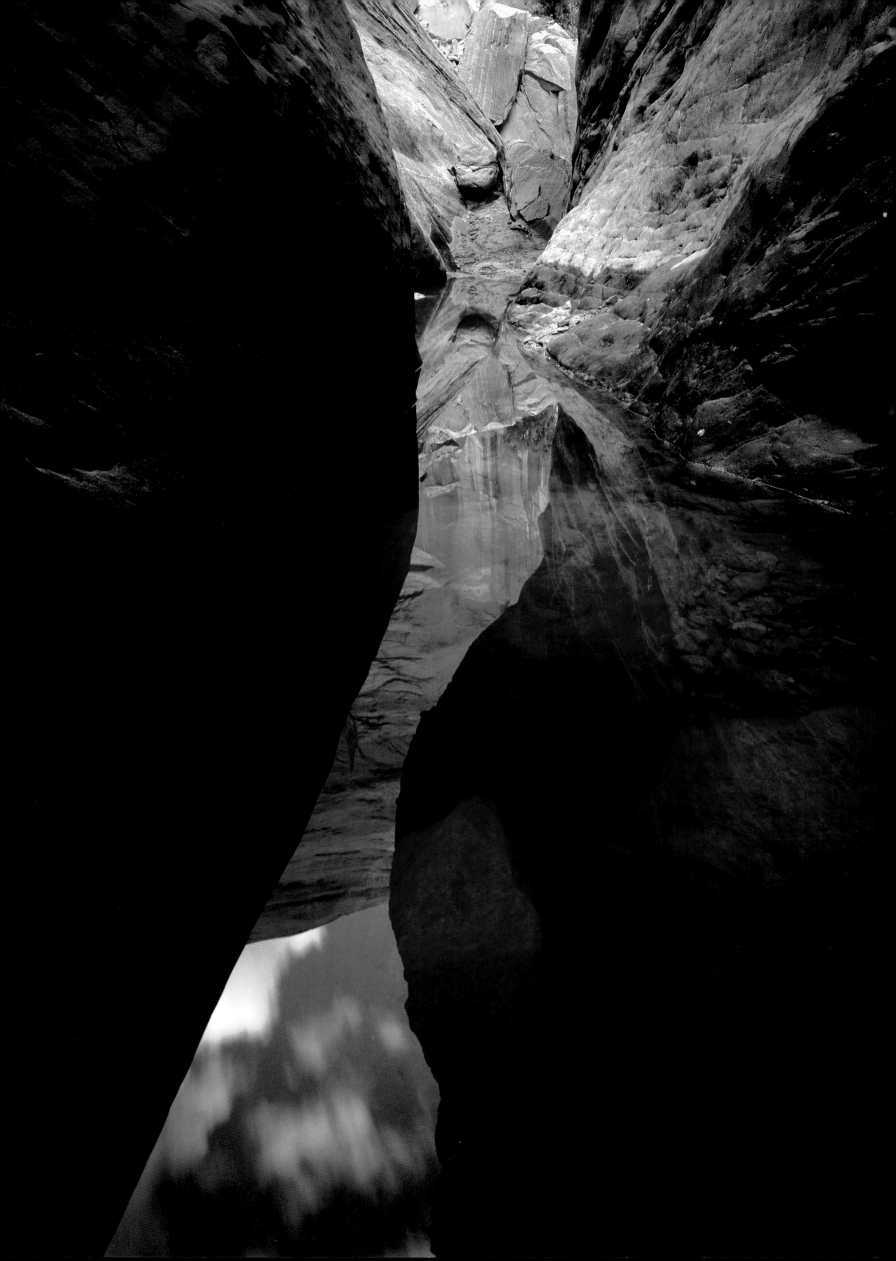

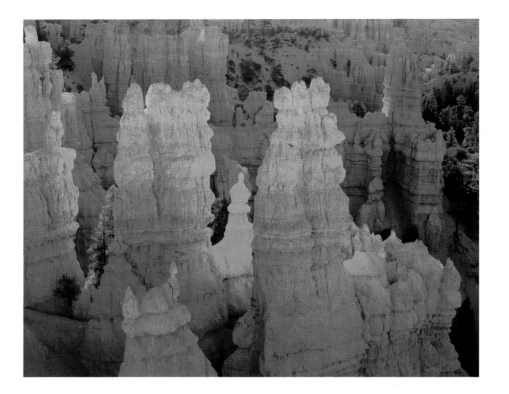

DAWN LIGHT, FAIRYLAND POINT

*Intricately carved breaks of the*

*Wasatch pink formation line the*

*eastern edge of Paunsaugunt*

*Plateau in a wilderness of hoodoos,*

*fluted walls and sculptured*

*pinnacles. Rain, snow, and ice*

*erosion have created pagodas,*

*gables, minarets, windows,*

*pedestals, and temples — fantastic*

*images transformed by a special*

*changing spectrum of color*

*and light. Established 1928.*

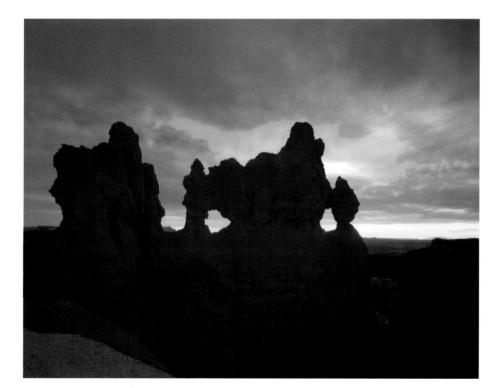

HOODOOS SILHOUETTE BELOW SUNSET POINT

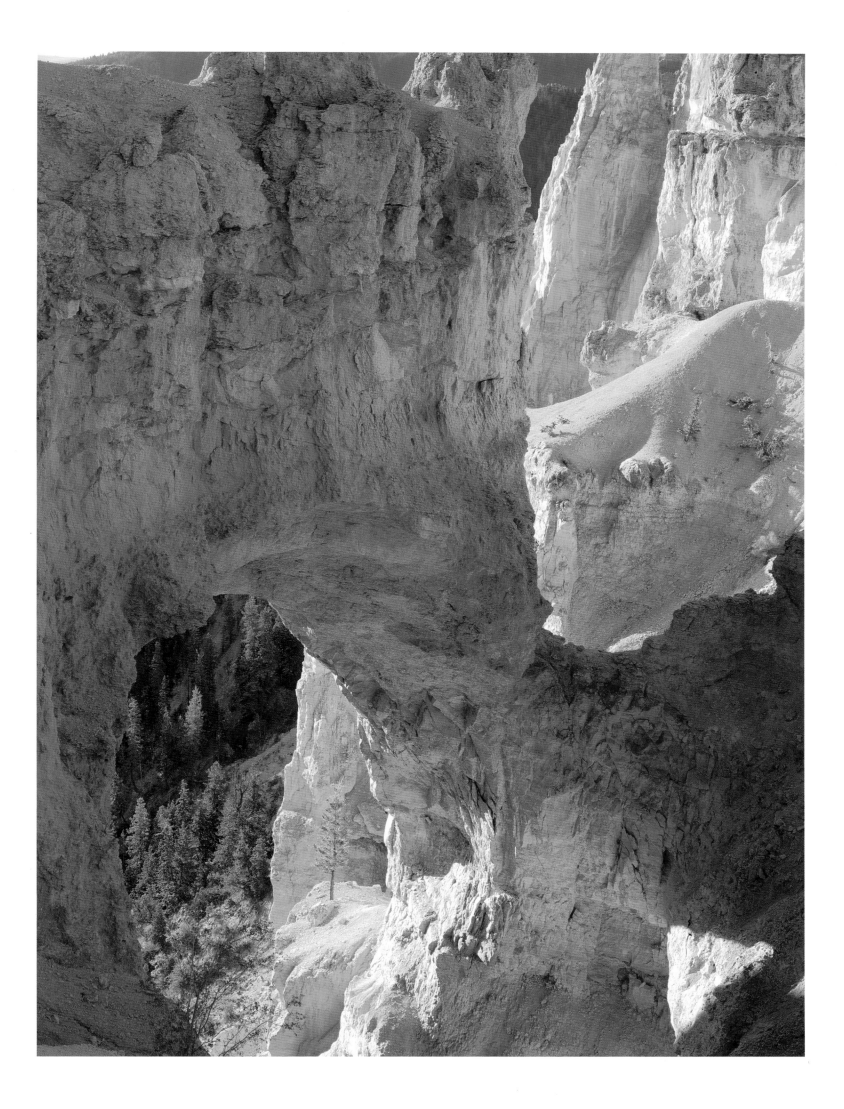

NATURAL BRIDGE IN THE WASATCH FORMATION

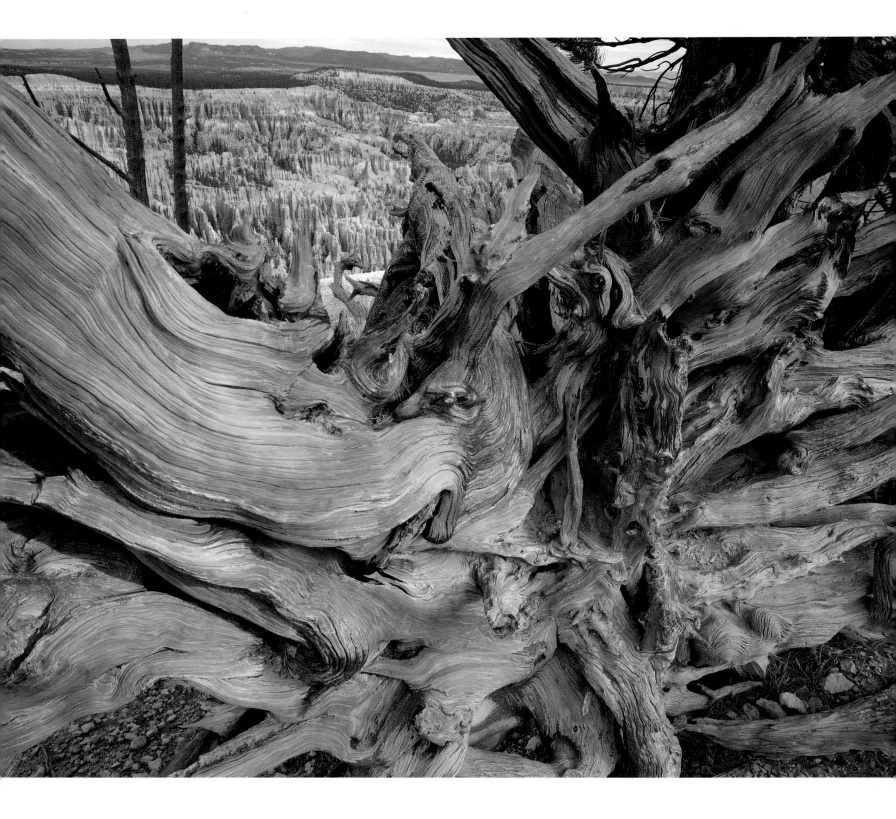

BRISTLECONE PINE ROOT SYSTEM, BRYCE POINT

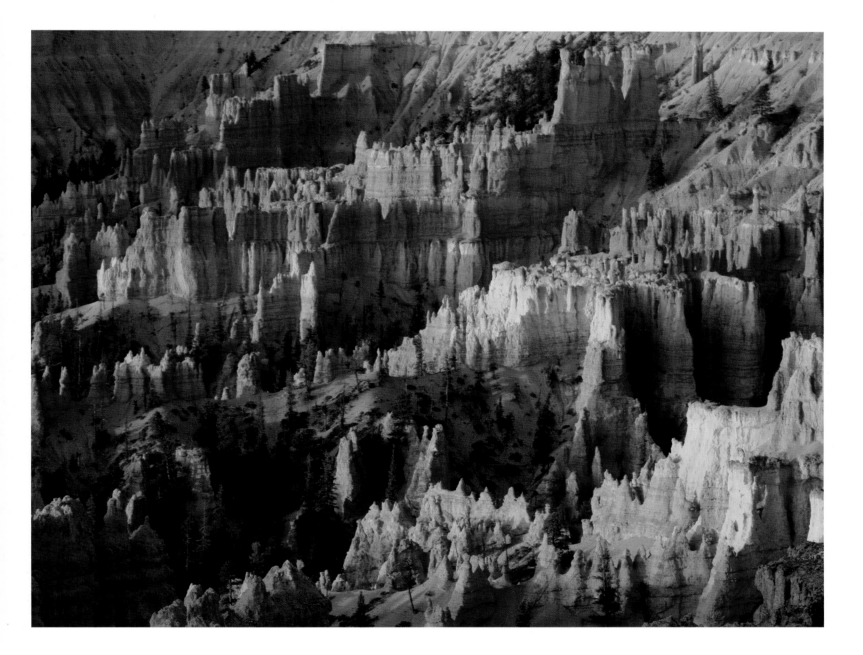

SILENT CITY BELOW INSPIRATION POINT

FOLLOWING PAGES: PINK CLIFFS AT AQUA CANYON

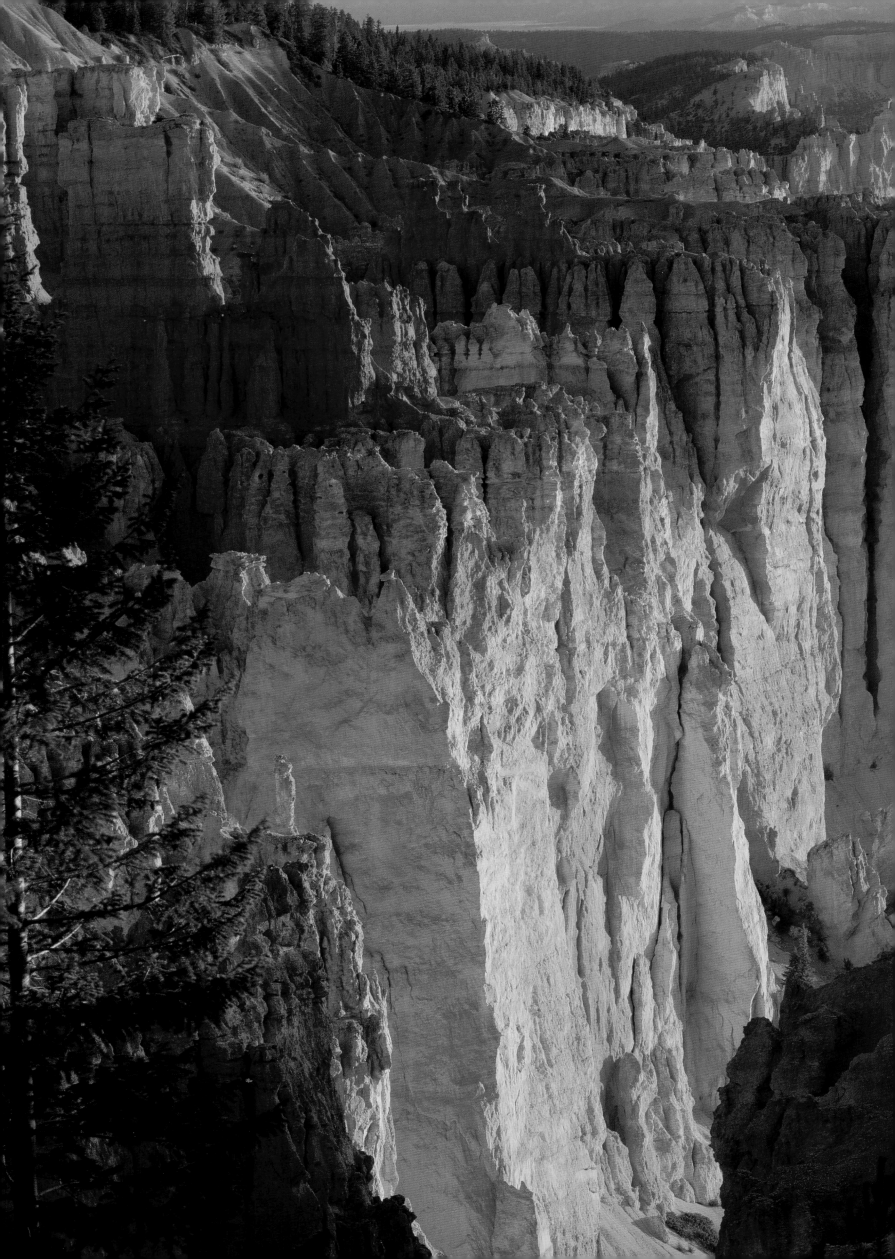

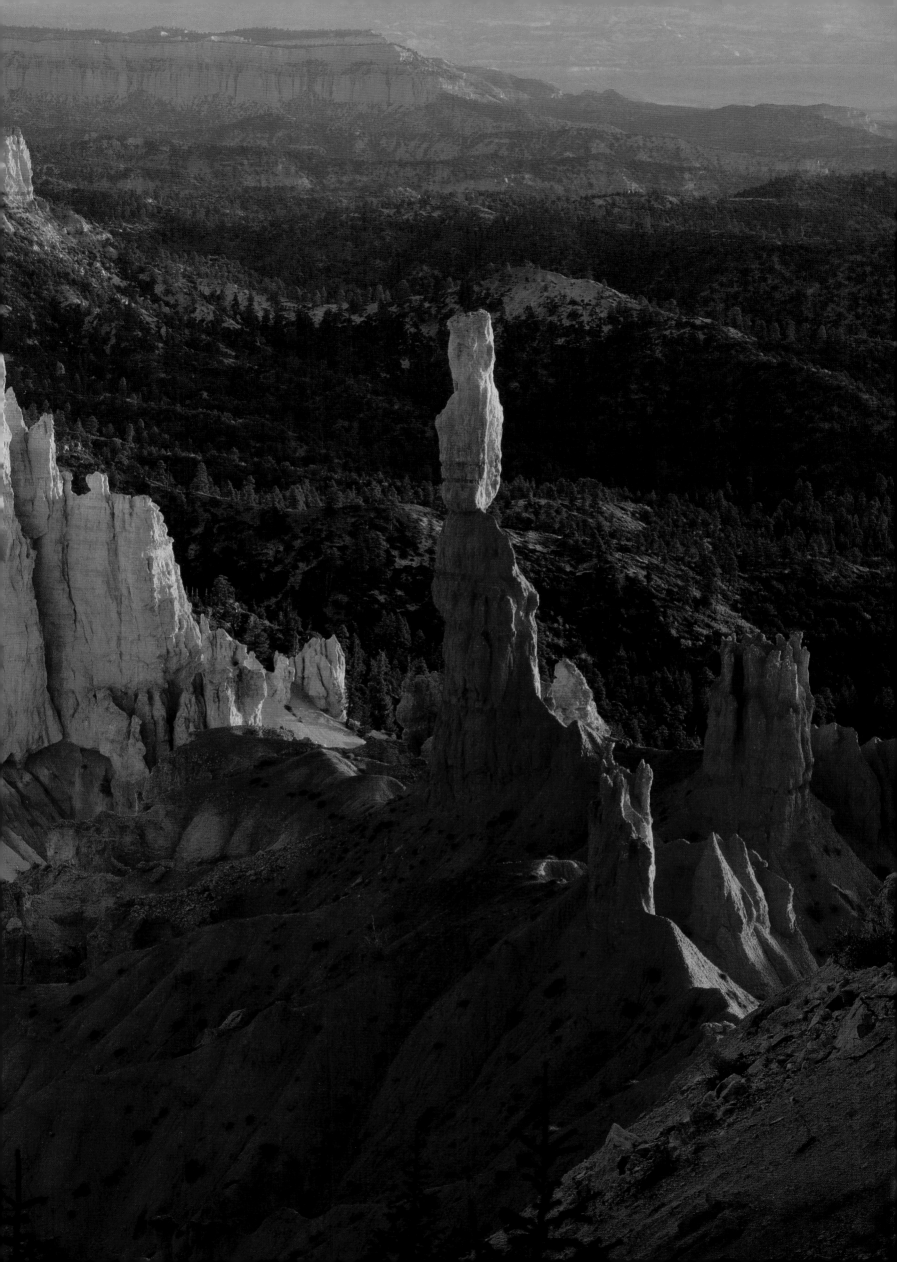

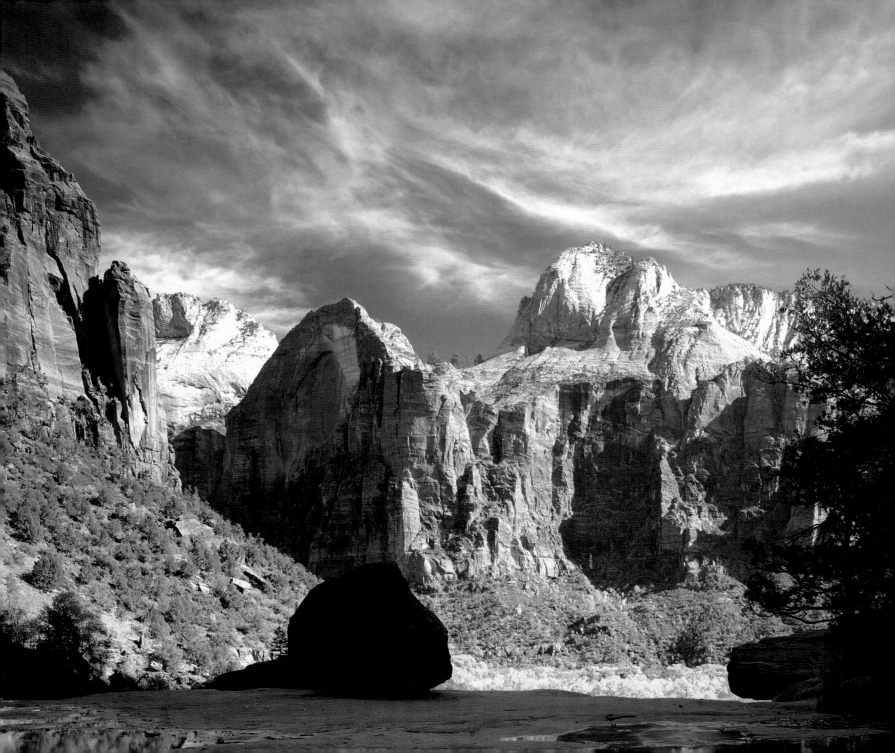

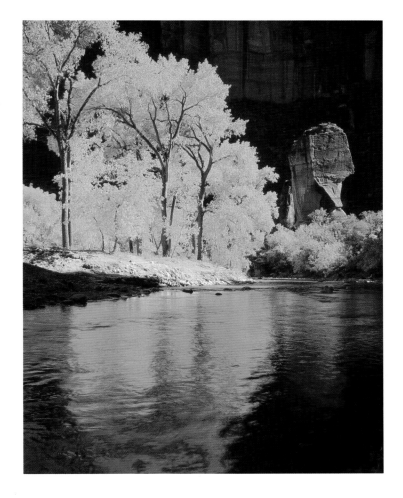

*Massive, vertical, multicolored*

*sandstone walls and narrow, deep*

*gorges — a cliff and canyon*

*landscape — are awesome, and the*

*centerpiece of Zion. A noble and*

*beautiful landscape, names include*

*Great White Throne, Towers of*

*the Virgin, Temple of Sinawava,*

*West Temple, South Guardian*

*Angel, The Subway, Checkerboard,*

*and Kolob. Established 1919.*

COTTONWOODS, VIRGIN RIVER, TEMPLE OF SINAWAVA

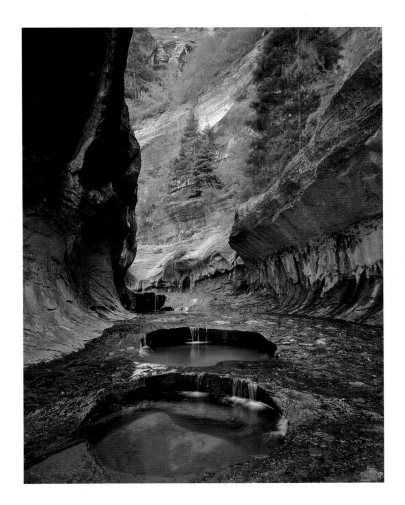

EMERALD POOLS, RED ARCH MOUNTAIN

POOLS IN THE SUBWAY, LEFT FORK NORTH CREEK

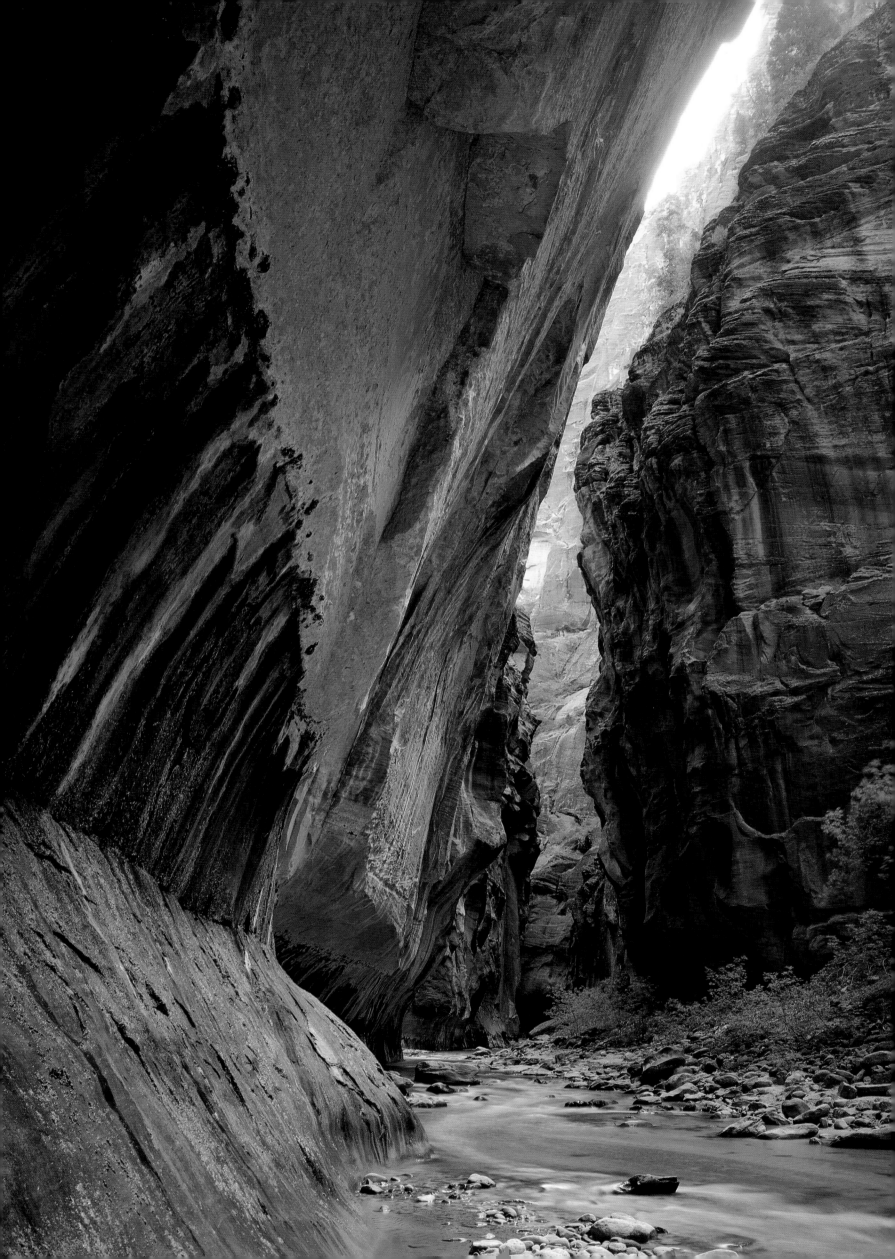

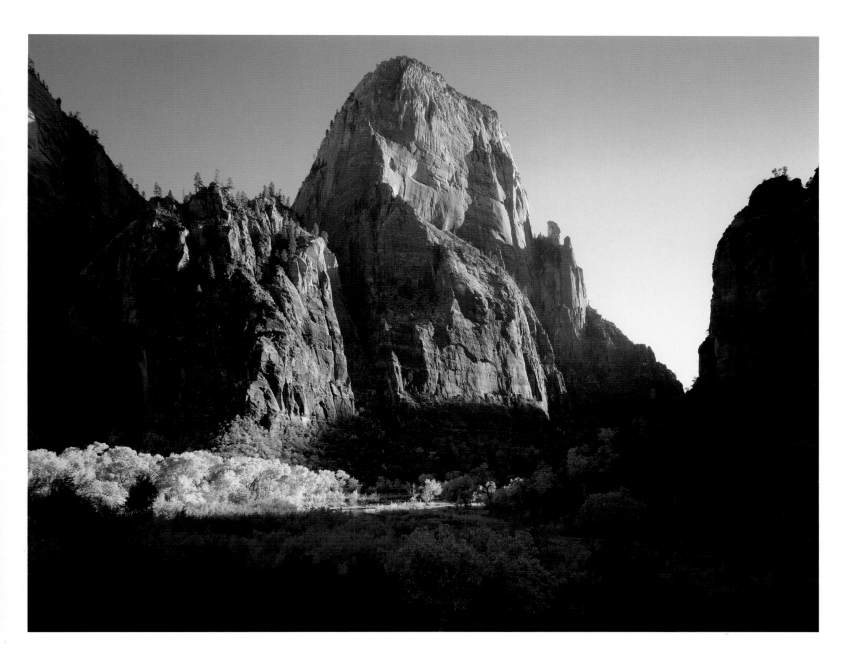

THE GREAT WHITE THRONE

THE NARROWS OF THE VIRGIN RIVER

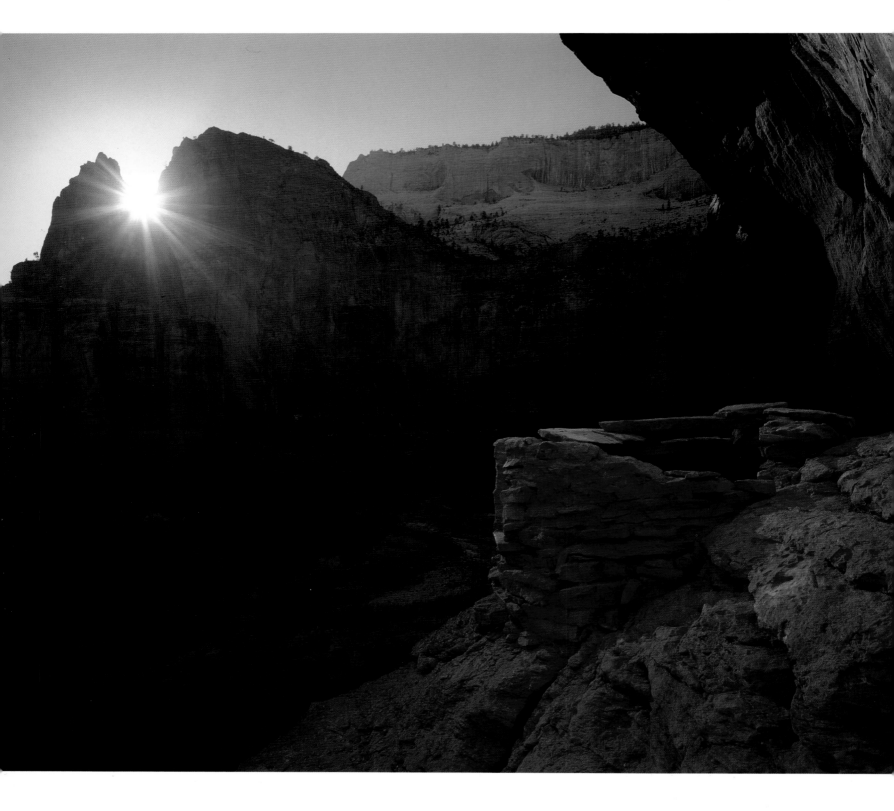

ANASAZI STORAGE RUIN AND ANGELS LANDING

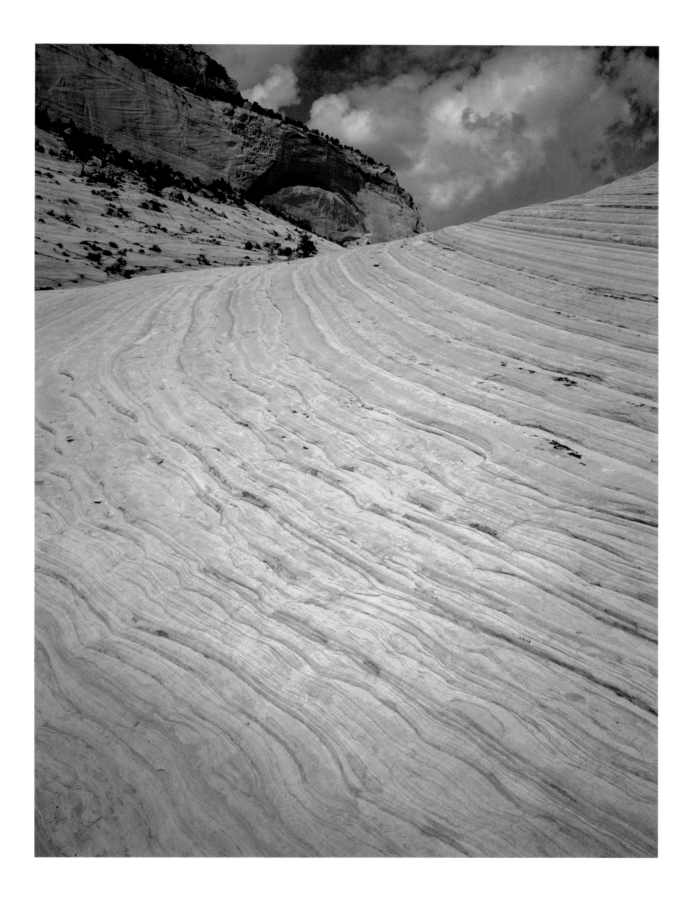

NAVAJO SANDSTONE, ZION-MOUNT CARMEL HIGHWAY

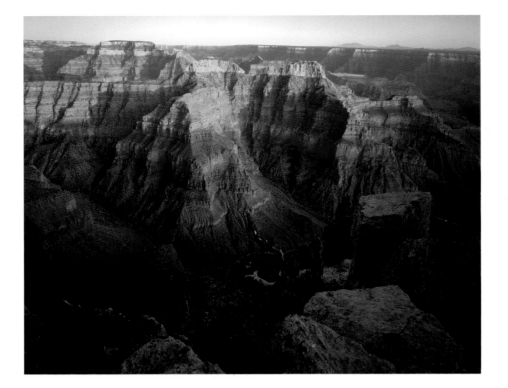

MENCIUS AND CONFUCIUS TEMPLES, POINT SUBLIME

*Spectacular and awesome—time and space, earth and sky—appear to fuse in this canyon extraordinaire. Between North and South rims, creator of the erosionary forces, flows the Colorado River. Names proceed down through time with awe and mystery to the 1.9-billion-year-old Inner Gorge—Osiris, Ra, Isis, Vishnu, Buddha, Brahma, Confucius, Krishna, Rama, and Bright Angel. A World Heritage Site. Established 1919.*

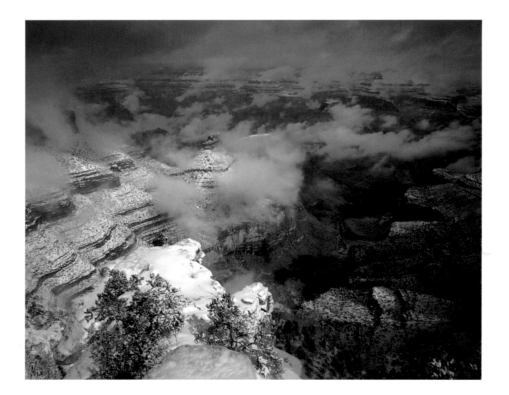

WINTER STORM OVER GRAND CANYON, SOUTH RIM

LAVA FALLS, COLORADO RIVER, TOROWEAP

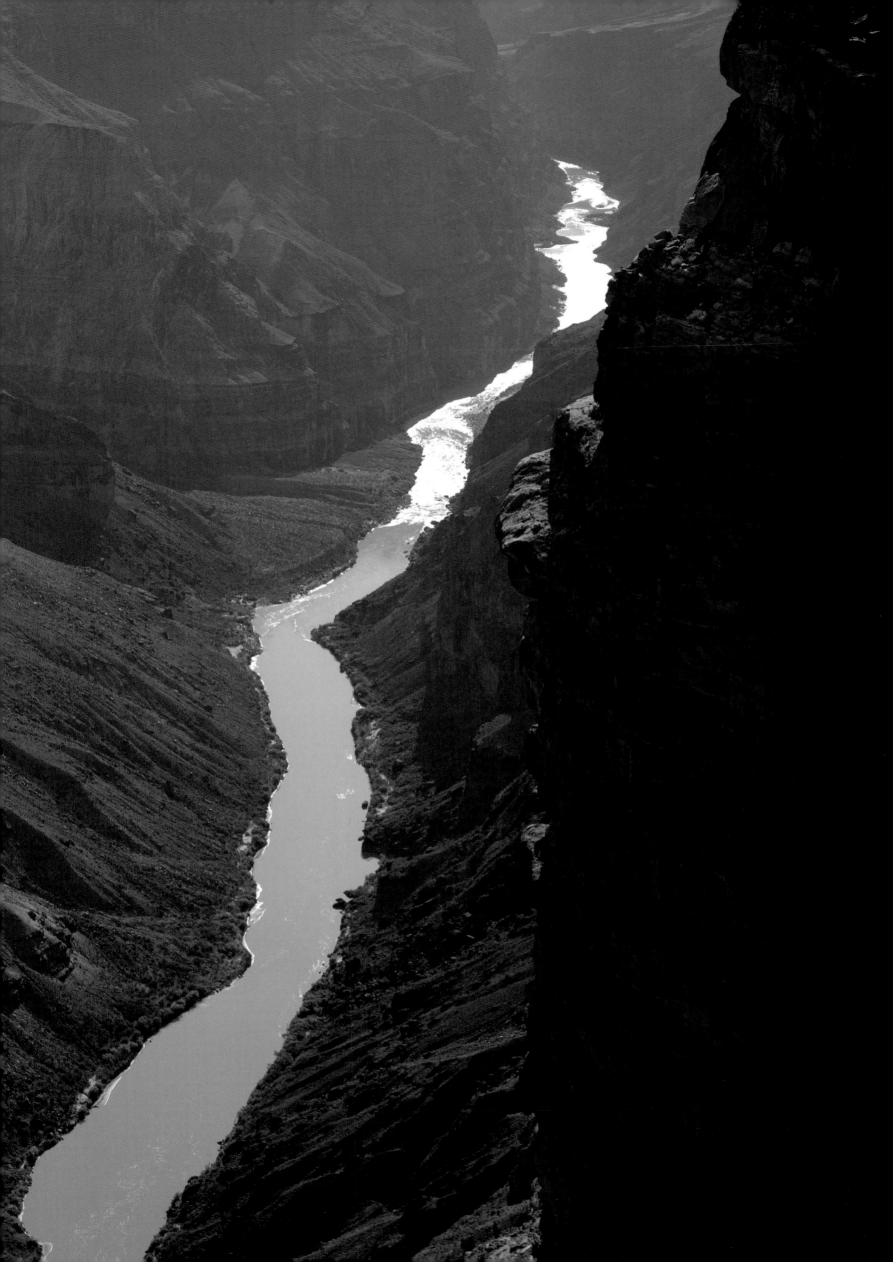

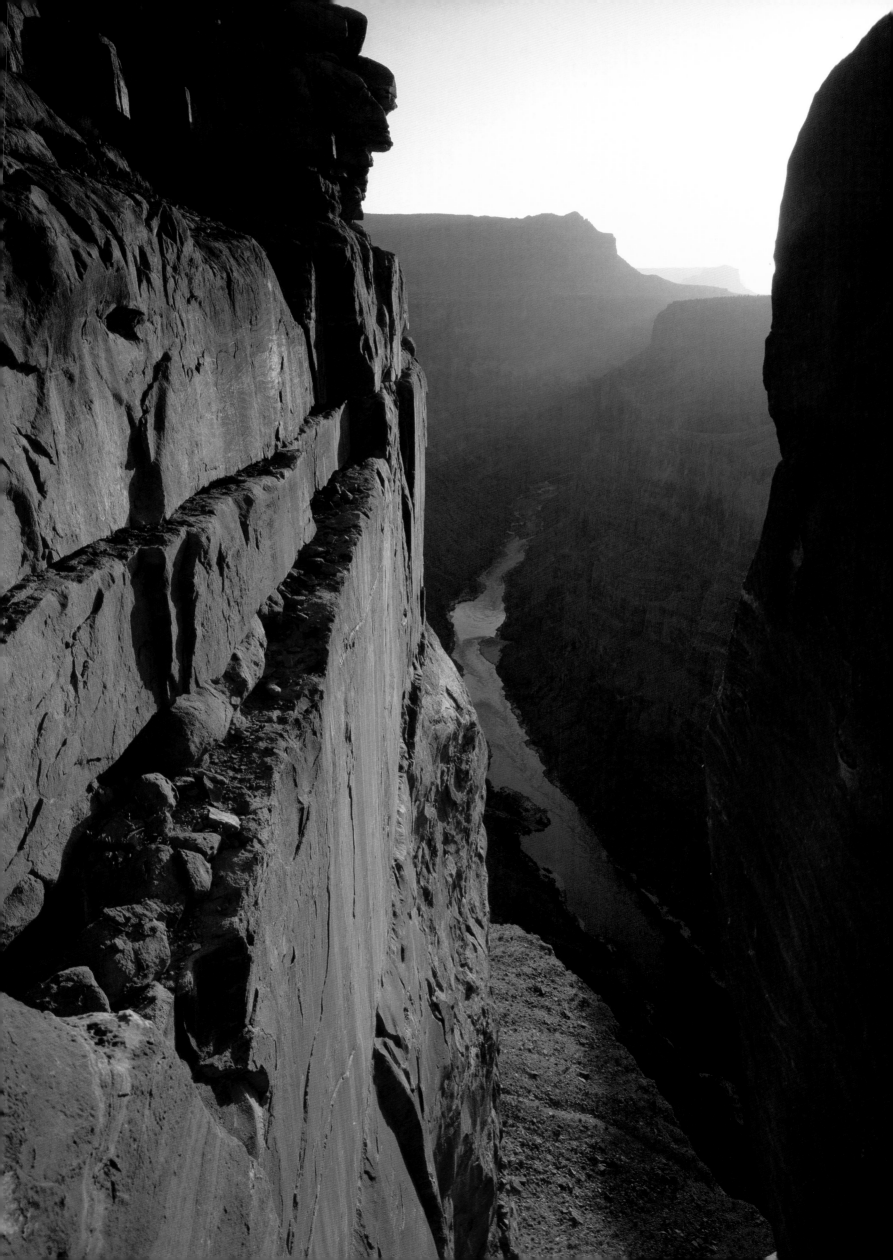

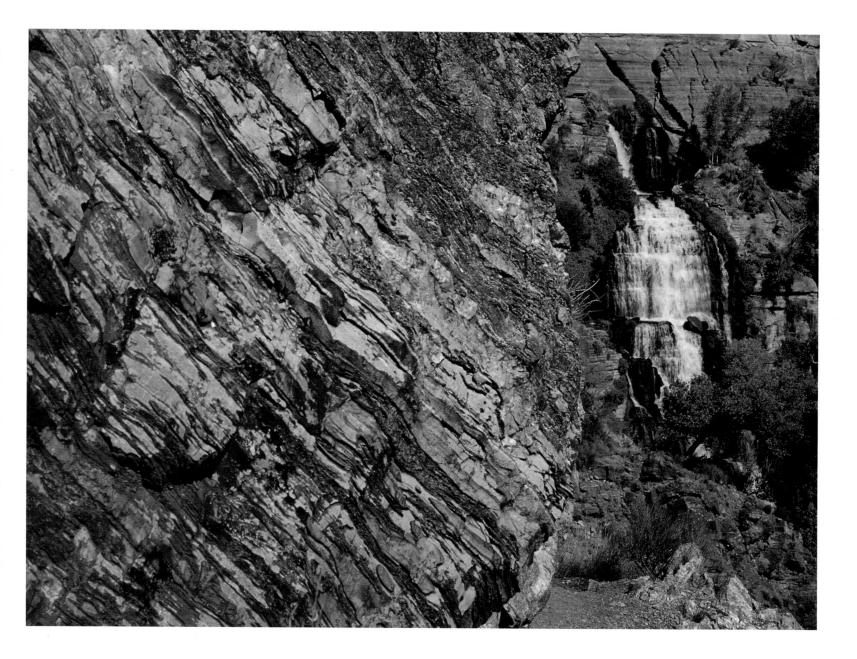

THUNDER SPRINGS, NORTH RIM

GRAND CANYON, COLORADO RIVER, TOROWEAP

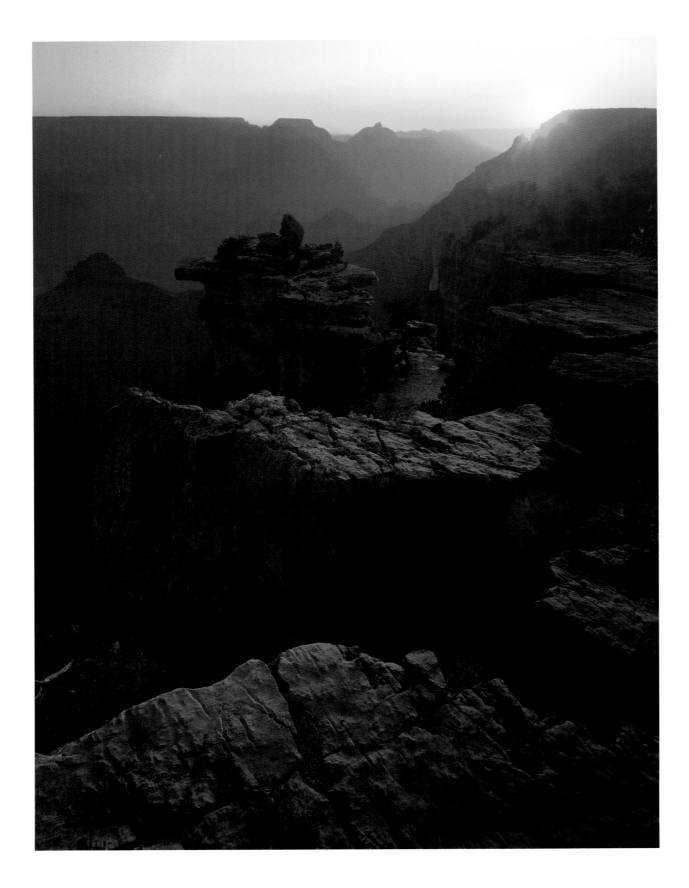

WOTANS THRONE AND VISHNU TEMPLE, MATHER POINT

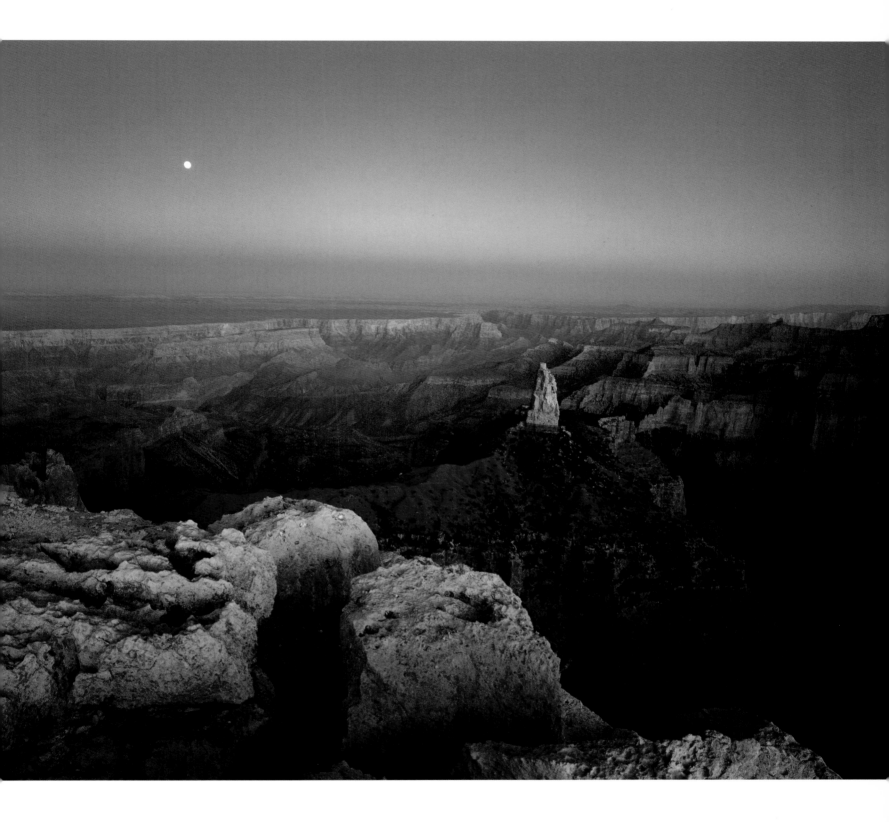

MOONRISE AND MOUNT HAYDEN, POINT IMPERIAL

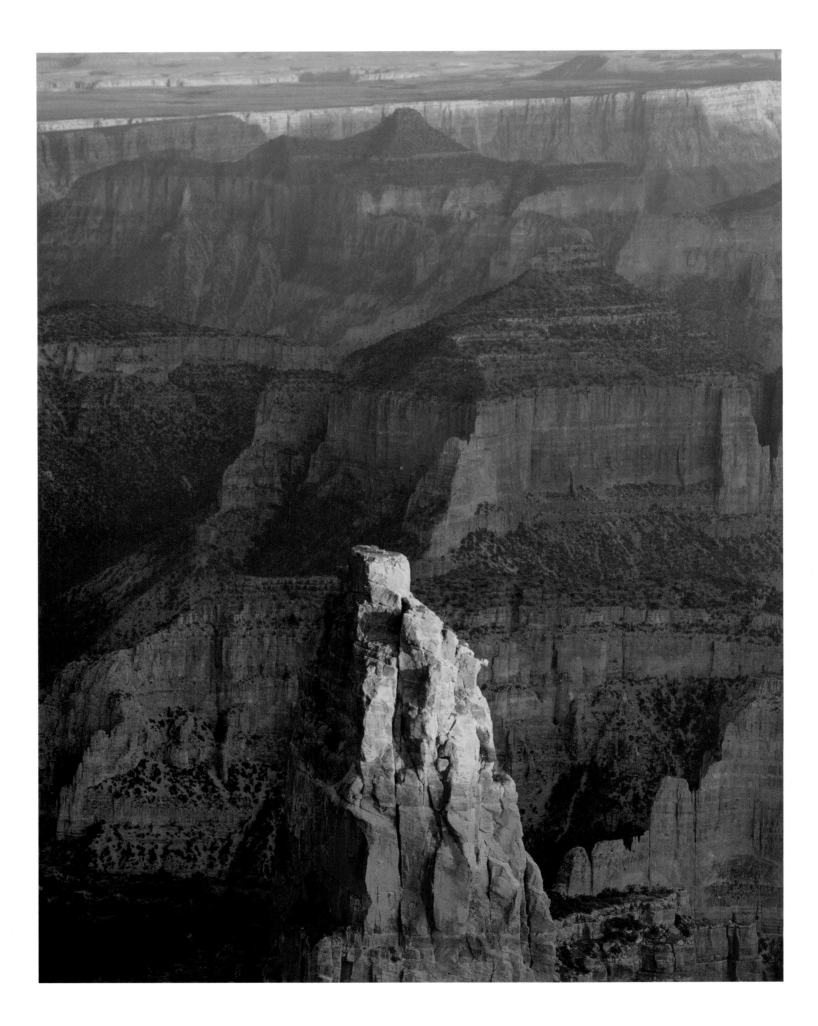

MOUNT HAYDEN FROM POINT IMPERIAL, NORTH RIM

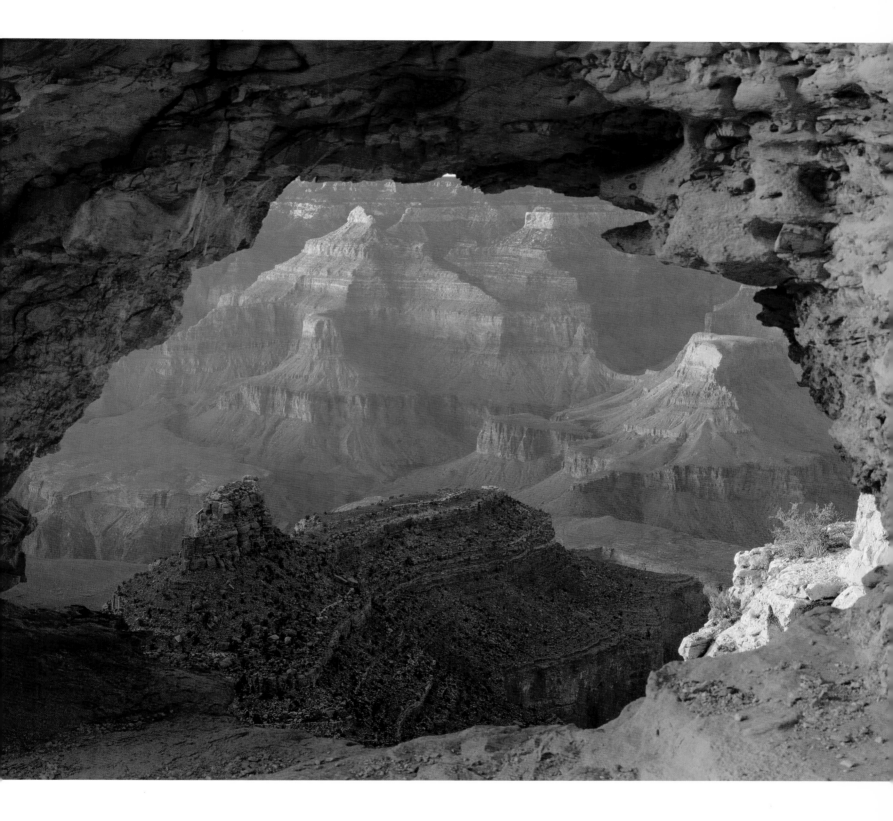

OSIRIS TEMPLE, LIMESTONE WINDOW, SOUTH RIM

FOLLOWING PAGES: BRIGHT ANGEL CANYON TEMPLES

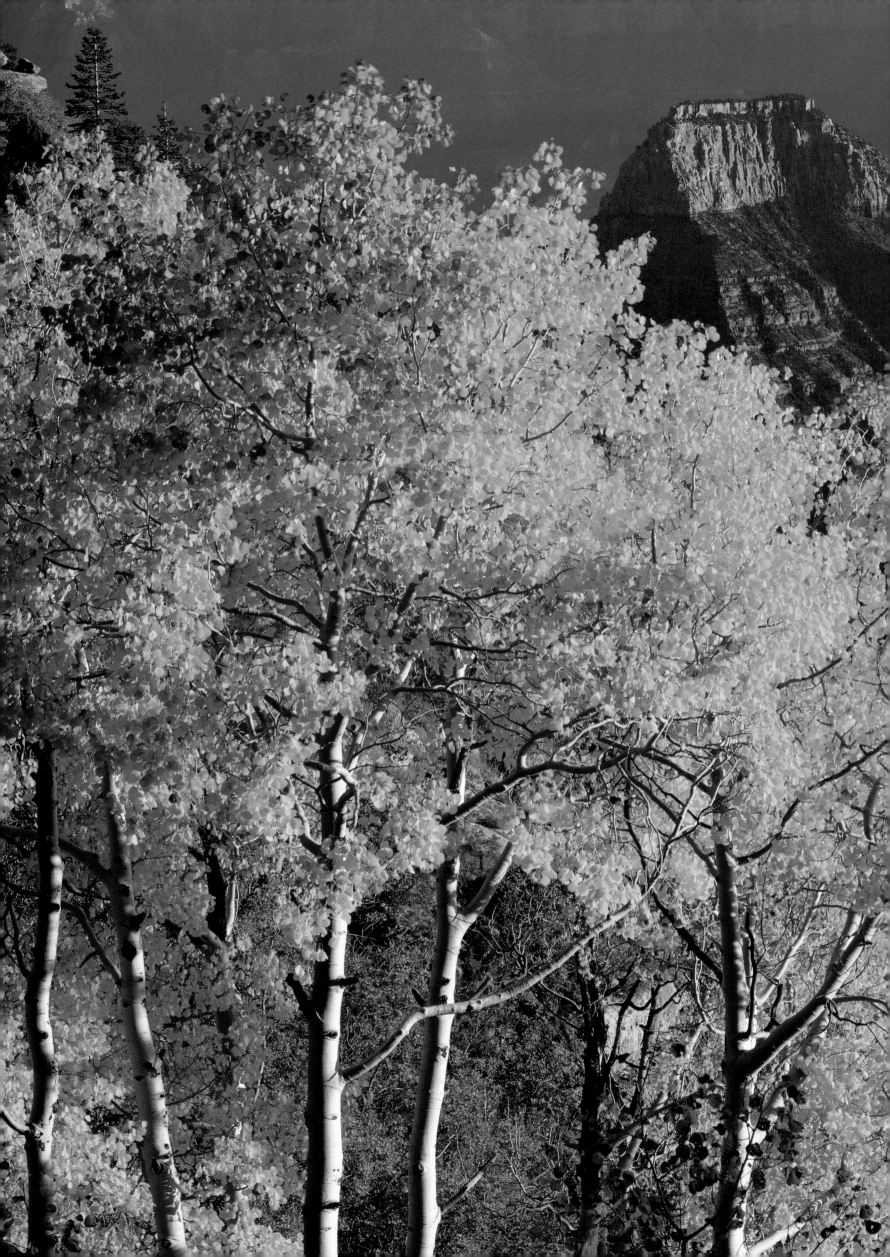

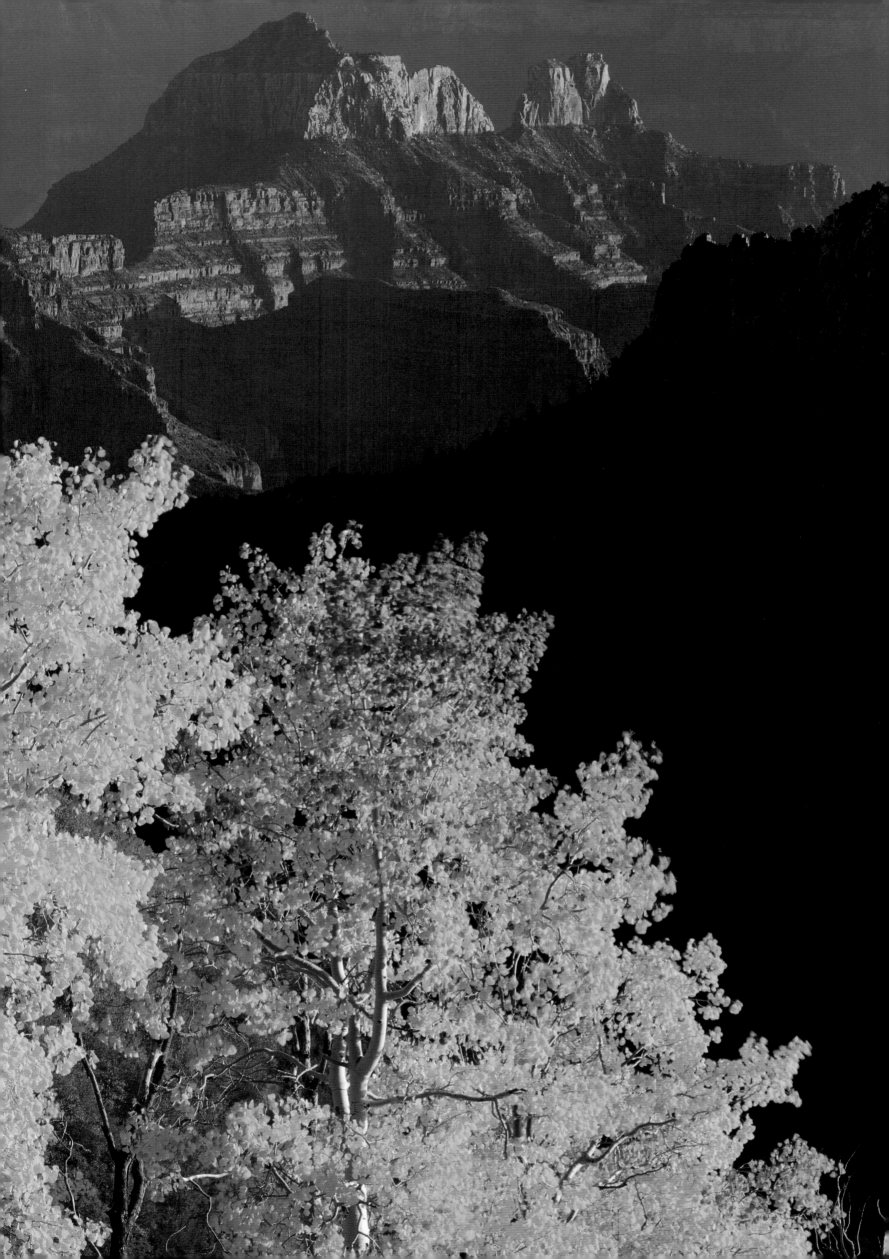

CROSS SECTION OF PETRIFIED LOG, RAINBOW FOREST

*A Painted Desert and trees turned to brilliantly colored stone mark this ancient landscape of the world's largest concentration of petrified wood. Dinosaurs once roamed among fossil plants from the 200-million-year-old Triassic Period. Rainbow tinted quartz replaced wood tissue of ancient Araucaria, to now become fragmented giant fossilized logs. Established 1962.*

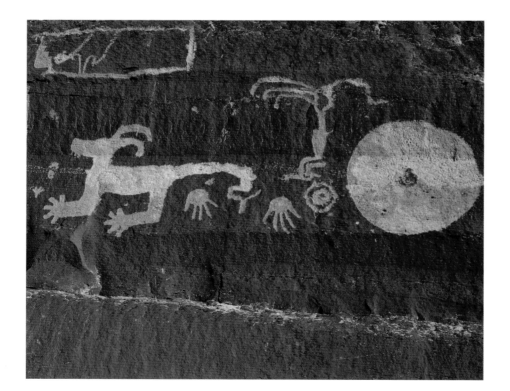

STYLIZED PETROGLYPH PANEL, NEWSPAPER ROCK

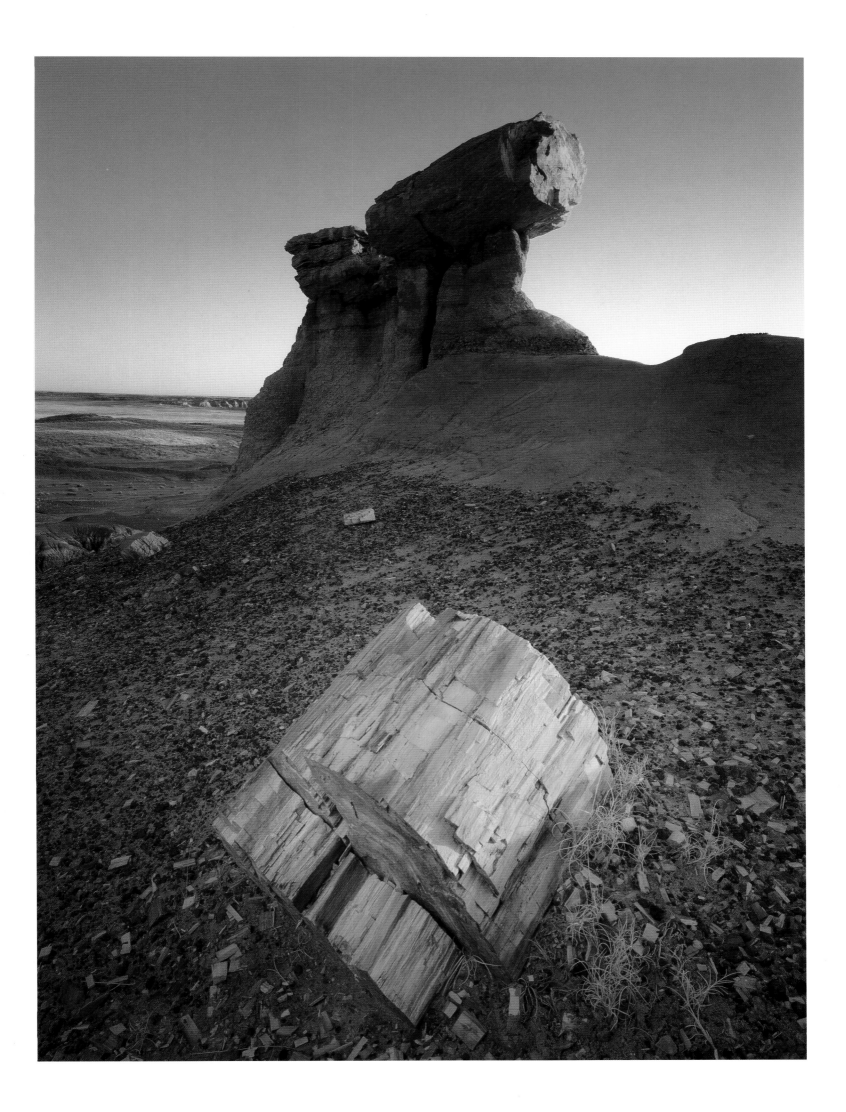

PEDESTAL LOGS, BLUE MESA

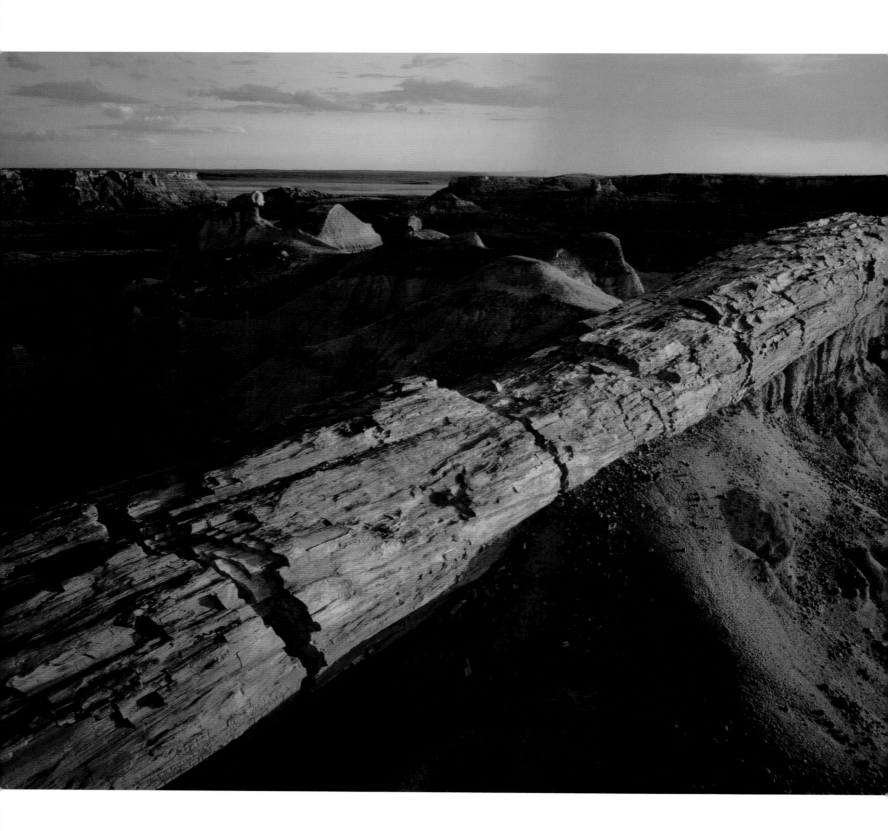

EXPOSED PETRIFIED LOG, BLUE MESA

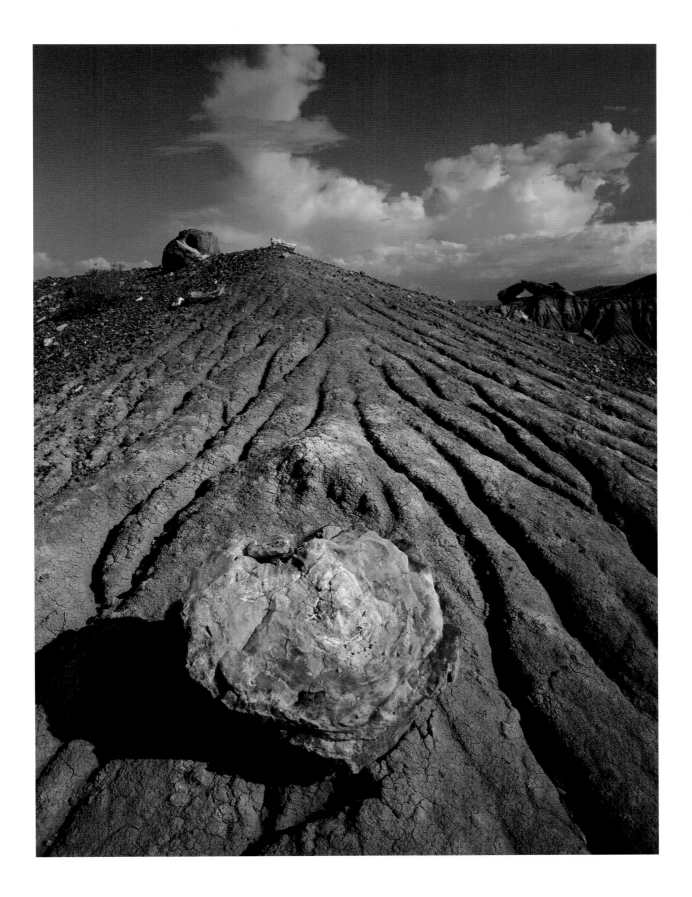

STONE LOG FRAGMENT, BLUE MESA

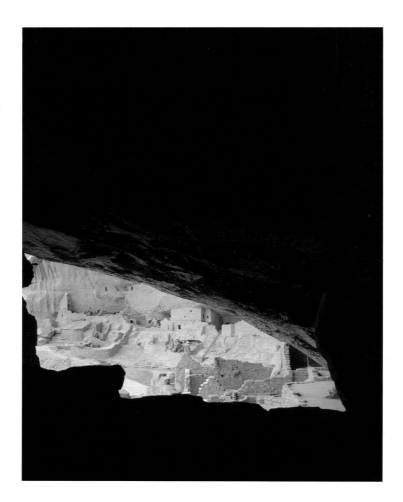

LONG HOUSE DWELLING, WETHERILL MESA

*Anasazi, "the ancient ones," lived in well-preserved cliff dwellings and mesa top pueblos from AD 550 to 1270. Through centuries of silence, the dwellings in sandstone canyons of Mesa Verde, speak with eloquence of the accomplishments in community living and arts and crafts as the finest expression of human culture in ancient America. Established 1906, and is a World Heritage Site.*

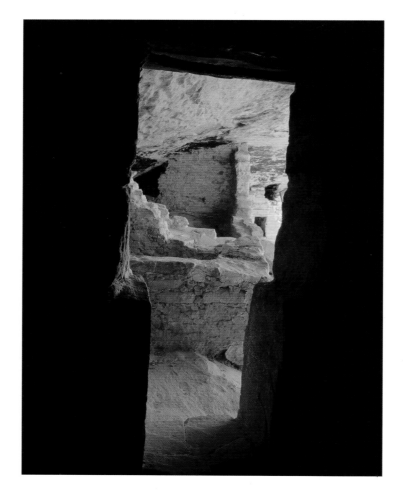

DOORWAY AT LONG HOUSE, WETHERILL MESA

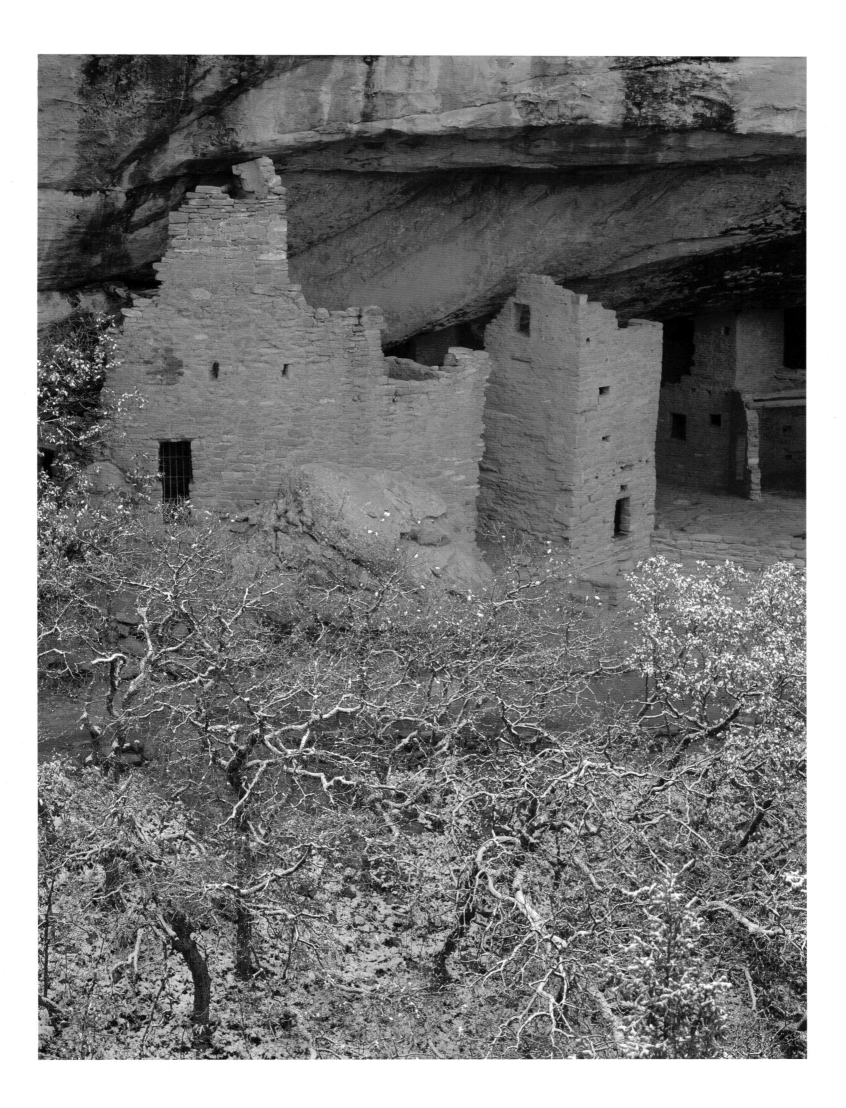

SPRUCE TREE HOUSE, CHAPIN MESA

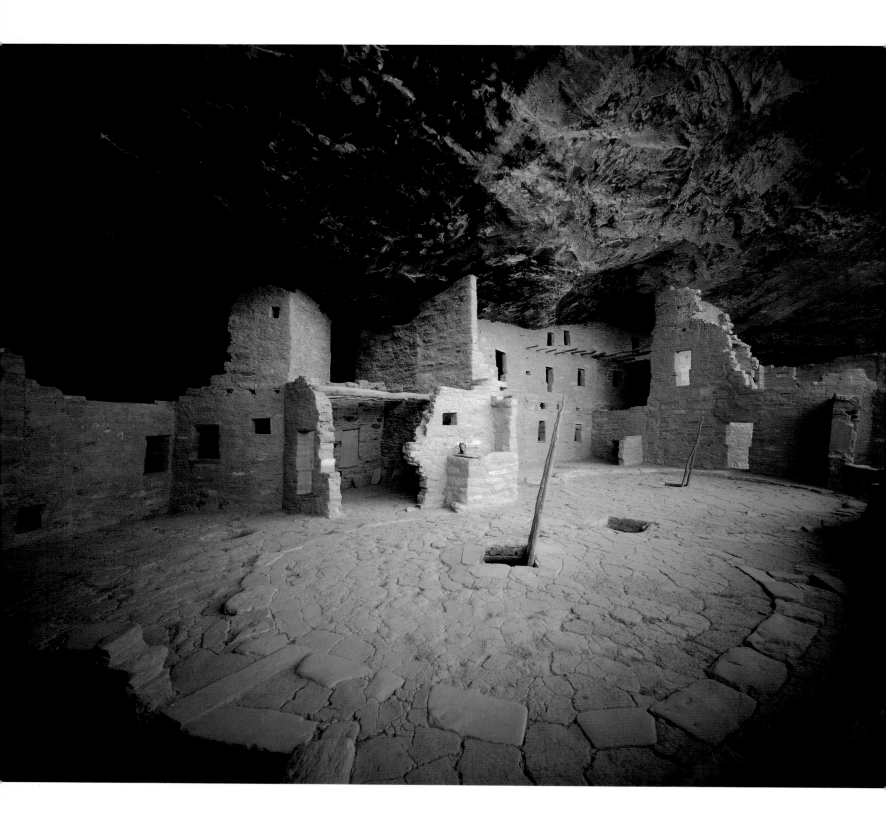

CEREMONIAL KIVAS, SPRUCE TREE HOUSE

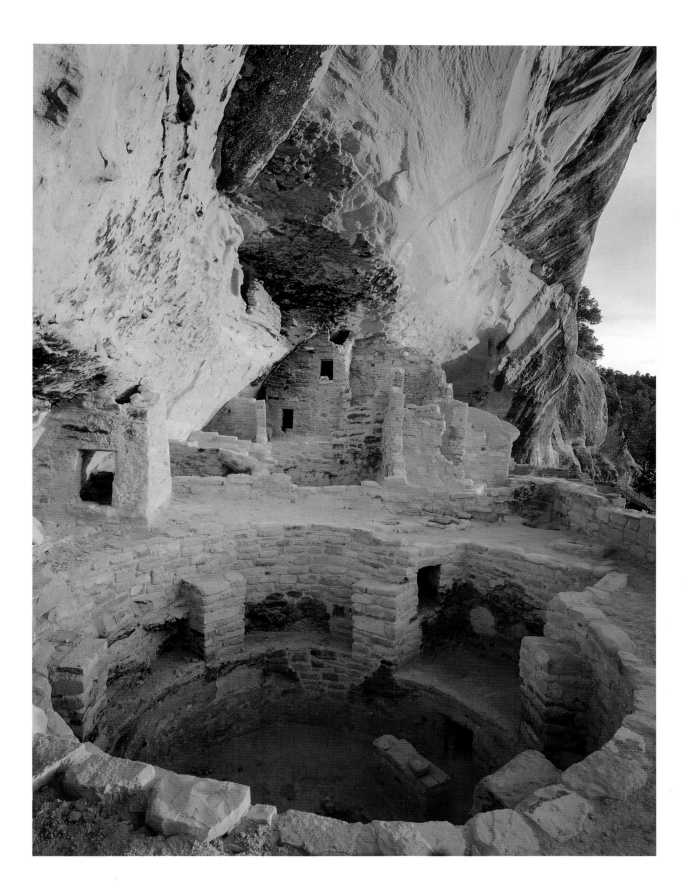

KIVA AND RUIN WALLS, MUG HOUSE, WETHERILL MESA

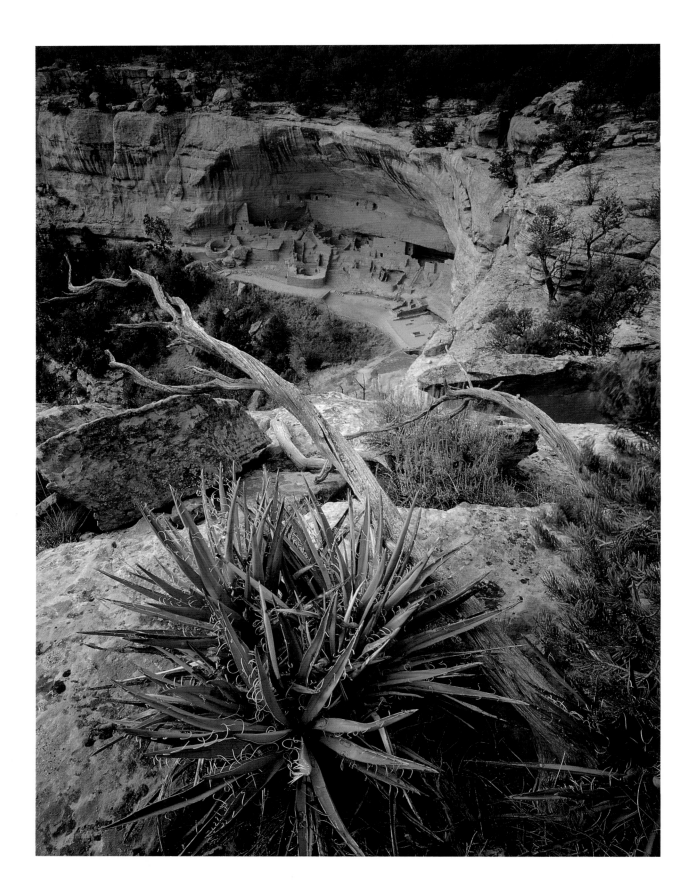

YUCCA ON RIM, LONG HOUSE, WETHERILL MESA

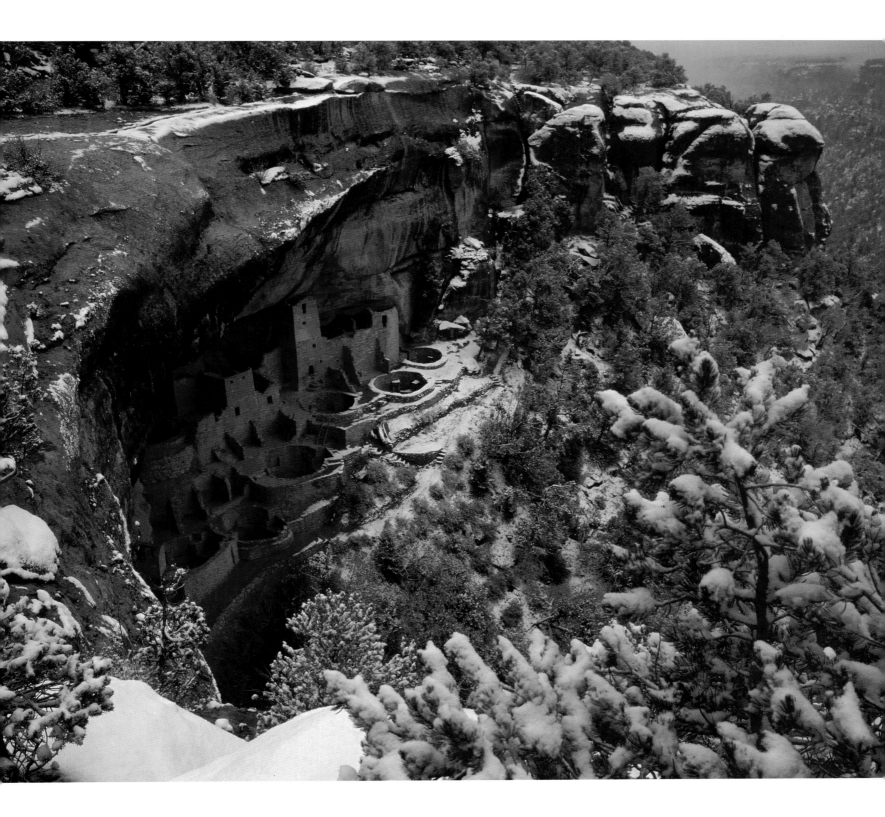

CLIFF PALACE, WINTER, CHAPIN MESA

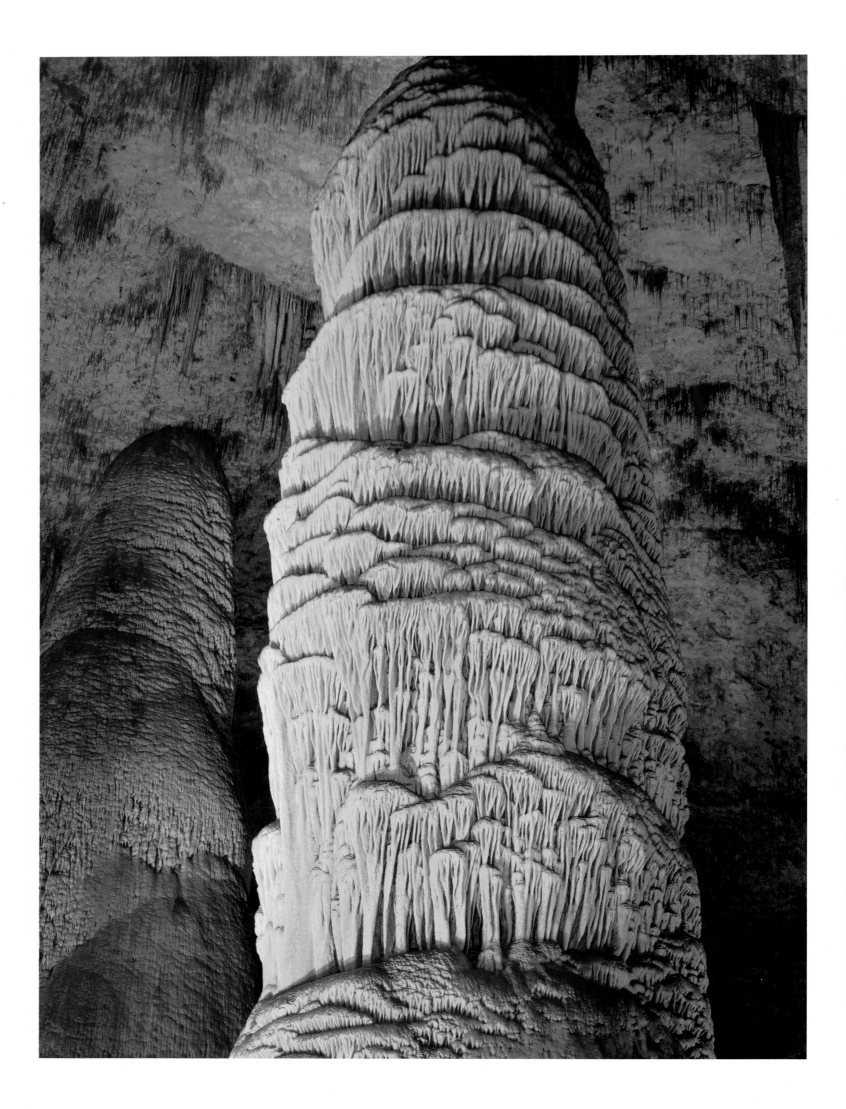

DOME FORMATION, CAVEMAN JUNCTION, THE BIG ROOM

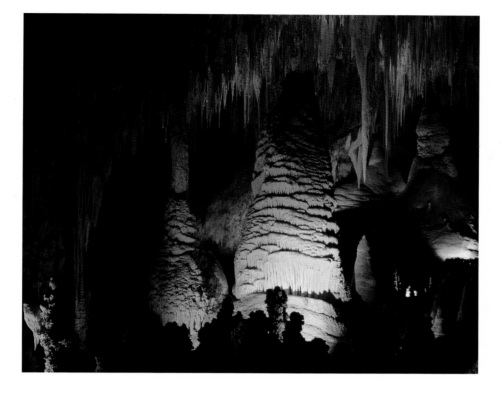

TEMPLE OF THE SUN AND BUDDHA, BIG ROOM

*Limestone-laden moisture has*

*built, drop by drop, crystal*

*by crystal, the great cave*

*decorations of stalactites,*

*stalagmites, columns, popcorns,*

*draperies, flowstone, helictites,*

*rimstone, lily pads, and cave*

*pearls at Carlsbad — an impressive*

*subterranean array beneath the*

*Chihuahuan Desert. The story of*

*creation lies within a long limestone*

*reef, now exposed as the Guadalupe*

*Mountains. Established 1930.*

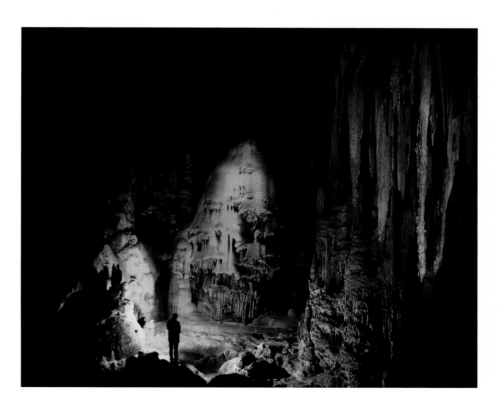

CHRISTMAS TREE FORMATION, NEW CAVE

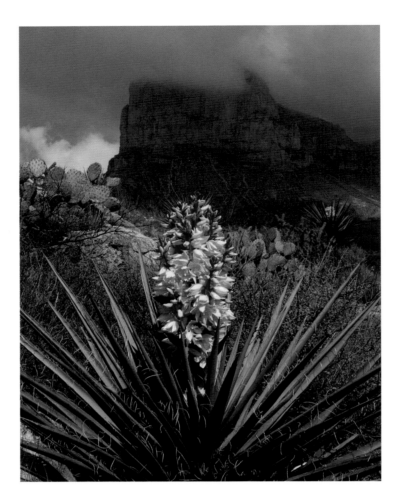

YUCCA AND PRICKLY PEAR CACTUS, EL CAPITAN

*A landscape of rock, thorn, and light—once an ancient marine fossil reef, the Guadalupe Mountains bring together a magnificent mix of Rocky Mountain and Chihuahuan Desert wilderness, where cactus, agave, and yuccas adapt to a harsh environment below pine-fir-aspen forest highlands, and diverse, cool, sheer-sided canyons in between. Established 1972.*

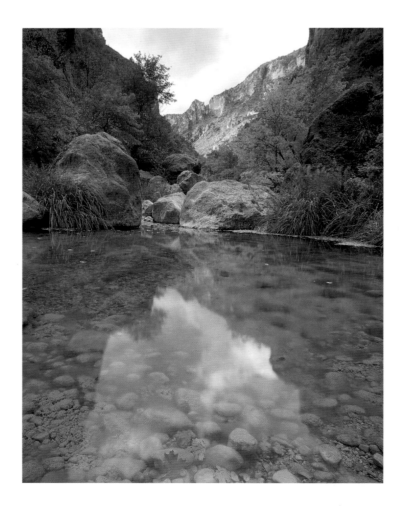

AUTUMN REFLECTIONS, NORTH MCKITTRICK CANYON

RAINBOW CACTUS, GUADALUPE MOUNTAINS

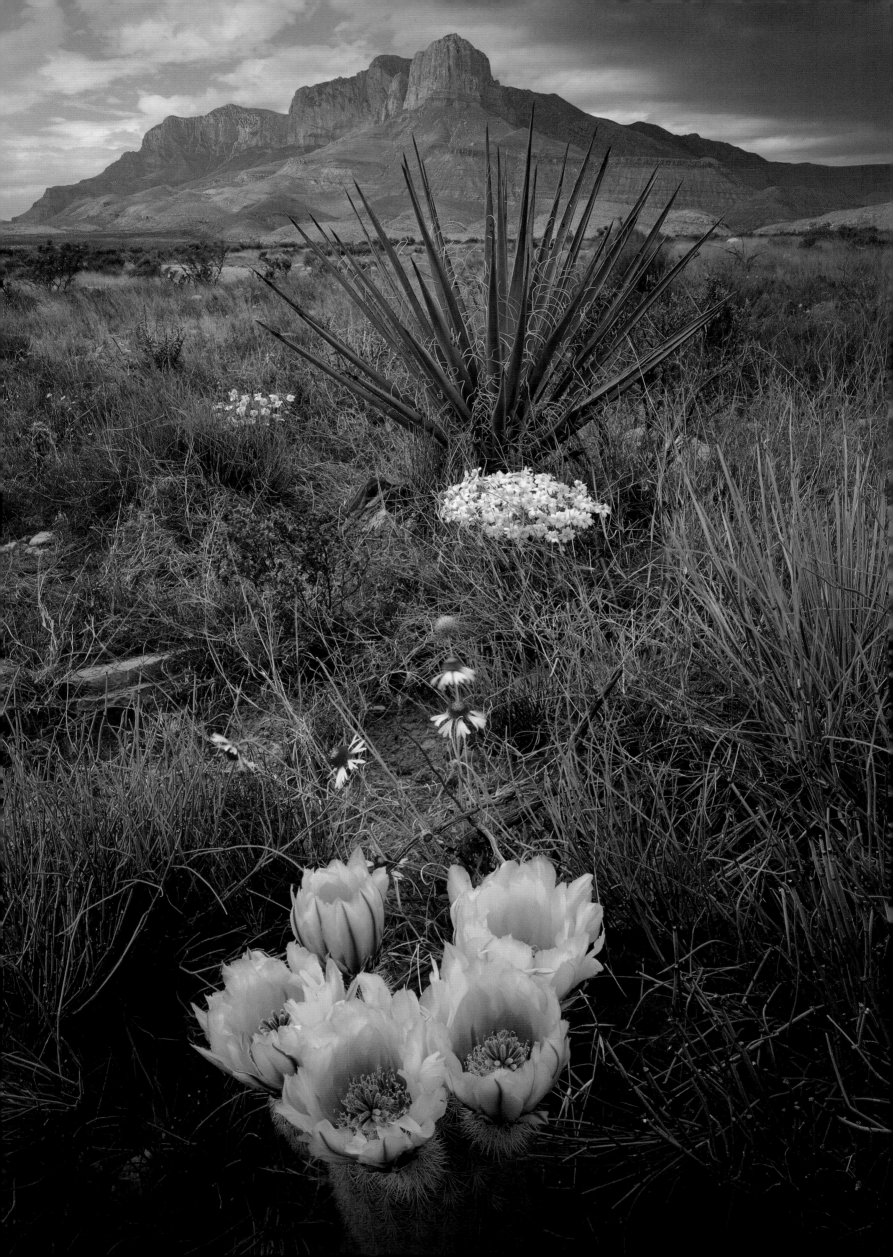

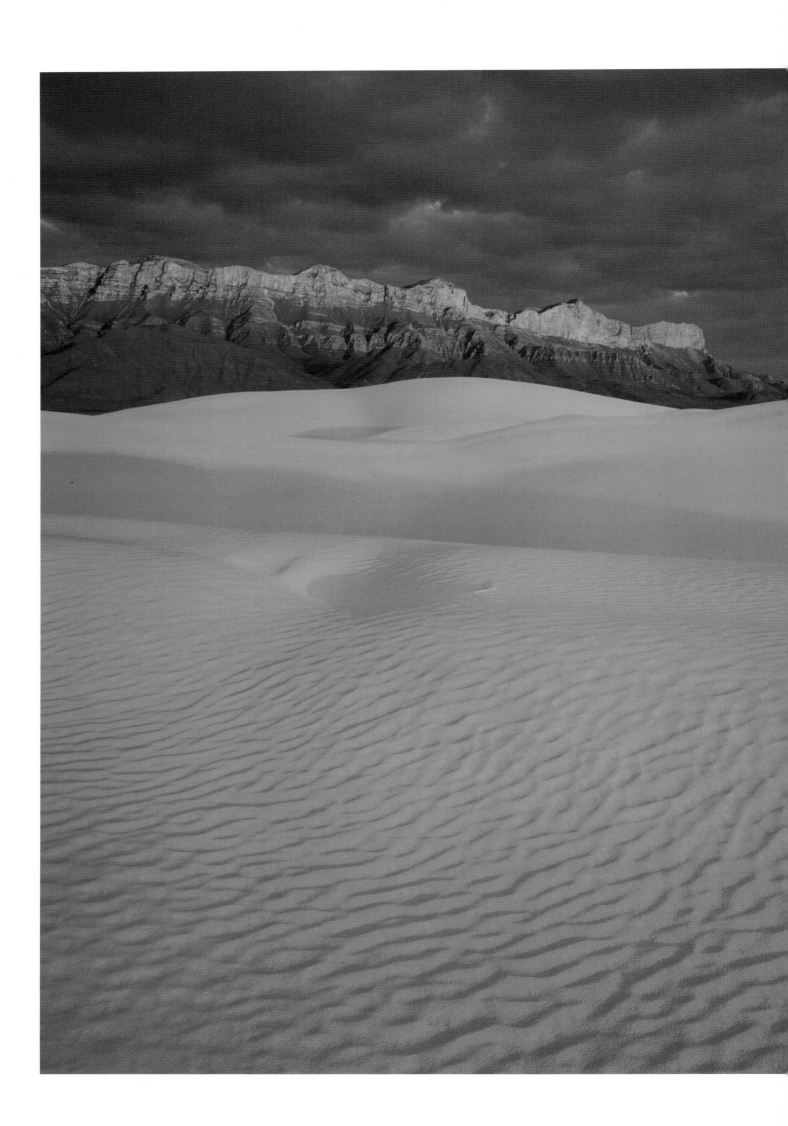

GYPSUM DUNES AND THE GUADALUPE MOUNTAINS

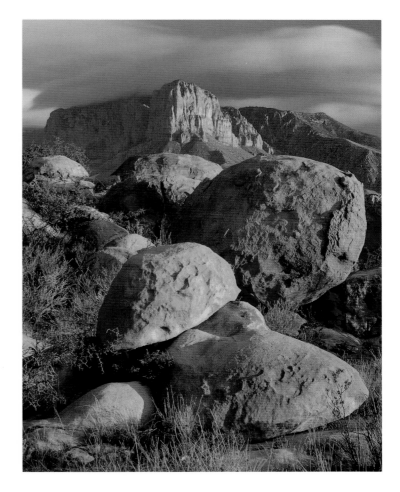

EL CAPITAN, GUADALUPE MOUNTAINS

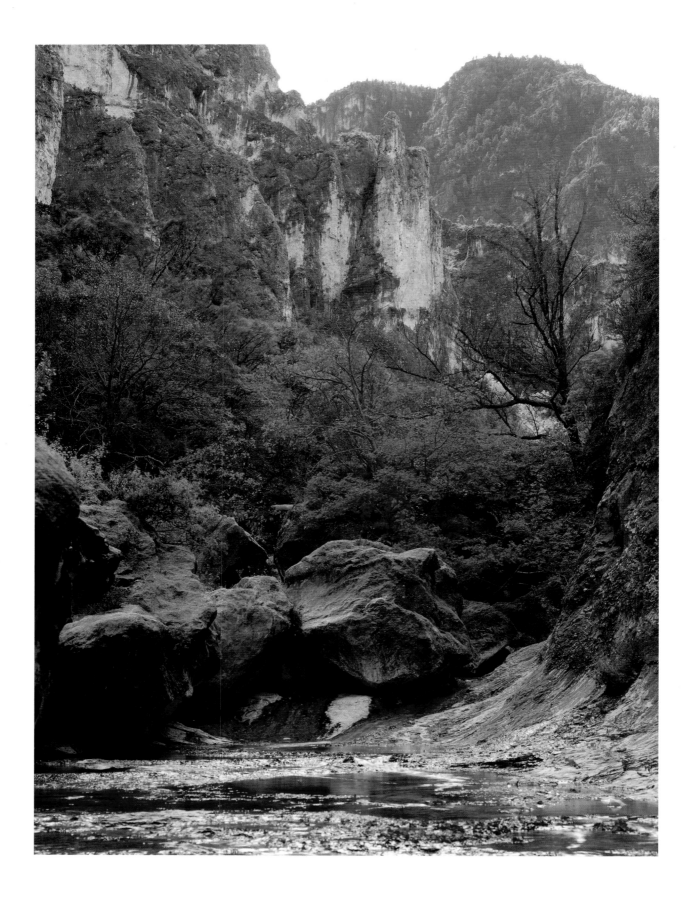

BOULDER STREWN MCKITTRICK CANYON, AUTUMN

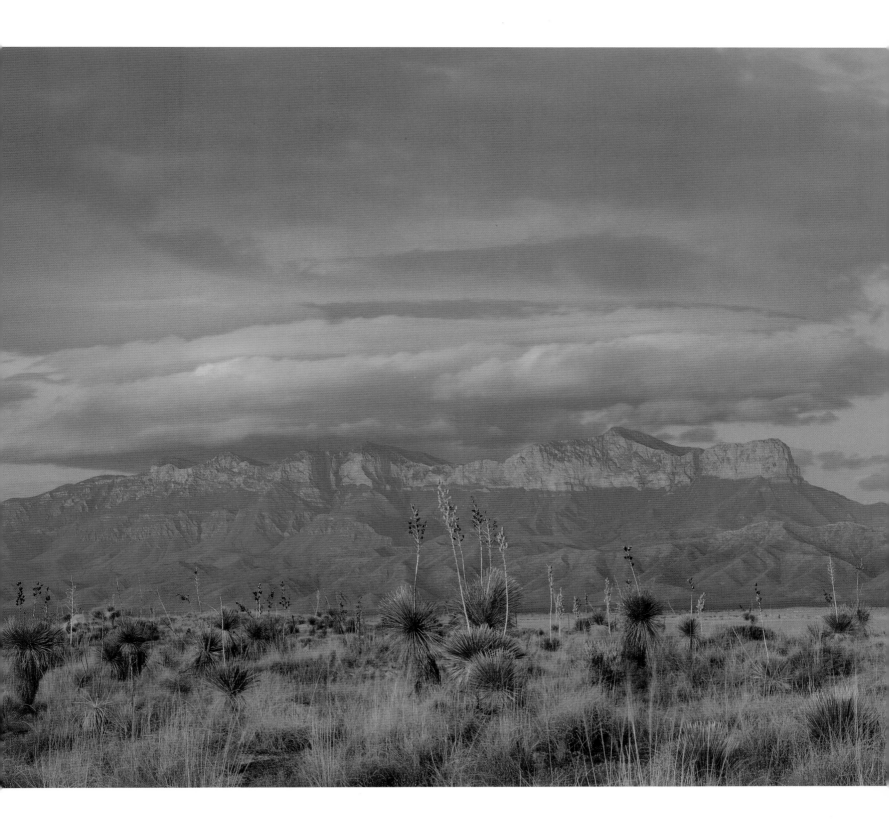

YUCCAS ACROSS SALT BASIN, GUADALUPE MOUNTAINS

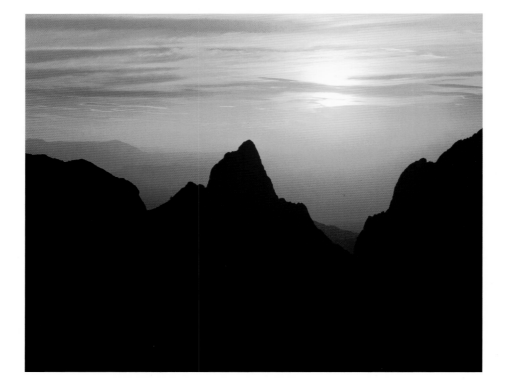

THE WINDOW FROM THE BASIN, CHISOS MOUNTAINS

*The Rio Grande River makes a giant horseshoe curve in the Chihuahuan Desert. The Indians said that after making the Earth, the Great Spirit dumped all the leftover rocks on Big Bend. Santa Elena, Mariscal, and Boquillas canyons string a ribbon of green across the desert — a desert often punctuated by profusion of floral displays. Established 1994.*

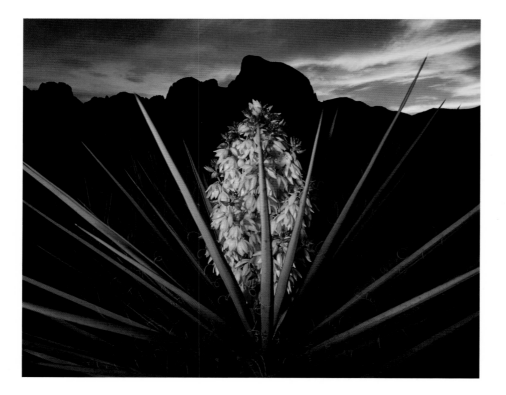

TORREY YUCCA BLOOM, EVENING, CHISOS MOUNTAINS

SANTA ELENA CANYON OF THE RIO GRANDE

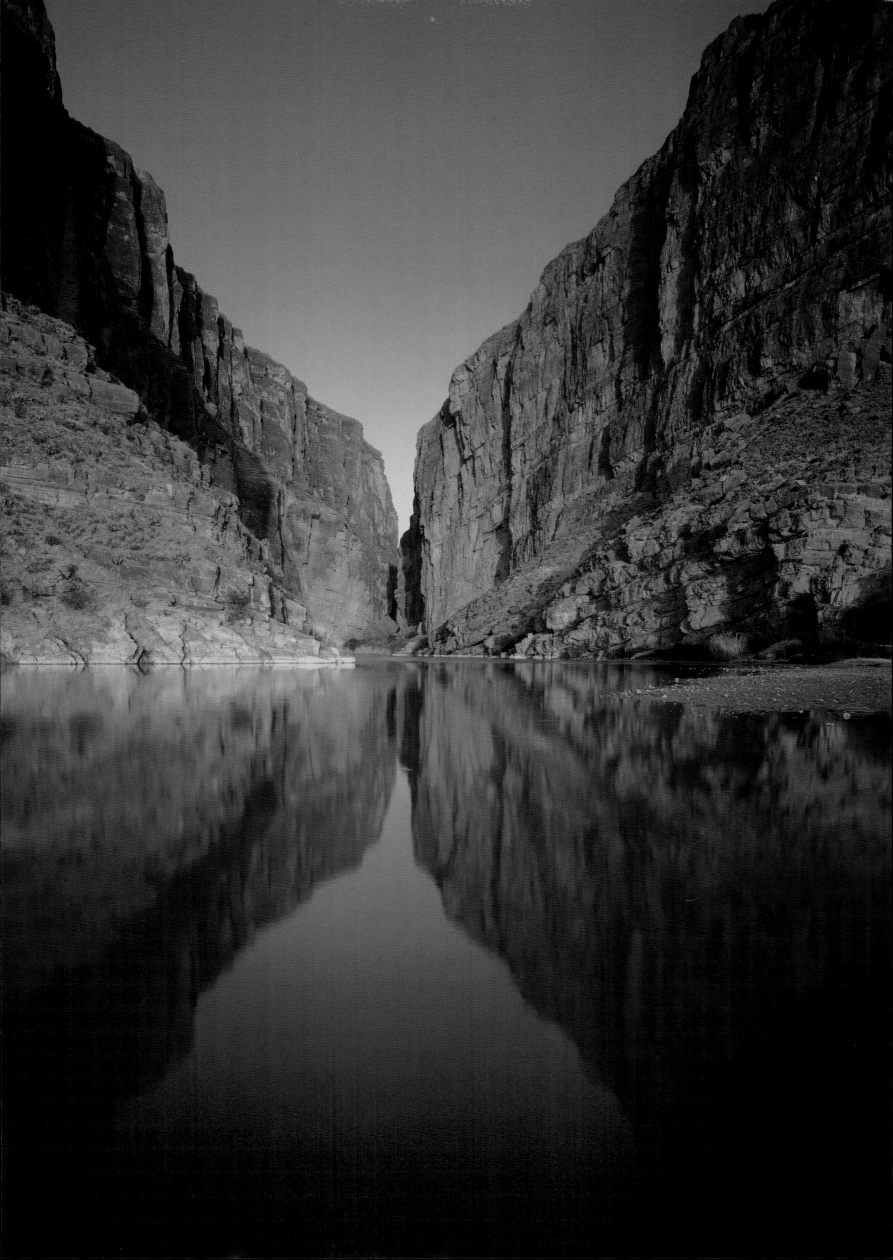

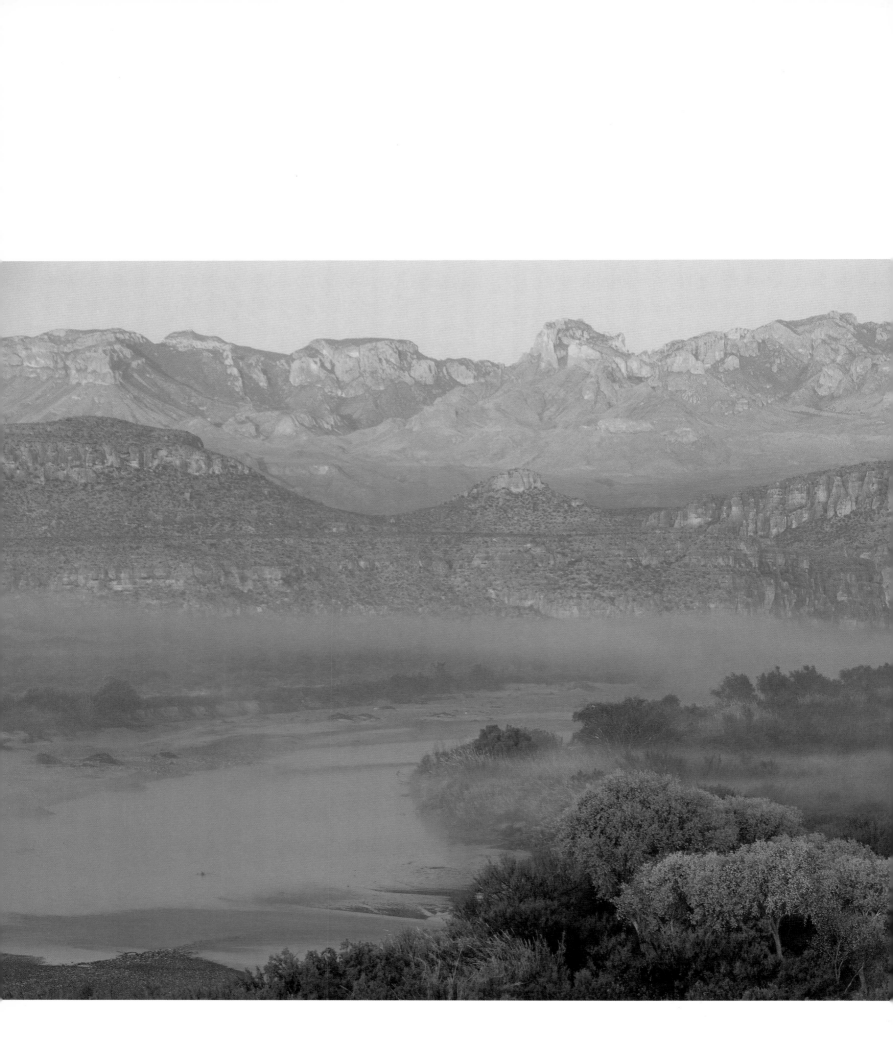

MORNING FOG ON THE RIO GRANDE

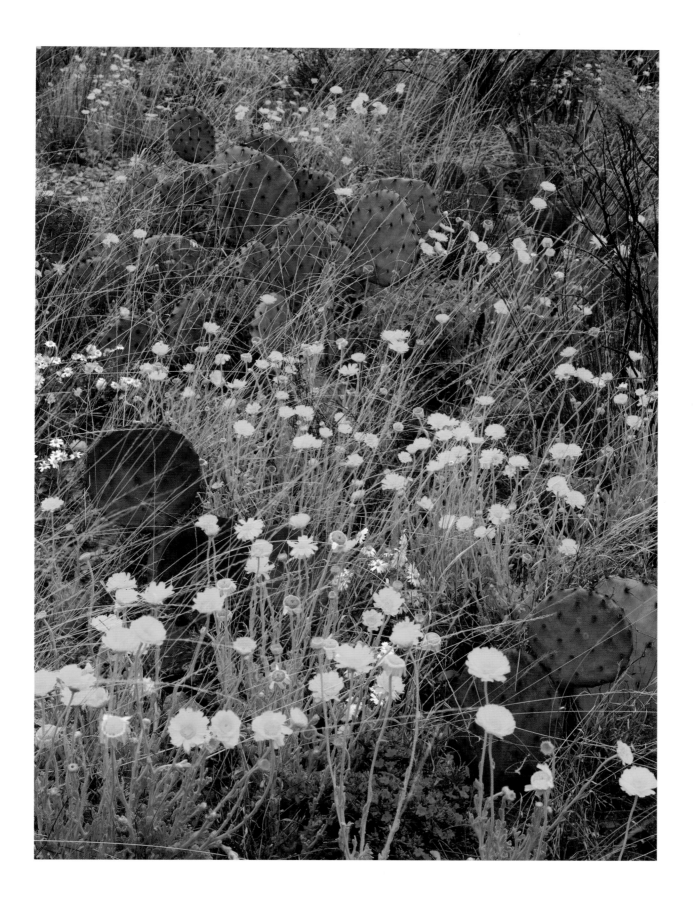

BLOOMS AND PRICKLY PEAR NEAR CROTON SPRING

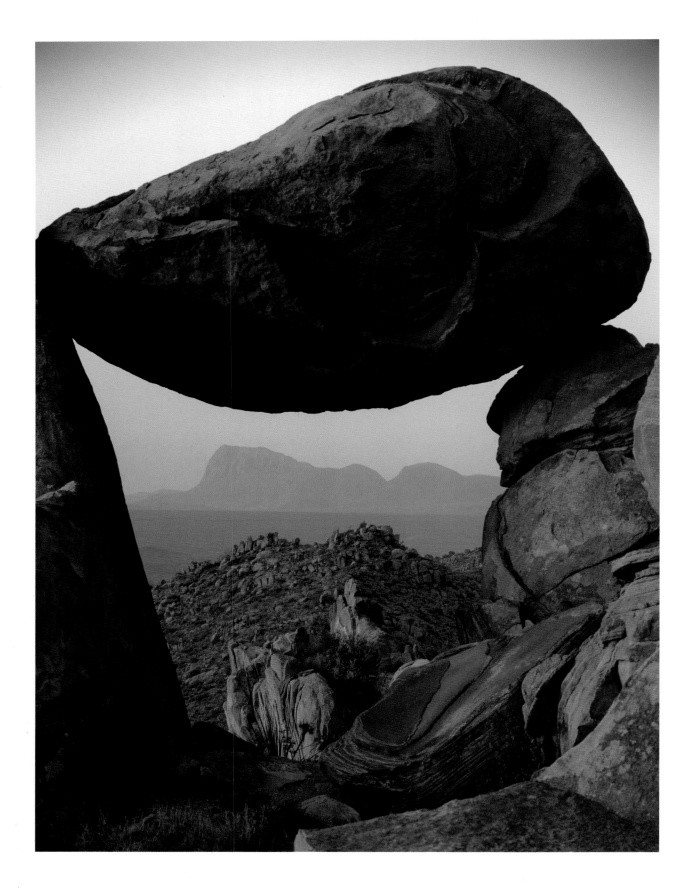

BALANCED ROCK IN THE GRAPEVINE HILLS

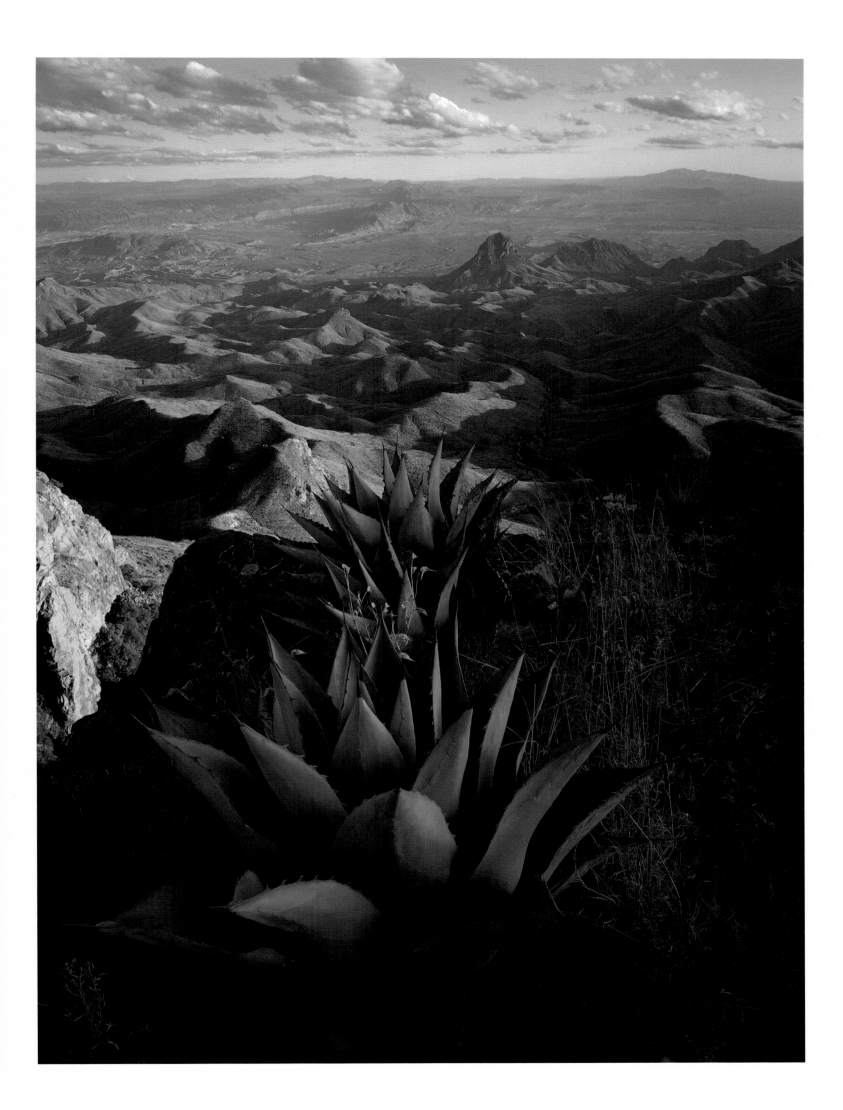

CENTURY PLANTS, SOUTH RIM, CHISOS MOUNTAINS

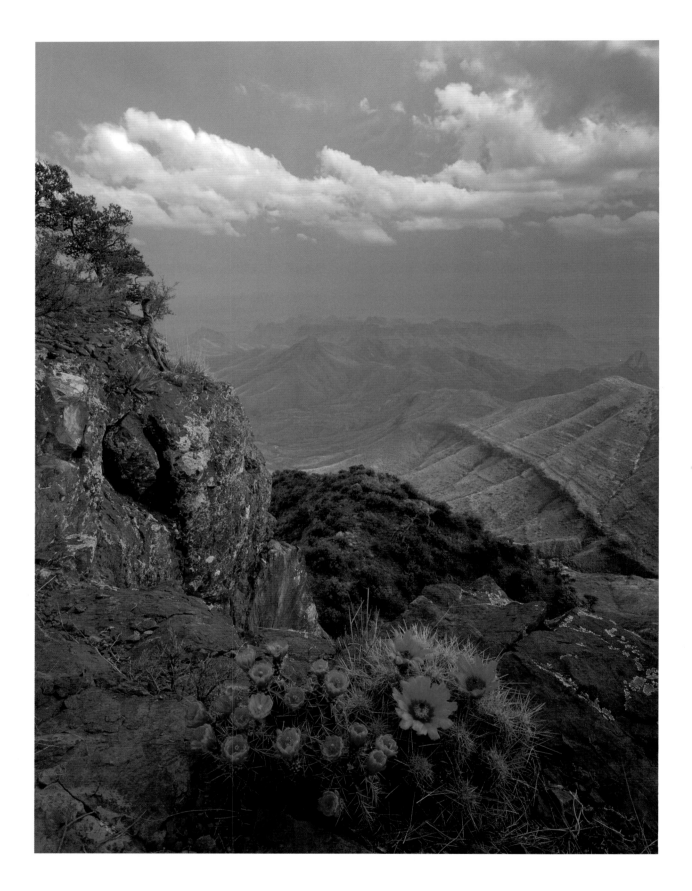

STRAWBERRY AND CLARET CUP CACTI BLOOMS

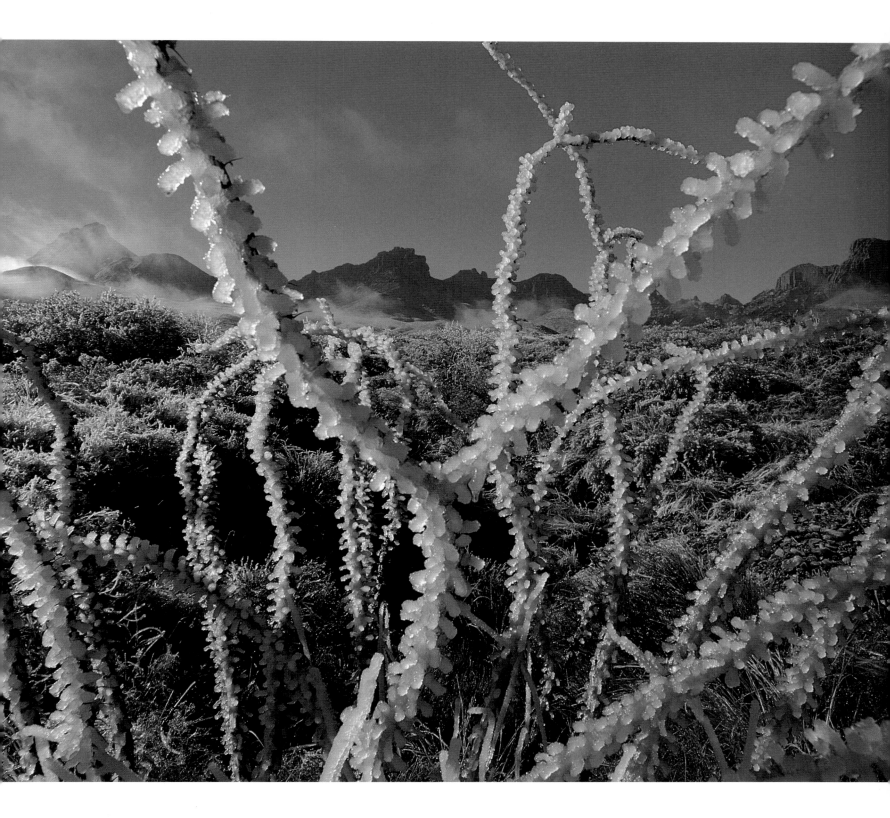

ICE STORM WITH OCOTILLO, CHISOS MOUNTAINS

HONEY COMB-SHAPED BOXWORK WIND CAVE

*Great forces created the Black Hills*

*limestone fissures for the trickling*

*water to dissolve rock and form*

*a cave labyrinth. Ponderosa*

*forest and mixed-grass prairie*

*of the western Great Plains*

*are above. Established 1903.*

POPCORN AND HELICTITES, WIND CAVE CEILING

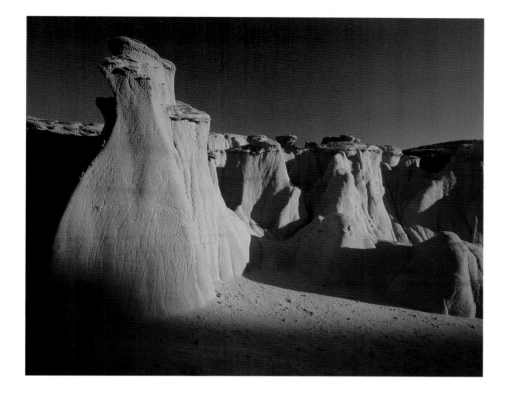

ERODED CAPROCK FORMATIONS, NORTH UNIT

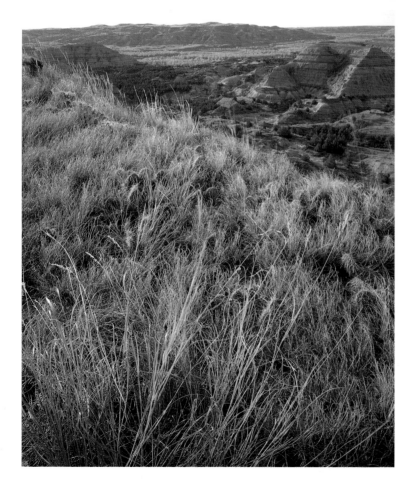

*This park preserves the memory of*

*an extraordinary conservation*

*president who accomplished much*

*for the National Park System.*

*It also preserves the extraordinary*

*landscape of the North Dakota*

*Badlands. Established 1978.*

GRASSLANDS, LITTLE MISSOURI RIVER

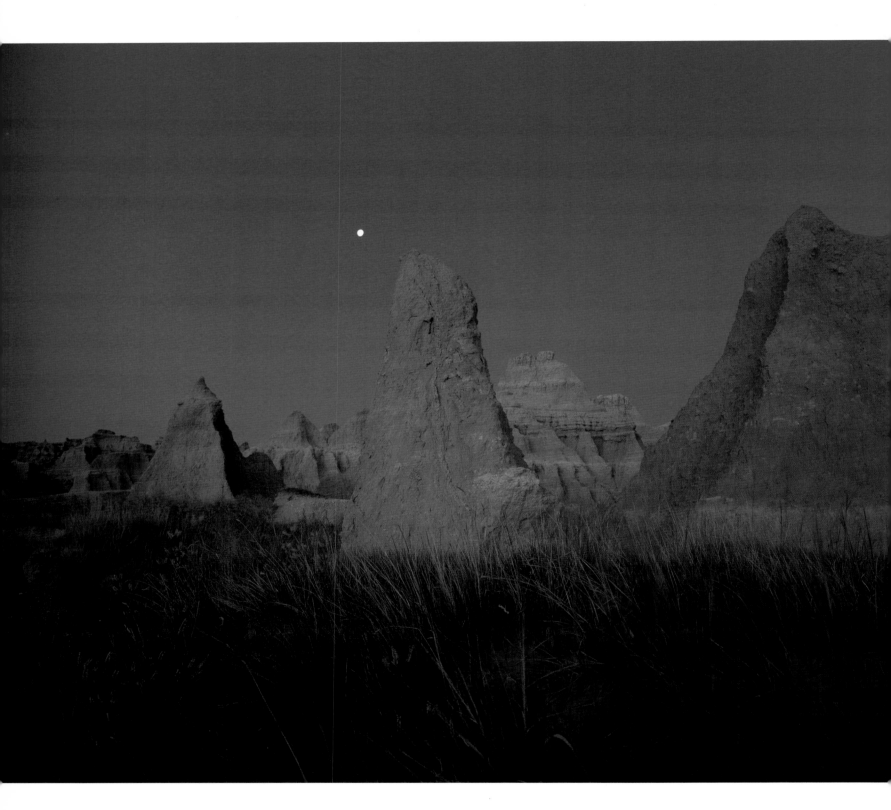

BADLANDS AT DAWN, CEDAR PASS

*Fossils of the Oligocene epoch — Golden*

*Age of Mammals — are exposed and*

*preserved in South Dakota clay*

*badlands, known as The Wall. They*

*are also a remnant of one of the world's*

*great grasslands. Established 1978.*

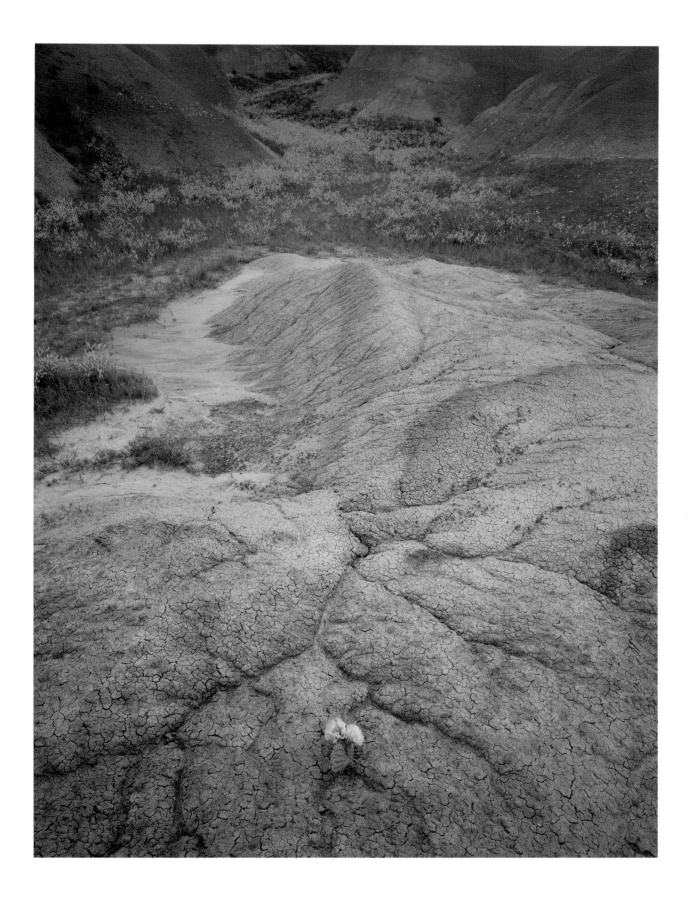

SPRING BLOOMS, THE PRAIRIE WINDS AREA

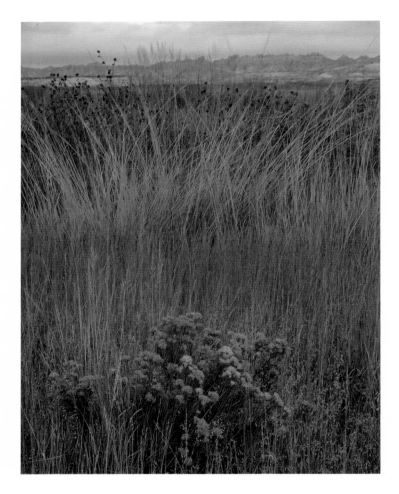

HIGH PLAINS GRASSES, STRONGHOLD UNIT

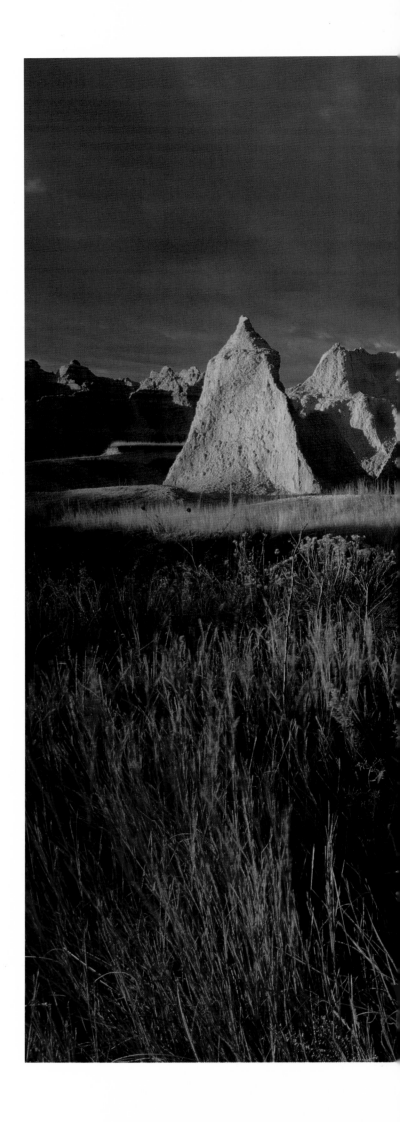

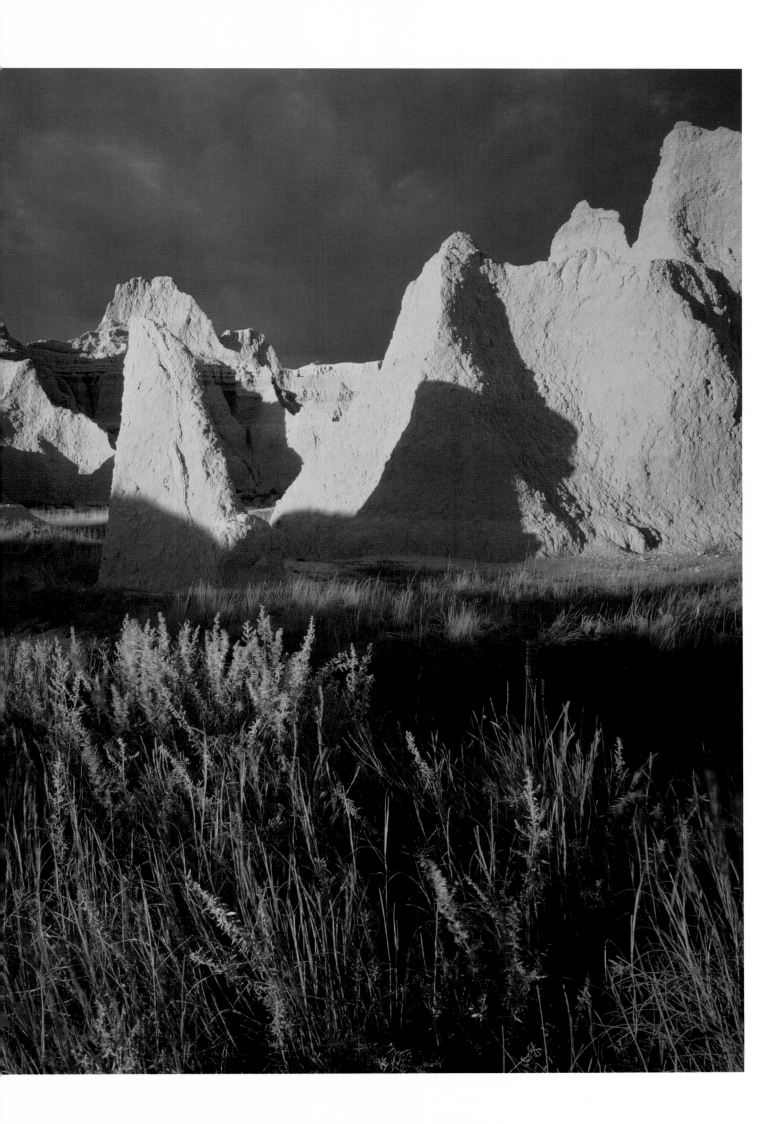

MOONSET AND ERODED CLAY FORMS NEAR CEDAR PASS

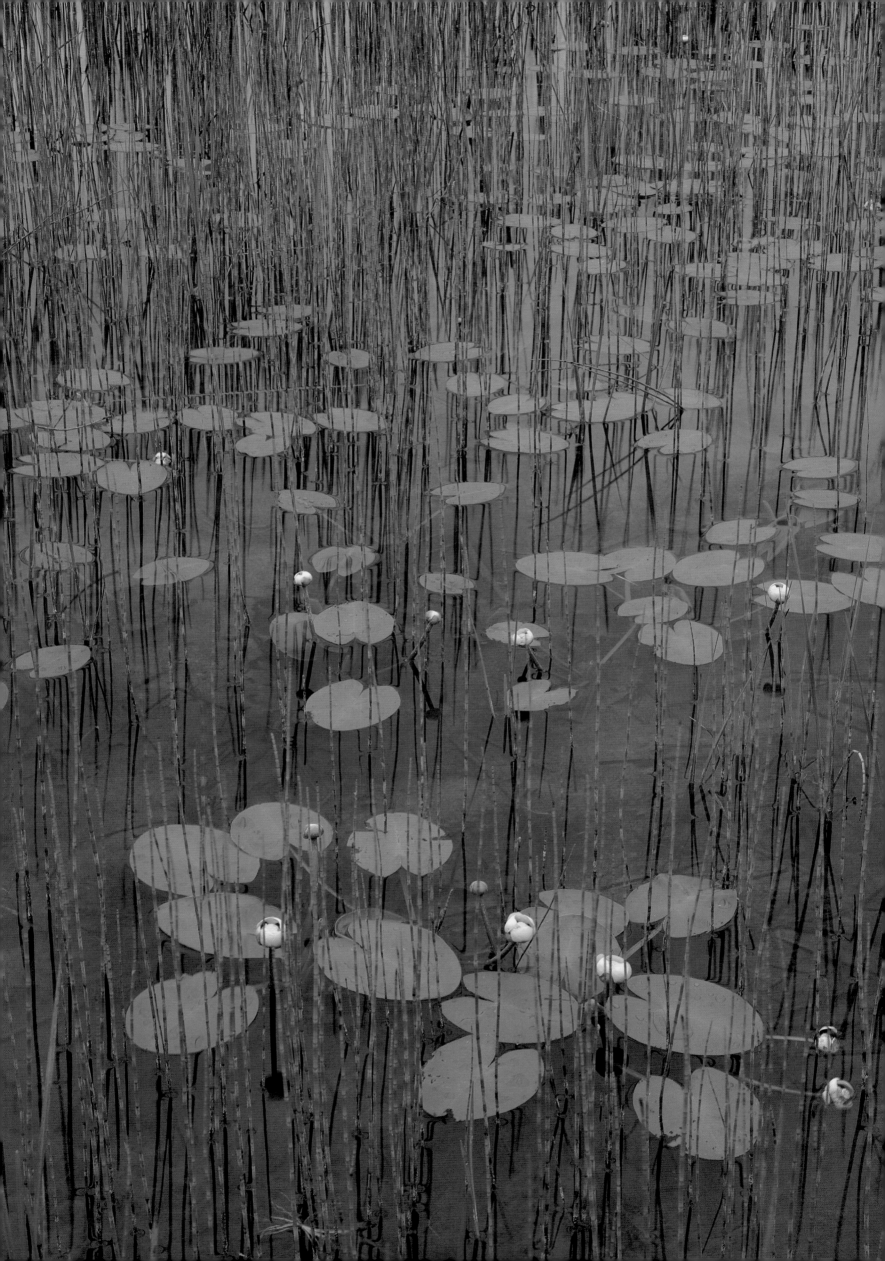

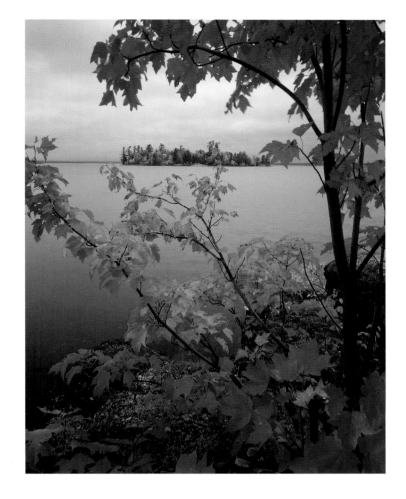

MAPLE, KABETOGAMA LAKE, KABETOGAMA NARROWS

*A mosaic of lakes and streams,*

*mixed with numerous islands,*

*form this north woods realm on*

*the U.S.-Canada border. It*

*is a celebration of the land*

*and waterways. French Canadian*

*voyageurs paddled their*

*birch-bark canoes for fur trading*

*companies, late in the 1700s and*

*early 1800s. Established 1975.*

WATER LILY, SNAKE GRASS, KABETOGAMA NARROWS

MOSS LADEN GRANITE DOME, ASH RIVER TRAIL

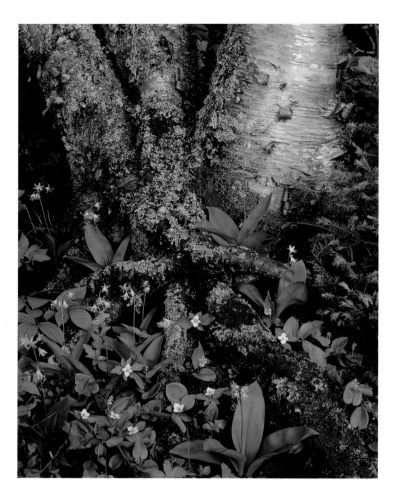

BUNCHBERRY, CLINTON LILIES AND BIRCH TRUNK

*A wilderness archipelago — an island in time of forested wildlands and lakes, all exist on Lake Superior's northwest corner. Visits are by boat, extended by hiking on the trail, where one experiences the natural rhythms of light and dark. The last major glaciation of the Wisconsin has smoothed, rounded, and polished this island landscape. Established 1931.*

BIRCH FOREST EDGE, WASHINGTON HARBOR

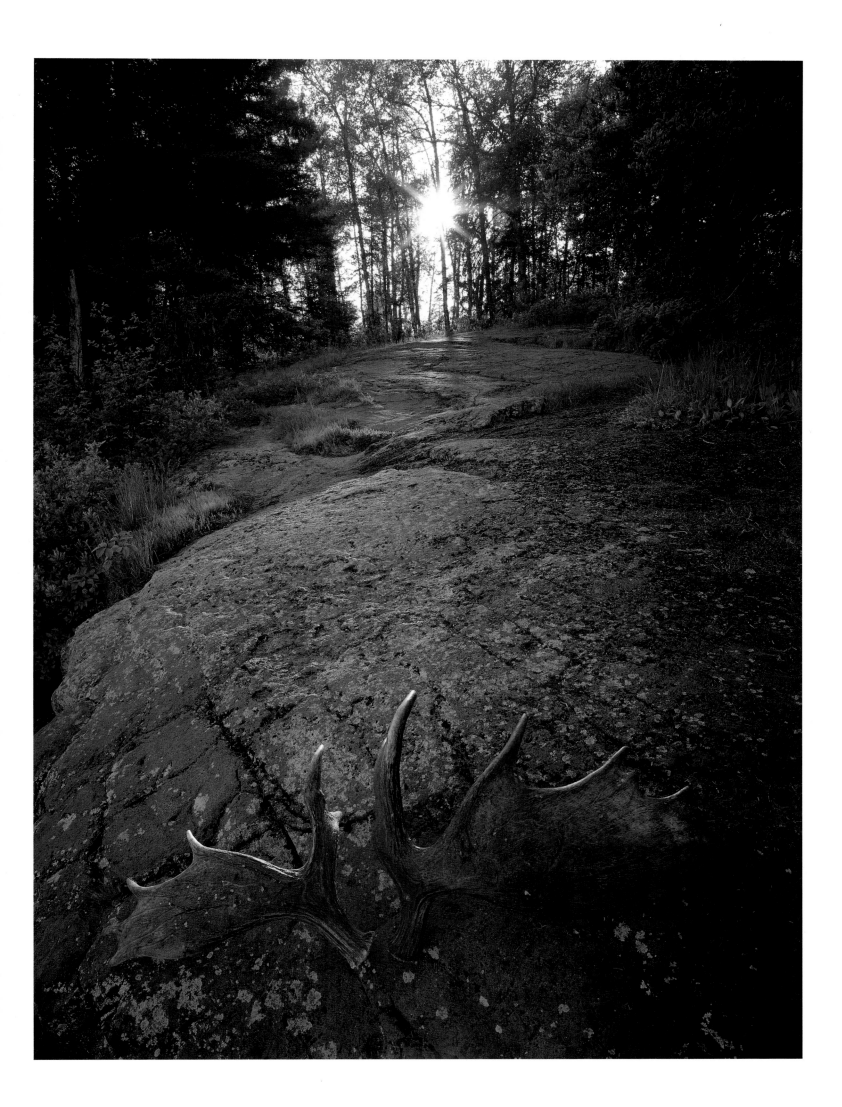

MOOSE ANTLERS, LAKE RITCHIE

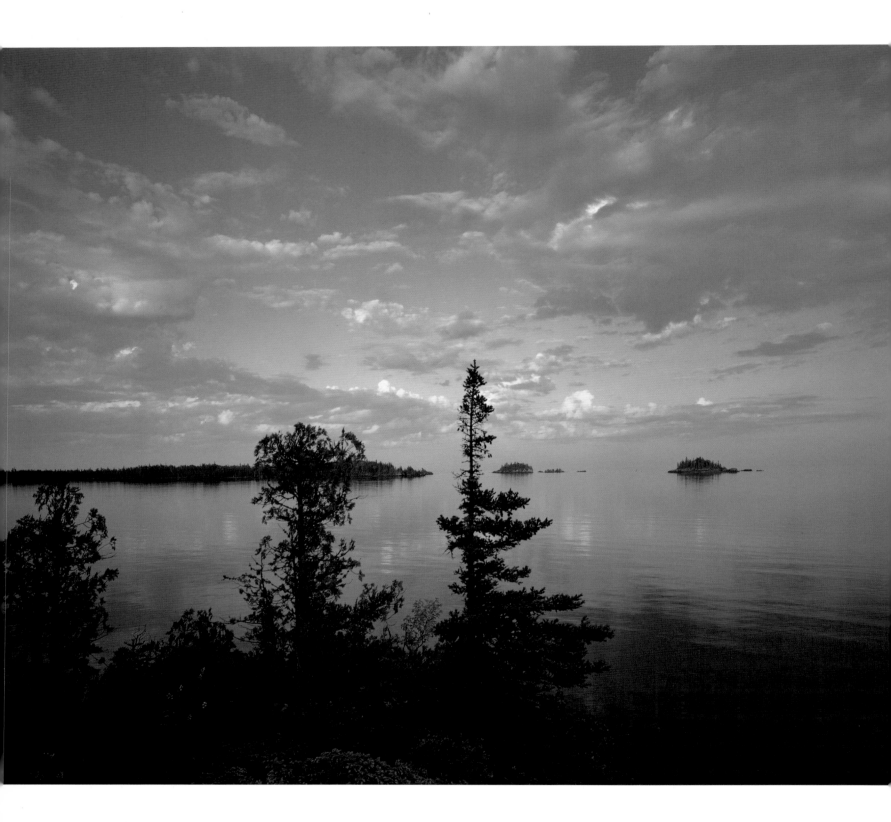

QUIET EVENING, ROCK HARBOR

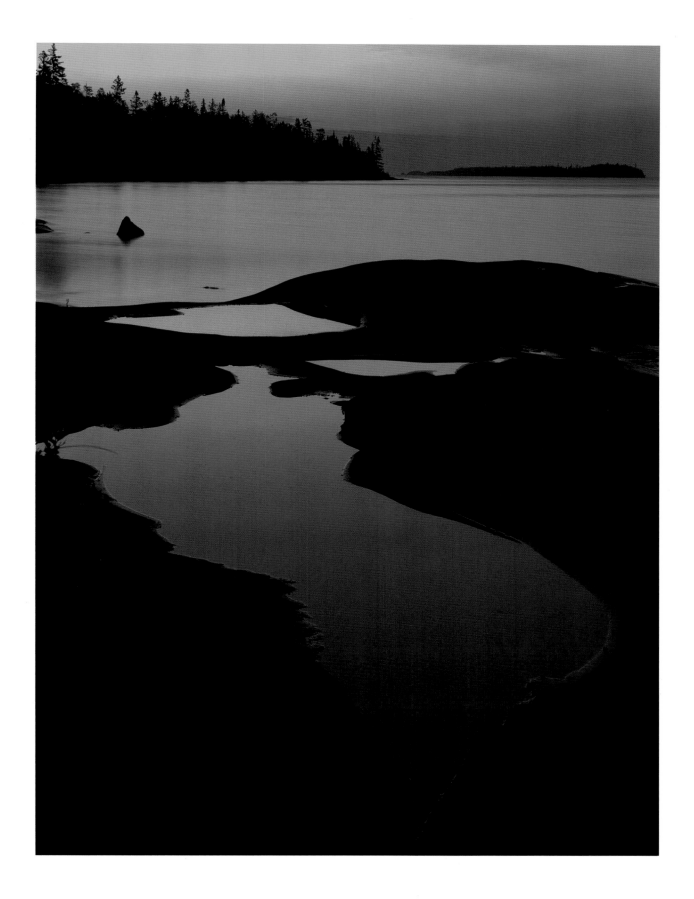

DAWN POOLS AT THREE MILE, LAKE SUPERIOR

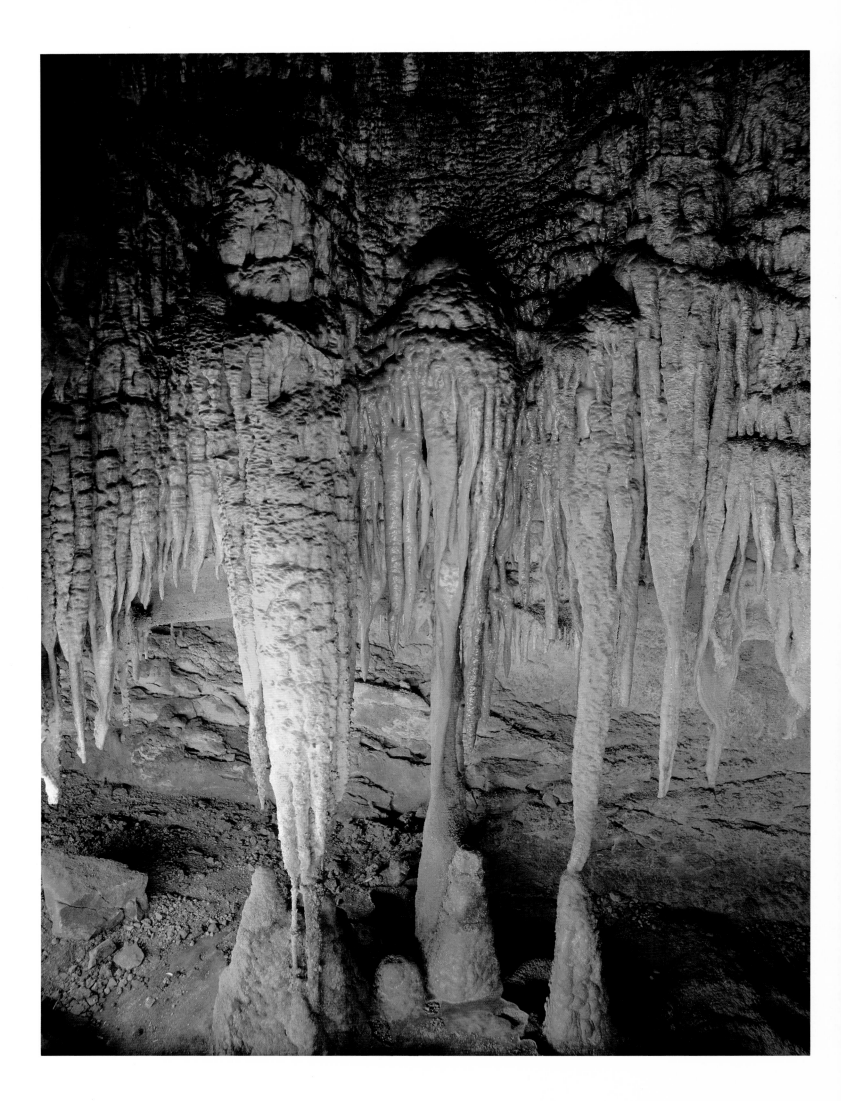

STALACTITES, STALAGMITES, AND COLUMNS IN MAMMOTH CAVE

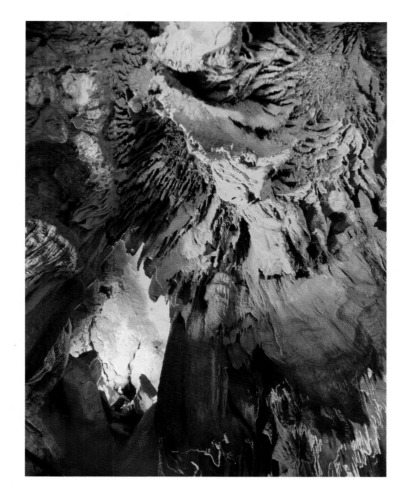

DRAPERIES AND FORMATIONS IN MAMMOTH CAVE

*A limestone labyrinth of*

*honeycombed passageways,*

*Mammoth is the world's largest*

*known cavern system. Features*

*inspire namesakes of Broadway,*

*Fat Man's Misery, Bottomless Pit,*

*Ruins of Karnak, Frozen Niagara,*

*Moonlight Dome, Established 1941*

*and is a World Heritage Site and*

*International Biosphere Reserve.*

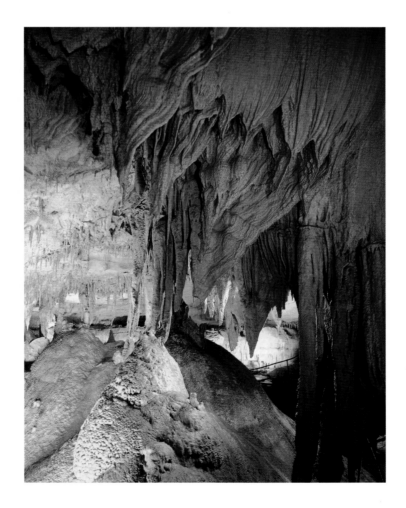

DRAPERY FORMATIONS IN THE DRAPERY ROOM

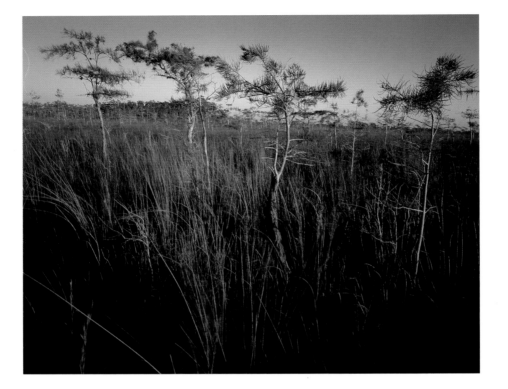

DWARF CYPRESS STRAND, EVERGLADES

*A fragile and threatened subtropical*

*wilderness — River of Grass — of*

*sawgrass prairie, mangrove*

*swamp and dense hammock, is*

*home to the alligator at the southern*

*tip of the Everglades. Big Cypress is*

*a mosaic of sandy islands, tree*

*islands, wet and dry prairies,*

*marshes, and coastal mangrove.*

*Established 1947 and 1974, and*

*is a World Heritage Site and*

*International Biosphere Reserve.*

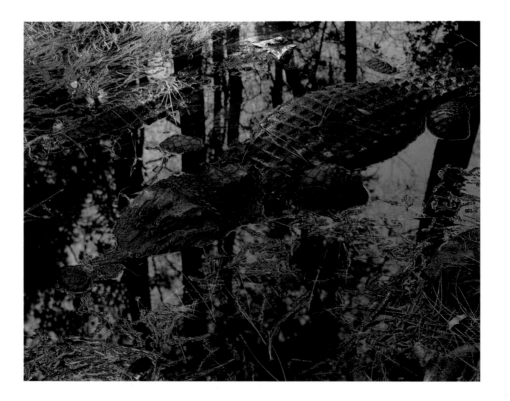

ALLIGATORS, ROBERTS STRAND, BIG CYPRESS

CABBAGE PALMETTO, SHARK RIVER SLOUGH

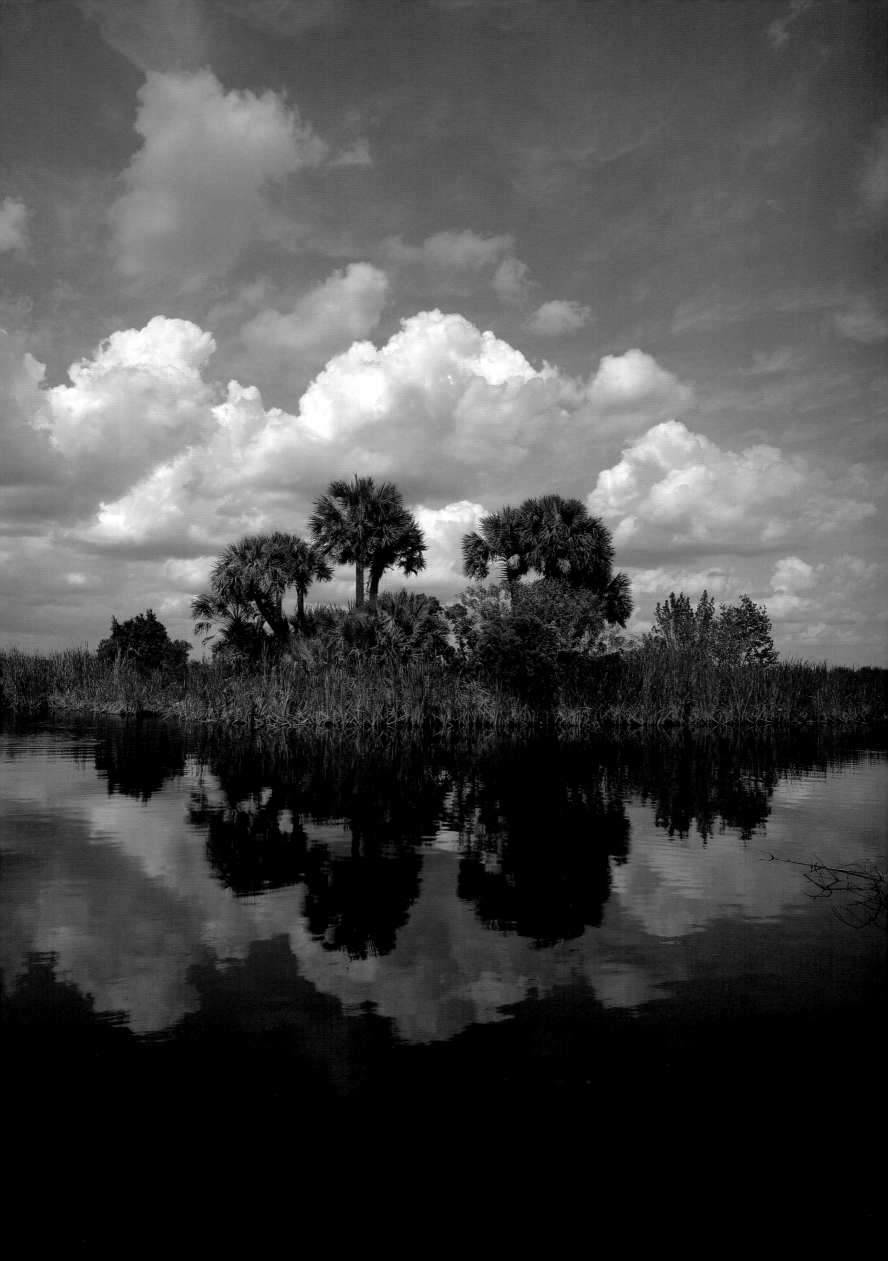

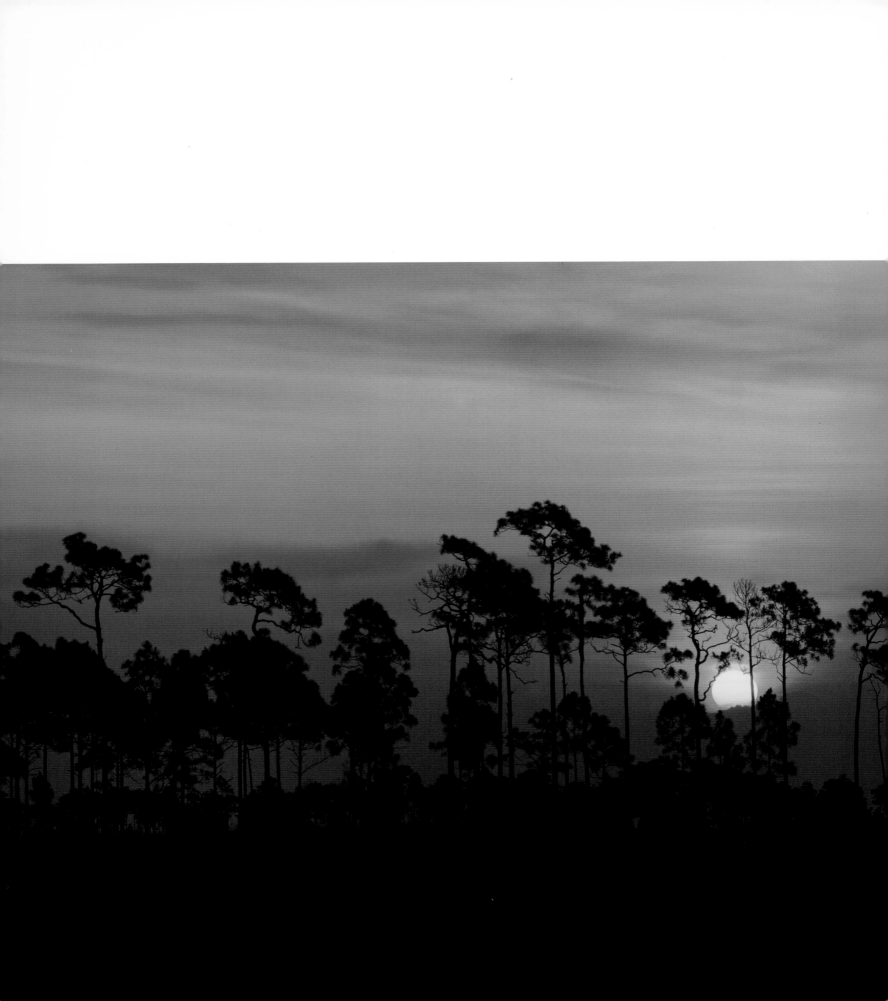

SUNRISE IN PINE GLADES, PA-HAY-OKEE

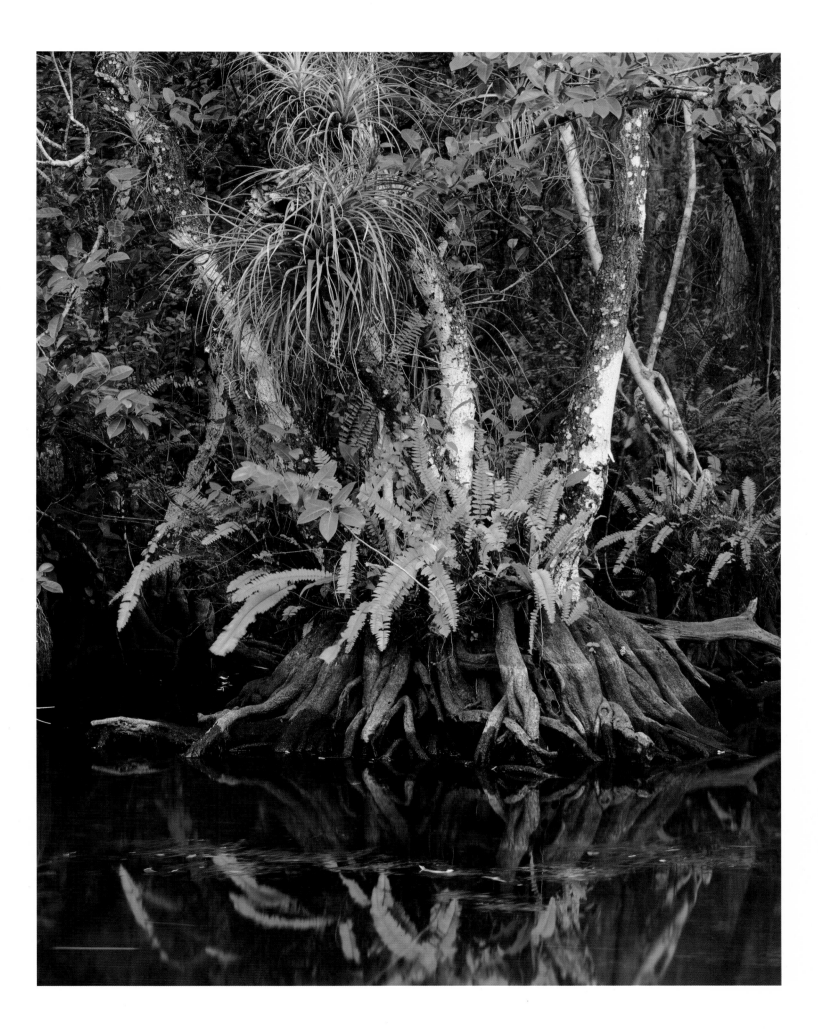

ROBERTS STRAND IN BIG CYPRESS SWAMP

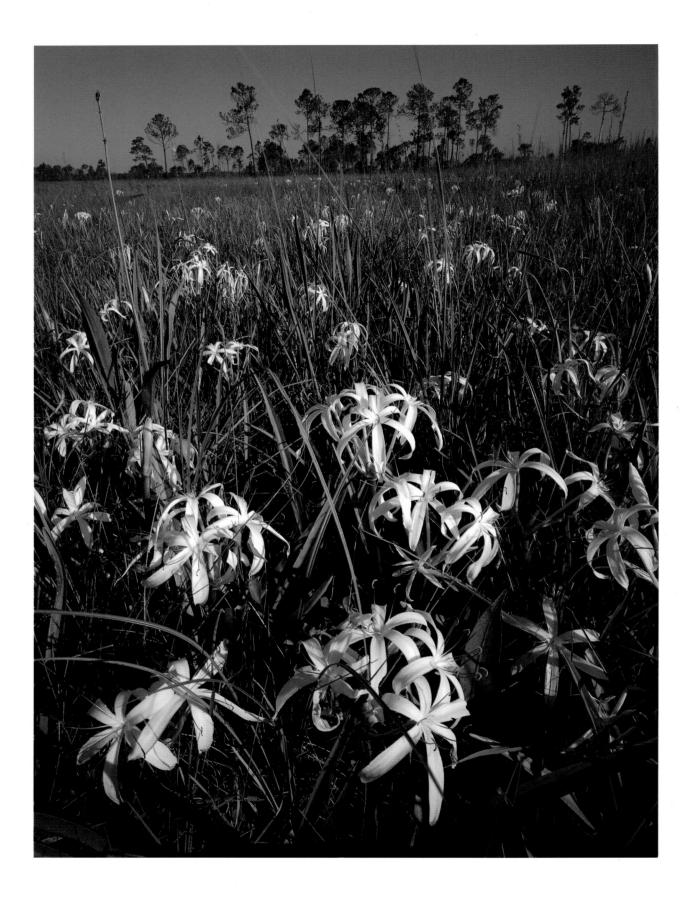

SWAMP LILIES, PINELANDS, PA-HAY-OKEE, EVERGLADES

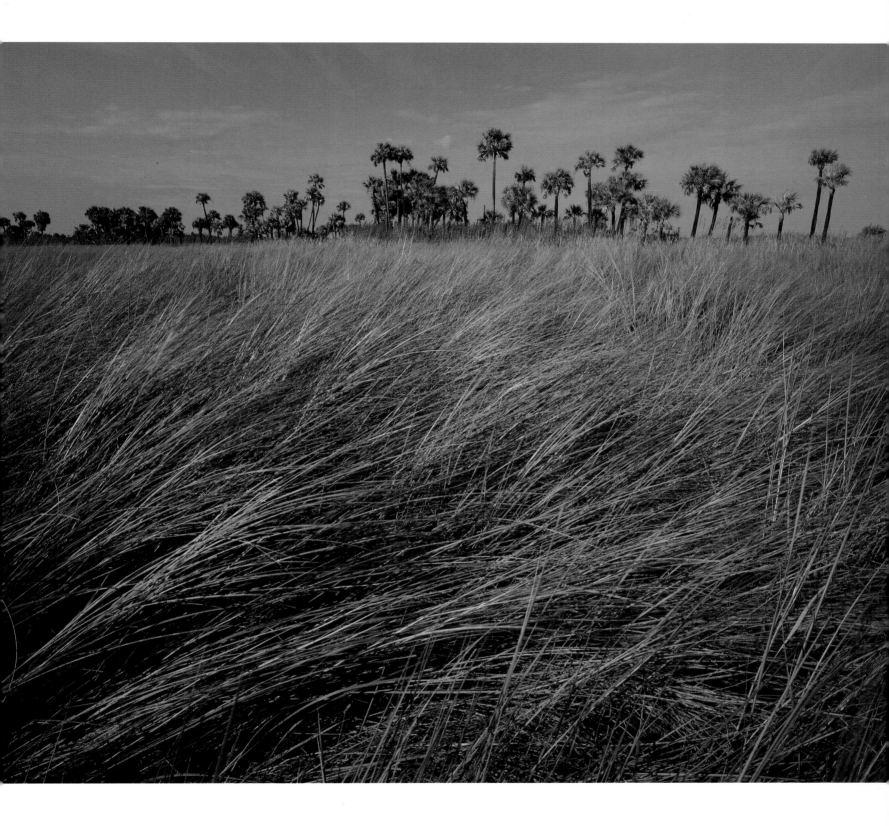

SAWGRASS WET PRAIRIE, BIG CYPRESS PRESERVE

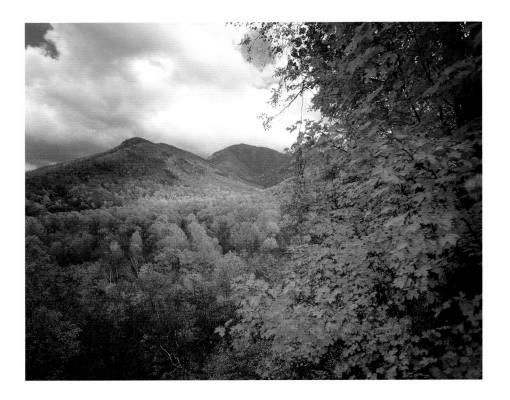

MOUNT LE CONTE WESTSIDE, AUTUMN

*Ice Age glaciers stopped short of the Smokies, giving a great mosaic of plant diversity. A mountainous terrain preserves the world's best examples of deciduous forest, including rhododendron and mountain-laurel. Blooming species flourish here and in the open heath balds. Water and hydrocarbons from the leaves create "smoke." However, air pollution is cutting visibility severely. Established 1934, and is an International Biosphere Reserve.*

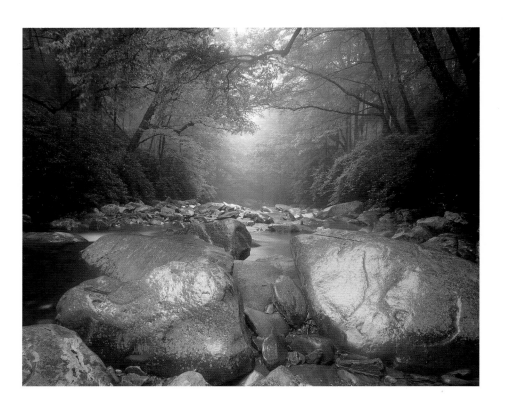

SPRING, WEST PRONG LITTLE PIGEON RIVER

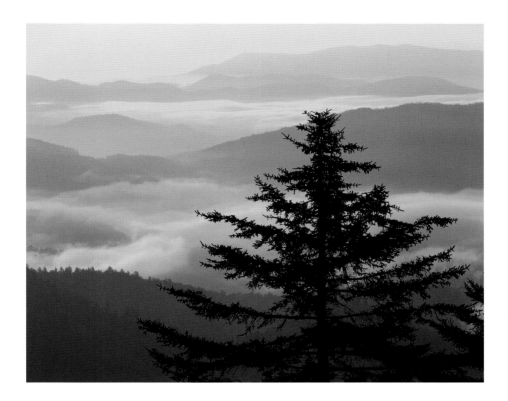

FOG AND SPRUCE, CLINGMANS DOME

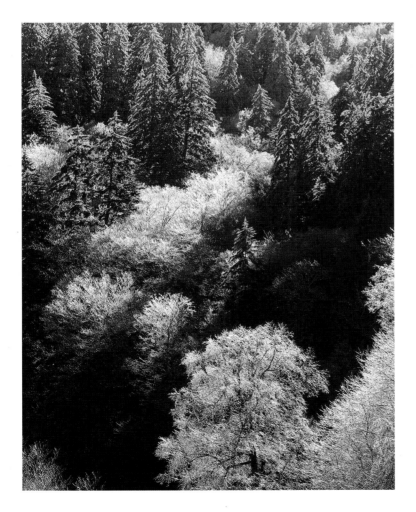

ICED FOREST, NEWFOUND GAP

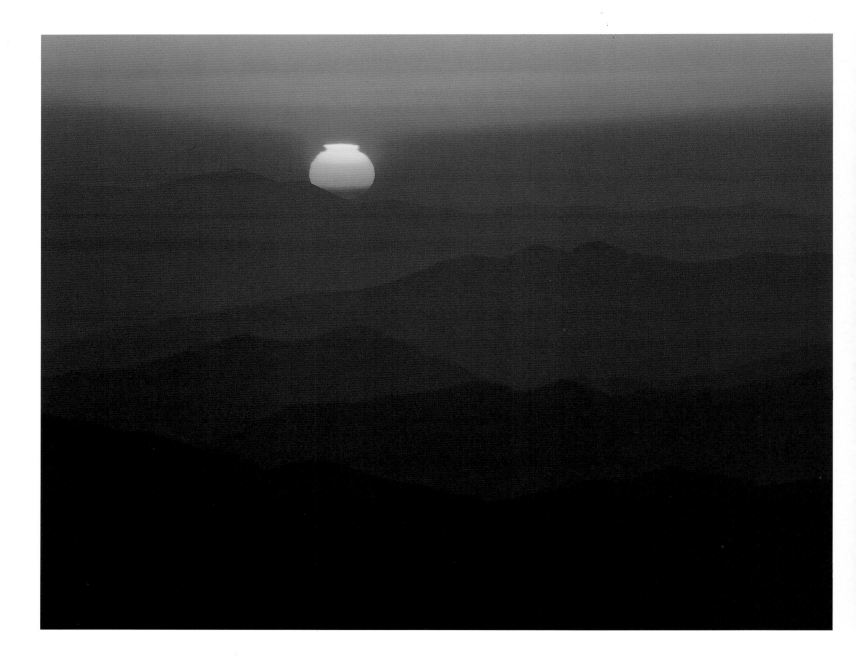

SUNSET AND FORESTED RIDGES, CLINGMANS DOME

STORMY RIDGES ABOVE DEEP CREEK DRAINAGE

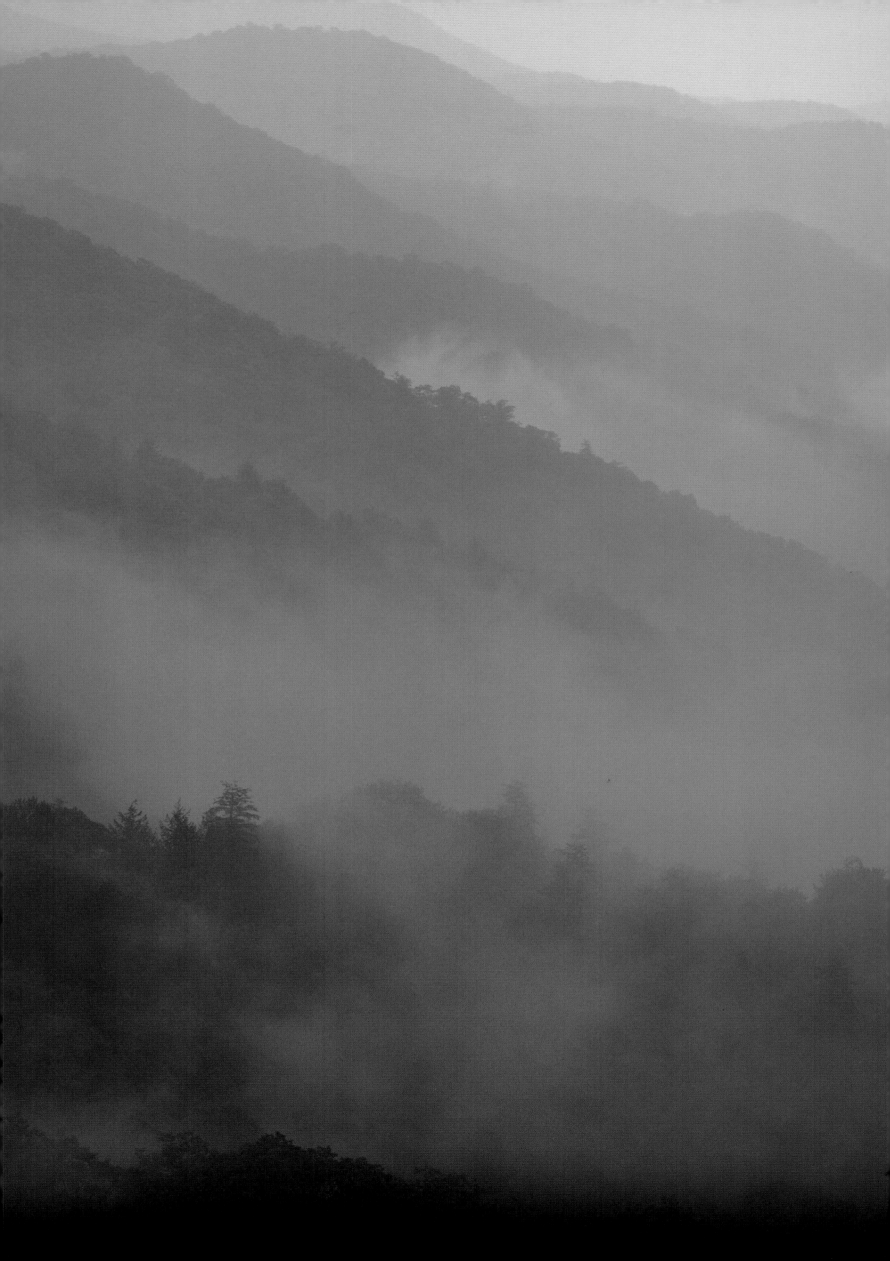

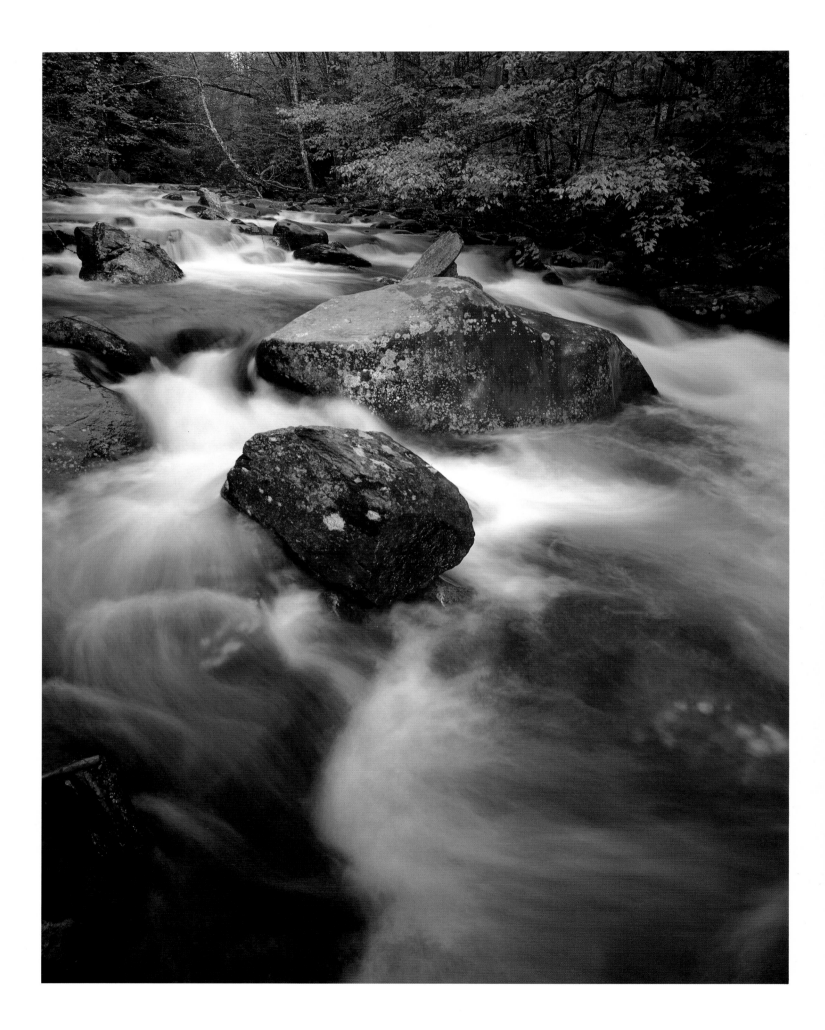

AUTUMN FLOW OF OCONALUFTEE RIVER

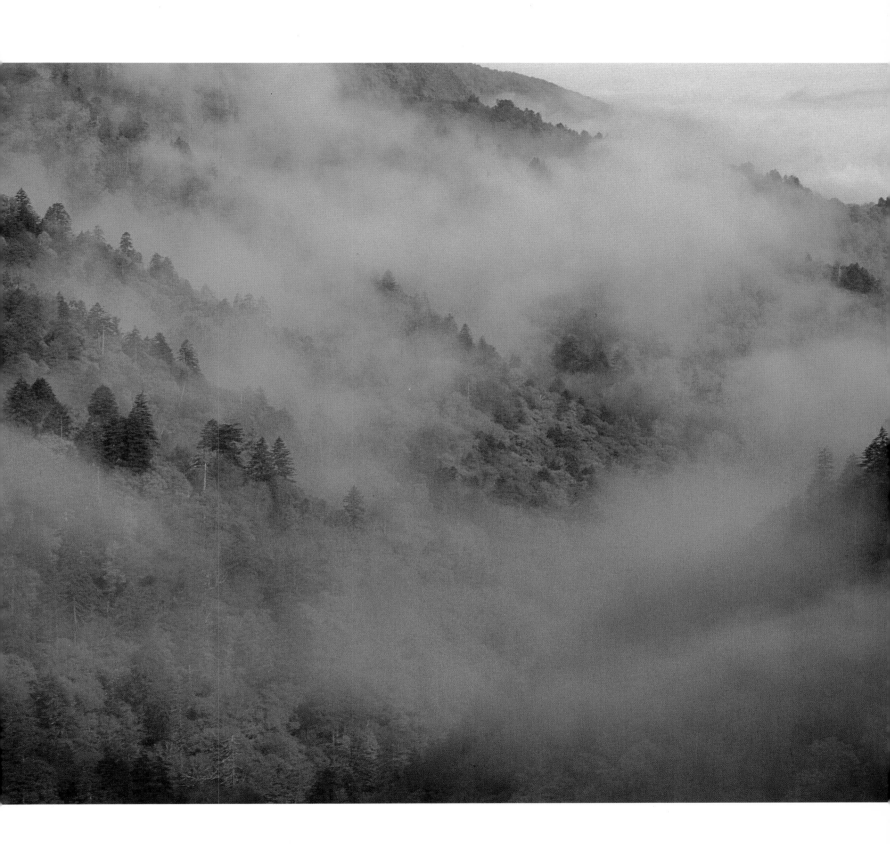

SPRING FOG, ABOVE WEST PRONG LITTLE PIGEON RIVER

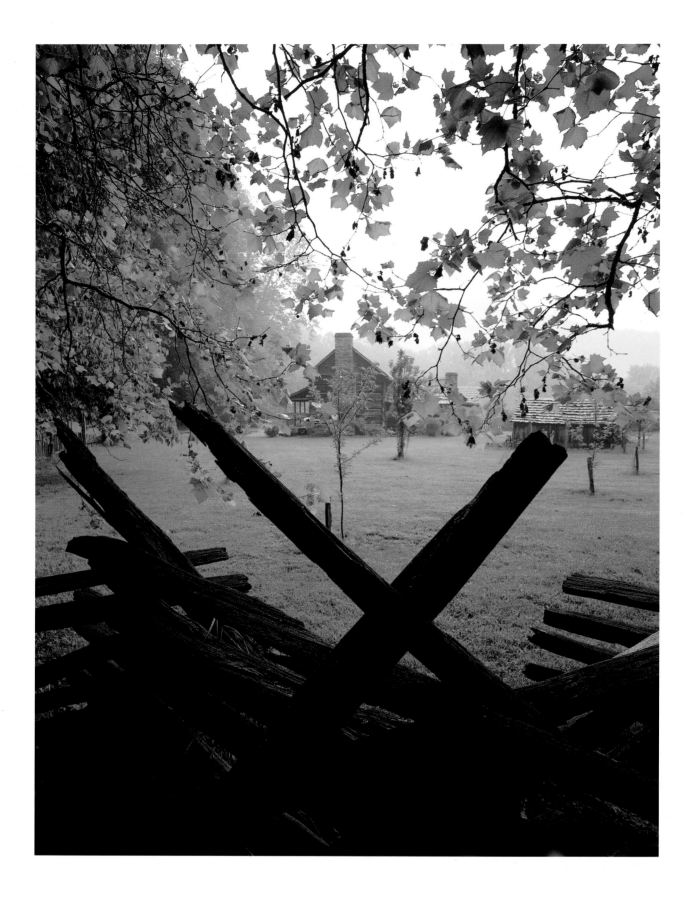

PIONEER FARMSTEAD, OCONALUFTEE

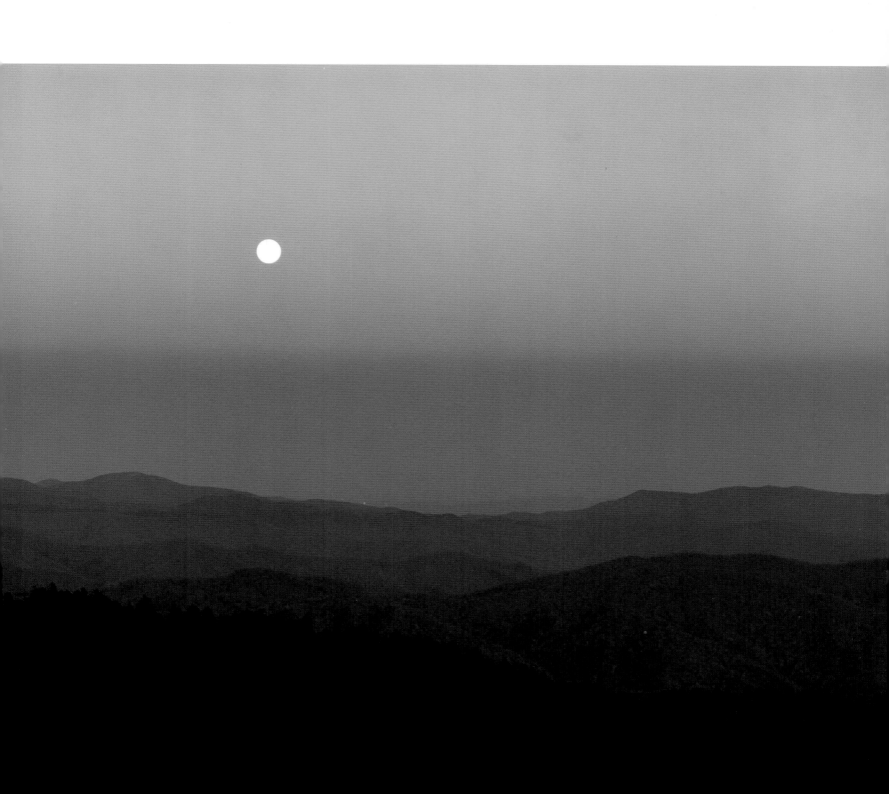

MOONRISE AND RIDGES EAST OF CLINGMANS DOME

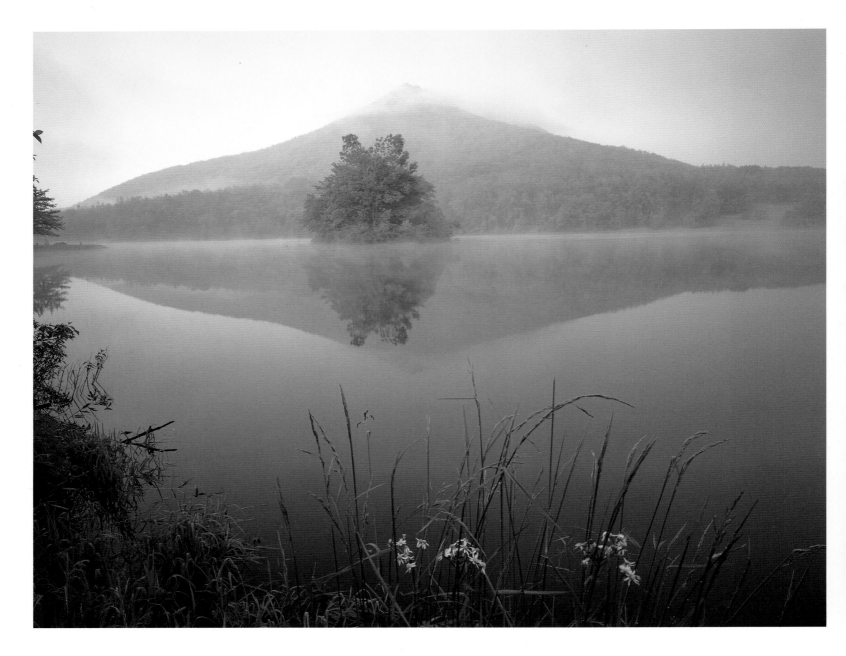

SHARP TOP PEAK, PEAKS OF OTTER

*The Blue Ridge Parkway travels*

*along the crests of the Southern*

*Appalachians for 469 miles,*

*linking together Great Smoky*

*Mountains and Shenandoah*

*national parks. Endless viewpoints*

*access parallel and cross ranges.*

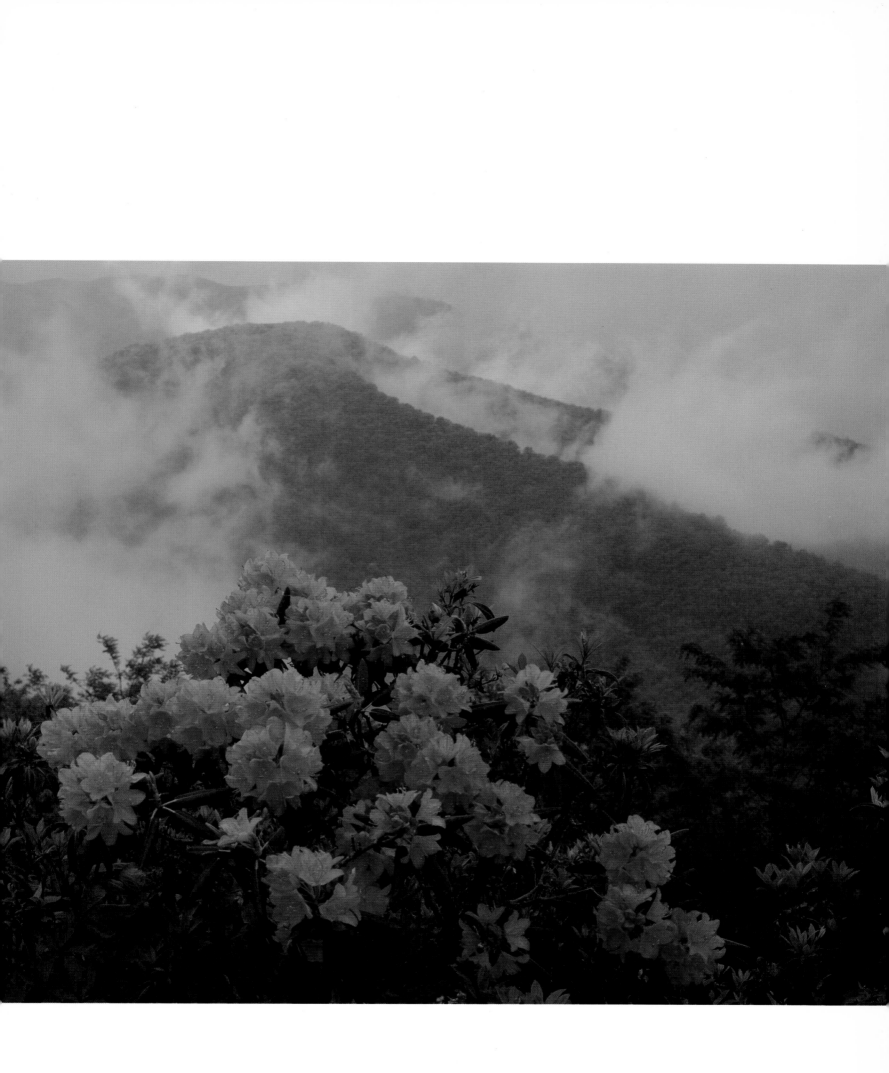

RHODODENDRON AND BLUE RIDGE, DOUGHTON PARK

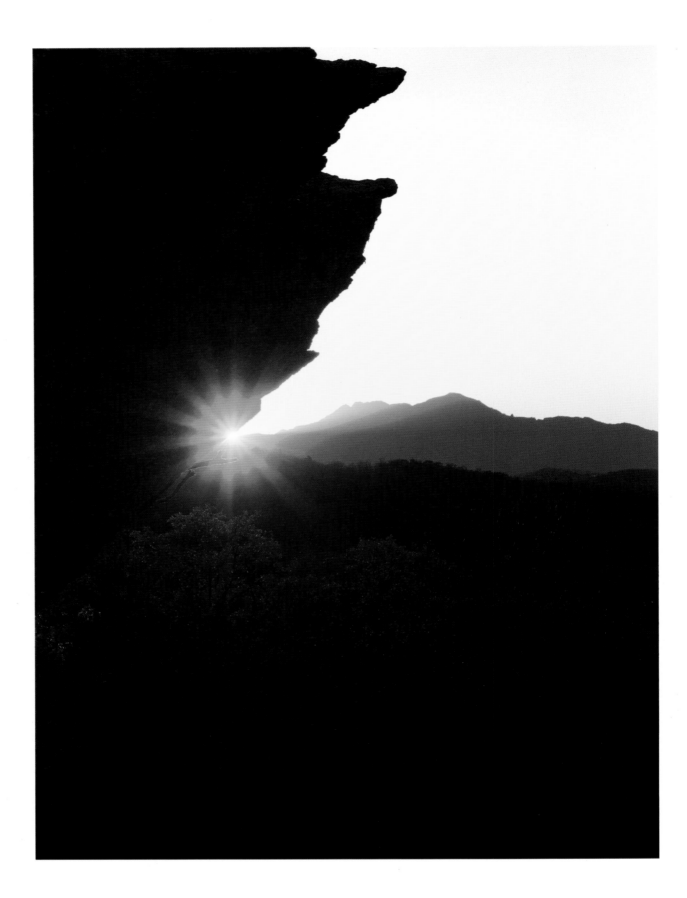

GRANDFATHER MOUNTAIN ALONG BLUE RIDGE

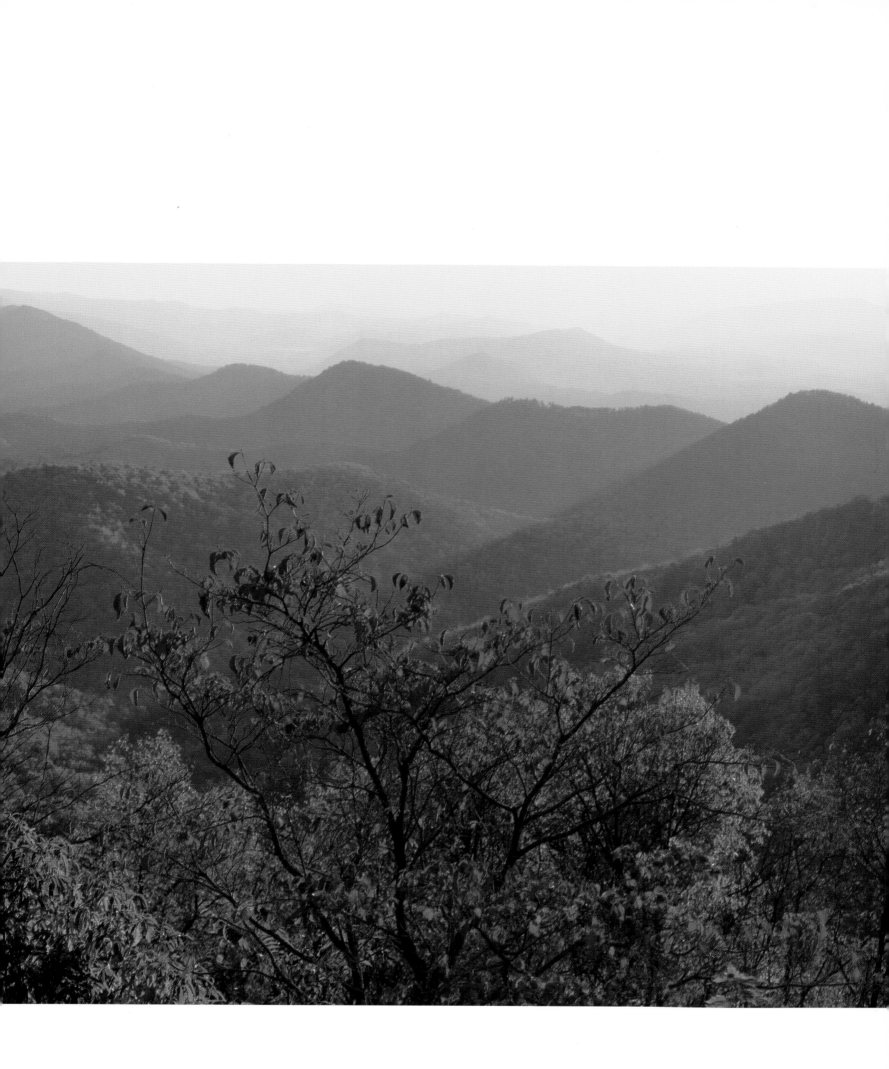

AUTUMN, BLUE RIDGE NEAR DEEP GAP

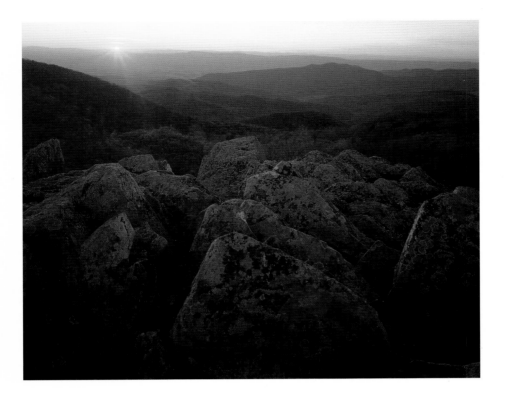

SHENANDOAH VALLEY, BEAR FENCE MOUNTAIN

*A spectacular landscape unfolds*

*from this continuation of the*

*Blue Ridge along Skyline Drive.*

*The Appalachian Trail parallels*

*the road for the whole length*

*of the park. It also follows*

*the ridgeline of the Great*

*Smokies on the total 2,147-mile*

*trek from Georgia to Maine.*

*Shenandoah established 1935.*

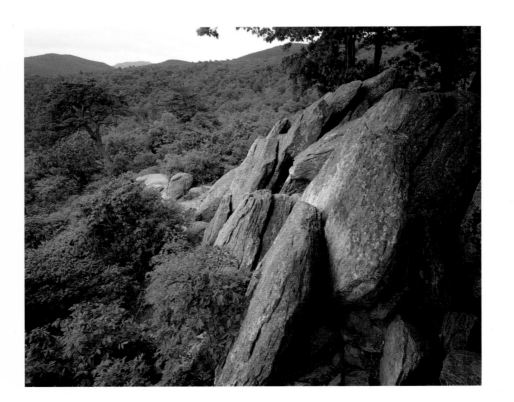

HAZEL MOUNTAIN OVERLOOK

DARK HOLLOW FALLS, BIG MEADOWS

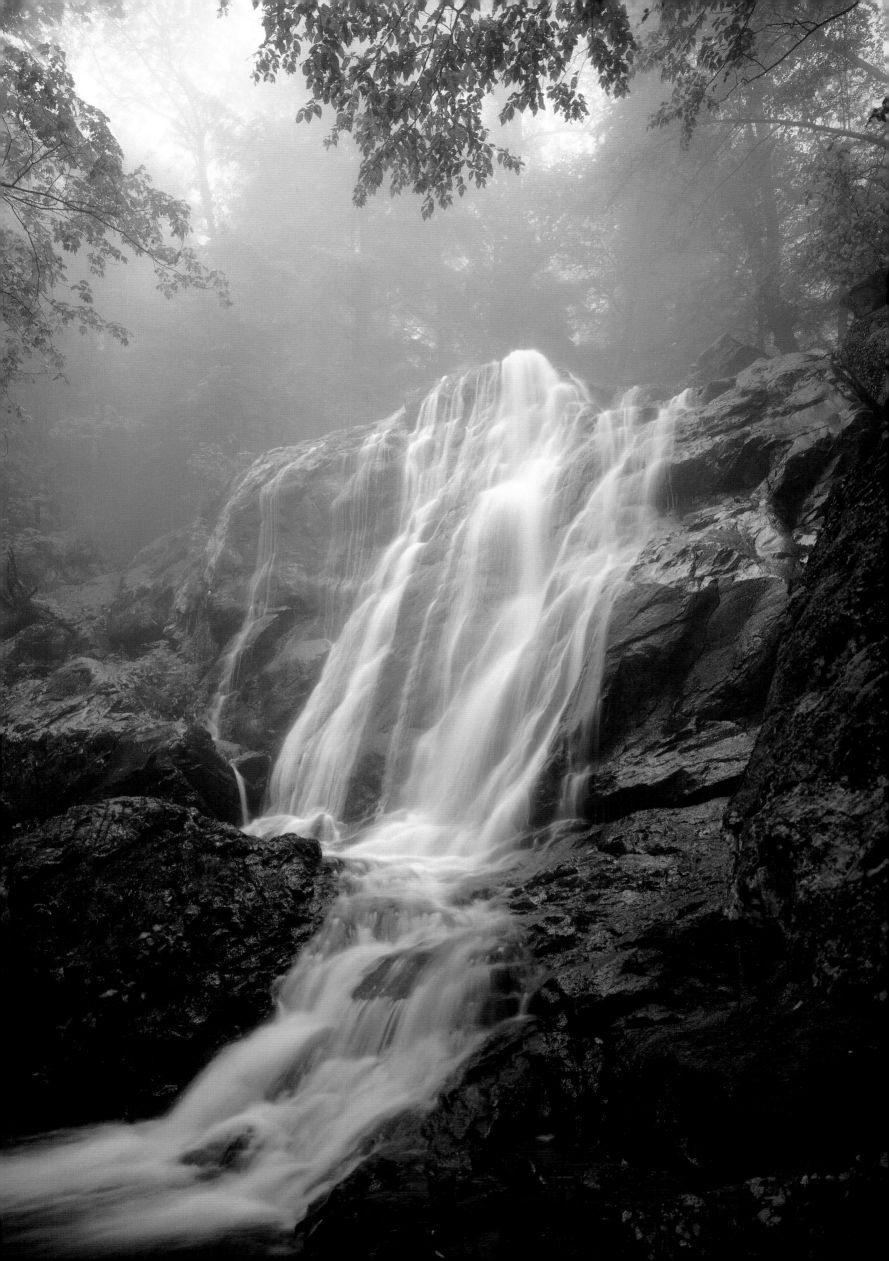

AUTUMN FOREST, ELK WALLOW

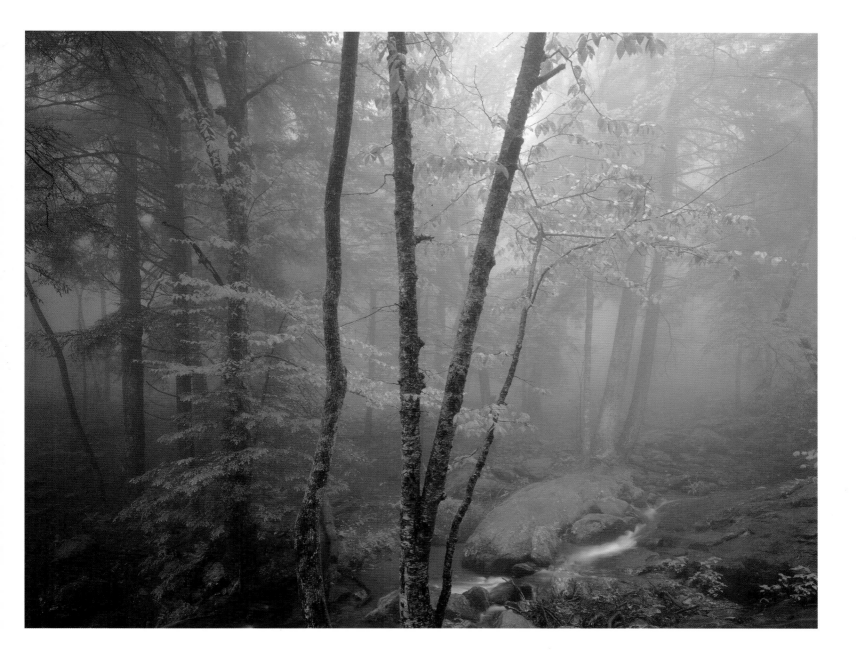

SPRING FOREST IN DARK HOLLOW

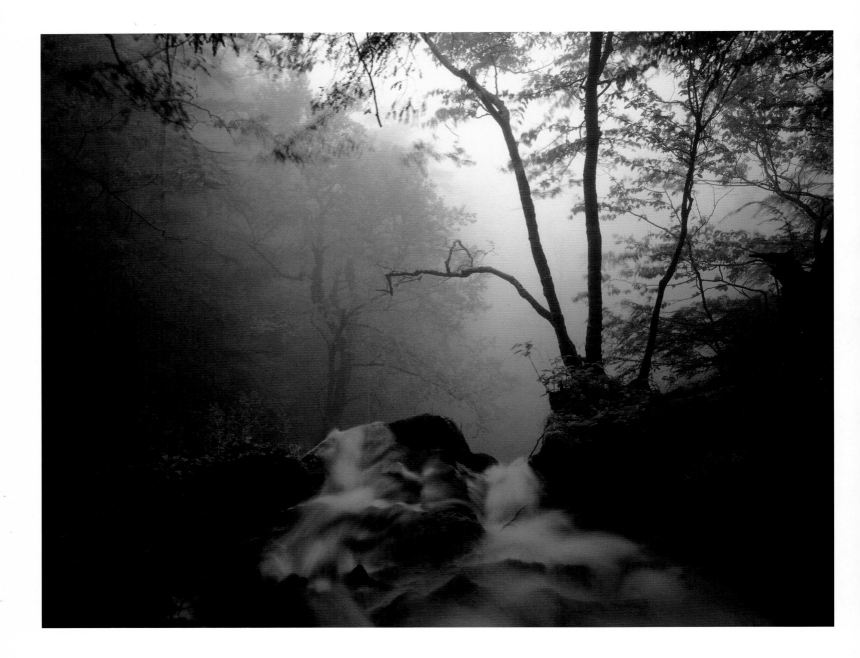

TOP OF LEWIS FALLS, BIG MEADOWS

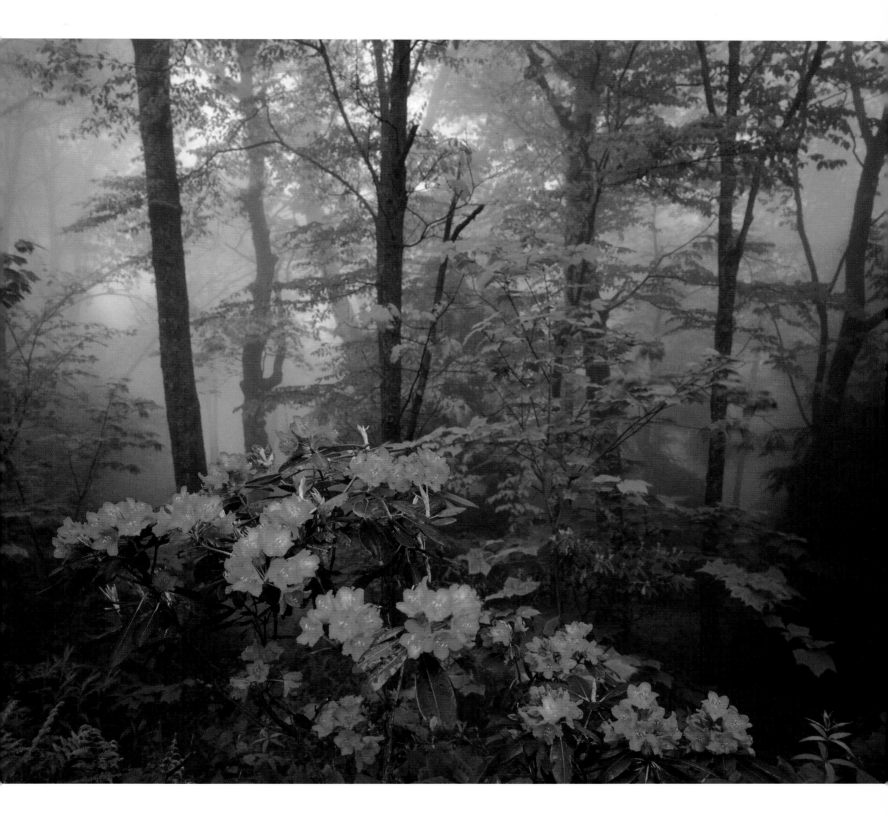

RHODODENDRONS IN HARDWOOD FOREST

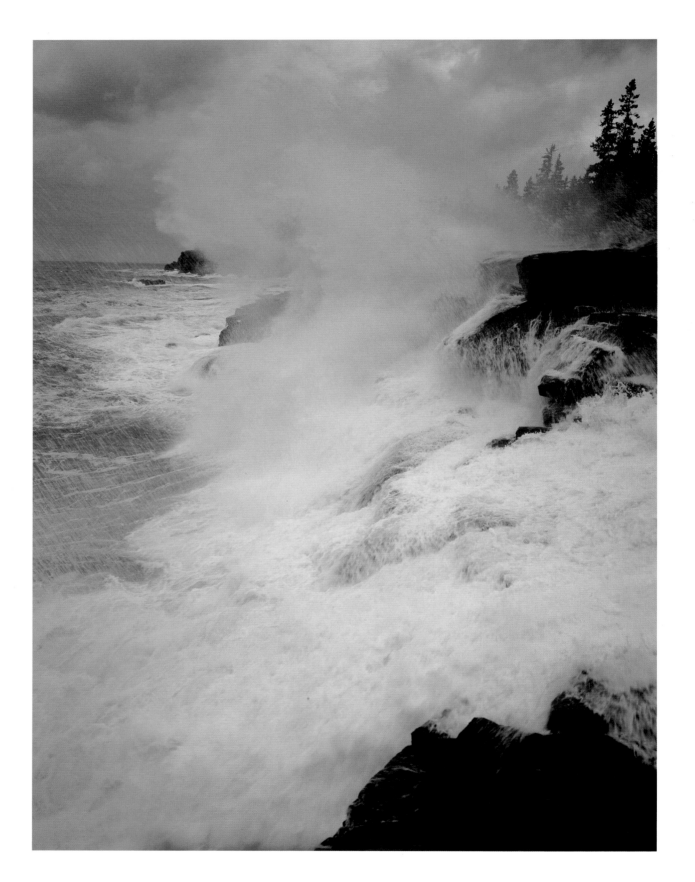

ATLANTIC STORM WAVES ALONG OTTER CLIFFS

*Acadia preserves an undeveloped natural beauty of the New England coastline.*

*Sea and mountain meet spectacularly on Mount Desert Island, so named in 1604*

*by Champlain for its barren granitic ridges. Muting fogs roll in off the sea,*

*encircle the glacially carved domes and lake troughs with namesakes like Cadillac,*

*Sargent, Dorr-Eagle, Jordan Somes, and Bass Harbor. Established 1919.*

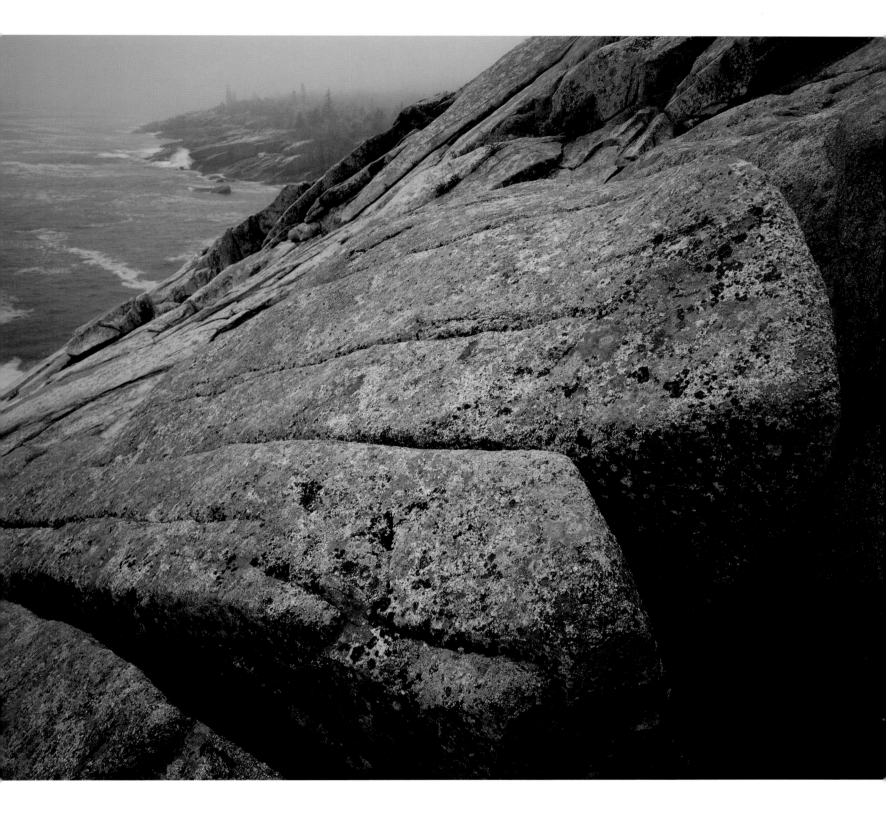

GRANITE SHORELINE AND OTTER CLIFFS

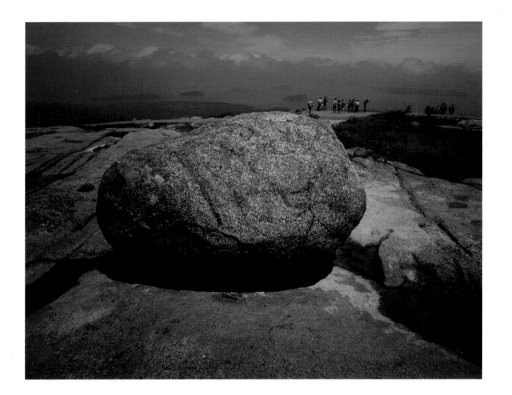

GLACIAL ERRATIC ON CADILLAC MOUNTAIN

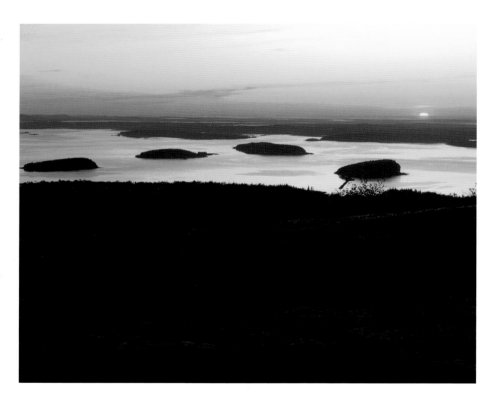

SUNRISE, CADILLAC MOUNTAIN, FRENCHMAN BAY

LICHEN DESIGN ON GRANITE, CADILLAC MOUNTAIN

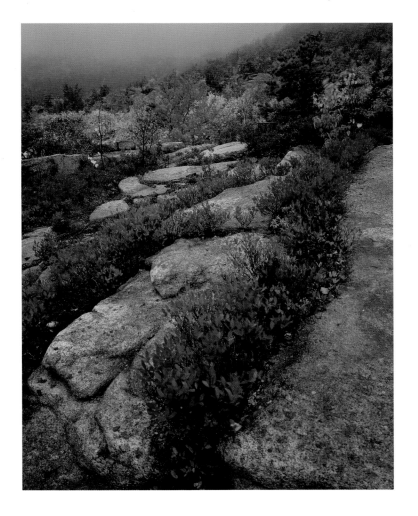

AUTUMN ON CHAMPLAIN MOUNTAIN GRANITES

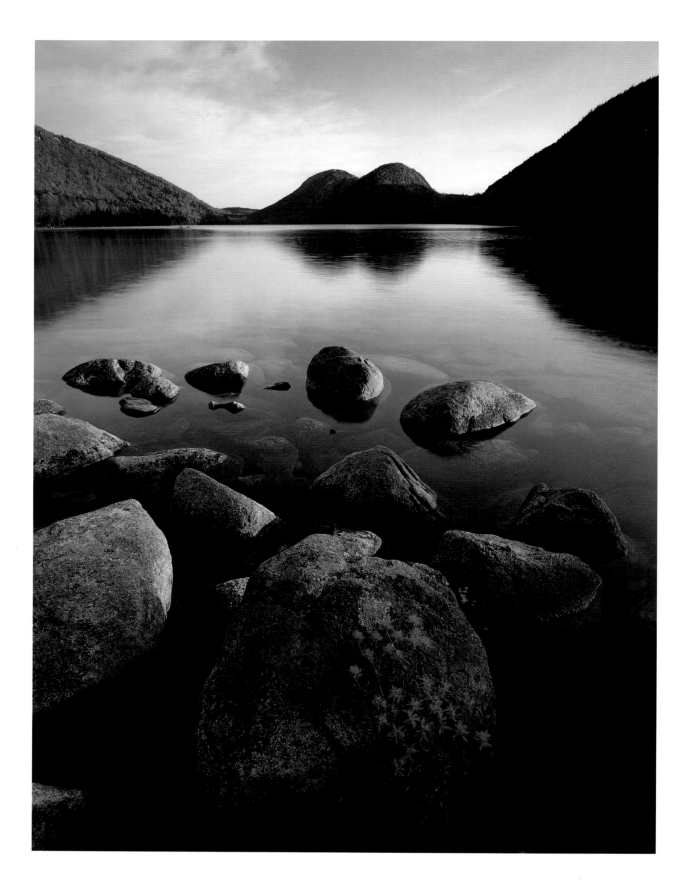

JORDAN POND AND THE BUBBLES

AN ODE TO OUR NATIONAL PARKS
by David Muench

This collection of photographs has its beginnings in a deep initial fascination with the national parks—islands of earth forms of beauty, sanctuaries so symbolic of a great American idea. For me, their inspiration has led to innumerable events, responses, and connections to intangibles and the delicate balance of energy interacting between landscape and my personal perceptions. Sacred and spiritual, the national parks, with their primal beauty, have focused and transformed my vision into a sense of reality, a kind of super realism that reveals the vital essence of wildness in the American landscape. Surprisingly, the theme of this book could clearly be an ode to wilderness—as large portions of the parks are preserved under a designation of Wilderness.

An ever-deepening fascination with elusive and timeless moments occurring in the landscape has given me an ideal way to share with others what I strongly feel about our national parks. It is an ongoing devotion—a searching eye—hopefully echoing these aspects of an elite core of our traditional parks. My intentions for the flow of images are a personal representation and inclusion of the great natural features I feel express each park's individuality. Added emphasis is made for the parks and preserves having a World Heritage designation because of their unique and global significance.

My involvement in photography is all about the awareness of light and its varying intensity. This is a celebration of familiar impressions—a response to the purest of form—the most mysterious of light. Mood and drama are an important function for me to express a sense of place. Symbolic relationships, dynamic moments, and water reflections play important roles in the fabric of my expression.

A split second may create the final photograph, despite the extensive travel and time-consuming effort made to capture this special moment. An intuitive quest to understand and explore the wilderness has guided me to be patient through the mysterious and magical flow of the daily and seasonal cycles.

The inspirations and challenges have been mine; hopefully, these photographs may help to rekindle our curiosity, intuition, and imagination in discovering beauty in our national parks and in bringing another gentle voice in the wilderness for a heightened awareness of the role of our national parks—as a special habitat, as enduring places to wonder and enjoy—and to understand our relationship to the natural world around us.

Equipment used for much of the photography is a mix between large-format (4" x 5") Ektachrome 64 and Fujichrome Velvia, to small-format (35mm) Kodachrome and Fujichrome Velvia. Some filtration is used sparingly, and a solid tripod also was used in most instances, all to render a quality level for optimum expression.

Thanks to Stuart Udall and James Udall for their superb statement on the changing role for the National Park Service and its stewardship of the national park idea. Thanks also to Marc Muench for his images on pages 25, 30, 31, 53, 55, 59, 61, 130, and 207.

RHODORA BLOOMS, ACADIA